Understanding Digital Humanities

Also by David M. Berry

COPY, RIP, BURN: The Politics of Copyleft and Open Source
THE PHILOSOPHY OF SOFTWARE: Code and Mediation in the Digital Age
LIBRE CULTURE: Meditations on Free Culture (*co-edited with Giles Moss*)

Understanding Digital Humanities

Edited by

David M. Berry
Senior Lecturer, Swansea University

First published 2012 by
PALGRAVE MACMILLAN

Palgrave Macmillan in the UK is an imprint of Macmillan Publishers Limited,
registered in England, company number 785998, of Houndmills, Basingstoke,
Hampshire RG21 6XS.

Palgrave Macmillan in the US is a division of St Martin's Press LLC,
175 Fifth Avenue, New York, NY 10010.

Palgrave Macmillan is the global academic imprint of the above companies
and has companies and representatives throughout the world.

Palgrave® and Macmillan® are registered trademarks in the United States,
the United Kingdom, Europe and other countries.

ISBN: 978–0–230–29264–2 hardback
ISBN: 978–0–230–29265–9 paperback

This book is printed on paper suitable for recycling and made from fully
managed and sustained forest sources. Logging, pulping and manufacturing
processes are expected to conform to the environmental regulations of the
country of origin.

A catalogue record for this book is available from the British Library.

A catalog record for this book is available from the Library of Congress.

10 9 8 7 6 5 4 3 2 1
21 20 19 18 17 16 15 14 13 12

Printed and bound in Great Britain by
CPI Antony Rowe, Chippenham and Eastbourne

For Felicity Ann Berry Hale

Contents

Illustrations

Table

Figures

Acknowledgements

This book is partly a result of a workshop organised at Swansea University called 'The Computational Turn', which explored key issues around software, code, the digital humanities and related themes. I would like to take this opportunity to thank Nikki Cooper, the Callaghan Centre for the Study of Conflict, Power, Empire, and the Research Institute for Arts and Humanities (RIAH) at Swansea University for funding it. Thanks also to N. Katherine Hayles and Lev Manovich and the other participants at this workshop who enthusiastically discussed many of the themes pertinent to this book in a rigorous and critical setting, including Noel Thompson, Helen Fulton, Christian De Cock, Peter Bloom, Mireille Hildebrandt, Joris Van Zundert, Smiljana Antonijevic, Kirsti Bohata, Bernhard Rieder, Theo Roehle, Dan Dixon, Yu-wei Lin, Scott Dexter, Federica Frabetti, Adelheid Heftberger, David Gill, Tim Cole, Alberto Giordano, Kevin Hayes, Marek Sredniawa, Joaquim Ramos de Carvalho, Sian Rees, Leighton Evans, Mostyn Jones, Adam Ganz, Fionn Murtagh, Andrew Klobucar, Tom Cheesman, William Merrin, Alkim Almila Akdag Salah, Morgan Currie, Annamaria Carusi, Yuk Hui and Julian Preece. I would like to thank Peter Jones for filming the keynote speakers and Sian Rees for assisting in the organisation of the conference, together with members of RIAH. I would also like to thank students on the MA Digital Media course who helped out on the day. Thanks are also due to Marcus Leis Allion for his continual support and excellent graphic design for the cover of this book. Additionally, I am grateful to the anonymous reviewers of the book manuscript for their helpful comments and criticisms.

This book would not have been possible without the support and generosity of a great number of friends and colleagues at Swansea University and elsewhere who also find the Computational Turn in both the arts and humanities and social sciences extremely interesting. It is also testament to the support of a distinctive research culture at Swansea University, enabling new areas of speculative and theoretical research into digital humanities and computationality more generally. I am grateful for the opportunity that has been given to create this anthology – in particular, thanks are due to the Head of College, Professor John Spurr, and Pro Vice Chancellor Professor Noel Thompson, who are committed to excellent research in the College of Arts and Humanities at Swansea.

With this book my family wisely decided that they would spend the editing period sojourned in Norway while I enjoyed Oslo vicariously during February and March 2011. I am grateful to Arne Andreassen and Tullen Bjørkmann for

graciously allowing us the use of their apartment during this time. I would also like to thank Noragric, Universitetet for miljø- og biovitenskap (UMB), and particularly Stig Jarle Hansen and Mohamed Husein Gaas, for the *Gjesteforskerstipend* which allowed me to stay in Oslo during June and July 2011 to undertake corrections to the manuscript. My gratitude is also extended to Anders Fagerjord for his kind invitation to IMK at the University of Oslo. I would also like to acknowledge the generous support of The Research Council of Norway and their Yggdrasil research fellow award ref: 211106/F11 supporting my sabbatical leave in Oslo during 2012. Finally, thanks, as always, to my wife, Trine, for her continual help and support throughout the writing process.

Contributors

Tara L. Andrews is a researcher and developer at the Catholic University, Leuven. She holds a PhD in Oriental Studies from Oxford and a degree in Computer Science from MIT. She was a lecturer of Byzantine History at Oxford University before moving to a research position at Leuven. Her research interests lie in Byzantine and Armenian history; her current work also focuses on computational stemmatology and text transmission studies.

Smiljana Antonijevic is Assistant Professor of Culture and New Media at Roskilde University. Smiljana holds a PhD in Rhetoric and Communication from the University of Minnesota–Twin Cities, a Master's in Social Anthropology, and BA in both Social Anthropology and Music. Her research interests intersect the areas of communication, culture and technology, and her work has appeared in edited volumes and peer-reviewed journals such as *The Sage Handbook of Rhetorical Studies* and *Information Communication and Technology*. Smiljana worked as a researcher at the Virtual Knowledge Studio and Alfalab between 2009 and 2011.

Caroline Bassett is Reader in Media and Film and Director of Research in the School of Media, Music and Film at the University of Sussex. She is the author of *The Arc and the Machine* (2007) on digital narrative, and her research interests include writing on gender, technology and culture. She has also written on the politics of anti-noise, on gender and medium theory, and on Firestone, early feminism, and hope. She is currently researching campaigns against computerisation and her book on this subject titled *Anti-Computing* is forthcoming in 2012.

Anne Beaulieu is Project Manager of the Groningen Energy and Sustainability Programme at the University of Groningen. She was a senior research fellow at the Royal Netherlands Academy of Arts and Sciences (KNAW), where she also acted as deputy programme leader of the Virtual Knowledge Studio for the Humanities and Social Sciences between 2005 and 2010. A dominant theme in her work is the importance of interfaces for the creation and circulation of knowledge. She has also done extensive work in the field of digital humanities, on new (ethnographic) research methods and on ethics in e-research.

David M. Berry is Senior Lecturer in Digital Media in the Department of Political and Cultural Studies at Swansea University, UK. He is the author of *Copy, Rip, Burn: The Politics of Copyleft and Open Source* (2008), *The Philosophy of Software: Code and Mediation in the Digital Age* (2011), editor of *Understanding*

Digital Humanities (2012), and co-editor, with Giles Moss, of *Libre Culture: Meditations on Free Culture* (2008). His current research is *Critical Theory and the Digital* (forthcoming, 2012).

Morgan Currie studied at the University of Amsterdam and the Institute of Network Cultures (INC), focusing on the economics of the digital commons and shifting practices in publishing and archiving. For the INC, she has co-produced two international conferences (Economies of the Commons 2, 2010, and the Unbound Book, 2011), where she chaired panels exploring the concept of 'open' and specifically how digital cultures promoting ideologies of openness have influenced video production and publishing. She has edited books and anthologies on new media topics and is currently a PhD candidate at UCLA's School of Information.

Karina van Dalen-Oskam is Head of the Department of Literary Studies/ Textual Scholarship at the Huygens Institute for the History of The Netherlands. Her research focuses on aspects and properties of literary style and literary quality, with special attention to names in literary texts. In her work she frequently applies advanced computational and statistical approaches for literary analysis.

Scott Dexter is Professor of Computer and Information Science at Brooklyn College of the City University of New York, where he has worked since receiving his PhD from the University of Michigan in 1998. He is co-author of *An Introduction to Programming Using Java: An Object-Oriented Approach* (2003) and *Decoding Liberation: The Promise of Free and Open Source Software* (2007), as well as numerous articles and presentations on ethics and technology, the aesthetics of programming, digital image watermarking and computer science pedagogy. He is currently PI or co-PI on three NSF-funded projects which address the pedagogy of linear algebra, cognitive aspects of creativity and programming, and computer ethics education. He recently completed a term as Director of Brooklyn College's Core Curriculum, and continues to serve as chair of the campus chapter of the Professional Staff Congress, the union which represents faculty and academic staff at CUNY.

Dan Dixon is Senior Lecturer at the University of the West of England in Bristol, a resident of the Pervasive Media Studio, and a member of the Digital Cultures Research Centre. He works in the intersection between technology and the humanities and is interested both in the way the humanities can investigate digital technologies and the way they are also transformed by this. His research mixes the disciplines of cultural studies and human–computer interaction to investigate fields such as social media, Web 2.0, ubiquitous computing and computer gaming. Prior to academia he spent ten years in the Web industry, leading multidisciplinary teams on large-scale, complex projects as

well as holding senior management roles. Before the move he had jobs such as senior consultant for a social software company, product manager for the BBC's online communities, and production director for a new media agency, Syzygy.

Leighton Evans is a doctoral candidate at Swansea University studying the use of the location-based social network, Foursquare, and how using this service is involved in an emergent computational ontotheology in users of mobile computational devices. His current work explores the relationship between space, place, user, and locative and mobile technologies.

Federica Frabetti is Senior Lecturer in the Communication, Media and Culture Programme at Oxford Brookes University. She has a diverse professional and academic background in the humanities and ICT and has worked for a decade as a software engineer in telecommunications companies. She has published numerous articles on the cultural study of technology, digital media and software studies, cultural theory, and gender and queer theory. She is the editor and translator of *The Judith Halberstam Reader* (in Italian) and is currently completing a monograph titled *Technology Made Legible: A Cultural Study of Software*. She is also the editor of the special issue of *Culture Machine* #12, titled 'The Digital Humanities: Beyond Computing'.

N. Katherine Hayles is Professor of Literature at Duke University. She teaches and writes on the relations of literature, science and technology in the twentieth and twenty-first centuries. Her book *How We Became Posthuman: Virtual Bodies in Cybernetics, Literature and Informatics* won the Rene Wellek Prize for the Best Book in Literary Theory for 1998–1999, while *Writing Machines* won the Suzanne Langer Award for Outstanding Scholarship. Her most recent book, *How We Think: Digital Media and Contemporary Technogenesis*, will be published in spring 2012.

Adelheid Heftberger is a researcher and archivist at the Austrian Film Museum in Vienna, where – among other responsibilities – she curates the Vienna Vertov-Collection. She holds Master's in Slavic Studies and in Comparative Literature, both of which she received from the University of Innsbruck in Austria. She is currently writing her PhD thesis on data mining and the visualisation of filmic structures in the films of Dziga Vertov.

Mireille Hildebrandt is Professor of Smart Environments, Data Protection and the Rule of Law at the Institute of Computing and Information Sciences (ICIS) at Radboud University, Nijmegen, Associate Professor of Jurisprudence at Erasmus School of Law in Rotterdam and a senior researcher at the Centre for Law, Science, Technology and Society (LSTS) at Vrije Universiteit Brussel. She works on the nexus of philosophy of law and philosophy of technology, with a focus on smart infrastructures. Together with Serge Gutwirth she edited *Profiling the European Citizen: Cross-Disciplinary Perspectives* (2008) and

together with Antoinette Rouvroy she edited *Law, Human Agency and Autonomic Computing* (2011). She is Associate Editor of *Criminal Law and Philosophy* and of the *Netherlands Journal of Legal Philosophy*.

Yu-Wei Lin is Lecturer in Future Media in the School of Media, Music and Performance at the University of Salford, UK. Her research interests centre on the Sociology of Science and Technology, Free/Libre Open Source Software (FLOSS) studies, digital cultures and user requirements analysis. She received her PhD in Sociology from the University of York in 2005, after which she conducted research at the Business School, Vrije Universiteit, Amsterdam, on social capital and social dynamics in virtual communities. Prior to taking up her current post, she worked as a research associate at the UK ESRC National Centre for e-Social Science at the University of Manchester, studying the opportunities and challenges of developing, implementing and adopting a variety of e-Research tools (including grid computing, text mining, data mining, social networking and data-sharing infrastructures) in the fields of social sciences and humanities.

Lev Manovich is Professor in the Visual Arts Department at the University of California, San Diego, Director of the Software Studies Initiative at California Institute for Telecommunications and Information Technology (CALIT2), and Professor at the European Graduate School (EGS). He is the author of *Software Takes Command* (2010), *Soft Cinema: Navigating the Database* (2005) and *The Language of New Media* (2001) which is described as 'the most suggestive and broad ranging media history since Marshall McLuhan'. He has been working with computer media as an artist, computer animator, designer, and educator since 1984. His art projects have been presented by, among others, the Graphic Design Museum (Breda), the Chelsea Art Museum (New York), ZKM, The Walker Art Center, KIASMA, Centre Pompidou, and the ICA (London). In 2007 Lev founded the Software Studies Initiative (softwarestudies.com). The lab is using digital image processing and new visualisation techniques to explore massive visual cultural data sets.

Jussi Parikka is Reader in Media and Design at the Winchester School of Art, University of Southampton, and Adjunct Professor of Digital Culture Theory at the University of Turku, Finland. He holds an Honorary Visiting Fellow position at Anglia Ruskin University. He has written about computer viruses and network accidents (*Digital Contagions*, 2007; *The Spam Book*, 2009), insects and the biophilosophy of digital culture (*Insect Media*, 2010; the special issue on *Media Ecology for Fibreculture*, 2011; and the MediaNatures – online-edited book, 2011) as well as on media archaeological theory and methods (*Media Archaeology*, 2011 and *What Is Media Archaeology?*, forthcoming, 2012). In addition, an edited collection of Wolfgang Ernst's writings is forthcoming in 2012. His blog can be found at http://www.jussiparikka.net.

Sian Rees teaches public relations, branding, marketing and media studies at Swansea University and is currently researching 'authenticity' in the representation of organisational images. Sian has worked in marketing and public relations for over 20 years and has developed marketing and public relations strategies and implemented campaigns across a variety of sectors. His recent papers include 'The Incorporation of Human Nature in Organisational Image' (June 2010), 'Authentic Organisational Voice in Wales' (May 2010), and 'A Social History of PR' (June 2009).

Bernhard Rieder has recently joined the New Media Department at the University of Amsterdam as Assistant Professor, after several years as Maître de Conférences in the Hypermedia Department at Paris 8 University. His research interests focus on the history, theory and politics of software, more particularly on the role of algorithms in social processes and the production of knowledge. Interrogating and working with digital methods is a central part of this endeavour. He has worked as a Web programmer on various projects and is currently writing a book on the history and cultural significance of information analysis and retrieval. He maintains a blog on his research at http://thepoliticsofsystems.net.

Theo Röhle is a postdoctoral researcher at the Research Training Group 'Automatisms' (www.upb.de/rtg-automatisms) and was a senior researcher (ad interim) for Digital Media/Mobile Media at the Institute for Media Studies at the University of Paderborn. His research focuses on digital knowledge and epistemology, new forms of surveillance, and concepts of power in media studies and science and technology studies. He received his PhD in Media Culture from the University of Hamburg in 2010; previously he studied History of Ideas, Cultural Studies and Media and Communication Studies at Stockholm University. His dissertation, entitled 'Der Google-Komplex. Über Macht im Zeitalter des Internets', was published in 2010 by transcript. Some of his other publications include 'Generation Facebook. Über das Leben im Social Net' (forthcoming); 'Desperately Seeking the Consumer: Personalised Search Engines and the Commercial Exploitation of User Data' in *First Monday* (2007); 'Power, Reason, Closure. Critical Perspectives on New Media Theory' in *New Media & Society* (2005).

Melissa Terras is Reader in Electronic Communication in the Department of Information Studies, University College London, and Deputy Director of the UCL Centre for Digital Humanities. His publications include *Image to Interpretation: Intelligent Systems to Aid Historians in the Reading of the Vindolanda Texts* (2006) and *Digital Images for the Information Professional* (2008). She is General Editor of *DHQ* and Secretary of the Association of Literary and Linguistic Computing. Her research focuses on the use of computational techniques to enable research in the arts and humanities that would otherwise be impossible.

Douwe Zeldenrust is Coordinator of External Cooperation at the Meertens Institute, a research institute of the Royal Netherlands Academy of Arts and Sciences. As an experienced project manager, ICT consultant, and researcher, he contributes to virtually all of the digital humanities projects of the Meertens Institute. He holds a Master's in History from the University of Amsterdam and Master's in Information and Document Management from Erasmus University, Rotterdam.

Joris van Zundert is a researcher and developer in the field of computational humanities at the Huygens Institute for the History of The Netherlands, a research institute of the Netherlands Royal Academy of Arts and Sciences (KNAW). As a researcher, his main interests include the application of computational techniques and algorithms for the analysis of literary text. Between 2009 and 2011 he led the Alfalab project, a cooperative project of six Royal Academy institutes, investigating and developing virtual research environments for the humanities.

1
Introduction: Understanding the Digital Humanities

David M. Berry

Across the university the way in which we pursue research is changing, and digital technology is playing a significant part in that change. Indeed, it is becoming more and more evident that research is increasingly being mediated through digital technology. Many argue that this mediation is slowly beginning to change what it means to undertake research, affecting both the epistemologies and ontologies that underlie a research programme (sometimes conceptualised as 'close' versus 'distant' reading, see Moretti 2000). Of course, this development is variable depending on disciplines and research agendas, with some more reliant on digital technology than others, but it is rare to find an academic today who has had no access to digital technology as part of their research activity. Library catalogues are now probably the minimum way in which an academic can access books and research articles without the use of a computer, but, with card indexes dying a slow and certain death (Baker 1996: 2001), there remain few outputs for the non-digital scholar to undertake research in the modern university. Email, Google searches and bibliographic databases are become increasingly crucial, as more of the world libraries are scanned and placed online. While some decry the loss of the skills and techniques of older research traditions, others have warmly embraced what has come to be called the digital humanities (Schreibman et al. 2008; Schnapp and Presner 2009; Presner 2010; Hayles 2011). As Moretti (2007) points out, the traditional humanities focuses on a

> minimal fraction of the literary field...[a] canon of two hundred novels, for instance, sounds very large for nineteenth-century Britain (and is much larger than the current one), but is still less than one per cent of the novels that were actually published: twenty thousand, thirty, more, no one really knows – and close reading won't help here, a novel a day every day of the year would take a century or so.... And it's not even a matter of time, but of method: a field this large cannot be understood by stitching together

1

separate bits of knowledge about individual cases, because it isn't a sum of individual cases: it's a collective system, that should be grasped as such, as a whole. (Moretti 2007: 3–4)

This new infinite archive also creates its own specific problems, such as huge quantities of articles, texts and data suddenly available at the researcher's fingertips:

> It is now quite clear that historians will have to grapple with abundance, not scarcity. Several million books have been digitized by Google and the Open Content Alliance in the last two years, with millions more on the way shortly; the Library of Congress has scanned and made available online millions of images and documents from its collection; ProQuest has digitized millions of pages of newspapers, and nearly every day we are confronted with a new digital historical resource of almost unimaginable size. (JAH 2008)

The digital humanities also try to take account of the plasticity of digital forms and the way in which they point towards a new way of working with representation and mediation, what might be called the digital 'folding' of memory and archives, whereby one is able to approach culture in a radically new way. To mediate a cultural object, a digital or *computational* device requires that this object be translated into the digital code that it can understand. This minimal transformation is effected through the input mechanism of a socio-technical device within which a model or image is stabilised and attended to. It is then internally transformed, depending on a number of interventions, processes or filters, and eventually displayed as a final calculation, usually in a visual form. This results in real-world situations where computation is event-driven and divided into discrete processes to undertake a particular user task cultural object. The key point is that without the possibility of *discrete* encoding there is no cultural object for the computational device to process. However, in cutting up the archive in this manner, information about the archive necessarily has to be discarded in order to store a representation within the computer. In other words, a computer requires that everything is transformed from the continuous flow of everyday life into a grid of numbers that can be stored as a representation which can then be manipulated using algorithms. These subtractive methods of understanding culture (*episteme*) produce new knowledges and methods for the control of memory and archives (*techne*). They do so through a digital mediation, which the digital humanities are starting to take seriously as their problematic.

The digital humanities themselves have had a rather interesting history. Originally called 'computing in the humanities', or 'humanities computing', in the early days they were often seen as a technical support to the work of the 'real' humanities scholars, who would drive the projects. This involved

the application of the computer to the disciplines of the humanities, something that has been described as treating the 'machine's efficiency as a servant' rather than 'its participant enabling of criticism' (McCarty 2009). As Hayles explains, changing to the term ' "digital humanities" was meant to signal that the field had emerged from the low-prestige status of a support service into a genuinely intellectual endeavour with its own professional practices, rigorous standards, and exciting theoretical explorations' (Hayles 2012). Ironically, as the projects became bigger and more complex, and as it developed computational techniques as an intrinsic part of the research process, technically proficient researchers increasingly saw the computational as part and parcel of what it meant to do research in the humanities itself. That is, computational technology has become the very condition of possibility required in order to think about many of the questions raised in the humanities today. For example, as Schnapp and Presner explain in the *Digital Humanities Manifesto 2.0*,

> the first wave of digital humanities work was quantitative, mobilizing the search and retrieval powers of the database, automating corpus linguistics, stacking hypercards into critical arrays. The second wave is *qualitative, interpretive, experiential, emotive, generative in character*. It harnesses digital toolkits in the service of the Humanities' core methodological strengths: attention to complexity, medium specificity, historical context, analytical depth, critique and interpretation. (2009; original emphasis)

Presner argues further that

> the first wave of Digital Humanities scholarship in the late 1990s and early 2000s tended to focus on large-scale digitization projects and the establishment of technological infrastructure, [while] the current second wave of Digital Humanities – what can be called 'Digital Humanities 2.0' – is deeply generative, creating the environments and tools for producing, curating, and interacting with knowledge that is 'born digital' and lives in various digital contexts. While the first wave of Digital Humanities concentrated, perhaps somewhat narrowly, on text analysis (such as classification systems, mark-up, text encoding, and scholarly editing) within established disciplines, Digital Humanities 2.0 introduces entirely new disciplinary paradigms, convergent fields, hybrid methodologies, and even new publication models that are often not derived from or limited to print culture. (2010: 6)

The question of quite how the digital humanities undertake their research, and whether the notions of first and second wave digital humanities captures the current state of different working practices and methods in the digital humanities, remains contested. Yet these can be useful analytical concepts

for thinking through the changes in the digital humanities. What isn't captured with the notion of 'waves' is the complementary simultaneity of the approaches. 'Layers' or 'moments' might be a better term. Indeed, layers would indicate that their interaction and inter-relations are crucial to understanding the digital humanities. We might, however, observe the following: first-wave digital humanities involved the building of infrastructure in the studying of humanities texts through digital repositories, text markup and so forth, whereas second-wave digital humanities expands the notional limits of the archive to include digital works, and so bring to bear the humanities' own methodological toolkits to look at 'born-digital' materials, such as electronic literature (e-lit), interactive fiction (IF), web-based artefacts and so forth.

I would like to explore here a tentative path for a third wave of the digital humanities, concentrated around the underlying *computationality* of the forms held within a computational medium (I call this move a *computational turn*; see Berry 2011). That is, I propose to look at the *digital* component of the digital humanities in the light of its medium specificity, as a way of thinking about how medial changes produce epistemic changes. This approach draws from recent work in software studies and critical code studies, but it also thinks about the questions raised by platform studies, namely the specifics of general computability made available by specific platforms (Fuller 2008; Manovich 2008; Montfort and Bogost 2009; Berry 2011). Currently digital humanities and software studies or critical code studies tend to be rather separate, but there is, of course, the potential for the fruitful exchange of ideas and concepts in terms of their respective theoretical and empirical approaches.

I also want to suggest that neither first- nor second-wave digital humanities really problematised what Lakatos (1980) would have called the 'hard-core' of the humanities, the unspoken assumptions and ontological foundations which support the 'normal' research that humanities scholars undertake on an everyday basis. The use of digital technologies can also problematise where disciplinary boundaries have been drawn in the past, especially considering the tendency of the digital to dissolve traditional institutional structures. For example, as Liu (2003) argues,

> [o]ne of the main tasks of those establishing programs in humanities technology, I suggest, is to use IT to refund and reorganize humanities work with the ultimate goal not of instituting, as it were, Humanities, Inc., but of giving the humanities the freedom and resources to imagine humanities scholarship anew in relation both to academic and business molds. The relation between narrow research communities and broad student audiences, for example, need not be the same as that between business producers and consumers. But unless the existing organizational paradigms for humanities work are supplemented by new models (e.g., laboratory- or studio-like

environments in which faculty mix with graduate and undergraduate students in production work, or new research units intermixing faculty from the humanities, arts, sciences, engineering, and social sciences), it will become increasingly difficult to embed the particular knowledge of the humanities within the general economy of knowledge work. (Liu 2003: 8)

Indeed, we could say that third-wave digital humanities points to the way in which digital technology highlights the anomalies generated in a humanities research project and which leads to the questioning of the assumptions implicit in such research, for example close reading, canon formation, periodisation, liberal humanism and so forth. We are, as Presner argues, 'at the beginning of a shift in standards governing permissible problems, concepts, and explanations, and also in the midst of a transformation of the institutional and conceptual conditions of possibility for the generation, transmission, accessibility, and preservation of knowledge' (2010: 10).

To look into this issue, I want to start with an examination of the complex field of understanding culture through digital technology. Indeed, I argue that to understand the contemporary born-digital culture and the everyday practices that populate it – the focus of a digital humanities second wave – we need an additional third-wave focus on the computer code that is entangled with all aspects of culture and memory, including reflexivity about how much code is infiltrating the academy itself. As Mathew Fuller argues, 'in a sense, all intellectual work is now "software study", in that software provides its media and its context...[yet] there are very few places where the specific nature, the materiality, of software is studied except as a matter of engineering' (2006). We also need to bring to the fore the 'structure of feeling' that computer code facilitates and the way in which people use software in their research thinking and everyday practices. This includes the increase in the acceptance and use of software in the production, consumption and critique of culture.

Thus, there is an undeniable cultural dimension to computation and the medial affordances of software. This connection again points to the importance of engaging with and understanding code; indeed, computer code can serve as an index of digital culture (imagine digital humanities mapping different programming languages to the cultural possibilities and practices that it affords, e.g. HTML to cyberculture, AJAX to social media), not to mention mapping 'editing' software to new forms of film narrative, music, and art more generally, or cultural criticism via the digital humanities.[1] As Liu (2011) argues:

In the digital humanities, cultural criticism – in both its interpretive and advocacy modes – has been noticeably absent by comparison with the mainstream humanities or, even more strikingly, with 'new media studies' (populated as the latter is by net critics, tactical media critics, hacktivists,

and so on). We digital humanists develop tools, data, metadata, and archives critically; and we have also developed critical positions on the nature of such resources (e.g., disputing whether computational methods are best used for truth-finding or, as Lisa Samuels and Jerome McGann put it, 'deformation'). But rarely do we extend the issues involved into the register of society, economics, politics, or culture. (Liu 2011)

This means that we can ask the question: what is culture after it has been 'softwarised'? (Manovich 2008: 41). Understanding digital humanities is in some sense then understanding code, and this can be a resourceful way of understanding cultural production more generally: for example, just as digital typesetting transformed the print newspaper industry, eBook and eInk technologies are likely to do so again. We thus need to take computation as the key issue that is underlying these changes across media, industries and economies. That is not to say that humanities scholars, digital or otherwise, must be able to code or 'build' (cf. Ramsay 2011), rather, that understanding the digital is in some sense also connected to understanding of code through study of the medial changes that it affords, that is, a hermeneutics of code (see Clinamen 2011; Sample 2011) or critical approaches to software (Manovich 2008; Berry 2011). This also raises questions of access to code itself, such that code is in some senses publicly readable or open-source (Berry 2008).

Knowing knowledge

In trying to understand the digital humanities, our first step might be to problematise *computationality*, so that we are able to think critically about how knowledge in the twenty-first century is transformed into information through computational techniques, particularly within software. It is interesting that at a time when the idea of the university is itself under serious rethinking and renegotiation, digital technologies are transforming our ability to use and understand information outside of these traditional knowledge structures. This is connected to wider challenges to the traditional narratives that served as unifying ideas for the university and, with their decline, has led to difficulty in justifying and legitimating the postmodern university vis-à-vis government funding.

Historically the role of the university has been closely associated with the production of knowledge. For example, in 1798 Immanuel Kant outlined an argument for the nature of the university titled *The Conflict of the Faculties*. He argued that all of the university's activities should be organised by a single regulatory idea, that of the concept of reason. As Bill Readings (1996) stated:

Reason on the one hand, provide[d] the *ratio* for all the disciplines; it [was] their organizing principle. On the other hand, reason [had] its own faculty,

which Kant name[d] 'philosophy' but which we would now be more likely to call the 'humanities'. (Readings 1996: 15)

Kant argued that reason and the state, knowledge and power, could be unified in the university by the production of individuals who would be capable of rational thought and republican politics – students trained for the civil service and society. Kant was concerned with the question of regulative public reason, that is, with how to ensure stable, governed and governable regimes which can rule free people, in contrast to tradition, represented by monarchy, the Church or a leviathan. This required universities, as regulated knowledge-producing organisations, to be guided and overseen by the faculty of philosophy, which could ensure that the university remained rational. This was part of a response to the rise of print culture, growing literacy and the kinds of destabilising effects that this brought. Thus, without resorting to dogmatic doctrinal force or violence, one could have a form of perpetual peace by the application of one's reason.[2]

This was followed by the development of the modern university in the nineteenth century, instituted by the German Idealists, such as Schiller and Humboldt, who argued that there should be a more explicitly political role to the structure given by Kant. They argued for the replacement of reason with culture, as they believed that culture could serve as a 'unifying function for the university' (Readings 1996: 15). For German Idealists like Humboldt, culture was the sum of all knowledge that is studied, as well as the cultivation and development of one's character as a result of that study. Indeed, Humboldt proposed the founding of a new university, the University of Berlin, as a mediator between national culture and the nation-state. Under the project of 'culture', the university would be required to undertake both research and teaching, that is, the production and dissemination respectively of knowledge. The modern idea of a university, therefore, allowed it to become the pre-eminent institution that unified ethnic tradition and statist rationality by the production of an educated, cultured individual. The German Idealists proposed

> that the way to reintegrate the multiplicity of known facts into a unified cultural science is through *Bildung*, the ennoblement of character...The university produces not servants but *subjects*. That is the point of the pedagogy of *Bildung*, which teaches knowledge acquisition as a *process* rather than the acquisition of knowledge as a *product*. (Reading 1996: 65–7)

This notion was given a literary turn by the English, in particular John Henry Newman and Mathew Arnold, who argued that literature, not culture or philosophy, should be the central discipline in the university, and also in national culture more generally.[3] Literature therefore became institutionalised within

the university 'in explicitly national terms and [through] an organic vision of the possibility of a unified national culture' (Readings 1996: 16). This became regulated through the notion of a literary canon, which was taught to students to produce literary subjects as national subjects.

Readings argues that in the postmodern university we now see the break-down of these ideals, associated particularly with the rise of the notion of the 'university of excellence' – which for him is a concept of the university that has no content, no referent. What I would like to suggest is that today we are beginning to see instead the cultural importance of the digital as the unifying idea of the university. Initially this has tended to be associated with notions such as *information literacy* and *digital literacy*, betraying their debt to the previous literary conception of the university, albeit understood through vocational training and employment. However, I want to propose that, rather than learning a *practice* for the digital, which tends to be conceptualised in terms of ICT skills and competences (see for example the European Computer Driving License[4]), we should be thinking about what reading and writing actually should mean in a computational age – which I call 'iteracy', drawing on the use of the term iteration within computation. This is to argue for critical understanding of the *literature* of the digital, and through that develop a shared digital culture through a form of digital *Bildung*. Here I am not calling for a return to the humanities of the past, to use a phrase of Fuller (2010), 'for some humans', but rather to a liberal arts that is 'for all humans'. To use the distinction introduced by Hofstadter (1963), this is to call for the development of a digital *intellect* – as opposed to a digital *intelligence*. Hofstadter writes:

> Intellect ... is the critical, creative, and contemplative side of mind. Whereas intelligence seeks to grasp, manipulate, re-order, adjust, intellect examines, ponders, wonders, theorizes, criticizes, imagines. Intelligence will seize the immediate meaning in a situation and evaluate it. Intellect evaluates evaluations, and looks for the meanings of situations as a whole ... Intellect [is] a unique manifestation of human dignity. (Hofstadter 1963: 25)

The digital assemblages that are now being built not only promise great change at the level of the individual human actor, they provide destabilising amounts of knowledge and information that lack the regulating force of philosophy – which, Kant argued, ensures that institutions remain rational. Technology enables access to the databanks of human knowledge from anywhere, disregarding and bypassing the traditional gatekeepers of knowledge in the state, the universities and the market. There no longer seems to be the professor who tells you what you should be looking up and the 'three arguments in favour of it' and the 'three arguments against it'. This introduces not only a moment of societal disorientation, with individuals and institutions flooded with information, but

also requires a computational solution to this state of events in the form of computational rationalities – something that Turing (1950) described as super-critical modes of thought. Both of these forces are underpinned at a deep structural level by the conditions of possibility suggested by computer code.

As mentioned previously, computer code enables new communicative processes, and, with the increasing social dimension of networked media, the possibility of new and exciting forms of collaborative thinking arises – network publics. This is not the collective intelligence discussed by Levy (1999); rather, it is the promise of a collective *intellect*. The situation is reminiscent of the medieval notion of the *universitatis*, but recast in a digital form, as a society or association of actors who can think critically together, mediated through technology. It further raises the question of what new modes of collective knowledge software can enable or constitute. Can software and code take us beyond the individualising trends of blogs, comments, twitter feeds and so forth, and make possible something truly collaborative – something like the super-critical thinking that is generative of ideas, modes of thought, theories and new practices? There is certainly something interesting about real-time stream forms of digital memory in that they are not afforded towards the past, as history, but neither are they directed towards a form of futurity. Instead we might say they seem to now-mediate? new-mediate? life-mediate? *Jetztzeit*-mediate (Benjamin 1992: 252–3). In other words, they gather together the newness of a particular group of streams, a kind of collective writing, that has the potential to be immensely creative. These are possible rich areas for research for a third-wave digital humanities that seeks to understand and experiment with these potentially new forms of literature and the medium that supports them.

For the research and teaching disciplines within the university, the digital shift could represent the beginnings of a moment of 'revolutionary science', in the Kuhnian sense of a shift in the ontology of the positive sciences and the emergence of a constellation of new 'normal science' (Kuhn 1996). This would mean that the disciplines would, ontologically, have a very similar Lakatosian computational 'hard core' (Lakatos 1980).[5] This has much wider consequences for the notion of the unification of knowledge and the idea of the university (Readings 1996). Computer science could play a foundational role with respect to the other sciences, supporting and directing their development, even issuing 'lucid directives for their inquiry'.[6] Perhaps we are beginning to see reading and writing computer code as part of the pedagogy required to create a new subject produced by the university, a *computational* or *data-centric* subject – or 'computational agent'.[7] This is, of course, not to advocate that the *existing* methods and practices of computer science become hegemonic, rather that a *humanistic* understanding of technology could be developed, which also involves an urgent inquiry into what is human about the *computational* humanities or social sciences. In a related manner, Fuller (2006) has called for a 'new sociological imagination'

pointing to the historical project of the social sciences that have been commit-
ted to 'all and only humans', because they 'take all human beings to be of equal
epistemic interest and moral concern' (Fuller 2010: 242). By drawing attention
to 'humanity's ontological precariousness' (244), Fuller rightly identifies that the
project of humanity requires urgent thought, and, we might add, even more so
in relation to the challenge of a *computationality* that threatens our understand-
ing of what is required to be identified as human at all.

If software and code become the condition of possibility for unifying the mul-
tiple knowledges now produced in the university, then the ability to think for
oneself, taught by rote learning of methods, calculation, equations, readings,
canons, processes and so forth, might become less important. Although there
might be less need for an *individual* ability to perform these mental feats or,
perhaps, even recall the entire canon ourselves due to its size and scope, using
technical devices, in conjunction with collaborative methods of working and
studying, would enable a cognitively supported method instead. The internal-
isation of particular practices that have been instilled for hundreds of years in
children and students would need to be rethought, and in doing so the common-
ality of thinking qua thinking produced by this pedagogy would also change.
Instead, reasoning could shift to a more conceptual or communicative method
of reasoning, for example, by bringing together comparative and communica-
tive analysis from different disciplinary perspectives – networked pedagogy, and
by knowing how to use technology to achieve a usable result – a rolling process
of reflexive thinking and collaborative rethinking (see Berry 2011).

Relying on technology in a more radically decentred way, depending on
technical devices to fill in the blanks in our minds and to connect knowl-
edge in new ways, would change our understanding of knowledge, wisdom
and intelligence itself. It would be a radical decentring in some ways, as the
Humboldtian subject filled with culture and a certain notion of rationality
would no longer exist; rather, the computational subject would know where to
recall culture as and when it was needed in conjunction with computationally
available others, a *just-in-time* cultural subject, perhaps, to feed into a certain
form of connected *computationally* supported thinking through and visualised
presentation. Rather than a method of thinking with eyes and hand, we would
have a method of thinking with eyes and screen.[8] Although, of course, this is
not to imply a screen essentialism, as Montfort (2004) argues:

> When scholars consider electronic literature, the screen is often portrayed
> as an essential aspect of all creative and communicative computing – a fix-
> ture, perhaps even a basis, for new media. The screen is relatively new on the
> scene, however. Early interaction with computers happened largely on paper:
> on paper tape, on punchcards, and on print terminals and teletypewriters,
> with their scroll-like supplies of continuous paper for printing output and

input both. ... By looking back to early new media and examining the role of paper ... we can correct the 'screen essentialist' assumption about computing and understand better the materiality of the computer text. While our understanding of 'materiality' may not be limited to the physical substance on which the text appears, that substance is certainly part of a work's material nature, so it makes sense to comment on that substance. (Montfort 2004; emphasis added)

This computationally supported thinking doesn't have to be dehumanising. Latour and others have rightly identified the domestication of the human mind that took place with pen and paper (Latour 1986). This is because computers, like pen and paper, help to stabilise meaning by cascading and visualising encoded knowledge that allows it to be continually 'drawn, written, [and] recoded' (Latour 1986: 16). Computational techniques could give us greater powers of thinking, larger reach for our imaginations and, possibly, allow us to reconnect to political notions of equality and redistribution based on the potential of computation to give to each according to their need and to each according to their ability. This is the point made forcefully by Fuller (2010: 262), who argues that we should look critically at the potential for inequality which is created when new technologies are introduced into society. This is not merely a problem of a 'digital divide', but a more fundamental one of how we classify those that are more 'human' than others, when access to computation and information increasingly has to pass through the market.

Towards a digital humanities?

The importance of understanding computational approaches is increasingly reflected across a number of disciplines, including the arts, humanities and social sciences, which use technologies to shift the critical ground of their concepts and theories – something that can be termed a *computational turn*.[9] This is shown in the increasing interest in the *digital humanities* (Schreibman et al. 2008) and *computational social science* (Lazer et al. 2009), as evidenced, for example, by the growth in journals, conferences, books and research funding. In the digital humanities 'critical inquiry involves the application of algorithmically facilitated search, retrieval, and critical process that ... originat[es] in humanities-based work'; therefore 'exemplary tasks traditionally associated with humanities computing hold the digital representation of archival materials on a par with analysis or critical inquiry, as well as theories of analysis or critical inquiry originating in the study of those materials' (Schreibman et al. 2008: xxv). In social sciences, Lazer et al. argue that 'computational social science is emerging that leverages the capacity to collect and analyze data with an unprecedented breadth and depth and scale' (2009).

Latour speculates that there is a trend in these informational cascades, which is certainly reflected in the ongoing digitalisation of arts, humanities and social science projects that tends towards 'the direction of the greater merging of figures, numbers and letters, merging greatly facilitated by their homogenous treatment as binary units in and by computers' (Latour 1986: 16). The financial considerations are also new with these computational disciplines as they require more money and organisation than the old individual scholar of lore did. Not only are the start-up costs correspondingly greater, usually needed to pay for the researchers, computer programmers, computer technology, software, digitisation costs and so forth, but there are real questions about sustainability of digital projects, such as: 'Who will pay to maintain the digital resources?' 'Will the user forums, and user contributions, continue to be monitored and moderated if we can't afford a staff member to do so? Will the wiki get locked down at the close of funding or will we leave it to its own devices, becoming an online-free-for all?' (Terras 2010).[10] It also raises a lot of new ethical questions for social scientists and humanists to grapple with. As argued in *Nature*,

> For a certain sort of social scientist, the traffic patterns of millions of e-mails look like manna from heaven. Such data sets allow them to map formal and informal networks and pecking orders, to see how interactions affect an organization's function, and to watch these elements evolve over time. They are emblematic of the vast amounts of structured information opening up new ways to study communities and societies. Such research could provide much-needed insight into some of the most pressing issues of our day, from the functioning of religious fundamentalism to the way behaviour influences epidemics...But for such research to flourish, it must engender that which it seeks to describe...Any data on human subjects inevitably raise privacy issues, and the real risks of abuse of such data are difficult to quantify. (*Nature* 2007)

For Latour, 'sociology has been obsessed by the goal of becoming a quantitative science. Yet it has never been able to reach this goal because of what it has defined as being quantifiable within the social domain...'. Thus, he adds, '[i]t is indeed striking that at this very moment, the fast expanding fields of "data visualisation", "computational social science" or "biological networks" are tracing, before our eyes, just the sort of data' that sociologists such as Gabriel Tarde, at the turn of the twentieth century, could merely speculate about (Latour 2010: 116).

Further, it is not merely the quantification of research which was traditionally qualitative that is offered with these approaches. Rather, as Unsworth argues, we should think of these computational 'tools as offering provocations,

surfacing evidence, suggesting patterns and structures, or adumbrating trends' (Unsworth, quoted in Clement et al. 2008). For example, the methods of 'cultural analytics' make it possible, through the use of quantitative computational techniques, to understand and follow large-scale cultural, social and political processes for research projects – that is, it offers massive amounts of literary or visual data analysis (see Manovich and Douglas 2009). This is a distinction that Moretti (2007) referred to as *distant* versus *close* readings of texts. As he points out, the traditional humanities focuses on a 'minimal fraction of the literary field',

> ... still less than one per cent of the novels that were actually published ... – and close reading won't help here, a novel a day every day of the year would take a century or so. ... a field this large cannot be understood by stitching together separate bits of knowledge about individual cases, because ... it's a collective system, that should be grasped as such, as a whole. (Moretti 2007: 3–4)

It is difficult for the traditional arts, humanities and social sciences to completely ignore the large-scale digitalisation effort going on around them, particularly when large quantities of research money are available to create archives, tools and methods in the digital humanities and computational social sciences. However, less understood is the way in which the digital archives being created are deeply computational in structure *and* content, because the computational logic is entangled with the digital representations of physical objects, texts and 'born digital' artefacts. Computational techniques are not merely an instrument wielded by traditional methods; rather they have profound effects on all aspects of the disciplines. Not only do they introduce new methods, which tend to focus on the identification of novel patterns in the data as against the principle of narrative and understanding, they also allow the modularisation and recombination of disciplines within the university itself.

Computational approaches facilitate disciplinary hybridity that leads to a post-disciplinary university – which can be deeply unsettling to traditional academic knowledge. Software allows for new ways of reading and writing. For example, this is what Tanya Clement says on the distant reading of Gertrude Stein's *The Making of Americans*,

> *The Making of Americans* was criticized by [those] like Malcolm Cowley who said Stein's 'experiments in grammar' made this novel 'one of the hardest books to read from beginning to end that has ever been published'. ... The

highly repetitive nature of the text, comprising almost 900 pages and 3174 paragraphs with only approximately 5,000 unique words, makes keeping tracks of lists of repetitive elements unmanageable and ultimately incomprehensible... [However] text mining allowed me to use statistical methods to chart repetition across thousands of paragraphs... facilitated my ability to read the results by allowing me to sort those results in different ways and view them within the context of the text. As a result, by visualizing clustered patterns across the text's 900 pages of repetitions... [th]is discovery provides a new key for reading the text as a circular text with two corresponding halves, which substantiates and extends the critical perspective that *Making* is neither inchoate nor chaotic, but a highly systematic and controlled text. This perspective will change how scholars read and teach *The Making of Americans*. (Clement, quoted in Clement et al. 2008)

I wouldn't want to overplay the distinction between pattern and narrative as differing modes of analysis. Indeed, patterns implicitly require narrative in order to be understood, and it can be argued that code itself consists of a narrative form that allows databases, collections and archives to function at all. Nonetheless, pattern and narrative are useful analytic terms that enable us to see the way in which the computational turn is changing the nature of knowledge in the university and, with it, the kind of computational subject that the university is beginning to produce. As Bruce Sterling argues,

'Humanistic heavy iron': it's taken a long time for the humanities to get into super computing, and into massive database management. They are really starting to get there now. You are going to get into a situation where even English professors are able to study every word ever written about, or for, or because of, Charles Dickens or Elizabeth Barrett Browning. That's just a different way to approach the literary corpus. I think there is a lot of potential there. (Sterling 2010)

Indeed, there is a cultural dimension to this process and, as we become more used to computational visualisations, we will expect to see them and use them with confidence and fluency. The computational subject is a key requirement for a data-centric age, certainly when we begin to look at case studies that demonstrate how important a computational comportment can be in order to perform certain forms of public and private activities in a world that is increasingly pervaded by computational devices. In short, *Bildung* is still a key idea in the digital university, not as a subject trained in a vocational fashion to perform instrumental labour, nor as a subject skilled in a national literary culture, but rather as a subject which can unify the information that society is now producing at increasing rates, and which understands new methods and

practices of critical reading (code, data visualisation, patterns, narrative) and is open to new methods of pedagogy to facilitate it. Indeed, Presner (2010) argues that the digital humanities

> must be engaged with the broad horizon of possibilities for building upon excellence in the humanities while also transforming our research culture, our curriculum, our departmental and disciplinary structures, our tenure and promotion standards, and, most of all, the media and format of our scholarly publications. (Presner 2010: 6)

This is a subject that is highly computationally communicative, and that is also able to access, process and visualise information and results quickly and effectively. At all levels of society, people will increasingly have to turn data and information into usable computational forms in order to understand it at all. For example, one could imagine a form of *computational* journalism that enables the public sphere function of the media to make sense of the large amount of data which governments, among others, are generating, perhaps through increasing use of 'charticles', or journalistic articles that combine text, image, video, computational applications and interactivity (Stickney 2008). This is a form of 'networked' journalism that 'becomes a non-linear, multi-dimensional process' (Beckett 2008: 65). Additionally, for people in everyday life who need the skills that enable them to negotiate an increasingly computational field – one need only think of the amount of data in regard to managing personal money, music, film, text, news, email, pensions and so forth – there will be calls for new skills of financial and technical literacy, or, more generally, a *computational literacy* – in other words, 'iteracy' or *computational pedagogy* that the digital humanities could contribute to – in other words, 'iteracy'.

One example, facilitated by software and code, is the emergence of the real-time stream of data, as opposed to the static knowledge objects humanities have traditionally been focused upon, for example, books and papers (see Flanders 2009; Berry 2011). These streams include geolocation, real-time data-bases, tweets, social media, SMS novels, and countless other processual and rapidly changing digital forms (including, of course, the Internet itself, which is becoming increasingly stream-like) (Berry 2011: 142–71). How are we to understand the forms of narrative and pattern that take place in streams on Twitter? For example, the @mention stream is a means to avoid the speed of a multiply authored follow streams, especially where tweets might number in the hundreds or thousands from the people you follow. Instead you might choose to watch your @mention stream instead. This only shows tweets that directly mention your username, substantially cutting down the amount of information moving past and relying on the social graph, that is, other people in your network of friends, to filter the data for you. The @mention stream becomes a

collectively authored stream of information presented for you to read as a fast-moving minimal-narrative flow of text, images, location and video. New methods and approaches, such as data visualisation, will be needed to track and understand these new streaming knowledge forms both in terms of pattern and narrative.[11] This is not merely a case of collecting real-time 'truths' or 'facts', the mere accumulation of pieces of information; rather it is the cumulative mastery of the methods that can be applied to these new real-time forms that is key to a digital *Bildung*, what Ryle (1945) calls 'dispositional excellence' which is actualised in the performance of producing 'intelligent powers' in relation to these digital streams. Of course, there are also many existing humanities approaches that could also provide real value by application and translation to these digital forms (both screenic and non-screenic).

Humanity and the humanities

As the advantages of the computational approach to research (and teaching) become persuasive to the positive sciences, whether history, biology, literature or any other discipline, the ontological notion of the entities they study begins to be transformed. These disciplines thus become focused on the *computationality* of the entities in their work.[12] Here, following Heidegger, I want to argue that there remains a location for the possibility of philosophy to explicitly question the ontological understanding of what the computational is in regard to these positive sciences. Computationality might then be understood as an ontotheology, creating a new ontological 'epoch' as a new historical constellation of intelligibility. The digital humanists could therefore orient themselves to questions raised when computationality is itself problematised in this way (see Liu 2011; Berry 2011).

With the notion of ontotheology, Heidegger is following Kant's argument that intelligibility is a process of filtering and organising a complex, overwhelming world by the use of 'categories', Kant's 'discursivity thesis'. Heidegger historicises Kant's cognitive categories by arguing that there is a 'succession of changing historical ontotheologies that make up the "core" of the metaphysical tradition. These ontotheologies establish "the truth concerning entities as such and as a whole", in other words, they tell us both what and how entities are – establishing both their essence and their existence' (Thomson 2009: 149–50). Metaphysics, grasped ontotheologically, 'temporarily secures the intelligible order' by understanding it 'ontologically', from the inside out, and 'theologically', from the outside in, which allows the formation of an epoch, a 'historical constellation of intelligibility which is unified around its ontotheological understanding of the being of entities' (Thomson 2009: 150). As Thomson argues,

> The positive sciences all study classes of entities…Heidegger…[therefore] refers to the positive sciences as 'ontic sciences'. Philosophy, on the other

hand, studies the being of those classes of entities, making philosophy an 'ontological science' or, more grandly, a 'science of being'. (Thomson 2003: 529)

Philosophy as a field of inquiry, one might argue, should have its 'eye on the whole', and it is this focus on 'the landscape as a whole' which distinguishes the philosophical enterprise and which can be extremely useful in trying to understand these ontotheological developments (Sellars 1962: 36). If code and software are to become objects of research for the humanities and social sciences, including philosophy, we will need to grasp both the ontic and ontological dimensions of computer code. Broadly speaking, then, I suggest that we introduce a humanistic approach to the subject of computer code, paying attention to the wider aspects of code and software, and connecting them to the materiality of this growing digital world. With this in mind, the question of code becomes increasingly important for understanding in the digital humanities, and serves as a condition of possibility for the many new computational forms that mediate our experience of contemporary culture and society.

Notes

1. HTML is the HyperText Markup Language used to encode webpages. AJAX is shorthand for Asynchronous JavaScript and XML, which is a collection of client-side technologies that enable an interactive and audio-visual dynamic web.
2. I am indebted to Alan Finlayson for his comments on this section.
3. For example, in *The Idea of a University* (Newman 1996) and *Culture and Anarchy* (Arnold 2009).
4. See http://www.bcs.org/server.php?show=nav.5829.
5. What Heidegger calls 'the Danger' (*die Gefahr*) is the idea that a particular ontotheology should become permanent, particularly the ontotheology associated with technology and enframing (see Heidegger 1993).
6. See Thomson (2003: 531) for a discussion of how Heidegger understood this to be the role of philosophy.
7. Kirschenbaum argues 'I believe such trends will eventually affect the minutiae of academic policy. The English department where I teach, like most which offer the doctorate, requires students to demonstrate proficiency in at least one foreign language. Should a graduate student be allowed to substitute demonstrated proficiency in a *computer-programming language instead*? Such questions have recently arisen in my department and elsewhere; in my own case, almost a decade ago, I was granted permission to use the computer language Perl in lieu of proficiency in the second of two languages that my department required for the Ph.D. I successfully made the case that given my interest in the digital humanities, this was far more practical than revisiting my high-school Spanish' (Kirschenbaum 2009, emphasis added).
8. This does not preclude other more revolutionary human–computer interfaces that are under development, including haptic interfaces, eye control interfaces, conversational interfaces (such as Apple's Siri), or even brain-wave controlled software interfaces.

9. See http://www.thecomputationalturn.com/
10. See the open digital humanities translation of Plato's *Protagoras* for a good example of a wiki-based project, http://openprotagoras.wikidot.com/
11. A good example of this is the work being done by Yngvil Beyer at the Nasjonalbiblioteket, Norway, on archiving the July 22 tragedy which happened in Oslo.
12. Here I don't have the space to explore the possibilities of a transformation of the distinction between research and teaching by digital technologies, themselves a result of the Humboldtian notion of the university. We might consider that a new hybridised form of research-teaching or teaching-research might emerge, driven, in part, by the possibility of new knowledges being created and discovered within the teaching process itself. This would mean that the old distinctions of research as creative, and teaching as dissemination would have to change too.

References

Arnold, M. (2009), *Culture and Anarchy* (Oxford: Oxford University Press).

Baker, N. (1996), *The Size of Thoughts: Essays and Other Lumber* (New York: Random House).

Baker, N. (2001), *Double Fold: Libraries and the Assault on Paper* (New York: Random House).

Beckett, C. (2008), *Supermedia: Saving Journalism So It Can Save the World.* (London: Wiley-Blackwell).

Benjamin, W. (1992), 'Theses on the Philosophy of History', in *Illuminations*, trans. H. Zohn (London: Fontana, 245–55).

Berry, D. M. (2008), *Copy, Rip, Burn: The Politics of Copyleft and Open Source* (London: Pluto Press).

Berry, D. M. (2011), *The Philosophy of Software: Code and Mediation in the Digital Age* (London: Palgrave Macmillan).

Clement, T., Steger, S., Unsworth, J. and Uszkalo, K. (2008), 'How Not to Read a Million Books', accessed 21 June 2010. http://www3.isrl.illinois.edu/~unsworth/hownot2read.html#sdendnote4sym.

Clinamen (2011), The Procedural Rhetorics of the Obama Campaign, retrieved 15 January 2011. http://clinamen.jamesjbrownjr.net/2011/01/15/the-procedural-rhetorics-of-the-obama-campaign/.

Flanders, J. (2009), 'The Productive Unease of 21st-Century Digital Scholarship', *Digital Humanities Quarterly*, Summer 2009, 3/3, retrieved 10 October 2010. http://digitalhumanities.org/dhq/vol/3/3/000055/000055.html.

Fuller, M. (2006), 'Software Studies Workshop', accessed 13 April 2010. http://pzwart.wdka.hro.nl/mdr/Seminars2/softstudworkshop.

Fuller, M. (2008), *Software Studies: A Lexicon* (Cambridge, MA: The MIT Press).

Fuller, S. (2006), *The New Sociological Imagination* (London: Sage).

Fuller, S. (2010), 'Humanity: The Always Already – or Never to Be – Object of the Social Sciences?', in J. W. Bouwel (ed.), *The Social Sciences and Democracy* (London: Palgrave Macmillan).

Hayles, N. K. (2012), 'How We Think: Transforming Power and Digital Technologies', in D. M. Berry (ed.), *Understanding the Digital Humanities* (London: Palgrave Macmillan).

Heidegger, M. (1993), 'The Question Concerning Technology', in D. F. Krell (ed.), *Martin Heidegger: Basic Writings* (London: Routledge, 311–41).

Hofstadter, R. (1963), *Anti-Intellectualism in American Life* (New York: Vintage Books).

JAH (2008), 'Interchange: The Promise of Digital History', *The Journal of American History*, retrieved 12 December 2010. http://www.journalofamericanhistory.org/issues/952/interchange/index.html.

Kirschenbaum, M. (2009), 'Hello Worlds', *The Chronicle of Higher Education*, accessed 10 December 2010. http://chronicle.com/article/Hello-Worlds/5476.

Kuhn, T. S. (1996), *The Structure of Scientific Revolutions* (Chicago: Chicago University Press).

Lakatos, I. (1980), *Methodology of Scientific Research Programmes* (Cambridge: Cambridge University Press).

Latour, B. (1986), 'Visualization and Cognition: Thinking with Eyes and Hands', *Knowledge and Society*, vol. 6, 1–40.

Latour, B. (2010), 'Tarde's Idea of Quantification', in M. Candea (ed.), *The Social After Gabriel Tarde: Debates and Assessments* (London: Routledge).

Lazer, D. et al. (2009), 'Computational Social Science', *Science* 323/5915 (6 February): 721–23.

Levy, P. (1999), *Collective Intelligence* (London: Perseus).

Liu. A. (2003), 'The Humanities: A Technical Profession', retrieved 15 December 2010. http://www.english.ucsb.edu/faculty/ayliu/research/talks/2003mla/liu_talk.pdf.

Liu, A. (2011), 'Where is Cultural Criticism in the Digital Humanities?', accessed 15 December 2011. http://liu.english.ucsb.edu/where-is-cultural-criticism-in-the-digital-humanities/.

Manovich, L. (2008), *Software Takes Command,* accessed 3 May 2010. http://lab.software studies.com/2008/11/softbook.html.

Manovich, L. and Douglas, J. (2009), 'Visualizing Temporal Patterns in Visual Media: Computer Graphics as a Research Method', accessed 10 October 2009. http://software studies.com/cultural_analytics/visualizing_temporal_patterns.pdf.

McCarty, W. (2009), 'Attending from and to the Machine', accessed 18 September 2010. http://staff.cch.kcl.ac.uk/~wmccarty/essays/McCarty,%20Inaugural.pdf.

Montfort, N. (2004), 'Continuous Paper: The Early Materiality and Workings of Electronic Literature', retrieved 16 January 2011. http://nickm.com/writing/essays/continuous_paper_mla.html.

Montfort, N. and Bogost, I. (2009), *Racing the Beam: The Atari Video Computer System* (Cambridge, MA: MIT Press).

Moretti, F. (2000), 'Conjectures on World Literature', retrieved 20 October 2010. http://www.newleftreview.org/A2094

Moretti, F. (2007), *Graphs, Maps, Trees: Abstract Models for a Literary History* (London: Verso).

Nature (2007), 'A matter of trust', *Nature* 449/(11 October): 637–38.

Newman, J. H. (1996), *The Idea of a University* (New Haven, CT: Yale University Press).

Presner, T. (2010), 'Digital Humanities 2.0: A Report on Knowledge', accessed 15 October 2010. http://cnx.org/content/m34246/1.6/?format=pdf.

Ramsay, S. (2011), 'On Building', retrieved 15 January 2011. http://lenz.unl.edu/wordpress/?p=340.

Readings, B. (1996), *The University in Ruins* (Cambridge, MA: Harvard University Press).

Ryle, G. (1945), 'Knowing How and Knowing That: The Presidential Address,' *Proceedings of the Aristotelian Society*, New Series, 46 (1945–1946): 1–16.

Sample, M. (2011), 'Criminal Code: The Procedural Logic of Crime in Videogames', retrieved 15 January 2011. http://www.samplereality.com/2011/01/14/criminal-code-the-procedural-logic-of-crime-in-videogames/.

Schnapp, J. and Presner, P. (2009), 'Digital Humanities Manifesto 2.0', accessed 14 October 2010. http://www.humanitiesblast.com/manifesto/Manifesto_V2.pdf.

Schreibman, S., Siemans, R. and Unsworth, J. (2008), *A Companion to Digital Humanities* (London: Wiley-Blackwell).

Sellars, W. (1962), 'Philosophy and the Scientific Image of Man', in R. Colodny (ed.), *Frontiers of Science and Philosophy* (Pittsburgh: University of Pittsburgh Press, 35–78).

Sterling, B. (2010), 'Atemporality for the Creative Artist', *Wired*, accessed 1 July 2010. http://www.wired.com/beyond_the_beyond/2010/02/atemporality-for-the-creative-artist/.

Stickney, D. (2008), 'Charticle Fever', *American Journalism Review*, accessed 18 March 2010. http://www.ajr.org/Article.asp?id=4608.

Terras, M. (2010), 'Present, Not Voting: Digital Humanities in the Panopticon', accessed 10 July 2010. http://melissaterras.blogspot.com/2010/07/dh2010-plenary-present-not-voting.html.

Thomson, I. (2003), 'Heidegger and the Politics of the University', *Journal of the History of Philosophy* 41/4: 515–42.

Thomson, I. (2009), 'Understanding Technology Ontotheologically, Or: the Danger and the Promise of Heidegger, an American Perspective', in Olsen, J. K. B, Selinger, E., and Riis, S. (eds), *New Waves in Philosophy of Technology* (London: Palgrave Macmillan).

Turing, A. M. (1950), 'Computing Machinery and Intelligence', *Mind* Oct. 1950: 433–60.

2
An Interpretation of
Digital Humanities

Leighton Evans and Sian Rees

There is a common thread running through this collection which highlights a new level of interaction with data and text, integrating thinker and machine in a complex relationship which questions the very concept of 'humanity'. This may have profound implications for our understanding of what we mean by the humanities; what exactly is a 'text' if it changes in the moment of consumption? Deep reading has always been a process of interaction with text (Carr 2010; Kittler 1999), but the digital humanities take this one step further. Instead of simply losing ourselves through our imagination, the nature of digital technology is such that we are becoming integrated with the text itself; our brain is not simply picturing a new world, it is instead developing a new world, opening up new neural pathways in reaction to the speed and expanse of interaction with digital data (Carr 2010: 141). The new digital readers, with hyperlinks and notes, offer a new mediated experience of 'reading'. What then can we define as the text itself if each person's interaction with it is completely different, following alternative links and pathways?

As the digital humanities provide us with new technologies such as 'cultural analytics'[1] and 'distant reading',[2] the importance of human hermeneutic interpretation potentially diminishes as patterns emerge to 'show us what we would never have been aware of otherwise' (Currie 2010: 1). It is not a question, however, of discarding deep reading in favour of new digital methods; we propose that the issue is more complex.

These essays follow a broad spectrum of work theorising media and the digital humanities and the way in which media alter our interpretation of 'reality' or, indeed, create a new reality for us. Kittler, for example, talks of how sound, film and video cameras can liquidate real events by creating new accounts which overlay existing versions in our memory, so that our recollection is of the packaged event, forged from spliced media clips and commentary, rather than our actual experience of it (Kittler 1999). The power of this kind of mediated reality is explored by authors such as Dyan and Katz who focus

on the 'causative power' of such 'pseudo' media events, and their ability to 'actively reinforce dominant paradigms' or replace them with new ones (Dyan and Katz 1994: 153–60). Silverstone considers the way in which media affect our interpretation of reality by directing our processes of recollection via 'the media's capacity to construct a public past' in which 'the texture of memory is intertwined with the texture of experience' (Silverstone 1991: 128).

We want to argue in this chapter that in some senses the 'computational turn'[3] is simply a continuation of a process which has led humans from an oral, to a written, to a visual tradition through the media of oratory, printing, and broadcasting, impacting during each phase a wide range of human activity from scientific interpretation and terminology, war technology, to political processes and social engagement (Kitter 1999; Dyan and Katz 1994). The fundamental argument is the same: media do not simply convey messages, they affect our very relationship with the world.

The idea of a blurring between human and machine is equally not revolutionary. The introduction of sound recording and film technology brought concepts of the 'other', of a new reality, that in the process of mirror-imaging 'reality' actually created a new entity, built from the cuttings of hours of recordings – something that looked real, but wasn't (Kittler 1999: Carr 2010). What is different about digital technology is that it may be challenging even further a fundamental acceptance of the boundaries of physical human identity. The first wave of cybernetic development, for example, brought about a new epistemology incorporating the concept that 'the boundaries of the human subject are constructed rather than given' (Hayles 1993: 84).

Carr's (2010: 22–35) overview of academic theory documenting the way in which our brains change in response to interaction with digital technology seems to confirm some of the concepts developed in this volume – that the digital change is profound. With each new interaction, we become something different, as our brains adapt to the new requirements of digital data processing. We become tailored to a 'hyper-attention mode (related to electronic media)', rather than a 'deep-attention mode (related to print)' (Hazel 2010).

This is a completely different conception from early Christian, courtly, and romantic notions of communications leading to the 'mutual salvation of souls' or 'shared interiorities' (Durham Peters 1999: 45–65). The exploration of patterns using new graphic analysis methodologies, such as Lev Manovich's use of 'cultural analytics' to explore correlations between 4,553 *Time* magazines (Hazel 2010), bypass the difficulties of word signification which plagued the ideal of this early notion of communication. Such new digital approaches address the problematic interpretative nature of language use, and bring us closer, perhaps, to Augustine's idea of divine communication which transcends the problems of translation: 'Angels carry dispatches that are never lost or misdelivered or garbled in transit' (Durham Peters 1999: 75). The digital

humanities, to some extent, capture the excitement brought by the introduction of radio which reactivated the concept of contact between people 'via an invisible or elusive material linkage' (Durham Peters 1999: 103). Berry suggests that software code is providing a new kind of elusive linkage, bringing evolutionary dimensions to human interactions and communications through networked software which enables a highly communicative, intensely creative environment of new human and non-human aggregates (Berry 2011: 8).

If we accept that modernist art and literature focused on the way in which human bodies 'may never be in absolute contact' (Durham Peters 1999: 178), then the posthuman digital media version would be an abandoning of the importance of even attempting such connection; instead, the new possibility is the notion that it is the machine that connects us, uniting us via a series of actions to become a new kind of temporary aggregate, made momentarily 'whole' via a system of actor networks and interactive loops.

This volume provides pathways of thought for refracting our study of the humanities through a new prism of digital media and technology, while simultaneously helping us to explore the intrinsic and inevitable connection between technology and humanity. The March 2010 conference it is based on[4] offered participants a snapshot of approaches to the digital humanities, which we propose might broadly be categorised into two waves of activity: the first based on new quantitative approaches to understanding the humanities, and the second an arguably more revolutionary qualitative approach in which the digital is embedded within our very perceptions of the humanities, providing a completely new interpretation and therefore the development of new theoretical concepts.

Old humanities presented in a new cross-disciplinary digital way

In the initial wave of activity we see evidence of 'old' humanities presented in a new digital way, often as the result of cross-disciplinary cooperation. The main emphasis here is on new ways for scholars to work with an abundance of empirical material using modern automated analysis methods for aggregating, seeing and interacting with large data sets across a number of disciplines. Such a multidisciplinary perspective offers different and potentially better ways of making sense of phenomena (Berger 2000). The promise of the new technology is potentially intoxicating: the ability to process more data than ever before with greater breadth and depth of analysis; extended zoomability between micro and macro; and the revelation of patterns and structures which would be impossible to discern with the naked eye. Two different types of software provide different technological methodologies: the first assists with deduction and hypothesis testing; the second helps with the exploration of data. Such software has the potential to offer researchers new and particular

perspectives on the phenomena being studied by helping certain properties and relations to become visible (Rieder and Rohle 2012).

Sredniawa and Hayes' Virtual Witkacy project provides a collaborative, multi-disciplinary Web-based tool, adding semantic and social networking dimensions to provide a dynamic way of representing and analysing the broad corpus of work of the twentieth-century Polish polymath Stanisław Ignacy Witkiewicz or 'Witkacy' (Sredniawa and Hayes 2011). The use of cultural analytics here is presented as an enabler, providing approaches for analysing cultural history and contemporary culture by facilitating multidisciplinary collaboration to generate a full view of multi-form texts and by doing so revealing complex relationships which exist between different genres of activities.

For Cole and Giordano (2011) such techniques enabled a cross-disciplinary team of historical geographers, GIScientists, dynamic cartographers, historians, and architectural historians to draw upon the methodologies of GIScience (Geographic Information Science) to visualise and interpret the spatiality of the Holocaust in a completely new way. The creation of an historical GIS map of the process of ghettoisation undertaken in Budapest in 1944, for example, enabled existing more traditional research to be re-analysed and represented differently. While providing new insights into a variety of themes, such as the spatial separation of Jews from other Jews, and the hiddenness of the ghetto over time to bystanders, it also raised new ethical questions. The digital visualisation tools used in the project provided a way of aestheticising human suffering, challenging the researchers to find a way of visualising serious subjects without reducing them to pretty pictures.

Some of the methodological issues raised by the application of digital processes are considered by Lin (2011) in her comparative study of the use of digital data-mining versus human coding in Frame analysis. The study found that the text miner produced a more expanded corpus than the human coder, but critiqued the way in which the subsequent digital data analysis incorporated an element of subjectivity, from the initial manual creation of a training data set to inform the algorithms. While the human coder was better able to detect different levels and layers of meanings, the text miner was potentially more objective in its rigid observance of standardised units of measurement, although such standardisation may jeopardise the flexibility of interpretation.

New humanities formed from digital media

Alongside cross-disciplinary opportunities, we propose that another emerging theme of the first wave of digital humanities research from the conference was the focus on new areas of the humanities formed from digital media. Currie (2012) considered the use of controversy as an epistemological device to map editors' concerns within Wikipedia. Using Actor Network Theory as a tool,

her research touches on the 'complex dynamism' of Wikipedia, arguing that a new analytical approach is needed for a digital text which is a continuous, non-static, collaborative process in which an article can evolve from editorial conflicts over a considerable period of time. The use of 'scraping software' facilitated graphic analysis of an article's editing history, of peaks of editing activity, and of actor dispersal, leading to the mapping of controversy both within an article and through its network. What we see here is not revolutionary; it involves a traditional theoretical framework being applied to the dynamic qualities of digital media, using new software technology to produce source material and represent it visually to facilitate interpretation.

For Hadzi (2011) the new area of humanities needing interpretation as a result of digital developments is the concept of open source and the intellectual property right challenges of the digital media environment. Hadzi uses Rousseau's Social Contract as a framework for analysing issues of sovereignty and community in collaborative computer-mediated communications, such as the collaborative Deptford TV documentary project. In parallel to Currie's work, it is the re-usage, re-mixing and re-interpreting process of digital media that Hadzi focuses on. He develops the concept of the 'data sphere', an extension of the public sphere, created by a coming together of coalitions by way of mechanical processes, arguing that a new approach to copyright is required for the shared cultural heritage of the file-sharing generation. Hadzi is mirroring new thinking introduced by Berry (2008) in which he identified two strands of theoretical development brought to light by issues of the digital creative commons: (1) a new 'model of human productive capabilities (often pre-capitalist, or previously held back by the fetters of capitalism)' or (2) 'a new form of collective production that undermines/re-writes capitalism' (2008: 98). Berry (2011) later also introduces the idea of code as a research subject, summarising the ways in which academic work on software to date has focused on phenomena created by code, and code as engineering, rather than code itself as an object. He proposes a new phenomenological approach to highlight the 'pragmata of code' and by so doing improve our understanding of how computational devices are influencing and affecting the shape of politics, society, economics, and everyday lives (Berry 2011: 11–15).

The digital and humanities: emerging research issues

A third theme of the digital humanities quantitative wave we have identified is a focus on research issues, encompassing theoretical debates and tensions, some of which surfaced at the Computational Turn conference. The 'computational turn' inevitably has its doubters. Cheeseman (2011) confessed being sceptical about the computability of most of the problems he dealt with as a literary translator, editor, critic, and cultural historian, while conceding that

digitisation and computation make helpful tools. For instance, digital software might be able to systematically and thoroughly analyse the differences and similarities between a large set of redactions of 'a' text, and would probably be essential, for example, to manage a large data set such as a broad corpus of texts across different languages. But, Cheeseman questions, what is it exactly that computation can offer other than searchability and low-level pattern recognition? He accepts that computation is capable of identifying recurrent or parallel lexical and syntactic features, but sees it as little help in dealing with semantics. For Cheeseman the connective, pattern-seeking abilities of digital machinery cannot replicate the deep reading of primary readings, the cultural context provided by further texts, and the development of a cognitive critical argument. Dixon (2012), on the other hand, sees pattern itself as worthy of contemplation and critiques its use as a research tool, proposing pattern as a useful epistemological construct for research projects which focus on evolutionary subjects.

The process of researching digital humanities is currently facing intense scrutiny. The gap between the critical thinking inherent to traditional humanities research and the quantitative approach common to computations studies, increasingly being incorporated into 'big humanities' projects, is a problem for Almila (2011), Van Zunder (2012) and Antonijevic (2012). Almila suggests that the issue is not simply the practicalities of collaboration between humanities scholars, scientists, and programmers, but their differing goals and epistemic traditions.

Almila (2011) encountered problems, such as discipline-specific terminology, when conducting a digital research project to analyse keywords from a selection of texts from three disciplines (art history, visual cultural studies, and cognitive science) and also identified the tension between a traditional humanities approach, where questions and methodologies might evolve during the course of study, versus computational methods which require the early identification of parameters, with little flexibility for ongoing structural change. Almila proposes that computational methodology is a further issue as humanities scholars do not normally have the expertise to write their own software programmes, thereby limiting new research to existing software programmes and concepts. The use of bibliometrics to analyse a large-scale corpus of Leonardo journals provided only a general overview and Almila concluded that in order to delve more thoroughly into the research question (did Leonard create a new culture?) a more traditional deep textual analysis of selected texts would be required. Almila, however, sees the practical problems of digital humanities research as minor, and concludes with an evolutionary vision for digital humanities, proposing a concept that we will return to later in this chapter; the digital, Almila suggests, will 'disappear' once it becomes accepted and integrated into the infrastructure of humanities research overall, which

will have expanded or redefined itself to incorporate newly classified research processes and discourses facilitated by digital technology, rather than simply being considered a tool for assisting existing humanities scholars with their studies.

Before it can disappear, however, Rieder and Rohle (2012) suggest that there are five specific research challenges facing digital humanities: objectivity; visualisation as rhetoric; black-boxing; institutions; and total science. While automatic collection and processing appears to eliminate problems of human error and subjective judgement, the process of inputting units of analysis necessarily involves elements of subjective judgement regarding selection, operationalisation, and modelling, and therefore cannot claim to be entirely objective. Here we see digital humanities facing the same technical problems as traditional research approaches in which it is argued that facts are inevitably shaped by the researchers who collect them (Booth et al. 2008) with the inevitable conclusion that objectivity is virtually impossible to achieve.

Likewise, visualisations, it is argued, are a specific kind of representation and not objective transfers from world to image. As such, they often perform a rhetorical function of presenting data, rather than interpreting it. The process of formalising empirical data into structures, algorithms, and symbols reduces the transparency of methodological procedures and makes secondary analysis and judgement of processes problematic. Rieder and Rohle perceive dangers to the structure and funding of existing research methodologies, born from the speed and efficiency of new digital technologies to interpret large scale data, in that more labour-intensive research approaches will appear increasingly unattractive and expensive. Again, this is not a new problem for the humanities. In the mid-twentieth century there were debates about the efficacy and value of empirical research, arguing that it tends to be expensive, and is generally paid for by someone, leading to concerns over objectivity, style, and methodologies which favour commercial paymasters (Wright Mills 1959: 64). Lastly, Rieder and Rohle caution against the use of 'big humanities' to seek a specific ontology of total science which reveals underlying cross-disciplinary constructs, citing structuralism, cybernetics, and systems theory as examples where this did not work.

Van Zundert and Antonijevic (2012) also reflect on the tense juxtaposition between the humanities and computing, arguing that critical reflection on formalisation practices is an important element of success. Echoing Almila's concern over the explicit definition of research objectives, van Zundert and Antonijevic seek to provide evidence of a more critical use of formalising technology. In historical analysis generations of interpretation can lead to layers of hypotheses too complex to fully compute neurologically and the process of aggregated argument and interpretation has been aided by the development of complex digital hypotheses dependency trees. Instead of taking the form

of the original text, the digital model represents the argumentative structure as a series of symbols which capture the argumentative statements and the relations between them, but the ability of researchers to trust the process of transcribing an argument structure from idiolect into a computable form has proven problematic. Another example given was the use of the photo-sharing website Flickr as a resource tool for researchers studying graffiti and Street Art, and the acknowledgement that without the formalisation of the photos by way of self-produced Flickr tags, identification, collation, and comparative analysis would be impossible. The argument here is that formulisation is various in its facets, directions, and motivations and is not a single unitary principle underlying computation.

Van Zundert and Antonijevic's work in itself seems representative of the 'computational turn', the moment of change between an initial first wave of new digital methodologies applied to 'old' humanities and a new, more complex, qualitative wave. Their case studies focus on new approaches to support existing humanities research, such as the digital hypotheses trees, and research into new humanities formed from digital media, such as the critical analysis of formalisation and the critique of formalisation in Flickr. But Van Zundert and Antonijevic propose a reading which sees computational humanities as just one stream of contemporary humanities research, arguing that if we position non-computational scholarship as conservative we run the risk of evoking resistance towards methodological and epistemological innovation. Instead they caution against unified computational analysis as the answer to all questions in humanities research, urging the consideration of a perspective that recognises the opportunities forged by the concept of a hybrid cognitive system in which human cognition is enhanced by computer functions. In doing so, we propose that they begin to bridge the gap between methodological applications of digital technology within the humanities and the idea of a systematic integration of the human and the digital. The question then becomes one of a deeper role and significance: are such digital methods simply another set of tools for researchers to use or are they transformational to the extent that they challenge established epistemology? (Rieder and Rohle 2012).

A new computational turn?

These critiques of the research challenges posed by the digital humanities focus specifically on the practicalities of using new technology to illuminate and reveal new ways of studying, interpreting, and understanding the humanities. We would like to suggest that what is missing is a different type of computational turn, in which the humanities, by embracing digital techniques, might be able to have a profound effect on our understanding and approach to science; so instead of embracing 'scientific' computation to illuminate the

humanities, and worrying about how to integrate new technology, we might use our sociological understanding to illuminate and challenge the sciences. C. Wright Mills (1959) was to some extent calling for this over half a century ago when he advocated the use of the 'sociological imagination' to bring human meaning, and the social role of science, to the fore in order to understand and challenge the impact of science in the world; this being necessary because men of science were locked in a positivist concept of research and were no longer looking at the whole picture and therefore not measuring, or even concerning themselves with, the ethical impact of discovery and innovation. Perhaps the new digital humanities face the same problem – by being too caught up in the excitement of new analytical tools, are we in danger of losing sight of the bigger picture of the humanities and its role in questioning and revealing the human condition? Will we fall instead into 'abstracted empiricism' (Wright Mills 1959: 50) which focuses so minutely on macro data that it fails to refine meaning? Will researchers in this environment become so involved in method that they cannot tackle or problematise the major issues of studying modern society and the impact of data sets and texts on society and culture?

There is no question, however, that some of the new digital techniques facilitate the kind of switching between macroscopic conceptions and detailed expositions that Wright Mills was seeking. They also unlock huge interpretive potential in exploring new ways for people to make sense of their social world. Taking the concept of interpretive research one stage further, instead of a working methodology where knowledge is co-produced as a result of multiple human encounters, conversations, and arguments (Deacon et al. 1999), we move towards a situation where knowledge is co-produced from encounters between humans and machines. The constructivist task here, then, is less about social reality and routine, and more about digital meanings and interaction, which bring about new interpretations of reality.

The new wave: digital humanities as a new field and discipline

To return to our opening hypothesis then, the essays in this collection raise the question of what the digital humanities actually *is*. We begin to see the emergence of a division between digital humanities as a set of qualitative tools or methods, and the digital humanities as a newly emerging field influenced by computation as a way of accessing, interpreting, and reporting the world itself. The first distinctive wave uses quantitative data production and analysis, while the second wave is identified as a new field within the humanities that utilises digital tools to address existing concerns in the humanities. In doing so, this second wave reveals new analytic techniques and ways of exploring problems that the humanities tackle and seek answers for. It is this second wave (Hayles 2012; Schnapp and Presner 2009) that we will now focus on – that is,

research identified as within the digital humanities, in pursuit of goals and outcomes thought of as the preserve of the traditional humanities, and which service the core methodological strengths of the humanities, such as attention to complexity, analytic depth, critique and interpretation (Schnapp and Presner 2009). Furthermore, we will identify two distinct movements within the second wave: 1) a movement that takes the existing humanities and analyses them in a different way through the use of digital technology; and 2) a movement that theorises new concepts in the humanities involving the digital. Papers from this collection will be used to illustrate these two movements and argue that opposition to the digital humanities, based upon an understanding that the field does not address the concerns of the humanities, is misguided.

First, we want to question what the digital humanities are as an area of study. In Hayles' *How We Think: Transforming Power and Digital Technologies* (2011), one definition of the digital humanities is offered through theoretical discussion. Hayles poses the possibility of what could be achieved by using computers to 'read' a greater number of books than would ever be possible for a single human or team of humans. The critical question would be what kind of 'reading' occurs when machines are analysing books. The mass analysis of such work (it could be argued) cannot reveal the fine detail and meanings that a traditional analysis can provide, but what is produced – structure, frequency of lexical choices, patterns of language use – can in itself form the foundation of a qualitative reading of the material. Rather than the reading of a few texts, text mining and computational analysis can extend the scope of an analysis of texts theoretically into the thousands, and with this provide a more complete analysis of an area or theme. In short, text mining can aid hermeneutic analysis – not replace it. Here, the qualitative approach of the digital humanities is laid bare. The text itself is treated to a hermeneutic analysis with the advantage of digital tools that uncover patterns, themes, and information that a close reading might miss or that would be outside of the scope of a traditional reading. The discussion of 'reading' (Hayles 2011: 8–9) is illustrative of the shift from the first to the second wave, and of the apparent rift between the traditional humanities and the digital humanities:

> In the traditional humanities, reading connotes sophisticated interpretations achieved through long years of scholarly study and immersion in primary texts. At the other end, 'reading' implies a model that eschews human interpretation for algorithms employing a minimum of assumptions about what results will prove interesting or important (Hayles 2011: 8).

The fears of scholars from the traditional humanities – that computer reading 'removes' the human eye for insight and interpretation, and therefore reduces the process of reading itself from a higher-level functioning position

of interpretation and evaluation to a lower-level function of identification and description – is clear. Hayles' interjection is that computer 'reading itself involves a necessary level of human intentionality and interpretation through the programming and implementation of 'reading' algorithms, along with the human interpretation of results', (Hayles 2011: 9). What we want to argue here is that the computational turn is an extension of the aims and desires of traditional research, along the lines that Hayles is proposing; that research in the digital humanities is driven by the same desire to know as traditional humanities, but that through the new 'knowing-how' that the presence of computation has given, the topics and areas of research, the methods and the results have changed, but the humanities are the humanities, whether digital or traditional. This is the second wave – the activities and functions of the humanities being served through digital methods, as well as through traditional close reading, but leading to a change in the methods and output of the humanities.

Hayles offers an analysis of the shifting ontology of the digital humanities based on this functional analysis of what the field is capable of, and how it is utilised in the humanities. Drawing on the first/second wave distinction of Schnapp and Presner (2009), Hayles contends that the digital humanities represents a movement from text-based study (although retaining this link) to closer links with time-based art forms (film and music), visual traditions (graphics and design), spatial practices (architecture and geography) and curatorial practices (Hayles 2011: 4). The qualitative, interpretive, experiential, emotive and generative character of the digital humanities as characterised by Schnapp and Presner (2009) are expressed in these expanded fields of enquiry, while the relationship with text that has characterised the humanities as a field since its inception is not severed, but augmented, by the computational techniques that are a feature of the new field. Hayles characterises the new field as one of diverse practices associated with computational techniques and going beyond print in its modes of inquiry, research, publication, and dissemination (Hayles 2011: 5). The human eye does not withdraw from the digital humanities, and it is not necessarily so that the digital humanities are posthuman in character, but the changes are radical enough to necessitate the label 'digital humanities'. In the future, perhaps it will be the humanities that will be discussed again, which, in the view we offer here, would be a victory for the second wave as an absorption of digital practices seamlessly into the field of the humanities. In such an event, the data and streams that concern the digital humanities are not considered apart from meaning, but are either a route to semantic understanding, or are understood semantically in themselves. Hayles argues this (2011: 15), and offers the view that the digital humanities will either follow this path or become a separate field with distinct aims and character from the traditional humanities. It is outside the scope of this discussion to argue the implications of the latter – what we want to follow here is a line of argument

which outlines and explains the second wave of digital humanities and proposes that it is this movement that links digital methodologies with the traditional concerns of the humanities, and in doing so redefines and positions the field of digital humanities firmly within the humanities itself.

New analysis of existing humanities: looking at things in a different way

A series of essays in this volume offer novel approaches to tackling existing research areas based on the use of digital technology. Manovich's paper, *Cultural Analytics: Annual Report 2010*, provides an update on his ongoing project of using visualisation techniques (computationally based) to explore cultural data – giving the examples of over a million manga pages, and every *Time* magazine cover since issue 1. The phrase 'Cultural Analytics' demands attention – the analysis of culture is the humanities, and analytics is the application of computation, computer technology, and statistics to solve a problem. While culture is the object of study, the methods of solving cultural questions here are quite clearly computational, and hence this is illustrative of the digital humanities tackling traditional humanities with the use of computational tools. Manovich argues for the application of cultural analytics software that can lead to insightful conclusions about changing trends over time, but also that those trends can be *seen* by the person observing the research. The graphic below – a visualisation of every Time magazine cover since the first publication – shows changes in colour and contrast over time, as well as how the present style and convention was reached over the entire history of the publication, thus offering a genealogical, rather than causal, history of the development of the publication.

Manovich's cultural analytics intersects the distinction between the first and second waves of digital humanities: on the one hand, the data mining is a quantitative method of analysing a large data set, and allows for the understanding of that data in a novel way which deep reading or analysis would not allow, but this work also illustrates how a digital toolkit can be put to use in the service of the digital humanities, that is, the technique and software allows for a traditional hermeneutic analysis, while retaining the advantages of large scope and comprehensiveness which digital data mining can provide.

The emphasis on hermeneutics, and the meaning of the array or stream, makes the link to the traditional humanities explicit, but there is also the clear change of material from text to other sources, and by returning to the five tenets of the digital humanities (qualitative, interpretive, experimental, emotive, and generative) it is clear that this work is rooted firmly in the second wave of the digital humanities. Heftberger (2012) offers an account of a research methodology, and method of visualising data and findings, used to explain

the work of the Digital Formalisation project in Vienna in relation to the work of the Soviet filmmaker Dziga Vertov. In doing so some alternative uses of the technology developed in Manovich's research work are offered. The digital formalism of the project had the intention of developing computer-based media tools for a digital analysis of the work, and aimed to assess what cinematic elements play on different aspects of perception – therefore, assessing how high-level media analysis can contextualise the phenomenal or experiential dimension of the cinema experience. In this research, there is not the intersection of analysis that can be traced back to textual analysis and its crossover with computation, however, the phenomenal, as a research area, has had long traditions in the fields of philosophy and literature to name two; this is still research with aims rooted in the humanities, with computation at the heart of the methodology.

The intersection of meaning and method is explored further in relation to textual analysis in Hildebrandt's 2012 paper, *The Meaning and Mining of Legal Texts*. Hildebrandt proposes that legal texts have an authority that is not inherent in literary texts – that is, legal texts form precedents that inform the legal process, and the meaning of the law comes from this reading. Due to the proliferation of legal texts on the Internet, Hildebrandt argues that data mining will eventually become the primary research method in the legal profession, but that this also poses the question of the difference between human interpretation and pattern recognition, and whether this difference will result in difference in the meaning of the law. The computational nature of the algorithms used (hidden and withdrawn from everyday understanding) is at the root of this question, and the digital humanities, informed by code and awareness of the nature and ontology of computation, seems ideally placed to identify, tackle, and theorise such an issue. Ganz and Murtagh (2011) address data mining as the possibility of a new analytic framework for film and TV scripts, by analysing the deep structure in narratives and the relationship between these textual prototypes and the visual narratives in the text itself. Carvalho (2011) outlines the intensive use of computational techniques that contribute to the understanding of historical processes, in particular an uncovering of complex self-organising historical processes that emerge without the intervention of a centralised coordinating entity, but rather as the result of local interactions of agents. The emergent nature of the process shows itself as a mathematical distribution called a Zipf law, and the case studies of settlement patterns, mail routes, and kin networks can also be presented visually in summary.

All these papers are thematically linked – they show traditional problems in the humanities (narrative analysis; semiotic analysis of magazines; textual analysis) and propose not just how computational methods and analytics can be used to investigate the area, but also how the findings derived from the method offer new insights and results that traditional methods cannot. Moreover, the

methods themselves pose new questions for research which were previously outside the scope of research and which will inevitably lead to new findings and interpretations. That the traditional questions of the humanities are being addressed is important – that computational techniques can offer new methods, results, findings, and paradigms is critical.

Theorising the new: concepts of the humanities emerging from the digital

In this collection there are a series of speculations on how the digital humanities may open new conceptual areas of study for the humanities, thereby evolving the discipline. When one questions whether the humanities have always been digital, what is being asked is whether technology and the relationship between technology and humans has always been a feature of the humanities. Fabretti (2012) uses the question of the mutual co-constitution of the human and technology as a staging post for questioning the nature of computer code and software, and whether deconstruction of software can be a means to exploring the relationship between the human and technology. In doing this, the project proposes a new contour in the humanities – not only in the methodology of a hermeneutic deconstruction of software, but also in proposing that the result will reveal a new position on the relationship between man and technology, and therefore questioning the role of computation in the constitution of the concept of the human. The 'deep opacity' (Stiegler 1998: 21) of technology makes such a reading difficult, but that difficulty is reflected in the constitution of the human in that decisions and actions are made with escalating uncertainty due to this opacity in the increasingly ubiquitous digital technology on which we depend. Fabretti demands that this opacity is tackled in order to understand the relationship and therefore bring a new perspective to the concept of the human. This certainly constitutes an application of humanities methodology in the pursuit of a novel theory in the humanities – using the digital to investigate the change in the human (following traditional research into the effect of new technology through history on the concept of the human).

Dexter (2011) also proposes a questioning of software, not on the level of what it does but *what it is*. A reading of code as poetics would involve not only the analysis along literary lines, but also an appreciation of the history and open nature of code – and hence a new form of criticism emerges. While these theorists deal with the changing nature of textual analysis in the digital humanities, Carusi (2011) questions how visualisation techniques derived from digital methods can infiltrate and enrich areas of the humanities that have been text dependent, and whether this approach is appropriate and can be successful – again, questioning the future of the humanities after this digital turn.

These speculative papers ask questions of where the humanities are going, and what we as humanities researchers might be doing and producing. This constitutes a treatise on the future of the humanities. Equally, in looking to the future and how new concepts will emerge there is a lineage to past theory that can inform such findings. Klocubar (2011) questions the role of databases and information technology used in everyday life and how this affects the phenomenal and existential truth of the place of the human subject in that world. Tracing the effects of location-based services and geospatial information technology back to Kant's transcendental subjectivity – the ephemeral nature of the transcendental subject akin to the blue dot on a Google map that locates a device on a map – and through Hegel and Foucault's notion of the 'modern episteme', Klocubar argues that mobile, accessible database technology creates an epistemological agnosia akin to Hegel's observation that human rationality involves a suspension of the subjective relationship between human and world. The agnosia is technologically induced – by having the world of knowledge at our fingertips we will miss the world itself. Bloom (2011) questions how digital technology, and the ubiquity of computation, alters the desire of an actor, and therefore the sense of self that an actor has – and then considers how this reflects upon the critical hegemony of our times. The creation of a computational subject is a fantasy in the Lacanian sense, which serves to legitimise the dominant capitalist ideology of our times through the strengthening of the shared utopian visions that are part of the capitalist hegemony.

These reflections indicate how the digital humanities through the use of, and reflected by, the proliferation of computation, are opening questions on the nature of the human in the world and how this status is subject to change thus requiring theoretical framing and debate. Hui's 2011 *Computational Turn or a New Weltbilt*, which uses Heidegger's concept of the world picture or world disclosure, acts as a critique of the entire collection of papers in this volume. The paper identifies the role of the discursive network as the key representation of understanding the world in the computational turn, and moves from there to use Heidegger's notion of the world disclosure, and this computational image, to sketch a theory of understanding a new way that entities could be disclosed to us in the world. Hui's paper points towards a different, alternative (in every sense of the word) view of the computational turn, not as a means and method of *doing* research, but as a turning in the sense Martin Heidegger meant it – a turning in the way we are oriented towards the world. It is apparent to us that while many of the papers in this volume do not address computation in this way, they do offer a scope to ask the question of whether what is being discussed is a change in methods or a change in viewing the world and the humanities itself, with those methods a manifestation of this new orientation.

These papers provide an illustration of the second wave of the digital humanities – using and theorising the computational to produce qualitative,

interpretive, generative, experiential, and emotive work within the humanities. Far from being quantitative, the digital humanities, as presented in this section, are examples of work that actively engage digital methods to probe existing questions in the humanities in a qualitative manner, or propose new theories and areas of research in the humanities by accepting and making problematic the inevitable presence of computation in the world, and therefore in the humanities. We argue that the digital humanities are concerned with addressing the key concerns of the humanities, and while the methods may differ, the intentions of the researchers – to address and reflect upon the human condition – are the same in the traditional and digital humanities, at least in this second wave of digital humanities research.

Digital humanities: in the world

The effect of new technologies on the humanities and writing in the humanities can be insidious. Carr (2010) has outlined how Nietzsche's writing was affected by the use of a typewriter, bought in 1882 to aid his failing eyesight and powers of concentration when writing. Carr notes the comments of a composer friend of Nietzsche's, who observed that his prose had become tighter and more telegraphic. Kittler writes that the prose had 'changed from arguments to aphorisms, from thoughts to puns, from rhetoric to telegram style' (Kittler 1999: 203). The aphorismic style attributed to the use of the typewriter can be seen clearly in *Beyond Good and Evil* (1886), *On the Genealogy of Morals* (1887) and *The Antichrist* (1888), a departure from the florid prose of earlier works such as *The Birth of Tragedy* (1872) – and indeed a crueller and harsher tone of criticism can be clearly seen in the later works (although technology may not be as culpable as mood and ill health in that case). Nietzsche himself said, 'Our writing equipment takes part in the forming of our thoughts' (Carr 2008). The argument is that the typewriter elicited a change in the practices and product of thinking in the great philologist, and that this change (in working habit and the direction, content, and style of work) was the result of a change in the conditions of the world that Nietzsche found himself part of in 1882. Nietzsche neither invented nor pioneered the use of the typewriter – it was already a presence in the world before his usage. His use did affect change in his work clearly though, and it is along these lines that we should consider the digital humanities. Digital technology, as a concrete and pre-existing thing in the world, is unavoidably affecting the way humanities scholars conduct research (or think about the world). It is also affecting the product of that research – the material that reflects how researchers in the humanities are reflecting on the world.

The humanities exist as part of the world, and we are not removed from the world, staring down with all-seeing, critical eyes that are permanently detached from the patterns and chaos of human activity. We are not, to quote Thomas

Nagel, in a position where we have a 'view from nowhere' (Nagel 1986: 3). The methods of the humanities though may provide extractions and abstractions from this all-encompassing milieu, but to argue that the humanities may be in a position detached and above the world that it studies is fallacious. This may seem self-evident, and should be; however, any debate over the effectiveness and appropriateness of digital methods, and the digital humanities in general, raises doubts around this point. The sceptic who states that data mining and pattern recognition in works of literature debases close reading ignores the prevalent mood of human action in a time of computational ubiquity – close reading has a role in the humanities, but it will not deal with the sprawl of textual information being produced daily and added to the incomprehensible deluge of textual information in the digital age. There will be no argument here that canonical texts should not be subject to close readings, but there is an underlying argument that digital humanities methods are necessary and appropriate as we attempt to grasp the information landscape available to us. It is this availability which is critical; we exist alongside, and interact with, computational devices continuously, and these devices offer easy, instant, and unhindered access to incomprehensible amounts of information. These conditions of availability have not been part of human life before, and hence the humanities require new, appropriate, and digitally focused methods to deal with this new condition of being-in-the-world.

We live in a world in which computational devices – computers, mobile phones, satellite navigation devices and so forth – exist alongside us, and, as Berry (2011) argues, these devices have become *embedded* in our everyday lives and being. Berry is arguing that the computational dimension is now a given – a part of the background to being where life experiences become procedural chains of digital information that are stored in databanks (Berry 2011: 149). The referential totality (which is the world) made up by the entities around us is increasingly populated with actors enabled with computational techniques and abilities, and it is through this continual exposure to computation that a computational 'knowing-that' (a presence-at-hand or *vorhandenheit)* emerges socially. The computational becomes therefore comportment towards the world, that takes as subject matter the manifest entities which it can transform through calculation and processing interventions (Berry 2011: 143), resulting in a form of computational reason.

It is this computational 'knowing-that' which is important in thinking about the place of the digital humanities in the world. We are comported towards the world computationally by the fact that the world is made up increasingly of computational things. As we use computational devices daily, new ways of interpreting and evaluating the world – and this includes the subject matter of the humanities, be it literature, visual material, speech, or any other information we care to study – become apparent to us through that usage. We can

now use databases to store and sort vast amounts of information that could not be done through traditional methods (without teams of thousands and time aplenty – two commodities even the most heralded of researchers cannot call upon) and have access to software to analyse visual material exponentially quicker than the eye can manage. These methods then are a product of the world itself – the world that the humanities purports to study.

We argue that digital technology is integral and embedded in the humanities (imagine the mess if we handwrote this rather than used a computer...) and that the emerging digital methods, some of which are described in depth in this volume, are a product of the role of digital technology within the world, evolving from our everyday practices as researchers, and our position as everyday people in our time. We already depend on digital technology to produce our work, just as Nietzsche depended on his typewriter, and we are seeing a change in the form, content, and product of research through the integration of the digital into practice. We caution against knee-jerk reactions to this change though; Nietzsche's style changed, but his scepticism, genealogical method, and perspectivism did not alter – the basis of his philosophical system remained the same. What can be said conclusively is that the technology allowed Nietzsche to continue to work, and that it effected a change in his working habits, and the product of his work (in style). This is what we are witnessing in the humanities; digital technology will change the way that some of us work, research, and produce *material*. It will likely also change the conclusions we draw from our work, because of the changes in the conditions of the world brought about by the presence of technology. Technology has always done this, and will do so more in the future. The humanities are about the world, and the research in this volume reflects as much the changes in the world as it does the changes in the research practices and thinking that embrace what we consider to be the humanities today.

Notes

1. In the synopsis to his keynote address at the Computational Turn conference in March 2010, Lev Manovich summarises a Cultural Analytics Annual Report 2010 which states: 'When we started work on Cultural Analytics in 2008, we established a number of larger goals: (1) being able to better represent the complexity, diversity, variability, and uniqueness of cultural processes and artifacts; (2) create much more inclusive cultural histories and analysis – ideally taking into account all available cultural objects created in a particular cultural area and time period ("art history without names"); (3) develop techniques to describe the dimensions of cultural artifacts and cultural processes which until now received little or no attention (such as gradual historical changes over long periods) and/or are difficult to describe using natural languages (such as motion); (4) create visualisation techniques and interfaces for exploration of cultural data which operate across multiple scales; (5) from

details of structure of a particular individual cultural artifact/processes (such as a single shot in a film) to massive cultural data sets/flows (such as films made in 20th century).'

2. In the synopsis to her keynote address at the Computational Turn conference in March 2010, N. Katherine Hayles summarises some of the characteristics and issues of the concept of 'distant reading': 'Within the Digital Humanities community, there is an on-going dispute about the relation of human to machine reading, in particular whether finding patterns can be a goal in itself or whether it must be linked to interpretation and meaning. This presentation argues for the importance of interpretation and illustrates it with results from data and text mining on Mark Danielewski's "Only Revolutions", an intricately patterned Oulipo-like work in which patterns compete (and cooperate) with overwhelming amounts of loosely structured data.'

3. The Computational Turn conference was held at Swansea University on 9th March 2010, focusing on a broad corpora of work examining the digital humanities. Organised and conceived by Dr David M. Berry the conference explored the potential for a turning point in our understanding of digital humanities, conceptualised as the 'computational turn'.

4. The Computational Turn digital humanities conference held at Swansea University on 9 March 2010.

References

Almila, A. (2011) 'Digital Problems/Digital Solutions?', The Computational Turn, accessed 11 January 2010, http://www.thecomputationalturn.com/.

Berger, A. (2000), *Media & Communications Research Methods* (London: Sage).

Berry, D. M. (2008), *Copy, Rip, Burn – The Politics of Copyleft and Open Source* (London: Pluto Press).

Berry, D. M. (2011), *The Philosophy of Software: Code and Mediation in the Digital Age* (London: Palgrave/Macmillan).

Bloom, P. (2011), *Computing Fantasies: Psychologically Approaching Identity and Ideology in the Computational Age,* The Computational Turn, accessed 11 January 2010. http://www.thecomputationalturn.com/.

Booth, C. W., Columb, G. G., Williams, J. M. (2008), *The Craft of Research* (Chicago: University of Chicago Press).

Carr, N. (2008), 'Is Google Making Us Stupid? What the Internet Is Doing to Our Brains', *The Atlantic* July/August 2008. http://www.theatlantic.com/magazine/archive/2008/07/is-google-making-us-stupid/6868/.

Carr, N. (2010), *The Shallows: What the Internet Is Doing to Our Brains* (New York: W. W. Norton & Co.).

Carusi, A. (2011), *Technologies of Representation, Images, Visualisations and Texts,* The Computational Turn, accessed 11 January 2010, http://www.thecomputationalturn.com/.

Carvalho, J. (2011), *Self-Organisation, Zipf Laws and Historical Processes: Three Case Studies of Computer Assisted Historical Research,* The Computational Turn, accessed 11 January 2010. http://www.thecomputationalturn.com/.

Cheeseman, T. (2011), 'Is What Computation Counts What Counts?', The Computational Turn, accessed 11 January 2010. http://www.thecomputationalturn.com/.

Cole, T. and Giordano, A. (2011), 'The Computational Turn: GIScience and the Holocaust', The Computational Turn, accessed 1/11/2010, http://www.thecomputationalturn.com/

Currie, M. (2010), 'Katherine Hayles Keynote Address at the Computational Turn', *Masters of Media*. accessed March 2010. http://mastersofmedia.hum.uva.nl/2010/03/13/katherine-hayles-keynote-address-at-the-computational-turn/. 2012, 'The Feminist Critique: Mapping Controversy in Wikipedia', in D. M. Berry, (ed.), *Understanding Digital Humanities* (London: Palgrave/Macmillan).

Dayan, D., and Katz, E. (1994), *Media Events* (London: Harvard University Press)

Deacon, D., et al. (1999), *Researching Communications*: *A Practical Guide to Methods in Media and Cultural Analysis* (London: Arnold).

Dexter, S. (2011), *Toward a Poetics of Code,* The Computational Turn, accessed 11 January 2010. http://www.thecomputationalturn.com/.

Dixon, D. (2012), 'Analysis Tool or Design Methodology? Is There an Epistemological Basis for Patterns?' in D. M. Berry (ed.) *Understanding Digital Humanities* (London: Palgrave/Macmillan).

Durham Peters, J. (1999), *Speaking Into the Air* (London: University of Chicago Press).

Fabretti, F. (2012), *Have the Humanities Always Been Digital? For an Understanding of the Digital Humanities in the Context of Originary Technicity,* in D. M. Berry, (ed.) *Understanding Digital Humanities* (London: Palgrave/Macmillan).

Ganz, A. and Murtagh, F. (2011), *From Data Mining in Digital Humanities to New Methods of Analysis of Narrative and Semantics,* The Computational Turn, accessed 11 January 2010. http://www.thecomputationalturn.com/.

Habermas, J. (1992), *The Structural Transformation of the Public Sphere* (Cambridge: Polity Press).

Hadzi, A. (2011), 'Data Spheres', The Computational Turn, accessed 11 January 2010. http://www.thecomputationalturn.com/.

Hayles, N. K. (1999), *How We Became Posthuman* (London: University of Chicago Press).

Hayles N.K. (2012), *How We Think: Transforming Power and Digital Technologies,* in D. M. Berry (ed.) *Understanding Digital Humanities* (London: Palgrave/Macmillan).

Hazel, P. (2010), 'The Computational Turn', *paulhazel.com*, accessed March 2010. http://www.paulhazel.com/2010/03/17/the-computational-turn/.

Heftberger, A. (2012), *Film Data for Computer Analysis and Visualisation.* In D. M. Berry, (ed.) *Understanding Digital Humanities* (London: Palgrave/Macmillan).

Hildebrandt, M. (2012), *The Meaning and The Mining of Legal Texts,* in D. M. Berry, (ed.) *Understanding Digital Humanities* (London: Palgrave/Macmillan).

Hui, Y. (2011), *Computational Turn or a New Weltbild,* The Computational Turn, accessed 11 January 2010. http://www.thecomputationalturn.com/.

Kittler, F. (1999), *Gramophone, Film, Typewriter,* trans. G. Winthrop-Young (Palo Alto, CA: Stanford University Press).

Klocubar, A. (2011), *'All Your Database are Belong to Us'y: Aesthetics, Knowledge and Information Management,* The Computational Turn, accessed 11 January 2010. http://www.thecomputationalturn.com/.

Lin, Y. (2011), 'Text Mining for Frame Analysis of Media Content'. The Computational Turn, accessed 11 January 2010. http://www.thecomputationalturn.com/.

Malpas, J. and Wrathall, M. (2000), *Heidegger, Authenticity, and Modernity/Heidegger, Coping, and Cognitive Science. Essays in Honour of Hubert L. Dreyfus,* vols. 1 and 2 (Michigan: MIT Press).

Manovich, L. (2012), *Cultural Analytics: Annual Report 2010,* in D. M. Berry, (ed.) *Understanding Digital Humanities* (London: Palgrave/Macmillan).

Nagel T. (1986), *The View From Nowhere* (Oxford: Oxford University Press).

Nietzsche, F. (1872), *The Birth of Tragedy: Out of the Spirit of Music* (London: Penguin Classics [1994]).

Nietzsche, F. (1886), *On the Genealogy of Morals* (London: Oxford University Press [2008]).

Nietzsche, F. (1887), *Beyond Good and Evil* (London: CreateSpace [2010]).

Nietzsche, F. (1888), *The Antichrist* (London: CreateSpace [2010]).

Reider, B. and Rohle, T. (2012), 'Digital Methods: Five Challenges', in D. M. Berry, (ed.) *Understanding Digital Humanities* (London: Palgrave/Macmillan).

Schnapp, J. and Presner, T. (2009), *The Digital Humanities Manifesto* (a collaborative document produced by the Mellon Seminar on the Digital Humanities, UCLA 2008–2009). https://docs.google.com/viewer?url=http://www.stanford.edu/~schnapp/Manifesto%25202.0.pdf.

Sennet, R. (1998), *The Corrosion of Character* (London: W. W. Norton & Company).

Silverstone, R. (1999), *Why Study The Media?* (London: Sage).

Sredniawa, M. and Hayes, K. A. (2011), 'A Cultural Analytics-Based Approach to Polymath Artists: Witkacy Case Study', The Computational Turn, accessed 11 January 2010. http://www.thecomputationalturn.com/.

Stiegler, B. (1998), *Technics and Time 1: The Fault of Epimetheus* (Stanford, CA: Stanford University Press).

Van Zundert, J., and Antonijevic, S. (2012), 'Cultures of Formalization: Towards an Encounter between Humanities and Computing', in D. M. Berry (ed.) *Understanding Digital Humanities* (London: Palgrave/Macmillan).

Wright Mills, C. (1959), *The Sociological Imagination* (Oxford: Oxford University Press).

3

How We Think: Transforming Power and Digital Technologies

N. Katherine Hayles

Arguably more print-based than the sciences and social sciences, the humanities are nevertheless also experiencing the effects of digital technologies. At the epicentre of change are the digital humanities. The digital humanities have been around at least since the 1940s,[1] but it was not until the Internet and World Wide Web that they came into their own as emerging fields with their own degree programs, research centres, scholarly journals, and books, and a growing body of expert practitioners. Nevertheless, many scholars – particularly in literary studies – are only vaguely aware of the digital humanities and lack a clear sense of the challenges they pose to traditional modes of enquiry. This essay outlines the field, analyses the implications of its practices, and discusses its potential for transforming research, teaching, and publication. The essay concludes with a vision that sees the digital humanities revitalising the traditional humanities, even as they also draw on the traditional humanities for their core strengths.

Coming to the scene with a background in scientific programming and a long-standing interest in machine cognition, I wanted to see how engagements with digital technologies are changing the ways humanities scholars think. The obvious and visible signs of a shift include the changing nature of research, the inclusion of programming code as a necessary linguistic practice, and the increasing number of large Web projects in nearly every humanities discipline. This much I knew, but I was after something deeper and more elusive: how engagements with digital technologies are affecting the assumptions and presuppositions of humanities scholars, including their visions of themselves as professional practitioners, their relations to the field, and their hopes and fears for the future. To explore these issues, I conducted a series of phone and in-person interviews with twenty U.S. scholars at different stages of their careers and varying intensities of involvement with digital technologies.[2] The insights that my interlocutors expressed in these conversations were remarkable. Through narrated experiences, sketched contexts, subtle nuances,

42

and implicit conclusions, the interviews reveal the ways in which the digital humanities are transforming assumptions. The themes that emerged can be grouped under the following rubrics: scale, critical/productive theory, collaboration, databases, multimodal scholarship, code, and future trajectories. As we will see, each of these areas has its own tensions, conflicts, and intellectual issues. I do not find these contestations unsettling; on the contrary, I think they indicate the vitality of the digital humanities and their potential for catalysing significant change.

Defining the field

Nowhere is this contentious vitality more evident than in the field's definition. The rapid pace of technological change correlates in the digital humanities with different emphases, opening a window onto the field's history, the controversies that have shaped it, and the tensions that continue to resonate through it. Stephen Ramsay recalls, 'I was present when this term was born ... "digital humanities" was explicitly created – by Johanna Drucker, John Unsworth, Jerome McGann, and a few others who were at IATH [Institute for Advanced Technology in the Humanities at the University of Virginia] in the late nineties – to replace the term "humanities computing." The latter was felt to be too closely associated with computing support services, and for a community that was still young, it was important to get it right.' Alan Liu also recalls using the term around 1999–2000. Although some practitioners continue to prefer 'humanities computing',[3] for Ramsay and his colleagues 'digital humanities' was meant to signal that the field had emerged from the low-prestige status of a support service into a genuinely intellectual endeavour with its own professional practices, rigorous standards, and exciting theoretical explorations. On this last point, Matthew Kirschenbaum (2009b) recalls the convergence of the digital humanities with newly revitalised bibliographic studies, as Jerome McGann and others were challenging traditional wisdom and advocating for a contextualised cultural studies approach. 'The combat in the editorial community ... provided first-wave digital humanities with a theoretical intensity and practical focus that would have been unattainable had we simply been looking at digitisation and database projects broadly construed ... the silver bullet of first-wave digital humanities, it seems to me, was the conjoining of a massive theoretical shift in textual studies with the practical means to implement and experiment with it.'

A decade later, the term is morphing again as some scholars advocate a turn from a primary focus on text encoding, analysis, and searching to multimedia practices that explore the fusion of text-based humanities with film, sound, animation, graphics, and other multimodal practices across real, mixed, and virtual reality platforms. The trajectory can be traced by comparing Unsworth's

2002 'What Is Humanities Computing and What Is Not', with Schnapp and Presner's 2009 'Manifesto 2.0'. At the top of Unsworth's value hierarchy are sites featuring powerful search algorithms that offer users the opportunity to reconfigure them to suit their needs. Sites billing themselves as digital humanities but lacking the strong computational infrastructure are, in Unsworth's phrase, 'charlatans'.

By contrast, the 'Manifesto' consigns values such as Unsworth's to the first wave, asserting that it has been succeeded by a second wave emphasising user experience rather than computational design:

> The digital first wave replicated the world of scholarly communications that print gradually codified over the course of five centuries: a world where textuality was primary and visuality and sound were secondary. ... Now it must shape a future in which the medium-specific features of digital technologies become its core and in which print is absorbed into new hybrid modes of communication.
>
> The first wave of digital humanities work was quantitative, mobilising the search and retrieval powers of the database, automating corpus linguistics, stacking hypercards into critical arrays. The second wave is **qualitative, interpretive, experiential, emotive, generative** in character [emphasis in original]. It harnesses digital toolkits in the service of the Humanities' core methodological strengths: attention to complexity, medium specificity, historical context, analytical depth, critique and interpretation.

Note that the core mission is here defined so that it no longer springs primarily from quantitative analyses of texts but rather from practices and qualities that can inhere in any medium. In this view the digital humanities, although maintaining ties with text-based study, have moved much closer to time-based art forms such as film and music, visual traditions such as graphics and design, spatial practices such as architecture and geography, and curatorial practices associated with museums, galleries, and the like.[4] Understandably, pioneers of the so-called 'first wave' do not unequivocally accept this characterisation, sometimes voicing the view that 'second wave' advocates are Johnnys-come-lately who fail to understand what the digital humanities really are.

In a quantitative/qualitative analysis of this tension, Patrick Svensson shows that the tradition of textual analyses remains strong, arguably maintaining its position as the dominant strand. From a very different perspective, Johanna Drucker argues that the digital humanities have been co-opted by a computational perspective inherited from computer science, betraying the humanistic tradition of critical interpretation. Positioning 'speculative computing' as the other to the digital humanities, she argues that speculative computing 'attempts to open the field of discourse to its infinite and peculiar richness

as deformative interpretation. How different is it from digital humanities? As different as night from day, text from work, and the force of controlling reason from the pleasures of *delightenment'* (2009: 30). Her analysis is less than compelling, however, because it flattens the field's diversity (many working in the digital humanities would argue they are practicing what she calls speculative computing), does not attend to critiques of humanities computing from within the field, does not acknowledge work in the second wave, and justifies claims by an idiosyncratic collection of influences. Nevertheless, her critique indicates that the field has not assumed a stable form, even as it puts pressure on traditional practices.

For my purposes, I want to understand the digital humanities as broadly as possible, both in its 'first wave' practices and 'second wave' manifestations (while acknowledging that such classifications are contested). Rather than being drawn into what may appear as partisan in-fighting, I posit the digital humanities as a diverse field of practices associated with computational techniques and reaching beyond print in its modes of enquiry, research, publication, and dissemination. In this sense, the digital humanities includes text encoding and analysis, digital editions of print works, historical research that re-creates classical architecture in virtual reality formats such as *Rome Reborn* and *The Theater of Pompey*, archival and geospatial sites, and since there is a vibrant conversation between scholarly and creative work in this field, electronic literature and digital art that draws on or remediates humanities traditions.

Scale matters

Perhaps the single most important issue in effecting transformation is scale. Gregory Crane (2008a) estimates that the upward boundary for the number of books anyone can read in a lifetime is 25,000 (assuming one reads a book a day from age 15 to 85). By contrast, digitised texts that can be searched, analysed, and correlated by machine algorithms number in the hundreds of thousands (now, with Google books, a million and more), limited only by ever-increasing processor speed and memory storage. Consequently, machine queries allow questions that would simply be impossible by hand calculation. Timothy Lenoir and Eric Gianella, for example, have devised algorithms to search patents on Radio Frequency Identification Tags, embedded in databases containing 6,500,000 patents. Even when hand searches are theoretically possible, the number and kinds of queries one can implement electronically is exponentially greater than would be practical by hand.

To see how scale can change long-established truisms, consider the way in which literary canons typically function within disciplinary practice, for example in a graduate program that asks students to compile reading lists for the preliminary examination. Most, if not all, of these works are drawn from

the same group of texts that populate anthologies, dominate scholarly conversations, and appear on course syllabi, presumably because these texts are considered to be especially significant, well-written, or interesting in other ways. Almost by definition, they are not typical of run-of-the-mill literature. Someone who has read only these texts will likely have a distorted sense of how 'ordinary' texts differ from canonised works. By contrast, as Gregory Crane (2008a) observes, machine queries enable one to get a sense of the background conventions against which memorable works of literature emerge. Remarkable works endure in part because they complicate, modify, extend, and subvert conventions, rising above the mundane works that surrounded them in their original contexts. Scale changes not only the quantities of texts that can be interrogated but also the contexts and contents of the questions.

Scale also raises questions about one of the most privileged terms in the traditional humanities, 'reading'. At the level professional scholars perform this activity, reading is so intimately related to meaning that it connotes much more than parsing words; it implies comprehending a text and very often forming a theory about it as well. Franco Moretti throws down the gauntlet when he proposes 'distant reading' as a mode by which one might begin to speak of a history of *world* literature (2007: 56–58). Literary history, he suggests, will then become 'a patchwork of other people's research, *without a single direct textual reading*' (2007: 57). He continues, 'Distant reading: where distance, let me repeat it, is a condition of knowledge: it allows you to focus on units that are much smaller or much larger than the text: devices, themes, tropes – or genres and systems' (2007: 57). In this understanding of 'reading', interpretation and theorising are still part of the picture, but they happen not through a direct encounter with a text but rather as a synthetic activity that takes as its raw material the 'readings' of others.

If one can perform 'distant reading' without perusing a single primary text, then a small step leads to Timothy Lenoir's claim (2008) that machine algorithms may also count as 'reading'. From Lenoir's perspective, algorithms read because they avoid what he sees as the principal trap of conventional reading, namely that assumptions already in place filter the material so that one sees only what one expects to see. Of course, algorithms formed from interpretive models may also have this deficiency, for the categories into which they parse units have already been established. This is why Lenoir proclaims, 'I am totally against ontologies' (2008). He points out that his algorithms allow convergences to become visible, without the necessity to know in advance what characterises them.

Lenoir's claim notwithstanding, algorithms formed from ontologies may also perform the useful function of revealing hitherto unrecognised assumptions. Willard McCarty makes this point about the models and relational databases he uses to analyse personification in Ovid's *Metamorphosis*. While

the results largely coincided with his sense of how personification works, the divergences brought into view strong new questions about such fundamental terms as 'theory' and 'explanation' (2005: 53–72). As he remarks (2008: 5), 'A good model can be fruitful in two ways: either by fulfilling our expectations, and so strengthening its theoretical basis, or by violating them, and so bringing that basis into question.'

The controversies around 'reading' suggest it is a pivotal term because its various uses are undergirded by different philosophical commitments. At one end of the spectrum, 'reading' in the traditional humanities connotes sophisticated interpretations achieved through long years of scholarly study and immersion in primary texts. At the other end, 'reading' implies a model that eschews human interpretation for algorithms employing a minimum of assumptions about what results will prove interesting or important.[5] The first position assumes that human interpretation constitutes the primary starting point, the other that human interpretation misleads and should be brought in after machines have 'read' the material. In the middle are algorithms that model one's understanding but nevertheless turn up a small percentage of unexpected instances, as in McCarty's example. Here human interpretation provides the starting point but may be modified by machine reading. Still another position is staked out by Moretti's way (2000, 2007) of unsettling conventional assumptions by synthesising critical works that are themselves already synthetic. Human interpretation here remains primary but is nevertheless wrenched out of its customary grooves by the scale at which 'distant reading' occurs. Significantly, Moretti not only brackets but actively eschews the level on which interpretation typically focuses, that is, paragraphs and sentences (2007: 57).

The further one goes along the spectrum that ends with 'machine reading', the more one implicitly accepts the belief that large-scale multi-causal events are caused by confluences that include a multitude of forces interacting simultaneously, many of which are non-human. One may observe that humans are notoriously egocentric, commonly perceiving themselves and their actions as the primary movers of events. If this egocentric view were accurate, it would make sense that human interpretation should rightly be primary in analysing how events originate and develop. If events occur at a magnitude far exceeding individual actors and far surpassing the ability of humans to absorb the relevant information, however, 'machine reading' might be a first pass towards making visible patterns that human reading could then interpret.

In either case, human interpretation necessarily comes into play at some point, for humans create the programs, implement them, and interpret the results. As Eyal Amiran (2009) observes, the motors driving the process are human desire and interest, qualities foreign to machines. Nevertheless, a human interpreting machine output constitutes a significantly different

knowledge formation than the traditional humanities' customary practice of having an unaided human brain–body read books and arrive at conclusions. Given that human sense-making must necessarily be part of the process, at what points and in what ways interpretation enters are consequential in determining assumptions, methods, and goals. Add the self-catalysing dynamic of digital information, and the momentum behind the digital humanities becomes clear. The more we use computers, the more we need the large-scale analyses they enable to cope with enormous data sets, and the more we need them, the more inclined we are to use them to make yet more data accessible and machine-readable.

That large-scale events are multi-causal is scarcely news, but analysis of them as such was simply not possible until machines were developed capable of creating models, simulations, and correlations that play out (or make visible) the complex interactions dynamically creating and re-creating systems.[6] In turn, the use of tools unsettles traditional assumptions embedded in techniques such as narrative history, a form that necessarily disciplines an unruly mass of conflicting forces and chaotic developments to linear story-telling, which in turn is deeply entwined with the development and dissemination of the codex book. As Alan Liu (2008) aptly observes about digital technologies (but would be equally true of print), 'These are not just tools but tools that we think through'. The troops march together: tools with ideas, modeling assumptions with presuppositions about the nature of events, the meaning of 'reading' with the place of the human.

The unsettling implications of 'machine reading' can be construed as pointing towards a posthuman mode of scholarship in which human interpretation takes a back seat to algorithmic processes. Todd Presner (2008), creator of *Hypermedia Berlin* (2005) and co-director of the *HyperCities* project, reacted strongly when I asked him if digital methods could therefore be seen as erasing the human. As he pointed out, 'human' is not a fixed concept but a construction constantly under challenge and revision. Although he conceded that one might characterise certain aspects of the digital humanities as posthuman, he insisted the shift should to be understood contextually as part of a long history of the 'human' adapting to new technological possibilities and affordances. Technologically enabled transformations are nothing new, he argued (indeed, anthropologists have shown that *Homo sapiens sapiens* emerged through an evolutionary spiral in which the use, development, and transport of tools played crucial roles [Deacon 1998]).

Moreover, the tension between algorithmic analysis and hermeneutic close reading should not be overstated. Very often the relationship is configured not so much as an opposition as a synergistic interaction. Matthew Kirschenbaum (2009) made this point when discussing a data-mining project designed to rank the letters Emily Dickinson wrote to Susan Huntington Dickinson in terms of

erotic language. In interpreting the results, Kirschenbaum and his colleagues sought to understand them by reverse engineering the sorting process, going back to specific letters to re-read them in an attempt to comprehend what kind of language gave rise to a given ranking. The reading practices consisted of what Kirschenbaum calls 'rapid shuttling' (2009) between quantitative information and traditional hermeneutic close reading. Rather than one threatening the other, the scope of each was deepened and enriched by juxtaposing it with the other.

The possibility of creating synergistically recursive interactions between close reading and quantitative analyses is also what Stephen Ramsay (2008a) has in mind when he calls for 'algorithmic criticism', where the latter word implies hermeneutic interpretation. Positioning himself against a mode of enquiry that praises computer analyses for their objectivity, Ramsay argues that this 'scientistic' view (2008b) forsakes the rich traditions of humanistic enquiry that have developed sophisticated and nuanced appreciation for ambiguities. 'Why in the world would we want the computer to settle questions', he asks, proposing instead that computers should be used to open up new lines of enquiry and new theoretical possibilities.

Productive/critical theory

What might these theoretical possibilities be? Conditioned by several decades of poststructuralism, many humanistic disciplines associate 'theory' with the close scrutiny of individual texts that uncovers and destabilises the founding dichotomies generating the text's dynamics. A different kind of theory emerges when the focus shifts to the digital tools used to analyse texts and convey results. Jay David Bolter (2008) suggests the possibility of 'productive theory', which he envisions as a 'codified set of practices'. (We may perhaps consider Gromola and Bolter (2003) as characteristic of the work productive theory can do.) The ideal, Bolter (2008) suggests, would be an alliance (or perhaps integration) of productive theory with the insights won by poststructuralist theories to create a hybrid set of approaches combining political, rhetorical, and cultural critique with the indigenous practices of digital media. Alan Liu articulates a similar vision (2004) when he calls for an alliance between the 'cool' (those who specialise in design, graphics, and other fields within digital commercial and artistic realms) and humanities scholars, who can benefit from the 'cool' understanding of contemporary digital practices while also enhancing it with historical depth and rich contextualisation.

If humanities scholars and the 'cool' can interact synergistically, so too can digital media and print. Todd S. Presner spoke of digitality's influence on his print book, *Mobile Modernity: Germany, Jews, Trains* (2007), specifically its network structure. He wanted the book to be experienced as a journey that takes

advantage of serendipitous branching to proceed along multiple intersecting pathways. Appropriately for his topic, he envisioned the structure as stations marking intersection points or signalling new directions. In the end, he said, the stations became chapters, but the original design nevertheless deeply informs the work. Matthew Kirschenbaum's print book, *Mechanisms: New Media and the Forensic Imagination* (2008), exemplifies traffic in the other direction, from the bibliographic methods developed over the long history of print back into digital media. The idea is to bring to digital media the same materialist emphasis of bibliographic study, using microscopic (and occasionally even nanoscale) examination of digital objects and codes to understand their histories, contexts, and transmission pathways. The result, in Kirschenbaum's phrase, is the emerging field of 'digital forensics'. Digital networks influence print books, and print traditions inform the ways in which the materiality of digital objects is understood and theorised. Thus two dynamics are at work: one in which the digital humanities are moving forward to open up new areas of exploration, and another in which they are engaged in a recursive feedback loop with the traditional humanities.

The effects of such feedback loops can be powerfully transformative, as shown in the work of historian Philip J. Ethington, a pioneer in incorporating spatial and temporal data into library records (Hunt and Ethington 1997). For more than a decade, Ethington has undertaken an intellectual journey towards what he calls 'the cartographic imagination'.[7] Beginning with the insight that spatial and temporal markers are crucial components of any data record, he conceived a number of digital projects in which meaning is built not according to a linear chain of A following B (a form typical of narrative history) but according to large numbers of connections between two or more networks layered onto one another. He writes in the highly influential website and essay, 'Los Angeles and the Problem of Urban Historical Knowledge', that the key element 'is a space-time phenomenology wherein we take historical knowledge in its material presence as an artifact and map that present through indices of correlation within the dense network of institutions, which themselves are mappable' (2000: 11).

A metaphor may be helpful in understanding this paradigm shift. Just as Ferdinand de Saussure proclaimed that significance is not created by a linear relationship between sign and referent but rather through networks of signifiers, so the movement here is from linear temporal causality to spatialised grids extending in all directions and incorporating rich connections within themselves as well as cross-connections with other grids. The extra dimensions and movements possible in spatial representations compared to linear temporality are crucial in opening up the cartographic imagination to multi-focal, multi-causal, and non-narrative modes of historical representation. In a similar vein, Ethington has argued that history is not a record of what takes place in time

but rather what happens in places and spaces (2007). His print book project, a *global* history of Los Angeles, uses these conceptions to create non-narrative series of networked correspondences instantiated in ten-inch-by-ten-inch format (allowing for 20-inch page spreads) that incorporates many different kinds of information into temporally marked geospatial grids.

Although the interactions between print and digital media may be synergistic, as in the examples above, they can also generate friction when the digital humanities move in directions foreign to the traditional humanities. As scale grows exponentially larger, visualisation tools become increasingly necessary. Machine queries frequently yield masses of information that are incomprehensible when presented as tables or databases of results. Visualisation helps sort the information and make patterns visible. Once the patterns can be discerned, the work of interpretation can begin. Here disagreement among my respondents surfaces, in a debate similar to the controversy over reading. Some argue that the discovery of patterns is sufficient, without the necessity to link them to meaning. Timothy Lenoir's observation (2008) forcefully articulated this idea: 'Forget meaning,' he proclaimed. 'Follow the datastreams.' Others, like Stephen Ramsay (2008), argued that the data must lead to meaning for them to be significant. If the digital humanities cannot do this, Ramsay declared (2009), 'then I want nothing to do with it. ' The issue is central, for it concerns how the digital humanities should be articulated with the traditional humanities.

The kinds of articulation that emerge have strong implications for the future: will the digital humanities become a separate field whose interests are increasingly remote from the traditional humanities, or will it on the contrary become so deeply entwined with questions of hermeneutic interpretation that no self-respecting traditional scholar can remain ignorant of its results? If the digital humanities were to spin off into an entirely separate field, the future trajectory of the traditional humanities would be affected as well. Obviously, this is a political as well as an intellectual issue. In the case of radical divergence (which I think would be a tragic mistake), one might expect turf battles, competition for funding, changing disciplinary boundaries, and shifting academic prestige.

Collaboration

Fortunately, there are strong countervailing tendencies, one of which is collaboration. Given the predominance of machine queries and the size of projects in the digital humanities, collaboration is the rule rather than the exception, a point made by John Unsworth when he writes about 'the process of shifting from a cooperative to a collaborative model' (Unsworth 2003). Examples of this shift are humanities laboratories in which teams of researchers collectively conceptualise, implement, and disseminate their research. The Humanities Lab

at Stanford University, directed by Jeffrey Schnapp through 2010, models itself on 'Big/Science', initiating projects that Schnapp (2008) calls 'Big Humanities'. Implementing such projects requires diverse skills, including Traditional scholarship as well as programming, graphic design, interface engineering, sonic art, and other humanistic, artistic, and technical skills. Almost no one possesses all of these skills, so collaboration becomes a necessity; in addition, the sheer amount of work required makes sole authorship of a large project difficult if not impossible. Unlike older (and increasingly untenable) practices where a humanities scholar conceives a project and then turns it over to a technical person to implement (usually with a power differential between the two), these collaborations 'go deep', as Tara McPherson (2008) comments on the work that has emerged from the online multimodal journal, *Vectors*. Conceptualisation is intimately tied in with implementation, design decisions often have theoretical consequences, algorithms embody reasoning, and navigation carries interpretive weight, so the humanities scholar, graphic designer, and programmer work best when they are in continuous and respectful communication with one another.

As a consequence of requiring a clear infrastructure within which diverse kinds of contributions can be made, 'Big Humanities' projects make it possible for students to make meaningful contributions, even as undergraduates. As I write these words, thousands of undergraduates across the country are engaged in writing essays that only their teacher will see – essays that will have no life once the course ends. As Jeffrey Schnapp (2009) and Gregory Crane (2008a) note, however, students can complete smaller parts of a larger Web project, ranging from encoding metadata to implementing more complex functionalities, that continues to make scholarly contributions long after they have graduated. In Timothy Lenoir's *Virtual Plowshares*, undergraduates did much of the virtual reality encoding, and in Todd Presner's *Hypermedia Berlin* (2006, 2009b) and *HyperCities* (2009a; Presner et al. 2008), Barbara Hui, a graduate student, was a critical member of the project team. Mark Amerika has instituted a similar practice at the University of Colorado, supervising undergraduate contributions to *Alt-X Online Network*, a large database that continues to grow through generations of students, becoming richer and more extensive as time goes on. Eric Rabkin, among others, writes about using digital platforms to give students enhanced literacy skills, including style, collaboration, and a sense of audience. He notes that encouraging students to incorporate graphics, hyperlinks, and so on in their work 'makes them exquisitely aware that...this technology is more than just an extension, as heels make us a tad taller, but rather a transformative reality, like the automobile' (2006: 142).

Collaboration may also leap across academic walls. For the first time in human history, worldwide collaborations can arise between expert scholars and expert amateurs. The latter term, I want to insist, is not an oxymoron.

The engineer who spends his evenings reading about the Civil War, the accountant who knows everything about Prussian army uniforms, the programmer who has extensively studied telegraph code books and collected them for years – these people acquire their knowledge not as professionals practicing in the humanities but as private citizens with passion for their subjects. I recall hearing a historian speak with disdain about 'history buffs'. Like history, most professional fields in the humanities have their shadow fields, for example, people who want to argue that Shakespeare did not write the works for which he is credited. Scholars often regard such activity as a nuisance because it is not concerned with questions the scholar regards as important or significant. But this need not be the case. Working together within a shared framework of assumptions, expert scholars and expert amateurs can build databases accessible to all and enriched with content beyond what the scholars can contribute. An example is the Clergy of the Church of England Database directed by Arthur Burns (2009), in which volunteers collected data and, using laptops and software provided by the project, entered them into the database. *Hypermedia Berlin* (Presner 2006, 2009b) offers another model by providing open-source software through which community people can contribute their narratives, images, and memories, while *HyperCities* (Presner et al. 2008) invites scholars and citizens across the globe to create data repositories specific to their regional histories. In addition to contributions to scholarship, such projects would create new networks between scholars and amateurs, from which may emerge, on both sides of the disciplinary boundary, a renewed respect for the other. This kind of model could significantly improve the standing of the humanities with the general public.

Collaboration is not, however, without its own problems and challenges, as scientific research practices have demonstrated. Aside from questions about how collaborative work will be reviewed for tenure and promotion, internal procedures for distributing authority, making editorial decisions, and apportioning credit (an especially crucial issue for graduate students and junior faculty) are typically worked out on a case-by-case basis with digital humanities projects. So too are questions of access and possibilities for collaborations across inside/outside boundaries, for example, deciding whether the XML (extensible mark-up language) metadata will be searchable or downloadable by users, and whether search algorithms can be modified by users to suit their specific needs. Discussing these questions in the context of *The Walt Whitman Archive*, Matt Cohen stresses the importance of an 'ethics of collaboration' (2009). Precedents worked out for scientific laboratories may not be appropriate for the digital humanities. While the lead scientist customarily receives authorship credit for all publications emerging from his laboratory, the digital humanities, with a stronger tradition of single authorship, may choose to craft very different kinds of protocols for deciding authorship credit, including giving

authorship credit (as opposed to acknowledgement) for the creative work of paid technical staff.

Databases

While scale and collaboration transform the conditions under which research is produced, digital tools affect research both at the macro level of conceptualisation and the micro level of fashioning individual sentences and paragraphs. David Lloyd (2008), a scholar working in Irish literature at the University of Southern California, recounted how he worked with a print essay on Irish mobility in the nineteenth century to re-envision it for digital publication in *Vectors*. Working with the flexible database form that Tara McPherson and her co-editor Steven Anderson devised, Lloyd rewrote his text, removing all the structures of coordination and subordination. The fragments were then entered into the database in a recursive process of specifying categories and modifying them as the work proceeded. Lloyd pointed out that in cutting out subordination and coordination, something was lost – namely the coherence of his argument and crafted prose of his original essay, a loss he felt acutely when he was in the midst of the fragmenting process. But something was gained as well. The effect of the database format, Lloyd said, was to liberate contradictory and refractory threads in the material from the demands of a historically based argument, where they were necessarily smoothed over in the interest of coherent argumentation. By contrast, database elements can be combined in many different ways, depending on how a reader wants to navigate the interface. In collaboration with designer Erik Loyer, Lloyd and Loyer (2006) visualised the topics as potatoes in a field, and the reader navigates by 'digging' them. The result, Lloyd suggested, was both a richer context and a challenge to the reader to understand their interactions. Like much electronic work, the task requires more patience and work on the reader's part than a traditional linear narrative, with the payoff being an enhanced, subtler, and richer sense of the topic's complexities. Lloyd, readily acknowledging that some research is no doubt best presented in print, was nevertheless sufficiently impressed with the advantages of a database structure to consider using it for his future poetic writing.

Another advantage of databases is the ability to craft different kinds of interfaces, depending on what users are likely to find useful or scholars want to convey. Given a sufficiently flexible structure, a large archive can have elements coded into a database for which different scholars can construct multiple interfaces. As Tara McPherson points out, the same repository of data elements can thus serve different purposes for different communities. Teams of collaborators might work together to create a shared database, with each team creating the interface best suited for its research purposes. Thus each team's efforts are leveraged by the magnitude of the whole, while still preserving the

priorities of its own needs and criteria. Another kind of example is Kimberly Christen's *Mukurtu: Wampurrarni-kari* website on aboriginal artifacts, histories, and images. She provided aboriginal users with a different interface offering more extensive access than that of the general public, giving different functionalities to each group (see Christen 2009a and 2008 for a discussion). In addition, the website honours tribal cultural practices, for example the prohibition on viewing images of deceased persons. When such a person appears in an archived photograph, the indigenous user is first warned and then asked if she nevertheless wishes the view the image. Rejecting the mantra 'Information wants to be free', Christen suggests an alternative: 'Information wants to be responsible' (2009b).

The collaborations that databases make possible extend to new kinds of relationships between a project's designer and her interlocutors. Sharon Daniel (2008), discussing her work with drug addicts and women incarcerated in California prisons, declared that she has moved away from an emphasis on representation to participation. She sees her digital artwork, for example her award-winning *Public Secrets*, as generating context 'that allows others to provide their own representation', particularly disenfranchised communities that might otherwise not have the resources to create self-representations. Eschewing documentary forms that emphasise a single authorial perspective, Daniel created a database structure that allows her interlocutors to speak for themselves. Given her political commitment to participation, the database structure is crucial. Daniel's method (similar in its procedures to many digital projects, for example the database created by Lloyd and Loyer), is to locate the topic's central problematics and design the data structure around them. With *Blood Sugar*, a companion piece to *Public Secrets*, the fact that addiction is both biological and sociological provided the essential parameters.

The emphasis on databases in digital humanities projects shifts the emphasis from argumentation, a rhetorical form that historically has foregrounded context, crafted prose, logical relationships, and audience response, to data elements embedded in forms in which the structure and parameters embody significant implications. Willeka Wendrich, director of the digital *Encyclopedia of Egyptology*, spoke eloquently about the ethical significance of this shift.[8] Working in archaeology, a field in which researchers sometimes hoarded artifacts and refused access to them to aggrandise their personal power base, Wendrich argues that database forms and Web dissemination mechanisms allow for increased diversity of interpretation and richness of insights, because now the data are freely available to anyone. Of course, those who design such websites still influence the range and direction of interpretation through selections of material, parameters chosen for the database structures, and possible search queries. As Leigh Starr and Geoffrey Bowker have persuasively argued, the ordering of information is never neutral or value-free. Databases are not

necessarily more objective than arguments, but they are different kinds of cultural forms, embodying different cognitive, technical, psychological, and artistic modalities and offering different ways to instantiate concepts, structure experience, and embody values (Manovich 2002; Vesna 2007).

Multimodal scholarship

In addition to database structures and collaborative teams, the digital humanities also make use of a full range of visual images, graphics, animations, and other digital effects. In best-practice projects, these have emotional force as well as conceptual coherence. Caren Kaplan spoke to this aspect of her project, *Dead Reckoning*, developed for *Vectors* in collaboration with designer Raegan Kelly. After encountering a wealth of cultural analysis and technical information about aerial surveillance and targeting, the user is presented with a section in which she can manipulate the target image herself. When it centres over Hiroshima, the emotional impact of occupying the position of the (virtual) bomber creates a strong affective resonance. Alice Gambrell and Raegan Kelly's *Stolen Time Archive*, a collection of female office worker ephemera from the 1940s and 1950s and later zines, achieves a different kind of emotional impact through the ambiguity of 'stolen time'. From the employer's point of view, time theft occurs when an employee produces such objects as the zines; from the worker's viewpoint, time is stolen from her by an alienating capitalist system, represented in the archive through posters and advice manuals intended to re-fashion her subjectivity so it will be more malleable for the system; from the user's point of view, time spent perusing the archive and contemplating its significance is the productive/unproductive dynamic revealing ambiguities at the heart of the archive. For these and similar works, multimodality and interactivity are not cosmetic enhancements but integral parts of their conceptualisation.

In light of such developments, Timothy Lenoir (2008a) draws the conclusion that the digital humanities' central focus should be on developing, incorporating, and creating the media appropriate for their projects. 'We make media,' Lenoir proclaims, 'that's what we do.' A case in point is the peace and conflict simulation *Virtual Peace: Turning Swords to Ploughshares* (2008) that he and his collaborators created. The collaboration involved professors, students, and programmers from the Virtual Heroes commercial game company. The simulation runs on Epic Games' Unreal Tournament game engine, for which Virtual Heroes had a license and adapted with tools, scripts, and other assets. Instead of preparing troops for war (as do many military simulations), this project aims to improve conflict resolution skills of stakeholders responding to an emergency (the simulation makes extensive use of the data from Hurricane Mitch in 1998, which caused extensive damage in Honduras and other places). The project

was funded by a $250,000 MacArthur grant; the inclusion of commercial programmers indicates that large projects such as this virtually require outside funding, either from corporate sponsors or foundations and granting agencies. Traditional humanities scholars, accustomed to requiring nothing more than a networked computer and some software, sometimes critique projects like *Virtual Peace* and *HyperCities* because they rely on commercial interests (in the case of *HyperCities*, the project makes extensive use of Google maps and Google Earth). Presner remarked that he has been told that he is 'in bed with the devil'.[9]

The remark points to tensions between theoretical critique and productive theory. In poststructuralist critique, a hermeneutic of suspicion reigns towards capitalism and corporations, while in the digital humanities a willingness prevails to reach out to funders (sometimes including commercial interests). Cathy N. Davidson and David Theo Goldberg (2004: 45) suggest we should move past the hermeneutic of suspicion: 'What part of our inability to command attention is rooted in humanists' touting of critique rather than contribution as the primary outcome of their work. ... Is it not time we critiqued the mantra of critique?' Some scholars in the digital humanities, including Presner (2008) and Anne Balsamo, are already moving in that direction. As Balsamo argues in *Designing Culture* (2011), humanities scholars should seize the initiative and become involved in helping to develop the tools our profession needs. We cannot wait, Balsamo contends, until the tools arrive readymade (and often illmade for our purposes). Rather, we should get in on the ground floor through collaborations not only among ourselves (as in the Project Bamboo digital humanities Initiative) but also with commercial companies such as Google.

Code

Another area of tension between poststructuralist approaches and productive theory is the environment in which digital humanities work. Underlying machine queries, database structures, and interface design is a major assumption that characterises the digital humanities as a whole: that human cognition is collaborating with machine cognition to extend its scope, power, and flexibility. The situation requires both partners in the collaboration to structure their communications so as to be legible to the other. For humans, this means writing executable code that ultimately will be translated into a binary system of voltages; for the machine, it means a 'tower of languages' (Cayley 2002; Raley 2006) mediating between binary code and the displays the user sees. Multiple implications emerge from this simple fact. If the transition from handwriting to typewriting introduced a tectonic shift in discourse networks, as Friedrich Kittler (1992) has argued, the coupling of human intuition and machine logic leads to specificities quite different in their effects from those

mobilised by print. On the human side, the requirement to write executable code means that every command must be explicitly stated in the proper form. One must therefore be very clear about what one wants the machine to do. For Tanya Clement (2008), a graduate student at the University of Maryland working on a digital analysis of Gertrude Stein's *The Making of Americans*, this amounts, in her evocative phrase, to an 'exteriorization of desire'. Needing to translate desire into the explicitness of unforgiving code allows implications to be brought to light, examined and modified in ways that may not happen with print. At the same time, the nebulous nature of desire also points to the differences between an abstract computational model and the noise of a world too full of ambiguities and complexities ever to be captured fully in a model.

The necessity for executable code creates new requirements for digital literacy. Not every scholar in the digital humanities needs to be an expert programmer, but to produce high quality work, they certainly need to know how to talk to those who are programmers. The digital humanities scholar is apt to think along two parallel tracks at once: what the surface display should be, and what kinds of executable code are necessary to bring it about. This puts subtle pressure on the writing process, which in turn also interacts with the coding. Reminiscent of David Lloyd's excision of coordination and subordination, many writers who move from print to digital publication notice that their writing style changes. In general, the movement seems to be towards smaller blocks of prose, with an eye towards what can be seen on the screen without scrolling down, and towards short conceptual blocks that can be rearranged in different patterns. The effects spill over into print. Alexander R. Galloway and Eugene Thacker's *The Exploit*: *A Theory of Networks* (2007), a print text about digital networks, parses the argument in part through statements in italics followed by short explanatory prose blocks, so that the book can be read as a series of major assertions (by skipping the explanations), short forays into various questions (by picking and choosing among blocks), or straight through in traditional print reading fashion.

Given the double demand for expertise in a humanistic field of enquiry and in computer languages and protocols, many scholars feel under pressure and wonder if they are up to the task. Even talented scholars recognised as leaders in their fields can occasionally have doubts. Rita Raley (2008), pointing out that she is trained in archival research and not in computer programming, wondered if, in writing about code poetry, she is committing herself to a field in which she is not a master. Tanya Clement (2008a), whose work as a graduate student has already achieved international recognition, says that she is 'not a Stein scholar' and is consequently hesitant about presenting her quantitative analyses of *The Making of Americans* (2008b) to Stein scholars. (I should add that these scholars are exemplary practitioners producing cutting-edge scholarship; their doubts reveal more about the field's problematics than any personal

deficiencies.) The problems become explicit when double expertise is formal-ised into an academic curriculum, such as in the Computational Media major recently instituted at Georgia Tech. Ian Bogost (2009), one of the faculty mem-bers leading the program, spoke eloquently about the difficulties of forging requirements fully responsive both to the demands of the Computer Science Department and to the expectations of a humanities major. I suspect there is no easy solution to these difficulties, especially in this transition time when dual expertise is the exception rather than the rule. In the future, academic programs such as Georgia Tech's Computational Media and the Humanities Computing majors at King's College may produce scholars fluent both in code and the traditional humanities. In the meantime, many scholars working in the field are self-taught, while others extend their reach through close and deep collaborations with technical staff and professionals in design, program-ming, and so forth.

Future trajectories

I asked my respondents what percentages of scholars in the humanities are seriously engaged with digital technologies. Many pointed out that, in a sense, virtually everyone in the humanities is engaged with digital technologies through email, Google searches, Web surfing, and so on. But if we take 'ser-iously' to mean engagements that go further into Web authoring and the con-struction of research projects using digital tools, the percentages were generally low, especially if averaged over the humanities as a whole. In September 2005, participants in the *Summit on Digital Tools in the Humanities* at the University of Virginia estimated that 'only about six percent of humanist scholars go beyond general purpose information technology and use digital resources and more complex digital tools in their scholarship' (2005: 4). Given developments since then, my estimate of where we are currently is about 10 per cent. But this fig-ure may be misleading, for as my interviewees agreed, the numbers are gener-ationally skewed, rising quickly within the younger ranks of the professoriate and even more so with graduate students. Many people estimated 40 to 50 per cent of younger scholars are seriously engaged. This demographic suggests that the digital humanities will continue to increase in the coming years, per-haps hitting about 50 per cent when those who are now assistant professors become full professors in 10 to 15 years. The prediction suggests that the schol-arly monograph will not continue indefinitely to be the only gold standard, and that Web publishing will not only be commonplace but will attain equal standing with print.

It would be naive to think that this boundary-breaking trajectory will happen without contestation. Moreover, practitioners in the field recall similar optimis-tic projections from 15 or 20 years ago; from this perspective, prognostications

for rapid change have cried wolf all too often. Among those sceptical that progress will be swift are Eyal Amiran (2009), co-founder of *Postmodern Culture*, one of the first scholarly journals to go online, and Jay David Bolter (2008), who remarked that literature departments in particular seem 'unreasonably resistant' to introducing digital technologies into the humanities. Nevertheless, new factors suggest a critical mass has been reached. Foremost is the establishment of robust digital humanities centres at the University of Maryland, King's College London, the University of Nebraska, the University of Texas, the University of California, Santa Barbara, the University of California, Los Angeles, and many other institutions. A concurrent development is the marked increase in the number of scholarly programs offering majors, graduate degrees, and certificate programs in the digital humanities, with a corresponding growth in the numbers of students involved in the field. Willard McCarty (2009) extrapolates from this development a future in which humanities scholars are also fluent in code and can 'actually make things'. Once critical mass is achieved, developments at any one place have catalysing effects on the field as a whole. Intimately related to institutionalisation and curricular development are changing concepts and presuppositions. The issues discussed here – scale, productive/critical theory, collaboration, databases, multimodal scholarship, and code – are affecting the structures through which knowledge is created, contextualised, stored, accessed, and disseminated.

Although these issues defy easy summary, their breadth and depth suggest the profound influence of digital technologies on theories, practices, research environments, and, perhaps most importantly, significances attributed to and found within the humanities. Disciplinary traditions are in active interplay with the technologies even as the technologies are transforming the traditions, so it is more accurate to say that the tectonic shifts currently underway are technologically enabled and catalysed rather than technologically driven, operating in recursive feedback loops rather than linear determinations. In broad view, the impact of these feedback loops is not confined to the humanities alone, reaching outward to redefine institutional categories, reform pedagogical practices, and re-envision the relation of higher education to local communities and global conversations.

Among my interviewees, scholars with administrative responsibilities for program development typically had thought most about future trajectories and were most emphatic about the transformative potential of digital technologies. Three examples illustrate this potential. Kenneth Knoespel, Chair of the School of Literature, Culture, and Communication (LCC) at Georgia Tech, pointed to the cooperative ventures his faculty had underway with Engineering and Computer Science; in these alliances, humanities students provided valuable input by contextualising technical problems with deep understandings of social, cultural, and historical embeddings. In his view, digital technologies

provide a common ground on which humanities scholars can use their special skills in interpretation, critical theory, close reading, and cultural studies to enhance and co-direct projects with their colleagues in the sciences, engineering, and social sciences. With team-based projects, sophisticated infrastructure, tech-savvy faculty, and an emphasis on studio work, LCC has re-imagined itself as a program that combines textual analysis with a wide variety of other modalities (Balsamo 2000). In Knoespel's view, LCC is not only about re-envisioning the humanities, but higher education in general.

A second example is the Transcriptions initiative that Alan Liu, Chair of the English Department at the University of California, Santa Barbara, has spearheaded. Like Knoespel, Liu actively reaches out to colleagues in engineering and scientific fields, using digital technologies as a common ground for discussions, projects, and grant applications. He sees this as a way to re-envision and re-invigorate humanities research along dramatically different lines from traditional humanities, while also providing support (financial, administrative, and institutional) for text-based research as well. Tara McPherson, co-editor of *Vectors* at the University of Southern California, also believes that humanistic engagements with digital technologies have the potential to re-imagine higher education. Like Knoespel and Liu, she takes an activist approach, finding the funding, infrastructure, and technical support to help humanities scholars move into multimodal projects and envision their research in new ways. When faculty move in these directions, more than their research is affected. Also re-imagined is their pedagogy as their students become collaborators in digital humanities projects, their relationships with colleagues outside the humanities and their vision of what higher education can achieve and contribute.

If, as public opinion and declining enrolments might indicate, the traditional humanities are in trouble, entangled with this trouble is an opportunity. As Cathy N. Davidson (2008: 708) argues, 'We live in the information age....I would insist that this is our age and that it is time we claimed it and engaged with it in serious, sustained, and systemic ways'. The digital humanities offer precisely this opportunity. Neither the traditional nor the digital humanities can succeed as well alone as they can together. If the traditional humanities are at risk of becoming marginal to the main business of the contemporary academy and society, the digital humanities are at risk of becoming a trade practice held captive by the interests of corporate capitalism. Together, they offer an enriched, expanded repertoire of strategies, approaches, and assumptions that can more fully address the challenges of the information age than can either alone. By this I do not mean to imply that the way forward will be harmonious or easy. Nevertheless, the clash of assumptions between the traditional and digital humanities presents an opportunity to rethink humanistic practices and values at the time when the Age of Print, so important in forming the explicit and preconscious assumptions of the humanities, is passing.

Engaging with the broad spectrum of issues raised by the digital humanities can help to ensure the continuing vitality and relevance of the humanities into the twenty-first century and beyond.

Notes

1. Stephen Ramsay (2008b) follows the mainstream view in identifying its origins with the work of the Jesuit priest Robert Busa in the 1940s; Willard McCarty (2009) suggests 'that machine translation ... and information theory ... are the beginnings of humanities computing.'
2. I also made site visits to the Centre for Computing in the Humanities at King's College, London, and to the School for Literature, Culture, and Communication at Georgia Tech. Space precludes a discussion of the results here, but they will be available in the book version of this essay.
3. Willard McCarty (2009) prefers 'Humanities Computing' precisely because it emphasizes the computational nature of the field as he practices it; he recognizes that there is a significant difference between text analysis and projects such as, for example, Bernard Frischer's *Rome Reborn*.
4. For the possibilities and challenges of partnering with museums and other art institutions, see Jeffrey Schnapp (2008).
5. Willard McCarty (2009), stressing the interaction between machine analysis and human reading, suggests that the result is 'reading in which the machine constitutes a new kind of book we don't even have the vocabulary to describe.'
6. Models, simulations, and correlations overlap but are not identical. As Willard McCarty (2008) points out in his analysis of modeling, models come in at least two main types: physical objects that capture some aspects of systems, and mathematical representations that (sometimes) have predictive power about how systems will react under given sets of circumstances. Simulations have similarly fuzzy boundaries, ranging from a set of computer algorithms that operate within a defined environment to play out various possibilities, to simulations that combine real-time input with programmed scenarios (the simulations the Institute for Creative Technology has created for army training purposes are examples). In complex dynamical systems, simulations frequently are the tools of choice because the recursive interactions and feedback loops are too complex to be modelled through explicit equations (for example, simulations of the weather). Correlations of the kind that Franco Moretti (2007) uncovers are perhaps the least precise, in the sense that the causal mechanisms are not explicitly revealed or implied and must be arrived at by other means.
7. Philip Ethington, email, 14 April 2009.
8. Response to a presentation of 'How We Think', Los Angeles, 1 June 2009.
9. See Presner 2009a for a discussion of the military technologies on which Google relies and the erasures Google maps and Google Earth perform.

References

Amerika, M., *Alt-X Online Network*. http://altx.com/home.html.

Amiran, E. (2009), Interview with Katherine Hayles. Los Angeles, CA, and Hillsborough, NC: 8 January 2009.

Balsamo, A (2011), *Designing Culture: The Technological Imagination at Work* (Durham: Duke University Press).

—— (2000), 'Engineering Cultural Studies: The Postdisciplinary Adventures of Mindplayers, Fools, and Others', in R. Reid and S. Traweek (eds), *Doing Science + Culture* (New York: Routledge).

Bamboo Digital Humanities Initiative. http://projectbamboo.org/.

Bogost, I. (2009), Response to 'How We Think: The Transforming Power of Digital Technologies', Presentation at Georgia Institute of Technology, Atlanta, GA, 15 January 2009

Burns, A. (2009), *Clergy of the Church of England Database,* 30 January 2009. www.theclergydatabase.org.uk/index.html.

—— (2009), Interview with Katherine Hayles. Centre for Computing in the Humanities, King's College. London: 23 January 2009.

Cayley, J. (2002), 'The Code Is Not the Text (Unless It Is the Text)', *Electronic Book Review.* http://www.electronicbookreview.com/thread/electropoetics/literal.

Christen, K. (2009a), 'Access and Accountability: The Ecology of Information Sharing in the Digital Age', *Anthropology News*, April. http://kimberlychristen.com/wp-cont/uploads/2006/12/50-4-kimberly-christen-in-focus-1.pdf.

—— (n.d.) *Mukurtu: Wampurranrni-kari.* http://www.mukurtuarchive.org/.

—— (2009b), Presentation, Institute for Multimedia Literacy, University of Southern California, 23 July 2009.

—— (2008), 'Working Together: Archival Challenges and Digital Solutions in Aboriginal Australia', *The SA Archeological Record* 8(2) (March): 21–4.

Clement, T. E. (2008a), Interview with Katherine Hayles. Lincoln, NE: 11 October 2008.

—— 2008b. '"A thing not beginning and not ending": Using Digital Tools to Distant-Read Gertrude Stein's *The Making of Americans*', *Literary and Linguistic Computing* 23(3): 361–81.

Cohen, M. (2009), 'Design and Politics in Electronic American Literary Archives', in A. Earhart and A. Jewell (eds), *The American Literary Scholar in the Digital Age* (Ann Arbor: University of Michigan Press [2010]).

Crane, G. (2008a), Interview with Katherine Hayles. Lincoln, Ne: 11 October 2008.

—— (2008b), 'Digital Humanities'. Workshop, University of Nebraska, Lincoln, NE: 10 October 2008.

Daniel, Sharon, with design and programming by Erik Loyer. "Blood Sugar," *Vectors 6* (2010). http://vectorsjournal.org/issues/6/bloodsugar/.

—— (2008), Interview with Katherine Hayles. Santa Cruz, CA and Hillsborough, NC: 13 October 2008.

—— (2007), *Public Secrets*, *Vectors* 2.2. http://vectors.usc.edu/index.php?page=7&projectId=57.

Denard, H. (2002), 'Virtuality and Performativity: Recreating Rome's Theater of Pompey', *PAJ: A Journal of Performance and Art* 24(1) (January): 25–43.

Davidson, C. N. (2008), 'Humanities 2.0: Promise, Perils, Predictions.', *PMLA* 123(3): 707–17.

Davidson, C. N. and Goldberg, D. T. (2004), 'Engaging the Humanities', *Profession 2004*: 42–62.

Deacon, Twerrence W. (1998), *The Symbolic Species: The Co-Evolution of Language and the Brain* (New York: W. W. Norton).

Drucker, J. (2009), *SpecLab: Digital Aesthetics and Projects in Speculative Computing* (Chicago: University of Chicago Press).

Ethington, P. J. (2009), Interview with Katherine Hayles. Los Angeles, CA and Hillsborough, NC: 8 January 2009.

—— (2000), 'Los Angeles and the Problem of Urban Historical Knowledge'. http://www.usc.edu/dept/LAS/history/historylab/LAPUHK.

—— (2007), 'Placing the Past: "Groundwork" for a Spatial Theory of History', *Rethinking History* 11(4) (December): 465–93.

Fitzpatrick, K. (2006), 'On the Future of Academic Publishing, Peer Review, and Tenure Requirements', *The Valve: A Literary Organ*. http://www.thevalve.org/go/valve/article/on_the_future_of_academic_publishing_peer_review_and_tenure_requirements_or.

Frischer, B. *Rome Reborn*. www.romereborn.virginia.edu.

Galloway, A. R. and Thacker, E. (2007), *The Exploit: A Theory of Networks*, (Minneapolis: University of Minnesota Press).

Gambrell, A. (2008), Interview with Katherine Hayles. Los Angeles, CA and Hillsborough, NC: 23 October 2008.

—— with Kelly, R. 'Stolen Time Archive', *Vectors* 1 (Winter). http://www.vectorsjournal.net/index.php?page=7&projectId=10.

Gromola, D. and Bolter, J. D. (2003), *Windows and Mirrors: Interaction Design, Digital Art, and the Myth of Transparency* (Cambridge, MA: MIT Press).

Hall, G. (2008), *Digitize This Book! The Politics of New Media, or Why We Need Open Access Now.* (Minneapolis: University of Minnesota Press).

Kaplan, C., with Kelly, R. (2007), 'Dead Reckoning: Aerial Perception and the Social Construction of Targets', *Vectors* 2.2. http://www.vectorsjournal.net/archive/?issue=4.

—— (2008). Interview with Katherine Hayles. Davis, CA, and Hillsborough, NC: 27 October 2008.

Kirschenbaum, M. G. (2009), Interview with Katherine Hayles. College Park, MD and Hillsborough, NC: 9 January 2009.

—— (2008), *Mechanisms: New Media and the Forensic Imagination* (Cambridge: MIT Press).

Kittler, F. (1992), *Discourse Networks 1800–1900*, trans. M. Metteer (Palo Alto, CA: Stanford University Press).

Lenoir, T. (2008a). Interview with Katherine Hayles, Durham, NC: 3 September 2008.

—— (2008b). 'Recycling the Military-Entertainment Complex with Virtual Peace'. http://virtualpeace.org/whitepaper.php.

Lenoir, T., and Giannella, E. (2007), 'Technological Platforms and the Layers of Patent Data'. National Science Foundation Grant No. SES 0531184.

Lenoir, T., et al. (2008). Virtual Peace: Turning Swords to Ploughshares. http://virtualpeace.org/.

Liu, A. (2008), Interview with Katherine Hayles. Los Angeles, CA and Hillsborough, NC: 13 October 2008.

—— (2004), *The Laws of Cool: Knowledge Work and the Culture of Information* (Chicago: University of Chicago Press).

Lloyd, D. (2008). Interview with Katherine Hayles. Los Angeles, CA and Hillsborough, NC: 7 October 2008.

Lloyd, D. and Loyer, E. (2006), 'Mobile Figures', *Vectors* 1.2. http://vectors.usc.edu/index.php?page=7&projectId=54.

Manovich, L. (2002), *The Language of New Media* (Cambridge: MIT Press).

McCarty, W. (2005), *Humanities Computing* (London, Palgrave).

—— (2009), Interview with Katherine Hayles. Centre for Computing in the Humanities, King's College. London: 23 January 2009.

—— (2008), 'Knowing…: Modeling in Literary Studies', in S. Schreibman and R. Siemens (eds), *A Companion to Digital Literary Studies* (Oxford: Blackwell) http://www.digital-

humanities.org/companion/view?docId=blackwell/9781405148641/9781405148641.
xml&chunk.id=ss1–6-2&toc.depth=1&toc.id=ss1–6-2&brand=9781405148641_brand.

McPherson, T. (2008), Interview with Katherine Hayles. Los Angeles, CA and Hillsborough,
NC: 20 October 2008.

McPherson, T. and Anderson, S. (eds), *Vectors: Journal of Culture and Technology in a
Dynamic Vernacular*. http://www.vectorsjournal.org/.

Moretti, F. (2000), 'Conjectures on World Literature', *New Left Review* 1 (Jan/Feb):
54–68.

—— (2007), *Graphs, Maps, Trees: Abstract Models for a Literary History* (New York and
London: Verso).

Presner, T. S. (2008), Interview with Katherine Hayles. Los Angeles, CA and Hillsborough,
NC: 3 September 2008.

—— (2006), 'Hypermedia Berlin: Cultural History in the Age of New Media, or "Is There
a Text in This Class?"' *Vectors* 1(2) (Spring 2006). http://www.berlin.ucla.edu/hyper-
media.

—— (2007), *Mobile Modernity: Germans, Jews, Trains* (New York: Columbia University Press).

—— (2009a), 'HyperCities: Building a Web 2.0 Learning Platform', in A. Natsina and T.
Tagialis (eds), *Teaching Literature at a Distance* (New York: Continuum Books).

—— (2009b), 'Digital Geographies: Berlin in the Age of New Media', in J. Fisher and B.
Menuel (eds), *Spatial Turns: Space, Place, and Mobility in German Literature and Visual
Culture* (Amsterdam: Rodopi).

Presner, T. S., et al. (2008), 'Hypercities'. http://www.hypercities.com.

Rabkin, E. S. (2006). 'Audience, Purpose, and Medium: How Digital Media Extend
Humanities Education', in M. Hanrahan and D. L. Madsen (eds), *Teaching, Technology,
Textuality: Approaches to New Media* (London: Palgrave Macmillan), 135–47.

Raley, R. (2006), 'Code.surface // Code.depth', *dichtung-digital*. http://www.brown.edu/
Research/dichtung-digital/2006/1-Raley.htm.

—— (2008), Interview with Katherine Hayles. Santa Barbara, CA and Hillsborough, NC:
20 October 2008.

Ramsay, S. (2008a), 'Algorithmic Criticism', in S. Schreibman and R. Siemens (eds), *A
Companion to Digital Literary Studies* (Oxford: Blackwell. http://www.digitalhumanities.
org/companion/view?docID=blackwell/9781405148641/9781405148641.xml&chu.

—— (2008b), Interview with Katherine Hayles. Lincoln, NE: 11 October 2008.

Schnapp, J. (2009), Interview with Katherine Hayles. Palo Alto, CA and Hillsborough,
NC: 7 January 2009.

—— (2008), 'Animating the Archive', *First Monday* 13(8) (August 2008).

Summit on Digital Tools in the Humanities, (2005), *A Report on the Summit on Digital
Tools*. University of Virginia: September.

Svensson, P. (2009), 'Humanities Computing as Digital Humanities', *DHQ: Digital
Humanities Quarterly* 3(3) (Summer): 1–16. http://digitalhumanities.org/dhq/
vol/3/3/000065.html.

Unsworth, J. (2002), 'What is Humanities Computing and What is Not?', *Jarbuch
für Computerphilologie* 4: 71–83. http://computerphilologie.uni-muenchen.de/jg02/
unsworth.html.

Unsworth, J. (2003), 'The Humanist: "Dances with Wolves" or "Bowls Alone"?'
Washington DC: Scholarly Tribes and Tribulations: How Tradition and Technology
Are Driving Disciplinary Change'. Association of Research Libraries. http://www.arl.
org/bm~doc/unsworth.pdf.

Vesna, V. (2007), *Database Aesthetics: Art in the Age of Information Overflow* (Minneapolis:
University of Minnesota Press).

Wardrip-Fruin, N. (2008), 'Expressive Processing Blog', *Grand Text Auto*. http://grandtex-tauto.org/2008/01/22/ep-11-media-machines/.

Wark, McK. (2006), GAM3R 7H30RY: Version 1.1. http://www.futureofthebook.org/gamertheory/.

—— (2007), *Gamer Theory* (Cambridge, MA: Harvard University Press).

Weber, S. (1987), *Institution and Interpretation* (Theory and History of Literature, Vol. 31). (Minneapolis: University of Minnesota Press).

4
Digital Methods: Five Challenges

Bernhard Rieder and Theo Röhle

While the use of computers for humanities and social science research has a long history[1], the immense success of networked personal computing has made both physical machines and software more accessible to scholars. But even more importantly, digital artifacts now populate every corner of post-industrial societies. This means that besides the study of non-digital objects and phenomena with the help of computers, there now is a continuously expanding space of cultural production and social interaction riddled by machine mediation, which has been, from the beginning, tied to digital schemes and formats. An obvious effect of this expansion has been the explosion of material available in digital form. 'Traditional' cultural artifacts like books or movies, 'native' digital forms such as software programs, online publications or computer games, and a deluge of all kinds of 'information' – logged traces of use practices, online interaction, and so forth – contribute to a growing mountain of *data* begging to be analysed.

Faced with this abundance of empirical material, researchers are increasingly turning towards automated methods of analysis in order to explore these artifacts and the human realities they are entwined with. These computational tools hold a lot of promise: they are able to process much larger *corpora* than would ever be possible to do manually; they provide the ability to seamlessly zoom from micro to macro and suggest that we can reconcile breadth and depth of analysis; they can help to reveal patterns and structures which are impossible to discern with the naked eye; some of them are even probing into that most elusive of objects, *meaning*.

Over the last few years, computers have been used in a wide variety of research projects. At the University of London, textual analysis techniques are used to identify and classify narrative structures in film scripts (Murtagha, Ganz, and McKieb 2009); projects such as the MUVIS System[2] developed at the University of Tampere use content-based image retrieval and other approaches to facilitate working with large multimedia collections; network analysis of godparent

choices is used at the University of Coimbra to uncover social stratifications in seventeenth- and eighteenth-century Portugal (Carvalho and Ribeiro 2008). Software-based research on the 'native' digital spaces of the Web has expanded at a staggering pace and the sheer volume of data being processed has become quite daunting. While the well-cited study by Adamic and Glance (2005) on the political blogosphere in the United States in 2004 continuously harvested 1,000 blogs, researchers at Orange Labs in France (Prieur et al. 2008) examined all of the five million public user accounts on Flickr in 2006 and one of the many recent studies on Twitter (Cha et al. 2010) analysed the interactions between 54 million profiles on the microblogging service. While some of these research projects seem more closely allied to physics than the humanities in both mindset and methodology, it is obvious that they represent new possibilities to study human interaction and imagination on a very large scale.

For the humanities – understood in a broad sense that includes most of the disciplines attentive to the human condition[3] – the emergence of digital tools is most certainly an important moment. The fact that after 50 years of experimentation many of the fundamental questions remain unsolved can be seen as an indicator of how close these questions come to core debates about the means and purposes of scholarly work. While terms like 'digital humanities', 'cultural analytics', or 'Web science' are certainly buzzwords, there are many indicators for a 'computational turn' that runs deeper than a simple rise of quantitative or 'scientific' modes of analysis. Rich graphical interfaces, advanced visualisation techniques, and 'fuzzy' processing have led some of those who have held numbers, calculations, and computers at a safe distance for a long time to warm up to new computational possibilities. But what are we to make of all of this? If these new digital methods are more than just another set of tools in our arsenal, how do we deal with the more fundamental transformations that challenge established epistemological paradigms?

1 Tools and methods

The concept of 'method' can serve as a starting point for our investigation. Defined by the *Oxford English Dictionary* as 'pursuit of knowledge, mode of investigation', the dictionary also reminds us that this pursuit is both *systematic* and *orderly*. Additionally, method is *directed* and *purposeful*: specific goals lead to specific decisions. Like a blueprint or recipe, research methods guide behaviour and even if some of our approaches in the humanities are only moderately explicit, their commonality allows us to share experience and establish reference points that provide orientation – even when there is little agreement on utility and validity.

If we look at how scholars use computers, we find that while most of us spend long hours in front of a screen every day, only a fraction of the tools we work

with actually aspire to the status of method in the narrow sense of 'heuristic procedure'. Most of them target 'auxiliary' functions such as communication, knowledge organisation, archiving, or pedagogy. These functions are certainly central to scholarly work and they are part of the process of knowledge production[4] but they are not *heuristic* – constitutive for the discovery or production of new knowledge – in the same way as, for example, participant observation, statistical regression techniques, or semiotic analysis.

While the difference between 'auxiliary' and 'heuristic' tools may often prove to be difficult to hold up in practice, similar graduations can be traced in history, for example the transformation of statistics from 'the mere presentation of numerical facts' to a 'refined method of analysis' (Gigerenzer et al. 1989: 58) over the course of the nineteenth century. This does not mean that questions of visual arrangement are epistemologically innocent, quite the contrary; it rather means that the way mathematical techniques like regression analysis have 'automated' or 'mechanised' certain analytical processes merits particular attention, not least because these are in many ways the closest relatives to computer-based methods. Making a distinction based on heuristic productivity is meaningful for another reason: even the most prudent, contextualised, and non-essentialist research methods associate certain 'truth claims' with their results and by laying out ontological preconceptions, methodological assumptions, and practical procedures, these claims are built on argumentative networks that are open to scrutiny and criticism. There is most certainly room for debate, but we do hold research methods to different standards than, say, pedagogical techniques. Many established methods have matured through decades of excruciating debate and while consensus in our disciplines is always partial and precarious, shared methodology is one of the elements that render collective knowledge production possible and ultimately legitimate the privileged position scholarship enjoys in larger society.

While the natural sciences have been tangled up in laboratories filled with tools and instruments for several centuries (Hacking 1983; Shapin and Schaffer 1985) even the most quantitative methods in linguistics or sociology have only begun to be mechanised with the advent of information-processing technology and more consistently so with the computer.[5] If the humanities are indeed becoming 'laboratory sciences' (Knorr-Cetina 1992), we are still in the early stages. The use of computers as *instruments*, that is as *heuristic* tools that are part of a *methodological* chain, may not be the most visible part of the 'digital revolution', but its institutional and epistemological repercussions for scholarship are already shaping up to be quite significant.

We should immediately add that 'digital methods' (Rogers 2009) are by no means homogeneous. Previously established non-digital research approaches can be 'packed up' into software programs and there is a tradition in the more 'scientific' areas of the humanities and social sciences – sociology, psychology,

linguistics, and so forth – to use computers to speed up many quantitative procedures that previously existed.[6] Despite ongoing debates about the validity and epistemological standing of these methods, there are traditions of reflexivity and established knowledge of pitfalls, best practices, quality standards, and so on. Still, the change in technology may have important consequences for how these methods are used, how they evolve, and how they produce knowledge. Since the 1950s however, there has been a steady trickle – that has widened into a torrent over the last two decades – of new methodological approaches that are *intrinsically* tied to the computer. Simulation, data exploration, automated visualisation, and many other techniques make use of computers to navigate and analyse data spaces that are simply too large or computationally demanding for human cognition. Because of their remarkable success in the natural sciences and in the economic sector, these methods have advanced very quickly on a technical level. When we look at humanistic research however, we find that robust experience is still rare and that best practices have yet to emerge. Interestingly though, while the mechanisation of existing research methods most often implies deductive procedures and hypothesis testing, the natively digital approaches seem to adopt a much more inductive perspective. John Tukey, one of the great statisticians of the twentieth century and a staunch defender of what he called 'exploratory data analysis', remarked nearly 50 years ago that '[d]ata analysis must progress by approximate answers, at best, since its knowledge of what the problem really is will at best be approximate' (Tukey 1962: 14) and it appears that his call has been heard.

The heuristic function of digital research methods in the humanities is mostly focused on the finding of patterns, dynamics, and relationships in data. By rendering certain aspects, properties, or relations visible, these tools offer us particular perspectives on the phenomena we are interested in. They *suggest* specific ways to view and interpret the data at hand. While their results may be visually impressive and intuitively convincing, the methodological and epistemological status of their output is still somewhat unclear. Nevertheless, it is these very tools that provoke the most enthusiastic reactions. Magazines such as *Wired* tout an 'end of theory' (Anderson 2008) and popular books with titles like *Super Crunchers* (Ayres 2007) argue that computer analysis will render human judgement obsolete in many areas. Even more sober scholars now speak of a 'post-theoretical age' (Cohen 2010) where *data* moves into the centre of attention. What is too often forgotten, though, is that our digital helpers are full of 'theory' and 'judgement' already. As with any methodology, they rely on sets of assumptions, models, and strategies. Theory is already at work on the most basic level when it comes to defining units of analysis, algorithms, and visualisation procedures.

Digital technology is set to change the way scholars work with their material, how they 'see' it and interact with it. A pressing question is how these methods

will affect the way we generate and legitimise knowledge in the humanities. In what way are the technical properties of these new tools constitutive of the knowledge generated? What does it mean to be a humanities scholar in a digital age? What are the technical and intellectual skills we need to master? To a large extent, the answers to these questions will depend on how well the humanities are able to critically assess the methodological transformations we are currently witnessing.

2 Five challenges

If there truly is a paradigm shift on the horizon, we will have no choice but to dig deeper into the methodological assumptions that are folded into the new tools we are using. We will need to uncover the concepts and models that have carried over from different disciplines into the programs we employ today and will tomorrow. This would seem like a task well suited to the humanities' capacity to analyse the conditions under which knowledge is produced, as long as we can avoid getting bogged down by naive technological enthusiasm or by a paralysing fear of technology. While we are ourselves quite enthusiastic about these new methods, we plead for a reflective approach that does not shy away from asking inconvenient questions concerning the impact of digital methods on scholarship, understood as both knowledge practice and social institution.

What follows is a non-exhaustive list of issues that we believe will have to be addressed if we want to productively integrate the new methods without surrendering control over the conceptual infrastructure of our work. Our question here is not how to conduct 'good' digital research in the narrow sense; we are not concerned with specific methodological pitfalls or 'errors' in data collection, or with the choice and application of methodological tools, but with the larger ramifications of digital research inside the field of the humanities and social sciences. In that sense, we want to tackle the challenges faced by even the 'best' work in the field.

Finally, we do not pretend that the issues we are trying to raise here have never been addressed before. In the 1966 inaugural issue of the journal *Computers and the Humanities*, the editors leave us with a word of warning: 'We need never be hypnotized by the computer's capacity to count into thinking that once we have counted things we understand them'. (*Computers and the Humanities* 1966: 1) What we have called 'five challenges' is directly aimed at making the relationship between *counting* (or rather *processing*) and *understanding* a fruitful one.

2.1 The lure of objectivity

A first issue that presents itself is the question of why computational tools have sparked such a tremendous amount of interest in the humanities. After all,

this is a discipline that is generally acknowledged to aim towards interpretive rather than verifiable knowledge. Optimistically, one could perceive this as the dawn of a new spirit of trans-disciplinarity. Digital humanities – an endeavour at the forefront of crossing boundaries and research traditions – would seem to bridge the gap between the 'two cultures' (Snow 1959), between the quantitative orientation of the natural sciences and critical cultural discourses in the humanities. Computational methods would provide the means to generate new kinds of knowledge in a productive and unconventional way.

On a more cautious note, however, the interest in computational tools might not only be aimed towards the unconventional, it might also indicate a desire to produce knowledge that can compete with the natural sciences on their own terms, by being as 'objective', as 'rigorous', with the help of machines. As Daston and Galison (2007) have shown, the history of the natural sciences is permeated by shifting ideals of objectivity, most of them directly connected to the use of instruments and machines. In the nineteenth century, the preoccupation with objectivity culminated in the notion of 'mechanical objectivity' – the belief that the production of knowledge had to be purged entirely from subjective judgement. Following the turmoils of war and revolution, human observers were perceived to be prone to bias and emotional reactions. In order to reach beyond these partialities, human intervention in the scientific process was to be reduced to a minimum. Machines were thought to be the more objective scientific witnesses – less attached, less partisan.

From 1900 onwards, this strong ideal of 'mechanical objectivity' was increasingly put into question. According to Daston and Galison (2007: 309–61), a new ideal of objectivity emerged that complemented mechanically produced evidence with 'trained judgment', the interpretation of (visual) evidence by human experts. While the natural sciences might not have abandoned the fascination for mechanically produced evidence altogether, the role of human interpretation at least began to be acknowledged. The humanities would thus be well-advised not to revitalise an ideal of knowledge production purged from human intervention. However, considering the generally low level of technical expertise and 'numeracy' (Hofstadter 1985) in this area, both the potentials and the limits of computation might remain unclear. In this scenario, the automated processing of empirical data may still suggest the possibility of a 'view from nowhere' (Nagel 1986) devoid of human subjectivity. Undifferentiated positive or negative responses to technology thus point towards an inherent risk that the lure of mechanically delivered 'objectivity' takes precedence over the interpretive capacities of a human researcher.

The confusion about the potential of computational tools can be traced back to one essential misconception that has carried over from the historical notion of 'mechanical objectivity': the impression that machine processing endows results with a higher epistemological status. The mathematician Hao Wang

counters this flawed idea wittily by referring to machines as 'persistent plod-
ders' (Wang 1963: 93). He reminds us that while machines can carry out cer-
tain repetitive tasks faster and more precisely than humans can, the adequacy
of the questions, models, and assumptions underlying the research are a com-
pletely different matter. The statistician John W. Tukey seconds this argument
when he states: 'Far better an approximate answer to the *right* question, which
is often vague, than an *exact* answer to the wrong question, which can always
be made precise' (Tukey 1962: 14).

While the 'plodding' capacities of machines can be usefully integrated into
many kinds of research, they should not be taken to guarantee a higher epis-
temological status of the results. Computers can certainly help to overcome
a whole range of practical obstacles in a research setting. However, on an
epistemological level, they *create* complications rather than resolving them.
Questions of bias and subjectivity, which the computer was thought to do away
with, enter anew on a less tangible plane – via specific modes of formalisation,
the choice of algorithmic procedures, and means of presenting results. Still,
it remains a strangely persistent fallacy to ascribe to the computer a capacity
to reach beyond human particularities and into the realm of objectivity. An
explanation for the endurance of this notion might be found in the fascination
that the ideal of detached, mechanical reasoning is still able to induce. The
pressing question is whether this fascination will keep us from laying bare the
kinds of decisions that went into our tools and instruments. Are we up to the
task of rendering our methodological decisions explicit and integrating them
into the overall epistemological outlook of our projects, rather than burying
them under layers of impressive evidence?

2.2 The power of visual evidence

Many of the computational tools that are used in the digital humanities prod-
uce some kind of visual output, for example depictions of network topologies,
timelines, or enriched cartographies. Often these visualisations possess spec-
tacular aesthetic qualities which make them powerful argumentative tools.
This begs the question of how to approach these rhetoric qualities and in what
way the argumentative power of images can (or should) be criticised. The per-
suasive impact of visual evidence has been subject to a wide range of research,
both within the humanities, science and technology studies and media stud-
ies (e.g. Jones and Galison 1998; Mitchell 1994). However, these investigations
have mostly focused on the use of images in the natural sciences. Since the
humanities have a distinct tradition of dealing with images, the situation
presents itself somewhat differently in this area.

Generally speaking, visualisations render certain aspects of a phenom-
enon more visible than others, thereby presenting a condensed or reduced
representation. Sometimes there is a practical rationale behind these

reductions – visualisations have to reduce informational dimensions to fit graphical requirements like screen size, resolution etc. Sometimes there are technical aspects to consider. Sometimes even manipulative intent might be at work and certain kinds of information might be left out for a reason. In any case, these selective reductions introduce a focus that renders certain interpretations and explanations more plausible than others. The remarkable aspect of images is that they can carry so much argumentative weight *despite* their reductive character. Following Heintz (2007), we can identify two reasons for why this is the case. First, images are usually considered to 'represent' something rather than simply being an artifact of the equipment in a laboratory. Heintz reconstructs how this (imagined) link to an external referent has been established via a long process of methodological standardisation in the natural sciences. It is this link that renders visualisations especially persuasive, even in cases where the featured patterns cannot actually be perceived by the naked eye.

The humanities have traditionally held a more critical distance to scientific images. Starting from the question of representation and referentiality, different image traditions have been compared, calling into question the epistemological status of images in the sciences. With the advent of computational tools, however, images increasingly become part of humanities scholars' *own* research practices – thereby posing the problem of referentiality from a different angle. From being an object of investigation, the image now becomes an epistemic device in our own fields – a tool or *instrument* that is employed in order to investigate specific phenomena. Additionally, the image now has a communicative function: it is used in order to present research results to peers and the public. It is in this context Heintz locates the second reason for the persuasiveness of scientific images. Following Shapin and Schaffer (1985), texts, numbers and images all can be interpreted as 'literary techniques' when employed to communicate research results. Heintz (2007) argues, however, that these techniques involve very different kinds of authority. Numerical and visual reasoning is much more easily accepted as 'evidence', while textual rhetoric usually stays on the level of 'argumentation'. She argues that this difference can be attributed to the respective production process of the argument. While a textual argument can easily be converted into its negation (anyone can quickly formulate a counter-argument) a visual or quantitative argument is not as easily reversed (one would need access to the instrument and its specifications). Therefore, the use of numbers and images in scientific communication has a certain tendency to overwhelm the recipients, rendering them less prone to question their inherent explanations.

In order to alleviate this problem, Heintz suggests a process-based approach to scientific images. Instead of presenting the image as a finished object with (seemingly) apparent interpretation, it should be presented as a temporary result of an ongoing process. This would shift the focus to the methodological

steps *prior* to the actual image – the decisions and reductions that went into its production, but also to the necessary steps *following* the presentation of the image – the need to interpret the results, to compare, and to ask questions about validity, generalisability and, above all, meaning. This seems like a feasible solution to the problem of overly conclusive visual argumentation. But it also runs counter to recommendations made by experts in the field of visual communication. According to Edward Tufte, perhaps the central figure in the field of graphical representation of quantitative data, 'graphical displays should…induce the viewer about the substance rather than about methodology, graphic design, the technology of graphic production, or something else' (Tufte 2001: 13). In this scenario, whoever creates the image gets to decide what its 'substance' is supposed to be. Moving the methodology to the foreground, however, gives the viewer a much greater chance to question the plausibility of the visual argument.

We have discussed two reasons for the persuasiveness of images: their imagined link to an external reality, and the obscurity of their production process. Both problems can be addressed to some extent by drawing on the tradition of critical enquiry into the use of images that the humanities have fostered over the years. Still, there remains a noticeable tension that is located at the heart of the double role of images in the digital humanities. On the one hand, researchers need to present images as evidence, to use them as a heuristic device. On the other hand, they need to *simultaneously* call their epistemic status into question, to treat them as research objects. It remains to be seen where this somewhat schizophrenic situation will take us – to a productive self-reflexive enquiry into our own visual practice or to a secret compliance with the power of visual evidence.

2.3 Black-boxing

A third question that is triggered by the growing use of computational methods in the humanities and social sciences concerns their technological underpinnings and how humanities scholars relate to them. In creating truly digital methods, we mechanise parts of the heuristic process, and we specify and materialise methodological considerations in technical form. Paradoxically, the practical need to formalise contents and practices into data structures, algorithms, modes of representation, and possibilities for interaction does not necessarily render the methodological procedures more transparent. Transparency, in this case, simply means our ability to understand the method, to see how it works, which assumptions it is built on, to reproduce it, and to criticise it. Despite the fact that writing software forces us to make things explicit by laying them out in computer code, 'readability' is by no means guaranteed. However, an open process of scrutiny is one of the pillars of scholarship and, in the end, scholarship's claim to social legitimacy. Technological black-boxing may therefore

prove to be a major issue if digital methods become more widespread. The problem can be understood on at least three different levels:

a. The first level has to do with the practical possibility to access the most obvious layer of functional specification, a tool's source code. Even detailed formal descriptions cannot pretend to document a program's inner workings the same way as its actual implementation does. This level of access can be blocked for different reasons, ranging from the common lack of resources for documenting and publishing source code to the use of proprietary tools or packages in the methodological chain. While there are legitimate arguments for concealing sources in a commercial setting, the specific requirements of academic scholarship render a closed-source approach highly problematic.

b. The second level could be termed 'code literacy' and concerns the fact that possibilities for critique and scrutiny are related to technological skill: even if specifications and source code are accessible, who can actually make sense of them? Algorithms for automatic classification based on full-text analysis or techniques for producing readable graph layouts are by no means trivial and in-depth understanding of many algorithmic procedures requires not only years of training in programming but also a certain level of fitness in advanced mathematics. Methodological coherence will in part depend on our ability to fully negotiate between our epistemological enterprise and the formal language of computers, both in our own work and when it comes to scrutinising the work of others.

c. The third level of black-boxing is even more abstract. Some of the approaches computer science provides us with are positively experimental, in the sense that the results they produce cannot be easily mapped back to the algorithms and the data they process. Many of the techniques issued, for example, from the field of machine learning show a capacity to produce outputs that are not only unanticipated but also very difficult for a human being to intellectually reconnect to the inputs. Despite being fully explicit, the method becomes opaque. Even in purely deterministic systems, small variations in the data or in system parameters may have far-reaching consequences, especially when techniques have a high iteration count, that is, when results are an aggregate of a very large number of individual calculations. What we are trying to say is that certain techniques imported from the computer sciences may never be understood in the same way we understand statistical concepts like variance or regression because there no longer is a 'manual' equivalent of the automated approach.

At first glance, these caveats may seem to apply exclusively to deductive methodologies that aim at proving or falsifying hypotheses and express strong claims to objectivity and validity. But even in settings where software tools are used to generate new representations and ideas, technological black-boxing

remains a problem: every form of automated analysis is one interpretation among others and there is an epistemological proposition, a *directedness*, to every tool we use. This should not keep us from using them; it may, however, be advisable to use different tools from the same category whenever possible in order to avoid limiting ourselves to a specific perspective. Two quick examples: different graph layout algorithms will push different features of a network into the forefront and thereby suggest different interpretations of the same data (Rieder 2010); Web crawlers will use different strategies to create a corpus and different criteria to decide where to stop crawling – identical starting points may lead to very different networks. In both cases, the technological elements may have strong implications for research results and the more we know about these assumptions, the better we can integrate them into our interpretations.

2.4 Institutional perturbations

Since the production of knowledge has itself become a subject worth of scrutiny, a large number of works in the philosophy of science and the more recent science and technology studies have shown that a distinction between 'internal' and 'external' factors is difficult to uphold; theoretical and methodological problems have repercussions for social and institutional parameters and vice versa. The introduction of new tools into scholarly practices can therefore have far-reaching consequences on very different levels. As Knorr-Cetina notes, '[t]he laboratory subjects natural conditions to a social overhaul and derives epistemic effects from the new situation' (Knorr-Cetina 2002: 118). The fact that most digital humanities projects have to assemble interdisciplinary teams is in itself already a 'social overhaul' – and the need to create shared concepts and to negotiate *arts de faire* (de Certeau 1990) over disciplinary boundaries necessarily leaves an imprint on the forms and contents of any results. Simultaneously, the shift in required skill sets may have significant consequences for recruiting processes. Given the growing need for computational expertise, the humanities may increasingly hire researchers from computer-adept disciplines.

On another somewhat speculative note, we wonder whether computerised tools will have a very significant impact on the larger institutional configurations of scholarly work in the humanities. Is it possible that, in the long run, the speed and efficiency of the new methods, their capacity to analyse large amounts of data, will render more traditional 'manual' approaches unattractive? In settings where even humanities' research is increasingly financed on a project basis – which implies very particular pragmatics based on clear time frames, planned expectations, and identifiable 'deliverables' – digital methods have a clear advantage. With reference to Kuhn (1962), we can ask whether computer-based approaches have the potential to constitute a *paradigm*, which would include a shared set of methods and assumptions as well as an important normative component concerning standards for acceptable procedures and 'good

work'. To put it in provocative terms: will the scholarly memoire hold up to the interactive full-screen visualisation? Could computerised research make more traditional scholarship (look) obsolete? We can already see that projects that use particularly spectacular visualisation techniques are well-publicised in magazines and the blogosphere. Is there a danger of catering too much to short attention spans while at the same time cruising on technology's aura of objectivity?

Shifts in methodological paradigms are connected to shifts in configurations of both power and knowledge, to speak in Foucauldian terms. It remains to be seen how these connected shifts will manifest concretely in and around our scholarly work. In order to develop a sensibility for the wider repercussions of methodological innovation, it is crucial that we understand not only the potential but also the limits of these new methods. Obviously, building research tools is not an end in itself and in many areas there is an argument to be made for the confident defense of methods that are based on principles other than 'persistent plodding'.

2.5 The quest for universalism

A fifth issue we want to highlight is the strong current of universalism running through discourses on the merits of computation. The history of computation is imbued with grand visions of a unified theory on the basis of mathematics. Many of these visions relate to the notion of *mathesis universalis*, the ideal of a universal mathematical science, which, according to Knobloch (2004), can be traced all through the history of Western thought. An important part in the genealogy of this notion is the concept of *ars combinatoria*, developed by Raymond Lullus in the thirteenth century. His idea was that a given set of propositions could be combined according to logical rules, allowing the process of knowledge production to be mechanised (at least in principle). The concept gained in impact in seventeenth-century baroque and, via Leibniz and Descartes, influenced later works on logical calculi.

A core tenet of *mathesis universalis* is the possibility to specify a set of rules of transformation that 'automatically' generate new knowledge. It represents the vision of being able to formalise certain principles that are universally applicable and to use these principles deductively in order to determine whether propositions are true or not. Traces of this vision can be found in the countless attempts to describe the world in universal languages, universal classification systems, or universal theories. Some research agendas, like systems theory and cybernetics, have explicitly acknowledged this legacy (e.g. Bertalanffy 1957). In other cases, such as structuralism and network theory, these associations are less manifest, but still significant.

The urge to discern a set of rules or a structure beneath the diversity of observable phenomena has hardly vanished from today's theoretical landscape either. 'What do we mean when we say that all the 'real-world' networks – the

technological, social, and metabolic ones – are similar to each other?' network theorist Albert-László Barabási recently asked in a conversation with political scientist James Fowler. His answer: 'They share a few fundamental organizing principles' (Barabási and Fowler 2010: 306). The quest for universalism does not seem to wither away, but is rather invigorated with each advent of new models and methodological options. What remains a highly problematic aspect of these positions, however, is that they tend to corroborate rather than challenge the models they employ. It often seems more attractive to affirm the propriety of an existing, mathematically 'elegant' model than to actively seek out mismatches and outliers, as both the historical case of the normal distribution (Desroisières 1993) and the current case of the power law distribution (Rieder 2007) show. However, especially in a humanities context, relevant details can often be found in the idiosyncrasies outside the models. In those cases, the desire to corroborate rather than challenge could lead to rather sterile results and the dismissal of productively diverting lines of reasoning.

The vision of universalism, which exerts a kind of gravitational pull in the sciences, becomes increasingly influential whenever computers come into play. When reality is perceived to adhere to a specifiable system of rules, the computer appears to be the quintessential tool to represent this system and to calculate its dynamics. As a consequence, the universal machine may extend an 'epistemological pull' even in the absence of universalist ambitions. In a foreword to a seminal collection of papers in information science, Machlup and Mansfield (1983: 27) state that 'a certain amount of transfer occurs' whenever computers are used to handle problems in disciplines other than computer science itself. Whenever domain knowledge is adapted to the demands of computational methods, that is, when it is formalised into data structures and algorithms, it is reduced in certain dimensions. A model that is based on this reduced representation necessarily has limited explanatory capacities. However, the reduced nature of the model is often 'forgotten' when it comes to the explanations derived from it. Instead, the scope of the explanations is extended indefinitely, reminiscent of the universalist aspirations found elsewhere. While there is no clear-cut solution to this issue, combining different methodological configurations, both digital and non-digital, might at least provide a more adequate demarcation of the explanatory reach of the formal models. In this respect, the cross-fertilisation of traditional and computational methods in the humanities holds a lot of promise. If applied undogmatically, each could serve as a corrective to the blind spots of the other, in turn uncovering fresh perspectives on the material.

3 Conclusions

In this chapter, we have addressed five areas of epistemological drift and uncertainty that arise through the growing use of computational methods in the

humanities. While none of these issues is unique to the digital humanities – some of them resurface at various points through the history of Western science – they are becoming especially pressing at this specific juncture. Visions of objectivity and universalism that hitherto had little currency outside of certain fields might gain momentum via an unreflected enthusiasm for technology. In our concrete scholarly practices, visual rhetoric and technological black-boxing form a conglomerate that is difficult to disentangle and has far-reaching epistemological consequences. Finally, a shift in institutional constellations and requirements might be underway, strengthening the role of fast, automated data processing vis-à-vis human cogitation.

The aim of this discussion is not to discourage anyone from the exploration of new digital methods; neither do we propose that it is (always) an option to return to hermeneutic reading. What we do advocate is *involvement* with the new methods. By involvement, we mean both the actual application of these methods in new domains and a critical reflection of such uses. We thus argue for a transfer of the concept of 'critical technical practice', proposed by Agre (1997), to the scholarly domain: a practice that oscillates between concrete technical work and methodological reflexivity. The five challenges presented above should thus be understood as actual *tasks* for the near future: issues that will have to be addressed and explored (be it technically, theoretically, as a research object, or in some other way) if we want the new computational approaches to be epistemologically sound.

One of the reasons why we think it is necessary to tackle these problems early on is that this might help to avoid a paralysing and sterile *Methodenstreit*. A situation where the advocates of computation and interpretation are locked in a dichotomous opposition hardly seems to be the way forward for the digital humanities. By mediating between these positions and specifying, as distinctly as possible, the strengths and weaknesses on both sides, our hope is that we can steer clear of such antagonisms. By explicitly addressing the problems that we are facing now as well as those that we might meet further down the road, our aim is to stimulate discussions about the epistemological ramifications of computer-based work in the humanities. In order to avoid schisms on the methodological level, it seems imperative to establish areas of collaboration between the disciplines and to foster the development of practical solutions for interaction – what Galison (1996) refers to as 'trading zones'. While Galison endorses the use of 'creole' or 'pidgin' languages in order to enable a rudimentary exchange of ideas between the disciplines, our exploration has focused on interactions on the level of methodology. Drawing on our discussion, we feel able to put forward a number of straightforward recommendations for scholarly practice in this area.

First of all, we concluded that questions of methodology should play a much larger role in the documentation of research projects. In order for results to be

challenged and critically assessed, there needs to be a high degree of transparency regarding assumptions, choices, tools, and so forth. How can we achieve this? One of the practical means would be the setting up of companion websites to research projects, a practice that has been more common over the last years. Such a website could further document methodological choices, provide in-depth information on technical aspects, and, if possible, source code. It could also, as part of a data-sharing plan, provide access to the 'raw' data that went into the project, allowing other researchers to experiment with different approaches and arrive at different results. Also, a companion website seems like an ideal vehicle to present results more dynamically and interactively. Instead of providing the research results as a closed, finished product, Web-based interfaces could allow audiences to explore them both inductively and deductively, involving them in the process of knowledge production. Admittedly though, the decision to provide this kind of extensive documentation is not always in the hands of individual researchers. It therefore requires a firm commitment to methodological transparency through all the stages of the planning process, which also needs to be reflected in the allocation of financial and time resources.

Secondly, it seems that recent discussions from the field of software development have a lot to offer in terms of project management. Agile methods such as extreme programming involve a continuous iteration between the actual product and customer requirements. Ideally, this process brings about a more productive conversation regarding problems and solutions than a conventional list of specifications would. Introducing such methods in a digital humanities context could help to initiate a reflexive cycle between the core research question, the epistemological level and concrete technical implementations. Rather than putting researchers in a position where they have to frame their question in a machine-understandable way from the outset, this approach would give them a chance to let questions and instruments gradually converge. It would provide both researchers and programmers with an opportunity to identify obstacles along the way and to address these complications as *part* of the research project. Ideally, the approach would make it possible to overcome the division of labour altogether, providing researchers with enough insight into their instruments so that they do not have to rely on the services of others. In the inaugural issue of *Computers and the Humanities*, Milic (1966: 3) even regards this insight as a prerequisite for the productive deployment of digital methods in the humanities:

> The programmer is not a scholar; he is the attendant of the machine. Essentially, he reduces any project for research in humanistic fields to the mechanistic level, which is most congenial to him. As long as the scholar is dependent on the programmer, he will be held to projects which do not

begin to take account of the real complexity and the potential beauty of the instrument.

In this regard, there is one aspect of the current developments that we see as a decidedly positive development, independently from the actual results software tools might deliver. The omnipresence of digital technologies has already forced the humanities to pay considerable attention to the dominant technological paradigm of our time, the computer. The rise of digital research methodologies may encourage us to take the next step and develop a better understanding of the inner workings of both software and hardware. The delegation of certain aspects of knowledge production – and consequently of decision-making – to computers is a phenomenon that is not confined to scholarly research but a larger process that touches most areas that depend heavily on information processing. While uncritical enthusiasm is out of place and the challenges we face are indeed considerable, the confrontation with advanced software tools in our own fields can help us in formulating the theories and forging the disciplinary alliances we need to build a critical understanding of the infiltration of software into every pore of contemporary society.

Notes

1. Roberto Busa starts collaborating with IBM on the *Index Thomisticus* in 1949. The journal *Computers and the Humanities* is first published in 1966 and one of the earliest anthologies on the topic (Bowles 1967) is published a year later.
2. http://muvis.cs.tut.fi.
3. We explicitly include those areas of the social sciences that reach beyond mere behaviour.
4. Rieger (2010) provides a closer examination of the use of auxiliary computational tools in the humanities, showing that their use is much more widespread than the use of the 'heuristic' tools our discussion is concerned with.
5. Punched-card machines were actually able to do many of the things early computers were used for: sorting data, performing basic arithmetic and statistics, and so on. But only the stored-program computer provided the flexibility needed to attract consistent interest from the humanities.
6. One of the first popular uses for computers in the humanities was the compilation of concordances, pioneered by Thomist scholar Roberto Busa. Tools like SPSS greatly facilitate and speed up the use of statistical methods that were in common use long before the advent of the computer.

References

Adamic, L. and Glance, N. (2005), 'The Political Blogosphere and the 2004 U.S. Election: Divided They Blog', *LinkKDD '05: Proceedings of the 3rd International Workshop on Link Discovery*, http://arsky.com/WWW2005/WorkshopCD/workshop/wf10/AdamicGlanceBlogWWW.pdf, date accessed 1 December 2010.

Agre, P. E. (1997), 'Toward a Critical Technical Practice: Lessons Learned in Trying to Reform AI', in G. C. Bowker, et al. (eds), *Social Science, Technical Systems, and Cooperative Work: Beyond the Great Divide* (Mahwah, NJ: Lawrence Erlbaum Associates, 131–57).

Anderson, C. (2008), 'The End of Theory. The Data Deluge Makes the Scientific Method Obsolete', *Wired,* http://www.wired.com/science/discoveries/magazine/16–07/pb_theory, date accessed 1 December 2010.

I. Ayres (2007), *Super Crunchers: Why Thinking-by-Numbers Is the New Way to Be Smart* (New York: Bantam Books).

Barabási, A-L. and Fowler, J. (2010) 'Social Networks. Albert-László Barabási and James Fowler', in A. Bly (ed.), *Science Is Culture: Conversations at the New Intersection of Science + Society* (New York: Harper Perennial, 297–312).

L. Bertalanffy (1957), 'Allgemeine Systemtheorie. Wege zu einer Mathesis universalis', *Deutsche Universitätszeitung* 5/6: 8–12.

E. A. Bowles (1967), *Computers in Humanistic Research: Readings and Perspectives* (Englewood Cliffs, NJ: Prentice-Hall).

Carvalho, J. and Ribeiro, A. (2008), 'Using Network Analysis on Parish Register. How Spiritual Kinship Uncovers Social Structure', in J. Carvalho (ed.), *Bridging the Gaps: Sources, Methodology, and Approaches to Religion in History* (Pisa: Pisa University Press, 171–86).

Cha, M., et al. (2010), 'Measuring User Influence in Twitter: The Million Follower Fallacy', *ICWSM '10: Proceedings of International AAAI Conference on Weblogs and Social Media,* http://www.mpi-sws.mpg.de/~gummadi/papers/icwsm2010_cha.pdf, date accessed 1 December 2010.

Cohen, P. (2010), 'Digital Keys for Unlocking the Humanities' Riches', *New York Times,* 16 November 2010, http://www.nytimes.com/2010/11/17/arts/17digital.html?_r=1&pagewanted=print, date accessed 1 December 2010.

Computers and the Humanities (1966), 'Prospect', *Computers and the Humanities* 1(1): 1–2.

Daston, L. and Galison, P. (2007), *Objectivity* (New York: Zone Books).

de Certeau, M. (1990), *L'invention du quotidien* (Paris: Gallimard).

Desrosières, A. (1993), *La politique des grands nombres. Histoire de la raison statistique* (Paris: La Découverte).

Galison, P. (1996), 'Computer Simulations and the Trading Zone', in P. Galison and D. J. Stump (eds) *The Disunity of Science: Boundaries, Contexts, and Power* (Stanford, CA: Stanford University Press, 118–57).

Gigerenzer, G., et al. (189), *The Empire of Chance: How Probability Changed Science and Everyday Life* (Cambridge/New York: Cambridge University Press).

Hacking, I. (1983), *Representing and Intervening: Introductory Topics in the Philosophy of Natural Science* (Cambridge/New York: Cambridge University Press).

Heintz, B. (2007), 'Zahlen, Wissen, Objektivität: Wissenschaftssoziologische Perspektiven', in A. Mennicken and H. Vollmer (eds), *Zahlenwerk. Kalkulation, Organisation und Gesellschaft* (Wiesbaden: VS Verlag für Sozialwissenschaften, 65–86).

Hofstadter, D. R. (1985), *Metamagical Themas: Questing for the Essence of Mind and Pattern* (New York: Basic Books).

Jones, C. A. and Galison, P. (1998), *Picturing Science, Producing Art* (New York: Routledge).

Knobloch, E. (2004), 'Mathesis – The Idea of a Universal Science', in R. Seising, M. Folkerts and U. Hashagen (eds), *Form, Zahl, Ordnung. Studien zur Wissenschafts- und Technikgeschichte* (Stuttgart: Steiner, 77–90).

Knorr-Cetina, K. D. (1992), 'Science as Practice and Culture', in A. Pickering (ed.), *The Couch, the Cathedral, and the Laboratory: On the Relationship between Experiment and Laboratory in Science* (Chicago/London: Chicago University Press, 113–38).

Kuhn, T. S. (1962), *The Structure of Scientific Revolutions* (Chicago: University of Chicago Press).

Machlup, F. and Mansfield, U. (1983), *The Study of Information: Interdisciplinary Messages* (New York: Wiley).

Mitchell, W. J. T. (1994), *Picture Theory: Essays on Verbal and Visual Representation* (Chicago: University of Chicago Press).

Murtagh, F., Ganz, A., and McKie, S. (2009), 'The Structure of Narrative: The Case of Film Scripts', *Pattern Recognition* 42(2): 302–12.

Nagel, T. (1986), *The View from Nowhere* (New York: Oxford University Press).

Prieur, C., et al. (2008), 'The Strength of Weak Cooperation: A Case Study on Flickr', http://arxiv.org/abs/0802.2317v1, date accessed 1 December 2010.

Rieder, B. (2007), Étudier les réseaux comme phénomènes hétérogènes: quelle place pour la 'nouvelle science des réseaux' en sciences humaines et sociales?', *Journées d'étude: dynamiques de réseaux – information, complexité et non-linéarité*, http://archivesic.ccsd.cnrs.fr/sic_00379526/, date accessed 1 December 2010.

Rieder, B. (2010), 'One Network and Four Algorithms,' http://thepoliticsofsystems.net/2010/10/06/one-network-and-four-algorithms/, date accessed 1 December 2010.

Rieger, O. Y. (2010), 'Framing Digital Humanities: The Role of New Media in Humanities Scholarship,' *First Monday* 10, http://firstmonday.org/htbin/cgiwrap/bin/ojs/index.php/fm/article/view/3198/2628, date accessed 1 December 2010.

Rogers, R. (2009), *The End of the Virtual: Digital Methods* (Amsterdam: Vossiuspers UvA).

Shapin, S. and Schaffer, S. (1985), *Leviathan and the Air-Pump: Hobbes, Boyle, and the Experimental Life* (Princeton, NJ: Princeton University Press).

Snow, C. P. (1959), *The Two Cultures* (Cambridge, MA: Cambridge University Press).

Tukey, J. W. (1962), 'The Future of Data Analysis', *The Annals of Mathematical Statistics* 33: 11–67.

Tufte, E. R. (2001), *The Visual Display of Quantitative Information,* 2nd ed. (Cheshire, CT: Graphics Press).

Wang, H. (1963), 'Toward Mechanical Mathematics', in K. M. Sayre and F. J. Crosson (eds), *The Modeling of Mind* (South Bend, IN: Notre Dame University Press).

5
Archives in Media Theory: Material Media Archaeology and Digital Humanities

Jussi Parikka

In his recent French Theory lecture series, also available on the Internet in MP3-format, media theorist Alex Galloway starts his introduction on October 25 with a parallel to Karl Marx. Galloway reminds how Marx is often described as a product of the intellectual debates in Europe of his time, three to be exact: British political economy, German idealism and French socialism. Galloway's parallel continues with the Europe of today, its intellectual debates stemming to a large extent from three distinctive directions of German media theory, Italian political theory, and French philosophy. Whereas Galloway continues in his lecture series outlining the last of these three – French philosophy and its current trends, through figures such as Catherine Malabou, Bernard Stiegler, and Quentien Meillassoux – we can continue to elaborate on the parallel or the comparison with a further idea. Cognisant of the history of humanities as critical theory of the twentieth century, Marx's synthesis of these three forces – and, one might add, the synthesis of Marx together with Nietzsche and Freud – cannot be underestimated, and if one wants to quantify it as is so often necessary in the culture of digital economy, just count the amount of undergraduate and graduate courses directly or indirectly linking up with Marxist or post-Marxist philosophy. The humanities tradition has revolved around a set of key questions, and debates, which slightly pejoratively have been recently labelled from a digital humanities perspective as 'isms' – that the legacy of humanities is a closed world of debates such as 'formalism, freudianism, structuralism, postcolonialism' (Cohen 2010), and that the future is beyond theory in the sense of going directly to data. Whereas this sounds in various ways a new guise for certain strands of positivism with a fair amount of distrust in theory, it also outlines some crucial points for the wider public about digital humanities. Digital humanities, it seems, is a way to deal with large data sets and hence provide new *digital* methodologies for analysis of our non-digital

cultural heritage – texts, images, archival material. What's more, often the discourse does not fail to mention the hefty support from companies (such as Google) or The National Endowment for Humanities for such projects, which is furthermore another reason for arts and humanities institutions that are currently struggling in terms of their funding to find new ways of making themselves viable again.

Whereas the discourse and practices in digital humanities has to a large extent been driven by practical needs looking at older humanities formations – digitalisation of archival material, manuscripts, canonical works and resources, the implications of network and virtual platforms for research collaboration, as well as teaching, digital libraries, literacy, and preservation – perhaps the needed step is to think the theoretical underpinnings of digital humanities in the context of the various intellectual traditions that formed the basis of what we used to call 'critical theory'. This article does not take 'critique' as its standing point, or horizon, nor is it going to offer Marxist insights into digital humanities nor is it going to act as an explicit defence of 'isms', but I want to continue on the idea that Galloway pointed towards. If contemporary European thought can be mapped along those three lines, German media theory (started by figures such as Friedrich A. Kittler), Italian political thought (emblematic through Antonio Negri, Maurizio Lazzarato, Franco Berardi, Tiziana Terranova, and others), and French philosophy (names that Galloway introduced, and following the wake of Michel Foucault, Gilles Deleuze, Jacques Derrida, and others), then how much would a digital humanities discourse actually benefit from being able to articulate a strongly theoretical stance, and talk through the implications offered by media theory and its relation to politics of the digital? In other words, what I am after is how we could actually find a common tune between the meticulous analyses offered by German media theorists, but so that we could through Italian political philosophy understand how such media techniques, or psychotechnologies to use a term that both Kittler and French philosophers as Bernard Stiegler share, contribute to ways in which the digital is recirculating power.

This chapter does not discuss philosophy, but rather media theory and especially the notion of the archive. I will introduce the centrality of the concept of 'archive' for understanding contemporary digital culture with a special emphasis on how it contributes to radical ways of understanding digital humanities in technical software and hardware culture. This chapter works through the highly original media theory, or media archaeology as he himself calls it, of Wolfgang Ernst. Ernst is professor of Media Sciences at Humboldt University in Berlin and one of the leading figures of current German debates around media archaeology and media theory. With a background as a classicist, and as a historian, Ernst however has increasingly turned to media theory, and pushed his analysis of the archival into directions which point towards its

relevancy for media studies, and, as I will argue, for digital humanities. Ernst's theoretical positions might seem familiar to scholars who have encountered Friedrich Kittler's at times controversial writings concerning literature, media and information systems, which have pushed at least the debate concerning medium specificity to such spheres where they have huge relevancy for digital humanities. What I propose is that Ernst is doing the same with the notion of the archive, and theoretical insight into how our cultures of memory are changing in the age of technical media should be seen as instrumental to any 'dataism' within digital humanities as well. Hence what is provided is another look at counting and calculation, and their relevance to the contemporary archival and memory cultures.

What follows is first a contextualisation of why in general the media archaeological debates might be useful for the digital humanities, then a more in-depth look at the recent German media theoretical work of Ernst as a contribution to a radical rethinking of humanities legacy in the age of technical media which and offers a media archaeological contribution to digital humanities.

Materialist media archaeology

The field of media archaeology in its more modern form (i.e. not discussing here such forerunners as Walter Benjamin and others) has emerged from a fruitful tension with media history and theory. Hence it already is a significant predecessor in thinking about new media as an access point to old media – a point well elaborated from a film studies perspective by Thomas Elsaesser (2006). Not only a narrative mode of writing histories of media in the empirical mode, media archaeology has tried to follow Foucault's path in articulating the coexistence of continuities and ruptures as elemental components in understanding the 'newness' of digital media and using that as a theoretical filter for excavations into past media. Arriving from a variety of directions, media archaeology has since the 1980s been without a proper institutional home, hovering between cinema studies, the emerging media studies, experimental media art practices, and other departments where such historical and theoretical interests could be combined. Indeed, the different ways of reading Foucault have produced the (seemingly) two camps of media studies: the German variant of hardcore/hardware media archaeology and the cultural studies Anglo-American style of focusing on content, users, and representations (Chun 2006a: 17, 2006b: 4). Such a division is, to a certain extent, useful in describing some of the debates and lines of thought through which media archaeology has been divided into some of the more 'media materialist' strands (where Friedrich Kittler is the frequently quoted inspiration) and contextualist strands (such as Tom Gunning, Anne Friedberg, and Erkki Huhtamo, for example). Naturally, such divisions that seemingly stem from specific national

traditions, or at least academic fields differentiated by language, are quite crude generalisations and leave out a number of thinkers who do not fit easily into either camp. Such divisions are more like heuristic tools to give clarity to a field that has not stabilised to such an extent to have institutional grounding.

For a historically tuned analysis of media cultures, media archaeology has been able to offer key concepts for thinking temporally in addition to historically. Key terms have included remediation (Bolter and Grusin), recurrence (Huhtamo), variantology and an-archaeology (Zielinski). More recently another kind of division has been emerging that seems to re-articulate the German versus Anglo-American divide (cf. Winthrop-Young 2006). This idea stems from a distinction of macrotemporal analysis from what could be called microtemporal or time-critical media archaeological ideas and practices. This orientation claims to lead into a new kind of understanding of 'media materialism' that takes into account temporality in a more radical, non-human fashion; a materialism of processes, flows, and signals instead of 'just' hardware and machines.

One of the strategic moves in Ernst's way of differentiation of the Berlin media archaeology relies on distinguishing it from cultural historical accounts of media. This is an important strategy for Ernst perhaps in the same way as differentiation from the Birmingham cultural studies school of media analysis was for some of the earlier 1980s German media theorists. Whereas scholars of media archaeology such as Huhtamo (2008: 38–42) have contextualised themselves strongly in the new cultural histories and new historicism, Ernst insists, despite his own classical historicist background, that media archaeology differs radically from the mode of writing of history. The mode of narrative that haunts history after the linguistic turn is what for Ernst in his Foucauldian manner distances a truly archaeological excavation of media pasts from history. Here, even if we can see echoes of an appreciation of Hayden White's way of taking into account the discursive epistemic conditions for different strands of historical writing, Ernst is often strict in his way of emphasising differences. For him, it's the non-discursive and what he curiously calls the 'agency of the machine' (Ernst 2005: 591) instead of the mode of narrative that ties subjects into a narrative continuity. In a manner that many would be tempted to tie in with theories of posthumanism, Ernst explains that it's the machine in which the past gets archived as a monument and that is the true subject of technical media culture, not the spectre of the human subject idealistically looming between the words and as summoned by modes of literary writing.

Media is for Ernst a mode of recording that takes on itself such characteristics of agency that usually are reserved for human subjects of history. Ernst has articulated media archaeology as media *archaeography*, a mode of writing in itself that resembles closely the Kittlerian dictum of media as inscription machines.

The processes of storage and archiving can be seen culturally dominant and as features in how media is linked to power, and similarly new technical media of storage from the audio technology of recordings since late nineteenth century to current software forms of archiving and storage represent important epistemological conditions for what can be said to exist. Ernst writes:

> Equally close to disciplines which analyze material (hardware) culture and to the Foucauldian notion of the 'archive' as the set of rules governing the range of what can be verbally, audiovisually or alphanumerically expressed at all, media archeology is both a method and aesthetics of practicing media criticism, a kind of epistemological reverse engineering, and an awareness of moments when media themselves, not exclusively humans any more, become active 'archeologists' of knowledge. (Ernst 2011, 239)

To paraphrase Ernst (2007: 31), the writing of history and hence memory becomes a function of non-discursive inscription systems (*Aufschreibesysteme*). One cannot help noticing the resemblance to Kittler's media theory which, to paraphrase John Durham Peters (2009: 5), is without people.

However, for Ernst (2003b: 6), it seems that agency is not an abstraction but attributable to the machines with the help of the 'cold gaze'[1] of the media archaeologist that shares much with that of scientists and engineers. It is 'object-orientated' in a manner that resembles material culture research and interested in the physicality of technical media including computation (2003b: 11). Such claims are clearly puzzling for the more politically aware interpretations of functions of memory in relation to power. Yet we need to understand more concretely the ontological and epistemological idea Ernst is proposing in his non-human media archaeology that he insists is not hardware fetishism but methodological concreteness inherent in his brand of thinking the media as an archive (2003b). Hence, in relation to what was mentioned at the beginning, perhaps despite the shortcomings in being able to articulate the relation to power, such media theoretical approaches could be linked up to more thorough articulations of memory, power, political economy, and technical media.

Software cultures of memory

Even if Ernst insists on the epistemological nature of the media archaeologist as a reverse-engineer (also literally, as elaborated below), his context for the ideas stem from a certain ontological understanding concerning technical media culture. In short, it is the calculatory, number-logic-based ontology of technical (and especially computational) media through which cultural memory gets articulated instead of the literary-based narrativisation. Ernst's position

is aware of the materialist media grounding of contemporary archives which practically engage not only with images and sounds, but nowadays increasingly with software-based cultural memory. In other words, similarly as the photographic and new image cultures in the early part of the twentieth century forced not only a rethinking of perception but also of collection, memory, and organisation as was evident for example in Aby Warburg's work (Buchloh 2006: 92), now software cultures demand a rethinking of similar extent. The issue of 'digital memory' is then less a matter of representation than of how to think through the algorithmic counting ontology of a memory. This of course resonates with Lev Manovich's (2002) important point about the database being the grounding cultural logic of software cultures instead of the narrative.

For Ernst, narrating differs from counting as narratives differ from lists. Yet he is not separating these as two modalities that do not have anything in common but rather explains how telling is also a mode of counting through differentiation. Telling is not only in Ernst's media archaeological vision (that takes its reference point from early medieval Europe's practice of Annales) a human mode of telling stories through meaningful structures of symbols but a way of counting as well. Telling-as-counting is not only linguistic but has a media technological mode of quantification embedded in it. What Ernst proposes is a media archaeology that ties together such modes of thinking about counting together with algorithmic media as the necessary non-discursive base through which we need to understand 'memory' or history:

> Historical imagination asks for iconic coherence, to be separated from the organization of knowledge about the past in the form of naked data banks. But the registering time does not necessarily require the narrative mode to organize the factual field in a form that we call information. In digital computing, the sequence of operations required to perform a specific task is known as an algorithm. Medieval annalism as well stands for a writing aesthetics of organizing a sequence of events in serial, sequential order. ... (Ernst 2003a: 36)

This points towards the primarily calculational and sequential operations of algorithmic culture in which, as a non-discursive platform, information is processed. This is the core area of the practice of digital humanities in the age of powerful everyday computing devices and techniques, and yet there is nothing much human in the humanities of the software age. However, this realisation comes less from a hype of cyberculture in the fashion of 1990s discourse but from an understanding of how storage of so-called-human-things (to borrow Kittler's term) works. Ernst extends this to storage but talks of interfaces as well. Multimedia is, despite its alluring surface that caters texts,

images, and sounds to us, actually at a foundational level about temporal algorithmic processes through which code translates into sights and sounds. Of course there is a long history of media devices which hide their working machinery from the user in order to create an aura of magic, but Ernst is specifically focused on the workings of code, software, and in general the temporal basis of calculation in computers. Despite the turn to spatialisation of digital aesthetics and narratives in terms of operating system and game-like environment spaces, what is primary and grounds such phenomenology is the medium of calculation that is based on algorithms, processes, and addresses (Ernst 2006: 108). Increasingly the basic concepts in the humanities, such as experience, meaning, and representation, have to encounter the effect software has on such fundamental notions. In addition to offering clues for analysis of aesthetic and perceptual words of digital culture, this claim by Ernst presents a crucial realisation to any contemporary archival practices and discourses: the archive in the age of online digital collections becomes a 'mathematically defined space' where retrieval – an essential part of reproduction of cultural discourses and identity – is not a matter of interpretative, iconological semantics but computing algorithms (2006: 117). Even more so, archives are not even spaces anymore but addresses: 'A necessary precondition for any data retrieval is addressability, the necessity of being provided with an external – or even internal – address' (2006: 119). The implications for a wider set of cultural institutions and museums are radical; the need to think of museums and archives as non-places, but as addresses and hence as modes of management of protocols, software structures, and patterns of retrieval which potentially can open up new ways of user engagement as well, and where data storage cannot be detached from its continuous distribution – data storage on the move, so to speak. Concrete examples concerning archival practices are at times missing from Ernst's writings; for example the increased use of computer forensics testifies to this move towards an understanding of cultural memory that looks as much at computational traces and data structures as it does on narrative forms.

In any case, addresses for such (non-)places of memory are less spatial and more defined by their temporal modulations. This is where the point about the various temporalities inherent in this brand of German media archaeology becomes clearest: time and cultural memory are not only to be understood as macrolevel historical events or narratives accessible to human senses and interpretation. In addition, we need to include the microlevel temporalities that Ernst refers to as the time-critical element crucial to digital technologies and hence to the non-discursive condition of writing of time for us humans. As a theory of cultural heritage and non-human temporality in the software age, it could not be any more relevant for a rethinking of the humanities.

Time-critical humanities

Proposing that time is a central category for humanities and cultural theory is hardly a new idea. Both investigations into ontology of time as well as historical understanding of culture are both foundational to several arts and humanities disciplines. However, the idea of time-criticality in this context stems both from a recognition of time-based arts as central to culture (from performing arts to cinema, video, and sound) as well as from a special emphasis on the temporalities inherent in technical media, including process-based calculation machines, computers.

Time-criticality is something that stems from the Kittlerian emphasis on the manipulation of the time-axis that modern technical media since, for example, Edison's phonograph that reversed sound (see Krämer 2006; cf. Kittler 2009: 166–7) introduce, but which for Ernst relates even more closely to signal-processing capacities. Both Kittler and Ernst share the appreciation of Claude Shannon as the technical father of modern media culture, as it was his techno-engineering perspective on the primacy of channels and signals temporally processed in channels that is the grounding on which data, information, and hence cultural forms are being sustained and distributed in technical media culture. Modern technical media are media of mathematical codes and in their execution they become processes defined by patterns of signals unfolding in time. In Ernst's more than technical definition of media that gets more nods from people in Science and Computing departments than from humanities and cultural studies scholars, it is to be understood from the viewpoint of its channel which 'counts with time'. Its less about the objects of/in those channels than about the operations which introduce the patterns, pulsations and intervals through which information becomes a reality of the channels before becoming a reality for the phenomenological viewers/listeners/readers of media. (Ernst 2003b: 20). The tradition of cultural theory and humanities gets redefined through figures such as Shannon, Wiener, von Neumann as well as Turing, instead of Saussure, Freud or Marx.[2]

What the concept of microtemporality suggests is to reconsider the notions of cultural memory combined with an understanding of the technical memory as an active process instead of a stable, permanent memory. Foucault abstracted the notion of the archive from a spatial constellation to encompass abstract but real conditions for cultural statements, and what could be said, heard, seen and understood. Now, with the current theoretical formations that have picked up this Foucauldian message, the conditions are seen as technical. The medium is the archive, and as such it is primarily not stable memory but a dynamic circuit for reproduction of culture on the level of technical signals. In terms of temporality, already the television is mapped in Ernst's (2002: 634) vision as a specific regime of the image that is not static but continuously regenerated

in cycles of scanning, and the computer itself in its storage capacities is far from a static machine of memory (see Kirschenbaum 2008: 73–109 for a close reading of motion and dynamics in computer hard drives). Digital machines are ephemeral in the sense that they are also based in constant regeneration as Wendy Chun argues referring to Wolfgang Ernst. This is time-criticality; the computer digital memory is not only a static being of memory but is also in need of constant repetition and regeneration in the technical sense as such early memory technologies as the mercury delay line and the Williams tube demonstrate (Chun 2008: 165). Critical is not understood in this context in the same sense as 'critical theory' á la Adorno and the generation of German thinkers that preceded the 1980s commenced media theory wave, but criticality as the decisiveness of the temporal event that happens in the engineered channel. Indeed we see again the influence of such practically oriented people as Claude Shannon for Ernst's media archaeology. What emerges from this mix is a dynamic, non-representational, non-meaning-based notion of cultural memory that is conditioned by the media machine as the archival apparatus.

The media archaeological method becomes part of the logic of time-critical media. The humanities is in itself inseparable from the technical media culture in which theory itself takes place. In a similar way that technical media is defined by its capacities to break continuous signals in discrete series through, for example, the Fourier transformation that is continuously an important reference point for German media archaeologists, media archaeology is itself non-interpretational dissecting defined by its 1) cold gaze, 2) anti-hermeneutics, and 3) a return to a Rankean way of understanding history that surely puzzles several cultural historians (Ernst 2003b: 6–7). As controversial moves, or emphases, some of these ideas especially around the 'cold gaze' and distancing, are what differentiate Ernst from other new materialist accounts emerging in cultural analysis – not least material feminism where the notion of materiality has been addressed quite contrarily as 'entanglement' (see, for example, Alaimo and Hekman 2008). Such theoretical moves as distancing have been more or less articulated together with a politically dubious rationalism and neglect of the messy ontologies of the world where things and humans are continuously entangled. But besides problems in terms of its relation to alternative materialist notions being debated at the moment, Ernst's provocative thoughts relate to how he suggests a non-textual way of addressing media archaeology and this merits more attention. The coldness is parallel to William Henry Fox Talbot's 'technological objectivism' expressed in *The Pencil of Nature* in 1844, and stems from the capacity of the photographic image – and more widely any technical media – to record much more than merely the symbolic (Ernst 2005: 589–91) The methodological realisations of non-meaning-based theories of cybernetics and Shannon are taken as guidelines for this humanities-based but still technically tuned media archaeology

(cf. Kittler 2006). Whereas the twentieth-century avant-garde (e.g. Dziga Vertov) celebrated similar figures concerning the gaze of the machine, for Ernst its part of the claim is that in the age of technical media, and especially computers, we are engaged in a cultural system beyond that of the human-focused world. Instead of media anthropology, or media sociology, he demands that *aisthesis medialis* is recognised through its constitutive, concrete difference from the human perception. Just like with Kittler, there is not much room for humans in the media ontology of Ernst and this is probably the point where he most detaches from the current Anglo-American enthusiasm for digital humanities.

Interestingly, Ernst, who became very familiar with new historicism and the emergence of new historical discourses in the 1980s and early 1990s, turned later to such figures as Ranke – but Ranke read as a media theorist, not as a historian. What Ernst hopes to achieve by referring to Ranke is not per se an idea of objective history, but history in objects – history and time that are recorded in the physical sense 'objectively' in material media objects. Ernst's new historicist roots that resonated strongly with the cultural studies directions of those years were discarded in favour of an epistemological position where Kittlerian ontology met up with Ernst's enthusiasm for rethinking temporality and the archive. In terms of methodology, this led him to posit more emphasis on what could be called 'operative diagrammatics' as a method of 'writing' media archaeology – or the objects themselves as inscriptions of such archaeologies and time, as we will see in the next section.

Media diagrammatics

The new generation of German media theorists follow Kittler, Niklas Luhmann, Wolfgang Hagen, Jochen Hörisch, Norbert Bolz, Siegfried Zielinski, and others in their theoretical formulations that had already turned to historical ways of questioning the *a priori* of media. As Eva Horn (2008: 9) has illustrated, this related to the earlier neglecting of technology from cultural theory as well as turning into a specific mode of historical criticism against such humanities' notions as 'sense', 'meaning', 'interpretation', and 'beauty' while also bridging new cross-disciplinary fields across the humanities and the sciences. Even though, as Horn points out, there might be a confusing lack of clarity of even what media are for such scholars, I would see this 'movement' (if one can call it such and neglect its heterogeneity) as opening up the normalised media studies checklist of broadcast media and digital media into a variety of processes of mediation. Horn agrees on this point, addressing the processual nature of various enterprises under the label of 'German media theory'. In Horn's (2008: 8) words:

> Such heterogeneous structures form the basis, the 'medial a priori,' as it were, for human experiences, cultural practices, and forms of knowledge.

Regarding media as processes and events, observing their effects rather than their technological forms or ideological contents, also implies a broadening of their analytical frame, which becomes more a certain type of questioning than a discipline in itself. Perhaps such an anti-ontological approach to media, a radical opening of the analytical domain to any kind of medial process, has been more productive and theoretically challenging than any attempt, however convincing, at answering the question of what media 'are'.

To me, the turn is not anti-ontological per se even if does not settle on a definition of media recognised by one disciplinary and institutional entity. Instead, the processuality of the work feeds into an ontologising questioning of 'what are media' (see Münker and Roesler 2008) as well as towards specifications concerning the ontology of the materiality of technical media conditions.

The historical focus of the 'earlier 1980s generation', that is still of course very active and influential, has recently taken a further media archaeological turn through writers such as Ernst, Claus Pias (2009), and Cornelia Vismann (2008), to name only some who are increasingly influential scholars in rethinking not only media but also archives and temporality. What distinguishes Ernst is his insistence on the time-critical notion of media archaeology that presents a microtemporal research agenda with very practice-bent, operational demands for the media scholar. Indeed, this orientation is an attempt to answer the methodological question of how do you then concretely research microtemporality – a concept that continuously is in danger of remaining slightly elusive.

What could be called 'operative diagrammatics' refers in the case of Ernst to a specific way of understanding the objects of media studies and the way they feed into theories concerning 'materiality-in-action'. In practical terms this refers to the 'add-on' to his media archaeological theories that resides in the basement of media studies as the 'Media Archaeological Fundus'. The archival is no metaphor for Ernst as a reader of Ernst who has been very interested in the concrete history cultures of the former East Germany where the centrality of the archive for the socialist nation-state cannot be overemphasised. The media archaeological collection of old media differs radically from what in the wake of Bruce Sterling's 1990s call came to be known as 'dead media' – a collection of media passed away, forgotten, dysfunctional. In contrast to such indexical collections that list an archive of past media, Ernst's project argues that media archaeological monumentality of the media technologies must be much more than descriptive and indexical. Instead, it needs to address the media technologies in their material processuality – the logical and material infrastructure which are media technological *only if they work*. The difference from museum-displayed technologies becomes evident with the task of the media archaeologist becoming less a textual interpreter and a historian, and more an engineer

and specialist in wiring and diagrammatics of circuits. Monumentality is here understood in its Foucauldian tone: archaeology focuses on the monumentality of traces that do not refer to any underlying hidden message or meaning, but are to be taken, methodologically, as such; all is there already to be seen, and presented, and the archaeologist has to focus on the actual inscriptions of what is there (see Foucault 2002: 122, 125; Deleuze 1988: 15).

In a very perceptive note concerning media archaeology, Vivian Sobchak has argued that instead of differentiating Anglo-American media archaeologies such as Huhtamo's from the materialist ones of Ernst, the notion of 'presence' ties them into a shared epistemological framework. Both are interested in what Sobchak (2011, 324) calls 'transference or relay of metonymic and material fragments or traces of the past through time to the "here and now"', which accurately captures the way Ernst places emphasis on operational machines carrying a certain transhistoricality (Sobchak's term). Indeed, on a more casual note, the enthusiasm for personal collections of several media archaeologists seems to index the insistence on the importance of the material machine for such excavations, which, however, for Ernst is less about the external design features and implicated interface uses, and more about the internal workings of media.

The archives of operative media consist of a variety of twentieth-century media technologies from radio receivers to oscilloscopes, televisions, and computers which all are characterised by the fact that they actually are operational. It is only in the moment of their active articulation of time that media are alive and become in that sense archaeological – transhistorically connecting over time. Far from nostalgia, such equipment is important due to the time-preserving and rearticulating nature that forces us to rethink present and past, and their complex intertwining in old media devices.

> A radio built in Germany during the National-Socialist regime (the famous *Volksempfänger* propagated by Josef Goebbels) receives radio programs when operated today, since the stable technological infrastructure of broadcasting media is still in operation. There is no 'historical' difference to the function of the apparatus now and then (until analogue radio will finally be completely replaced by digitized transmission of signals), rather a media-archaeological short-circuit between otherwise historically clearly separated times. (Ernst 2011, 240)

Intriguingly, the archive becomes a central node in this mode of media studies. Media become archives themselves in the way they transmit between the past and the present, and those archives themselves need to be thought of as technical media apparatuses where cultural memory becomes technical memory. For the archaeological gaze, already such technical media as the phonograph,

photograph, and other technologies are able to record and hence transmit much more than human symbolical meanings. Here is the point that Ernst seems to adopt from Kittler's understanding of technical media as defined by noise – that is, all that does not seem to fit in with the meaning-making human world, but is recorded by the accuracy of the phonograph; as much as utterances, it's the noises of the larynx and the body that stick on the phonographic plates in their fidelity to the world of the real (Kittler 1999: 16).

Ernst makes this characteristic of technical media a methodological guideline. The phonographic and other similar media carry semantics as much as they carry the sound as a raw phenomenon of noise and scratch as much as the meanings of whoever happens to utter his or her voice on the phonograph. It is at this level of paying attention in a McLuhanesque manner that Ernst says the work of the media archaeologist starts by listening to the noise as much as to the message; to the media as a constellation between present-pasts as well as the mediatic wiring between the human and the technological. For Ernst, any media analysis should be less about the content of a medium and more about the mathematical-statistical existence of a signal that does not per se make distinctions between message and noise in the hermeneutic sense. 'White noise does not mean nonsense, but a ceaseless particle stream of information in constant motion' (Ernst 2002: 629). Hence, what becomes registered with scientific equipment – the fields of pulsations, magnetic fields, waves, and such – is something that humanities methodology needs to take into account. Outside meaning, there is the concrete regime of non-meaning, too often neglected only as noise, that itself imposes new demands on humanities in the age of technical media.

Furthermore, it points towards the microtemporal layers of this brand of media archaeology that seem to be a crucial characteristic of the Berlin Humboldt School of media archaeology. 'The micro-temporality in the operativity of data processing (synchronisation) replaces the traditional macro-time of the "historical" archive (governed by emphatic historical consciousness) – a literal "quantization". Our relation not only to the past but to the present thus becomes truly "archival"' (Ernst 2011, 251). In other words, a focus on archives and archaeology becomes a mode of analyzing and engineering contemporary media in the way they channel and synchronise patterns of 'cultural' life. At the core of media archaeology one does not find history, but the previously mentioned cold gaze of the Foucauldian archivist-become-engineer that is as much digging historical material as it is interested in the layered realities of technologies around him/her. Curiously, Ernst suggests a combination of the objectivist cold gaze of the historian Ranke with the genealogist Foucault whose works offered a crucial backbone for new historicism and new cultural historical critiques of positivist historiography. For Ernst, this paradox remains unaddressed, even if his emphasis on Foucault through the notion

of monumental history as well as probably the idea of the positivist in Foucault (that he himself in *The Archaeology of Knowledge* (2002: 141) hinted at by referring to his 'positivism', interested in accumulations, not origin) would be the ways to trace out an interesting even if subtle connection.

The idea concerning layerings and accumulated but non-linear and discontinuous temporalities becomes clearer when Ernst elaborates that the media archaeological practices include such media artistic and activist practices as hardware hacking, circuit bending, and other techniques of literally opening up technologies. As explained by Ernst, media archaeology is processual, and focuses on the time-critical processes which engineer our lives. This means that media archaeology does not only tap into the past but can dedicate itself to opening up technologies in an artistic/hacker vein. Ernst's examples of media archaeological arts are actually less about artists working with historical material than about hardware hacking, open software, and circuit bending. For Ernst (2009), exemplary of such work is the Micro Research Lab (http://www.1010.co.uk/org/) run by Martin Howse. Similarly we can address the work of such circuit benders as Reed Ghazala and other practice-based media archaeologists as elaborating both new kinds of art methods as well as hinting towards the question whether digital humanities is able to address hardware as well (see Hertz and Parikka 2012).

For such laboratories of hardware and media archaeology, excavation into the layered existence of technical media infrastructure in our physical environment media is seen as a hidden language of sorts that needs specialist understanding to be reached. Embedded in the materialist media theoretical considerations of hardware as well as electromagnetism, the Micro Research Lab projects investigate the technical and often ephemeral worlds of perception and sensation involved in high-tech media worlds. From experimenting with computer monitors and keyboards to the task of opening up hardware this can be of political importance in the world of increasingly closed electronics. Other projects investigate notions of material, but invisible, traces such as electromagnetism as emblematic of high-tech culture as well in addition to creating autonomous zones in computer memory (Island2-software project: http://1010.co.uk/org/island2.html).

In general, the practical projects exemplify what Ernst seems to mean by the diagram. Of interest already to Foucault, the diagram becomes a literal crossing-point between epistemologically wired humanities analysis of technical media and the engineering-enabled understanding of and tinkering with operationality. In other words, the diagram is for him a perfect gripping point to understand technical media culture as both based in logic but also mathematics-in-action – that is, engineering. The diagram as a central figure for technical media devices is both an indexical mapping of circuitry which guides both the machine processes and a way to tap into how temporality

– the new regimes of memory – are being circuited on this microlevel. The diagram shows how machines work, but it also is a way to understand how society operates through the diagrams of machines. The diagram is then an operational dispositif, which does not tie it only to Foucault's idea of how power is distributed diagrammatically, non-discursively, and in various forms across society (see Deleuze 1988: 34–5) but also to a technical definition of the diagram as a way of understanding visually the flow of signals in a structural way. Already Foucault's notion of the archive emphasised it not as a collection of 'dust of statements' (Foucault 2002: 146) but as the system of the functioning of statement-things. Ernst brings this realisation to the core of his media archaeology.

Despite the obvious differences between, for example, a Deleuzian reading of Foucault and Ernst, the points about power working through diagrammatics coalesce here. For Ernst, it is exactly that which in other circles would be called 'power/knowledge' that becomes circulated through the microtemporal diagrams embedded in concrete machines and their abilities to process and synchronise temporal processes. Diagram is then not only a representation of what happens, but an instructional and hence operational tool for executing time-critical processes in technical environments. Foucault talks of the flow of power circulating and through that circulation constituting its subjects (Foucault 2001: 180–4), and for Ernst's appropriation of Foucault it is a matter of circulation through signal processing that is the core of technical media culture. This is again a point where we see how the macrotemporal and spatial understanding of archives turns into an epistemological-engineering perspective into the machines of archiving-as-temporal modulation. In other words, and to clarify, through the practical and machine-focused approach two constitutive notions of the diagrammatic archive emerge:

1. The archive as a central place for collecting and engineering technical media; a site of study in the same manner as the laboratory or the classroom. It refers to a media studies appropriation of the sites of memory for excavations into the constituents of contemporary media culture. Such sites as the archive in this sense are specifically cross-disciplinary and dedicated to science–humanities collaboration.
2. The archive as referring not only to the macrotemporal histories and spatial archives. Instead, archives can be also understood as the diagrammatics of machines which are constantly operationalising social and cultural functions into algorithmic contexts. Media studies and digital humanities should be interested in the microtemporal archives as well – those that are embedded in the time-critical processes of media, which means incorporating 'intervals', 'temporal architectures', 'real-time', 'algorythmics' and other time-critical concepts at the heart of media studies (see Volmar 2009).

However, what is missing from this emphasis on the diagrammatics and the potential in combining hacker/circuit-bender methodology into a media archaeology of microtemporality is the dimension of political economy, or at least its clear articulation. Similarly, as we indicated at the beginning, that from the French philosophy direction theorists such as Stiegler are showing the need for a new political economy in the age of technical memory machines, we need to ask if the German media theoretical projects are able to afford such as well – the important articulation of knowledge through technical media in connection with power in its micropolitical levels. Whereas writers such as Raiford Guins (2009) have recently been able to extend some similar epistemological considerations into a thorough analysis of the political economy of contemporary digital culture and its closed devices, Ernst's program does not include this dimension and it remains merely an implicit possibility.[3] To note, media archaeology has never been too strong in terms of political economy even if early on setting itself as a counterforce to the logic of the new in the hype around 'new media cultures' can be seen in such a context. And similarly, such topics are not strongly visible on the digital humanities agenda either. Indeed, what I want to point out is that despite its great promise in terms of widening media archaeology from a historical method into analysis of contemporary technical media in its operationality, it still needs to articulate more tightly the wider networks in which the techno-mathematics of media take place. Hence, in terms of the heuristic divisions concerning contemporary media studies and cultural theory intellectual traditions, perhaps one of the most fruitful links for a rethinking of humanities would come from the crossovers of political theory (branded as the trademark of Italian theorists) and media theory (branded as German) – an articulation of humanities in the age of digital machines as a conjunction of new forms of labour and machines, of cognitive capitalism in technical media culture.

Conclusions

This chapter has offered theoretical insights into how we can define the archive in the age of technical media and how this might connect to digital humanities discourse. Indeed, in the midst of the rethinking of the archive and the remediations of old media through new digital software techniques used in book and other projects, we are confronted with the fundamental questions of how such sites and conditions of cultural memory work. Hence it is interesting and useful to look at such approaches which place the archive at the centre of digital culture – which forces both a rethinking of the archive as a software constellation and a condition for knowledge and experience, but also to look at histories of the archive afresh.

The transformations of such a foundational institution, practice, and concept of modernity as the archive has been mapped by, for example, Sven Spieker

(2008) who is interested in its transformation from filling a solely legal func-
tion to a 'hybrid institution based in public administration' (2008: xii) – a
key formation for the bureaucratic nation-state. Spieker continues to analyse
how such a formation has afforded a range of art practices from the earlier
avant-garde to more recent works. Most of such have not only questioned the
archive's status as the foundation of knowledge in modern cultures, but also
mapped its material, mediatic constituency as well as alternative rationali-
ties such as the Dadaist montage as an anti-archive that also includes trash.
Furthermore, the constitution of the humanities since the nineteenth century
is intimately tied to the question of archives, records, and documents, and any
acknowledgement concerning the change of the archive naturally has implica-
tions for how we think of the humanities. Hence it's not only the humanities
that are changing our perspective to archives in the age of technical media,
but that technical media as a culture of archives and databases demands a
new, more digital, more soft-wary and hard-wary humanities, both in terms of
institutional strategies for preservation and re-use of material, but also because
of the expansion of the archive to much more personalised, everyday and use-
orientated forms in the age of social media. Social media applications and sites
are increasingly reliant on differing notions of the archive, both in terms of
their business logic (data-mining user patterns, preferences, and such) and
hence political economy, but also in terms of how they allow personalised
storage (cloud computing), as well as remediation of the past, as with YouTube
as a key repository for past popular and music cultures. Also, with the Library
of Congress starting to archive Twitter tweets, a new level of archivability of
the ephemeral everyday is going to be reached.

To be fair, it would be a simplification to brand these kinds of approaches
addressed in this chapter only as German. The notion of German media theory
is far from unproblematic (see e.g. Winthrop-Young 2010) and can be heuris-
tic at most. The approaches afforded by software studies and platform stud-
ies are emblematic of theoretically informed humanities in the age of digital
machines and similarly scholars as Matthew G. Kirschenbaum's (2008) argu-
ments have both significant resonance with theorists such as Ernst and carry
the theoretically informed and medium-specific nature of humanities analysis
further.

Indeed, such analyses point towards the move from the at times rather vague
discourse of 'virtuality', 'cyber', and even 'digital' to the more specific notions
of machine analysis, but furthermore to a breaking down of the notion of
machine into much more specific components for material analysis. To quote
Kirschenbaum:

A bibliographical/textual approach calls upon us to emphasise precisely
those aspects of electronic textuality that have thus far been neglected in

the critical writing about the medium: platform, interface, data standards, file formats, operating systems, versions and distributions of code, patches, ports and so forth. *For that's the stuff electronic texts are made of.* (Quoted in Brown 2010: 56)

The primacy of the text – also in its transformed state – is what paradoxically ties such approaches to the media materialism of Ernst's German media archaeology. Kirschenbaum's (2008: 217) way of emphasising how both the historian and 'the textual scholar do not study the past as much as the patterns of its transmission and transformation as they are manifest in the document and the artefacts of the present' is what Ernst picks up from Foucault's emphasis on the monumentality of the archival interest of knowledge; the here and now of what we have, and what conveys the concrete object/process of our investigation. Text becomes, again, material, and the document – which here is extended to include software as well – becomes the primary starting point of analysis.

To return to the beginning, the way we can tie in a much wider theoretical knowledge and critical theory of media as part of digital humanities discourse is still very much needed. The seeming reinvention of technology as part of humanities has its predecessors. Similarly the knowledge base of both approaches that has actively sought to articulate the intertwining of old media and new media such as media archaeology as well as the solid theoretical insights into the ways of thinking, remembering, and experiencing always embedded in technical preconditions such as in materialist media theory should not be neglected. Hence the theoretical basis of digital humanities continues to be revived dynamically, and the core humanities assets of theory and practice in relation to politics and economics are brought back to the disciplinary discourses.

Notes

An earlier version of this chapter was published as "Operative Media Archaeology: Wolfgang Ernst's Materialist Media Diagrammatics" *Theory, Culture & Society* September 2011 vol. 28 no. 5, 52–74.

1. The trope of the 'cold gaze' is for Ernst a way of stepping outside a human perspective to the media epistemologically objective mode of registering the world outside human centred sensory perception. Ernst's idea borrows as much from a celebration of modern science-based media in its technical characteristics of non-human temporalities as well as the early twentieth-century avant-garde discourse: 'The gaze is no longer a privilege of animals or humans (who are always emotionally vulnerable) but is rivalled by the cold camera lens – a new epistemological field which was later cin-aesthetically celebrated by Anton Giulio Bragaglia's treatise *Fotodinamismo Futurista* (1911–1913) or Dziga Vertov's film *Man with a Camera* (USSR, 1929). Thus theoría truly becomes media: the camera actively renders insights (such as long-time exposure) which have otherwise been inaccessible to humans, whose temporal window of immediate perception of events is neurologically limited between two and four seconds.' (Ernst 2005: 597).

2. Kittler's (2006) "Thinking Colours and/or Machines" is an important precursor in this respect in how it outlines a short genealogy of modern thought from Kant to computer science, and the problematics of integrating science and computing into philosophical epistemologies which are the ground of humanities. Reading such insights, and writing such genealogies, are of interest to digital humanities as well as illuminate the wider connections (and disconnections) of humanities theories and technical media.

3. A thank you goes to Geoffrey Winthrop-Young for pointing out an important context for the distance-taking, rationalistic subjectivity in German cultural history. Helmut Lethen's (2002) *Cool Conduct* analyzes the interminglings of politics of affect, distance/proximity and theoretical thought in Weimar Germany, offering another kind of a characterization of 'coolness' and distancing gaze as part of demand for rational objectivity.

References

Alaimo, S. and Hekman S. J. (eds) (2008), *Material Feminisms* (Bloomington, IN: Indiana University Press.)

Buchloh, B. H. D. (2006), 'Gerhard Richter's Atlas: The Anomic Archive//1993' in Charles Merewether (ed.), *The Archive* (London: Whitechapel and Cambridge, MA: The MIT Press, 85–102).

Brown, Bill (2010), '"Materiality" in W. J. T. Mitchell and Mark B. N. Hansen (eds), *Critical Terms for Media Studies*.

Cohen, P. (2010), 'Digital Keys for Unlocking the Humanities' Riches', *New York Times*, 16 November 2010, http://www.nytimes.com/2010/11/17/arts/17digital.html.

Chun, W. H-K. (2006a), *Control and Freedom: Power and Paranoia in the Age of Fiber Optics* (Cambridge, MA: The MIT Press).

Chun, W. H-K. (2006b), 'Introduction. Did Someone Say New Media?', in W. Chun and T. Keenan (eds), *New Media, Old Media: A History and Theory Reader* (New York and London: Routledge, 1–10).

Chun, W. H-K. (2008), 'The Enduring Ephemeral, or the Future Is a Memory', *Critical Inquiry* 35(1) (2008): 148–71. Also (2011) in Erkki Huhtamo and Jussi Parikka (eds), *Media Archaeology* (Berkeley, CA: University of California Press, 184–203).

Deleuze, G. (1988), *Foucault,* trans. Seán Hand (Minneapolis: University of Minnesota Press).

Elsaesser, T. (2006), 'Early Film History and Multi-Media: An Archaeology of Possible Futures?', in W. Chun and T. Keenan (eds), *New Media, Old Media: A Reader*, edited by Wendy Chun and Thomas Keenan (New York: Routledge, 13–26).

Ernst, W. (2002), 'Between Real Time and Memory on Demand: Reflections on/of Television', *The South Atlantic Quarterly* 101(3) (Summer 2002): 625–37.

Ernst, W. (2003a), 'Telling versus Counting? A Media-Archaeological Point of View', *Intermédialités* 2 (Autumn): 31–44.

Ernst, W. (2003b), *Medienwissen(schaft) zeitkritisch. Ein Programm aus der Sophienstrasse.* Antrittsvorlesung (inaugural lecture), Humboldt University, 21 October 2003.

Ernst, W. (2005) 'Let There Be Irony: Cultural History and Media Archaeology in Parallel Lines', *Art History* 28(5) (November): 582–603.

Ernst, W. (2006), 'Dis/continuities: Does the Archive Become Metaphorical in Multi-Media Space', In W. Chun and T. Keenan (eds), *New Media, Old Media: A History and Theory Reader* (New York and London: Routledge).

Ernst, W. (2007), *Das Gesetz des Gedächtnisses* (Berlin: Kadmos).

Ernst, W. (2009), 'Method and Machine', lecture at Anglia Ruskin University, Cambridge, 18 November 2009.

Ernst, W. (2011), 'Media Archaeography – Method & Machine versus History & Narrative of Media', in E. Huhtamo and J. Parikka (eds), *Media Archaeology* (Berkeley, CA: University of California Press, 239–255).

Foucault, M. (2001), 'Cours du 14 janvier 1976', in M. Foucault, *Dits & ecrits II, 1976–1988* (Paris: Gallimard).

Foucault, M. (2002), *The Archaeology of Knowledge,* trans. A. M. Sheridan Smith (New York and London: Routledge).

Guins, R. (2009), *Edited Clean Version:Technology and the Culture of Control* (Minneapolis: University of Minnesota Press).

Hertz, G. and Parikka, J. (2012), "Zombie Media: Circuit Bending Media Archaeology into an Art Method". *Leonardo-journal,* forthcoming 2012.

Horn, E. (2008), 'There is No Media', *Grey Room* 29 (Winter): 7–13.

Huhtamo, E. (2008), *The Roll Medium: The Origins and Development of the Moving Panorama Until the 1860s*. PhD dissertation, University of Turku. Book version forthcoming from University of California Press in 2011.

Kirschenbaum, M. (2008), *Mechanisms: New Media and the Forensic Imagination* (Cambridge, MA: The MIT Press).

Kittler, F. A. (1999), *Gramophone, Film, Typewriter,* translated, with an introduction, by G. Winthrop-Young and M. Wutz (Stanford, CA: Stanford University Press).

Kittler, Friedrich A. (2006), 'Thinking Colours And/Or Machines' Theory', *Culture & Society* 23(7–8): 39–50.

Kittler, F (2010), *Optical Media,* trans. Anthony Enns (Cambridge: Polity Press).

Krämer, S. (2006), 'Cultural Techniques of Time Axis Manipulation: On Friedrich Kittler's Conception of Media', *Theory, Culture & Society* 23(7–8): 93–109.

Lethen, H. (2002), *Cool Conduct: The Culture of Distance in Weimar Germany,* trans. D. Reneau (Berkeley and Los Angeles, CA: University of California Press).

Manovich, L. (2002), *The Language of New Media* (Cambridge, MA: The MIT Press).

Münker, S. and Roesler, A. (eds) (2008), *Was ist ein Medium?* (Frankfurt: Suhrkamp).

Peters, J. D. (2010), 'Introduction: Friedrich Kittler's Light Shows', in Friedrich Kittler, *Optical Media* (Cambridge: Polity Press, 1–17).

Pias, C. (2009), 'Time of Non-Reality. Miszellen zum Thema Zeit und Auflösung', in A. Volmar (ed.) *Zeitkritische Medien* (Berlin: Kadmos, 267–79).

Sobchak, V. (2011), 'Afterword: Media Archaelogy and Re-presencing the Past', in E. Huhtamo and J. Parikka (eds), *Media Archaeology* (Berkeley, CA: University of California Press, 323–333).

Spieker, Sven (2008), *The Big Archive: Art From Bureaucracy* (Cambridge, MA: The MIT Press).

Vismann, C. (2008), *Files: Law and Media Technology* trans. Geoffrey Winthrop-Young (Stanford, CA: Stanford University Press).

Volmar, A. (ed.) (2009), *Zeitkritische Medien* (Berlin: Kadmos).

Winthrop-Young, G. (2006), 'Cultural Studies and German Media Theory', in G. Hall and C. Birchall (eds), *New Cultural Studies* (Edinburgh: Edinburgh University Press., 88–104).

Winthrop-Young, G. (2010), *Kittler and the Media* (Cambridge: Polity).

6
Canonicalism and the Computational Turn

Caroline Bassett

This chapter considers the computational turn in relation to some of the diverse frameworks through which digital artifacts and practices, taken separately or explored in various configurations, are being defined, categorised, and claimed for various disciplines, sub-disciplines, anti-disciplines, or academic fields; for this tradition or that. In this process of course not only the artifacts and practices, but also the frameworks themselves, are being reconstituted. If the latter are rendered computational in various ways, the former are hacked into shape, rendered fit, or made amenable and suitable for certain modes of analysis. This kind of work might thus redefine conventional takes on computation and its (cultural, social, economic, aesthetic, material) significance, replace the traditional object of enquiry within a particular field with its computationally transformed upgrade, and relocate the field itself so that it extends across new terrain – or operates in new dimensions.

All of these activities make a claim, a play for ownership of the exploration rights, a play for position on an adjusted field, a demand that the re-organised field of enquiry follows a chosen ground plan, an insistence that *this* is how such an artifact should be investigated or how its relative qualities should be taken into account. In this article these claims are explored as they are made through the past, in the name of the game, in terms of literary dominion, and through a double-sided demand for software empiricism and code literacy.

Many of these claims are not fully acknowledged as claims. But to declare a research framework 'appropriate', to declare that the real or important question concerning technology is *this* not *this*, to define the 'right' scale and level for enquiry, to determine language(s), to define appropriate tools for enquiry, to taxonomise and to create taxonomies, is, as we know, to make a disciplinary claim. And here I refer both to the broad Foucauldian sense in which discipline might be thought, as well as to its narrower deployment in relation to university disciplinarity or interdisciplinarity where claims around knowledge and its categorisation take a specific material and symbolic form.

Of course the two disciplines are connected: claims being articulated in theoretical or speculative register, through critical interventions, or through material artistic practice, play out within the material political economies of learning institutions. In particular the invocation of the digital humanities, at least in the United Kingdom, often signals the start of a territorial scuffle between traditional humanities subject areas, or traditional subject couplings, this despite the fact that many of those involved share a feeling that a more radical re-shaping is required – and are also unconvinced that the digital humanities can provide it. The objects and practices the digital humanities collates often need rigorous pruning before they conform to the prescriptive coupling of computerisation and literary values that the latter term sometimes.

There is always the hope (or the fear) that even such restrictive economies might produce more radical transformation than had been anticipated: the question of mutual influence, even the possibilities of various reverse takeovers, are significant factors to take into account here. Bound into this traffic is the question of delegation (see Latour 1992, 1996) – of what else (human and inhuman, material or symbolic, desire or anxiety) may be imported through these mutual but asymmetric incursions; of computing into the humanities and (less) of the humanities into computing. And here it is the capacity of information technology to operate, or be operated, as a delegate of neo-liberalism, carrying its values through a process of dissimulation that plays on the visible rather than deploying concealment, that is of striking concern. After all, the expanded address of the digital work, which emerges as result of its material alignment with the substrates held central to the dominant values of digital economy, can mean it appears – and work on it appears, and the discipline that owns it appears – to be 'worth more' than what came before, for instance worth more than scholarship based around disciplinary investment in an old technology or in a more traditional text (already in part a remembered object). The linkage between disciplinary enclosure and debates around (value and) intellectual property is clear – and it is worth noting that knowledge rights are considered as rights only when they generate profits in the new world of intellectual enclosure of the twenty-first century, as Ashley Dawson points out (2010). At any rate, in the United Kingdom at least, the current vogue for digital humanities (it might often be more accurate to call it a desperate lurch than a voguish stroll) sometimes looks like a fetish as much as anything else. And one twist here is that the fetish may not replace a *lack* of connections already being made. It may rather – and increasingly perhaps – tend to smother those that do not function to align the computational, and therefore re-align the humanities, with the market in the required way. It should also be noted that smothering is a murderous act[1] that provides its own cover.

Convergence and simulation

The continued existence of small worlds in the academy (see Selzer 2011) should not be a surprise. But the fact that their boundary defence should be most rigorously pursued around a series of cultural objects and practices that emerged as the result of various convergences, that are recognised as boundary breaking and flexible, that, as a consequence of their materiality, might be said to provoke and encourage forms of slippage and traffic, has a certain irony. Digital media in general is characterised by its propensity to link, connect, join, and translate between forms, to break and re-make boundaries, including those between genres and forms, text and practice, and between different media streams holding various forms of sense data. The MP3 player, designed to transport music, is a paradigmatic example of this, as Jonathan Sterne has pointed out (Sterne 2006). Elsewhere I have suggested that this promiscuity might indicate or begin to provoke the prioritisation of a certain sonic aesthetic in contemporary culture – one that might find expression not only in auditory but also visual and haptic form (Bassett 2011).

The scent of kinesthesia (when one sense becomes another) invoked here brings to mind that other (connected) characteristic of new media, which is of course its ability to simulate – and this complicates the landscape given by convergence and the ways in which it might encourage disciplinary dissolution or re-making. Marshall McLuhan observed that old media becomes the content of new media, and Bolter and Grusin, along with many others, considered this in relation to the re-mediatory qualities they discerned in digital media formations (1999). Remediation is often understood to entail the *fragmentation* of older systems, the break up and re-use of older genres, forms, uses, and practices, but its logic may also be turned around in various ways. For instance, if the Internet can make the media activity (including interpersonal interactions and performances) it carries (old media as the content of new) look like (simulate) the old world of text, why not explore it within the frameworks developed to explore text, why not remain within, or rather bring this artifact within, the grounds of the literary – even the covers of a book? Or, if life is now permeated by the digital to the extent that it is fully mediated, so that there is no ground zero of mediation, as it was recently put, why not assume that screen action is now real-world action – that all activity is simply real.

Through the dissimulations of simulation, the social sciences and the arts and humanities can more feasibly retain a traditional division between living subjects versus textual research.[2] Kinds of simulatory reversals might allow for a certain re-appropriation by traditional disciplines, or perhaps it is more useful to say a certain re-incorporation of the new into traditionally established

disciplinary fields. But that isn't to say that these fields remain the same, since in this process research 'objects' (as construed by disciplines) and the disciplines that construe them, are also silently re-configured, perhaps until nothing remains of them that is the same but the name. Film Studies was always about the televisual as well as the cinematic image. Media Studies was always as much about medium as message, experience as well as representation, gaming as narrative. Of course in part they *were* 'about' those expanded objects, but largely they were not. In these disciplinary war games memory is short. I am aware of the over-schematisation of what I am invoking here, but distinctions and trajectories emerging from the diverse and sometimes conflicting effects of convergent and simulatory qualities of digital media pertain. It is useful to note, however, that even allowing for the comfort simulation provides (it is still a text; it's just people), there is a growing sense that ethical frameworks developed in various disciplinary conditions do need rethinking to handle new kinds of computationally informed projects and new kinds of computationally informed environments what was a 'specialist' discussion for those studying digital questions has become a more broadly considered topic.

This chapter explores some of these ambiguities, not with the intention of declaring disciplinary war (not least because I am myself not entirely 'at home' in an arts and humanities school), nor of demanding a dissolution of the disciplines, or a statute of limitations for canonicalism (which I conclude will itself always be frustrated as well as encouraged by new media's simulatory possibilities and its protean development; something its best proponents often recognise). I do believe interdisciplinary approaches are intrinsic to digital research, but recognise that interdisciplinarity too may be operated as a mode of an appropriation rather than as a tool for connection, and certainly shouldn't be seen as disciplinary canonicalism's opposite.[3] Finding or building 'new media' a permanent new home (intersectional or not), would seem to me to be an exercise both pointless and endless – perhaps the former as a result of the latter. Canonicalism may be creative, it may be a defensive move (it creates somewhere else to go in the arid precincts of the neo-liberal university), but it is also one that can be very aggressive. The question is what would be, or what kind of canon might be, more or differently (critically) productive?

Below I open up this ambiguous terrain by considering a series of distinctive attempts to re-appropriate or re-classify aspects of the computational terrain, via the construction of taxonomies and canons, the definition of new fields, by proclaiming certain exclusions, or entry qualifications, or through the writing of authorised histories (or 'authorising histories' perhaps). The intention is to understand more about why this kind of work is emerging now, and to expose

some of the tensions between incorporation, expansion, and exclusion that classification raises.

Authorised versions

My students declare that 'these days' the Internet – by which they largely mean not the Internet but the platforms they use[4] – is interactive. They compare this new Internet to the old Internet, which was, so they say and confidently believe, 'one-way'. They make their claims in relation to Web 2.0, a classification that for them[5] defines what the Net is now compared to what it was then, this despite the fact that Web 2.0 is, at least in part, a nomenclature that pulls together a set of technologies and platforms that evolved in the 'old' Web. Ten years ago the same debate was had, using essentially the same terms, but at that time passive old media was television and interactive new media was the now 'old' Internet. Theorists of old new media, including notably Martin Lister, pointed out, somewhat vainly, that years of study of television – and its viewers – had moderated the couch potato view of the world, and so passive/active definition was therefore misjudged (Lister 1995). Contemporary claims that new media ecologies represent a decisive break with the recent past may thus be questioned; the salience of various relatively stable features of new media is recursively revived and re-understood.

However, the 2.0 formation, if not in reality dealing entirely with the new, does contribute to the production of a real change in perspective and provides for a moment both of projection (discussed below) and retrospection. There is an increasing awareness of the lengthening history of new media and of the hugely complex twentieth- and twenty-first-century history of computing. This might provoke both space for a moment of retrospection and an arena within which claims may be made. The historian Paul Edwards thus argues both for work to be done on computer history and acknowledges that this latter is too complex to be encompassed through any single approach (Edwards 2001). The doors are open for many forms of historiography, for instance for work based around broad historical formations, industrial innovators, or on technologies themselves.

Edwards' open call stands in contrast to the striking cohesion observable across a series of archaeological accounts of new media. Archaeological writing, considering the long history of mediation also explores the dynamics of innovation itself, for instance through concepts such as variantology (Zielinksi) which set out to explore the deep time and space of media. More or less informed by Foucault (1972) these histories begin with discontinuity, rupture, threshold, limit, series, and transformation, key dynamics of a mode of exploration based on a sense of history's fractured continuity.[6] Given this, something surprising

about these accounts is their cohesion, their tendency to circulate around a restricted series of figures and technologies. Insofar as these figures become canonical, origin figures and/or the origin technologies, for digital media this tends to produce, rather than disrupt, teleological accounts.

This is accelerated perhaps by the informal but common categorisation of new media archaeology as a subsection of new media history. This categorising defines the technologies and individuals that are the subject of these histories, *as computational*, before the act. Media archaeology thus threatens to be undermined, as a mode that seeks not to reveal history but to trace fragmented connections, partly by the shifting framing contexts within which it is placed. Through this placement, confounding the sense (or spirit) of archaeology as productive, these works come to suggest/be read, sometimes despite themselves, as concerning the revealing of origins, rather than as constructing possible archaeologies. This is one of the ways in which the turn to media history may thus itself operate canonically – and it is useful to note that it occurs despite the computationally influenced shift in distribution, which might imply works less easily drawn in under headings that constrain them.

Finally, I want to draw attention to another underlying issue of categorisation and computationalism here, and that concerns a certain blurring between the hazard of the retrospective determination (what came to seen as the inevitable precursor of an inevitable outcome) in archaeological enquiry in general and how this might play out in relation to questions of technological determinism. To work with an analogy here it is useful to turn to Lewis Mumford's work to define series of eras by the technology that produced them – glass, for instance, opens up life to light, and Enlightenment emerges.[7] Mumford linked each era to its concept technology, and declared each technology a prime mover (1946). My sense has always been that Mumford was aware of the constitutive force of the model he produced, even as he argued for the determinate force of technology upon which it was based. Thus even here, where a strong (the strongest) case is being made for technology as determinate (as prime mover), there is a realisation that what is made is partly 'made' through a process not of material alteration, but through the power of taxonomy itself. History has been explored through the optic of glass, but also by cod, or salt, or longitude – and in the latter cases claims are not based on the prime mover status of the chosen object (fish, longitude), but rather on the basis of the organisation that a particular figure produces. Taxonomy taxonomises as Foucault told us, invoking the famous instance of Borges's list, including the stray dog and animals belonging to the Emperor. Moreover, it never does so 'naturally', nor I would suggest, entirely technologically. The risk of the archaeological approach in relation to technology, it might be said, is that there is always the risk of trumping contingency with technological determinacy. Where this occurs,

archaeology risks operating in confirmatory mode (the 'this is what is was going to be' that comes from its acquired name as Internet early history): an authorised version of a given past.

You and whose army? Games studies against narrative

A well-known battle concerns the question of digital productions and form – games or narrative, database or story, narrative versus pattern. The terms of the oppositions vary, but these connected debates over form have disciplinary consequences. Notably, in a peculiar recursion, the question of games or narratives becomes, like the game itself, an apparently rarefied space to argue out a set of questions relating to more material divisions and filiations. Thus when Espeth Aarsen asks what has media studies done for us (see *Gaming* 1.1 – an intervention but also in a sense an FAQ or a gaming 101), he is recapitulating, in disciplinary terms, an argument he has run at the level of the game: what has narrative (which he reads as representation) done for games (read as action)?

Intervening in this debate, and once again consciously referencing the contemporary moment as one ripe for retrospective analysis of the field so far, is Marie Laure Ryan, the veteran analyst of narrative and/in its computerised forms. In particular in *Avatars of Story* Ryan looks back on 15 years or so of new media production, and also at the sometimes bad-tempered wrangling between some of those studying it. The focus is on debates between narratives and gaming, and Ryan engages directly with those who wish to develop a very separate sense of 'games studies' (notably Espen Aarseth; see above), the latter making their case on the twin grounds of narrative's (alleged) predominance as a critical framework for analysis in the field of media, and its (declared) incompetence as a tool for analysis for the game. The debate between narratology and ludology has often become a symptom of a divide between gamers and literary scholars, and between gamers and media studies scholars. It is framed, at least by one side, in computational terms – in that gaming is set up as the apogee of the 'new', the latter operating here both as a test point for distinction and as a synonym of the properly computational, with narrative framed as fading continuity, essentially an old medium become content of a new medium – the yellowed paper of the novel thinly disguised in its newly rekindled form.

Theorists such as Jsper Juul have been consistently hostile to narrative approaches to new media, arguing they over-egg the narrative moments in new media formations in which narrative is incidental or at least subordinate to other more algorithmic logics. Juul (2001) was one of those active in staging a series of 'narratology versus ludology' debates, in the first wave of the Web.[8] Ryan's way through this tangle is interesting. First, she recognises

that judged by conventional standards the ludologists do not need to be undertakers because narrative, of the traditional interactive kind, is failing all on its own; despite the early fanfare, engaging with Interactive Fiction (I.F.) has always been largely academic pursuit (a question less about high or low culture than might at first appear. It may be related as much to the failure of the CD-ROM platform, which, it was once presumed, would 'mainstream' I.F. along with other forms of consumer infotainment content).[9] Second, she goes on to argue that to understand digital 'stuff in narrative terms requires rethinking narratology and as a first move rejecting gamer-derived descriptions of 'what narrative is'. The latter, it is argued, are reductive and superficial, relying on definitions of narrative pared down to a skeletally thin form based almost entirely on a few highly selective lines from Gerald Prince's *Narratology: the Forms and Functions of Narrative* in which drama is disqualified from narrative on the basis that the latter requires a narrator recounting to a narratee, while in drama events 'rather than being recounted occur directly on stage' (Ryan 2006: 184). This restricted definition of narrative operates to confirm the opinions of those who invoke its illegitimacy for new media platforms – since the interruptions integral to interactive forms of narrative would place it in the category of the direct event. If computers are in any way 'theatre' (the reference is to Brenda Laurel's well-known analysis of the Internet's first wave), then they can't be narrative.

This caricatured account of narratology, deployed as a decoy by the gamer armies, is firmly set aside by Ryan, leaving her free to reconsider structural narratology as a possible tool to understand narrative. Thus, staying more or less within this model she seeks to develop a model of narrative able to integrate that combination of 'top down' design features and actions 'from below' that typically constitutes new media narratives. Such an integration would, Ryan declares, constitute a 'miraculous convergence' (2006: 99), a phrase that might allude not only to its apparent impossibility within the grounds of traditional narratology, but also to the contingent aspect of this convergence. In the essentially cognitive template proposed, the langue/parole pairing is reconfigured as a dynamic operating between 'structures of choice' (textual architectures) and 'modes of user involvement' (types of interactivity enabled) (2006: 100), where questions of priority and determination are reworked and varying degrees of freedom afforded to either side of the pairing. These operations suggest a series of axes – internal/external and exploratory/ontological – across which narrative types may be mapped and their dynamics categorised. Various modes of narrative are thereby produced and are classified as simulative, emergent, and participatory. All enable the emergence of a more or less recognisably coherent 'story-time' within which a desired 'integrity of narrative meaning' can be retained (2006: 100).

So here is a new model of story – but one that, it turns out, can explain narratives in the wild that are not so new at all. The twist in Ryan's argument comes when this model of story, used to reconsider interactive narrative as this has conventionally been understood (e.g. early hypertext to Web 2.0), is used to rethink an *existing* form of storytelling – not that of the novel but that of *live* television, a format that breaks down that division between world and text that is at the heart of narratology as a model in literary productions. One way to get at how narrative can work on computer platforms says Ryan (and I would agree), is to shift the focus away from literary productions and towards 'life'. Televised sport, where what is thrown into the tale is bound back in real time by commentators who reach before and behind the ball (commenting retrospectively, prospectively), bind the game into the tale, is invoked as a beautifully worked example of this.

That Ryan finds coherent narrative in a game is nicely ironic, given her tilting at games scholars' attacks on narrative. Moreover, her argument makes it clear that the supposedly miraculous convergence of narrative and the interactive form, that which appears necessary if narrative is to flourish in new media platforms given that this is the general mode of their use, is a convergence based on forms of time organisation and blending that already occur in a well-known form of old media. This is not a rare form at all (which the miraculous might be expected to be) but rather is miraculously common – both often found and easily accessible. Rethought this way, narrative might also be common in new media landscapes, particularly if it is listened for in the less rarefied zones than those represented by I.F. as a literary project.

It is useful to stress that the defence of narrative, sketched above, is a *computational* defence. It centres on recognising the degree to which computers are able to extend the operations of metalepsis – traditionally operating between the diegetic and extra-diegetic worlds but remaining 'in the tale'. The new narrative stack exceeds the symbolic and so metalepsis may be rhetorical and also ontological (as the live game model and its catch-ups show). Interestingly, Helen Thornham produces something like the same operation, although she reverses it, in her consideration of game play as ontological narrative (Thornham 2011), a study that draws on connections explored between Ricoeur's explorations of narrative activity and life history developed in my own work (Bassett 2007). Following Ricoeur's model, narrative is a resolution in time, a way in which humans make sense of their time in the world. It can thus be argued that not only the tale, but what the tale is, its form, emerges as a result of a particular historical, technical, and cultural constellation, that is, as a result of material culture and social struggles (Bassett 2007). This more critically orientated approach offers a different route into considering the question of the story-time and its coherence in the life-time. But via both routes

the point carried is that narrative itself might be transformed and re-forged, and might thus remain a meaningful category, in new media circumstances.

Central to this transformation, the core problematic, is the question of a new relationship between symbolic and 'real' forms (rhetorical and onto-logical metalepsis). If one way to trace this out is to consider the complex relationship between the narrative identity and the narrative form, it is salu-tary – and a measure of the artificiality of distinctions between the two forms – to note that gaming actually addresses the same issue, coming at, for instance, in relation to what Juul calls the half-live quality of the game (Juul 2008). Not games studies, but the disciplinary bid that games studies makes, essen-tially an isolationist bid, made in part on the modernist basis that the game form crystallises the abstract logic of its architecture, is rendered problem-atic when the *computational* quality of other activities is underscored. Games studies has many good reasons for its caution and defensiveness, but the computational turn will make connections, and will tend to transform rather than render obsolete. The mode of attack on narrative, in fact renders, not narrative, but gaming itself, more narrow; it fails to grapple with ways in which the relationship between gaming and play, and the fields of play and the models of the game, may be re-approached in relation to the computa-tional. The computational turn thus, while it appears to demand the pri-oritisation of particular forms, might also be used to challenge particular exclusions that of narrative (in the gamer lexicon), and particular hierarchies (that of gaming over narrative), partly by recognising that the forms them-selves, 'gaming' and 'narrativity', are subject to processes of technological transformation.

Finally, a caveat: thinking through narrative in relation to gaming's claims produces a consideration of narrative that focuses on metalepsis as the bleed into 'life'; a different way to come at the distinction between new and old forms of narrative would be to consider how it operates not through increased connection, but through the capacity of new media to provide distance – it is this that provides the scale and perspective necessary for the kinds of dis-tant or external reading that Franco Moretti has explored (2009), and for consideration of new forms of narrative patterning which may operate at vast scales.

Canonicalism (and cannibalism?)

Electronic Literature has been defined by a committee as that form of literary production that 'takes advantages of the capabilities and contexts provided by standalone or networked computer(s)'. Noting this definition Katherine Hayles seeks to improve on it, launching a project whose goals are to 'survey the entire field of electronic literature' (Hayles 2008: ix), identify 'the major genres and

the central theoretical issues', and explore 'new horizons for the literary' (2008: ix). This definition, expanding the horizons as well as altering the material of what is found in homelands of the terrain, is considerably more flexible than the committee version. It is also very ambitious. And it is set out in a single work that sets out to be a definitive survey of E.L. so far, a book that clearly aims to prescribe a new canon: if there were any doubt about this, it is dispelled by the DVD collection that arrives with the print edition. Like a Norton anthology here is what 'should' be read (or used) and here is what will tend to be read (or used) because it is so collated: the massy wheel of canonical taxonomy turns – and in turning makes itself central.

The works assembled in this collection certainly include some unexceptional choices. Hayles confirms rather than inaugurates hypertext works such as *Afternoon* and *Frankenstein*, already part of a nascent canon (as evidenced by their inclusion – by citation and interrogation in a slew of other collections).[10] However, the remit of the literary work is extended here to include media-rich pieces produced for lab-based immersive CAVE (Cave Automatic Virtual Environments) experiences on the one hand, and dispersed locative productions designed for mobile platforms on the other. It is useful to consider the extensions to the literary that are made in this canonical gesture, and to explore the principles behind them – and to do that, with some sense being open to accusations of textual bias, below I trace out two key concepts in the supporting book.

Hayles' starting point is that she is mounting an enquiry drawing on the 'rich traditions of print literature and criticism' (2008: 30) and is thus seeking to understand the specificity of networked and programmable media, and to explore its ramifications in the context of literary work and literary values. Extended grounds suitable for literary enquiry, as well as the literary work itself are thus being (re-)mapped here. This extension is justified in a series of ways, one of the most compelling once again that the works being brought in have much more to do with conventional works than might at first appear. On an account of the transition from old to new media (e.g. print technology to computer technology), Hayles argues that the extension of the 'new materiality' of informatics into the zone of the literary is well underway – many literary objects and practices are already largely digital. Decades of transformation (of an industry, of a craft, of materials and techniques) lie between the production processes historically associated with the book (those of moveable type) and the contemporary situation in which the printed book remains as the pre-eminent literary format but is visibly on the cusp of partial deliquescence into a digital format. The result is that there is no old and new media, at least in the sense that, despite the rhetoric of the new surrounding electronic literature (and devices such as Kindle), books appearing in traditional bound form are already mostly digital (2008: 43).

Printing out, it might be said, is simply one way to view what is already a digital text.

The peculiar turn in this argument is that Hayles asserts that this shift is largely unacknowledged, that it is even a kind of a secret. Simulation, it might be said, masks the computational and in doing so also masks the convergences digitalisation processes silently inaugurate in registers beyond the technical. Even so, from the perspective of media studies, or from that of those engaged in exploring the history of the book or the transformation of specific print genres (e.g. the encyclopedia), this assertion is very hard to give credence to. Attention has been paid to the visible and recorded transformations in the print industries, to impacts on production shifts brought about through digital technologies (see Cockburn, for instance, for long-standing work on the industrial consequences of some of this), and works directly considering the reconfiguration of the humanities and cultural studies through a shift in cultural materials are, after all, not thin on the ground, and are found in public as well as academic zones.

In suggesting that this change in material is 'secret', Hayles can thus only be understood to be addressing her remarks the restricted audience of traditional humanities. Essentially she is calling for a shift in the belletristic tradition which, she asserts, has seen computers as 'soul-less other' to humanistic literature. Somehow then, the question of soul (and who or what has got 'soul') is mixed up, not only in a debate about what is new about digital making as a new form of cultural production, but in a debate that can only be understood when it is framed in disciplinary terms. Here it is useful to turn to Hayles' declaration that as a writing machine the PC is mightier than the pencil – and that the difference between the two is found in 'the degree to which the two technologies can be perceived as cognitive agents' (2008: 57). The enhanced cognitive 'agency' of the computer leads to new forms of partnership – or 'partner' ship (2008: 58) since these are not envisaged as equal – between humans and computers.

The obvious question, and one addressed by others, then concerns what form these partnerships might take. As others have done before her, Hayles frames this in terms of a continuum marked at one end by the media philosophy of Mark Hansen, for whom embodiment gives meaning, and at the other by Friedrich Kittler, for whom the media and the forms of perception and interpretation they organise give us the world and are therefore viewed as 'the proper locus of inquiry' (2008: 87).

Hayles, routing between these poles, argues that electronic literature is neither made in machines, nor made meaningful only by way of embodiment: essentially electronic literature arises as the outcome of cognitive *interaction*. She thus argues, in a metaphor that joins the layered operating systems of the computer with processes of human cognition, that 'cascading processes

of interpretation that give meaning to information are not confined solely to human interpreters as Hansen argues, but take place within intelligent machines as well' (2008: 102). Developing this model, Hayles draws on Bernard Steigler's consideration of the (originary and ongoing) co-evolution of humans and machines, which would suggest that 'partner'ships are nothing new, but that the relative capabilities, symmetries, and dis-symmetries involved in them might take specific form in relation to new materials.

This is explored in part through recent developments in neuroscience – (particularly considerations of plasticity). Arguably the parallels pursued here (the brain as reprogrammable machine) are sometimes strained, but do produce suggestive insights. Notably however – and this gets us back to the question of soul, and whose soul, or what soul might be found in newly soulful computers – Hayles deploys the argument that the 'void within' computers (what cannot be seen or understood of silicon processes) can set up a mirror exposing the 'void within' ourselves (our ignorance of the workings of our own clay-based consciousness). This is a move that might provoke a reappraisal of the scale and forms of enquiry electronic literature might materialise – and reappraisal of the degree to which traditional divisions operate. For instance, those between the work and the life, and/or of course those between the soulless machine and its calculation and the human's soulful cognition. One reason I find this intriguing is that it recapitulates at the level of literary material, the content of Ishiguro's *Never Let Me Go*, where clones perhaps reflect humanity's own ignorance or failure to fathom the human condition; a work that might be critiqued for its unqualified humanism, and/or applauded as a kind of critique of medical cannibalism, but also one which is based on the temporality provided by the pre-given if as yet unacknowledged horizon, the world of the known secret.[11] Viewed from these new perspectives, that is, viewed in relation to questions of 'soul', or at least cognitive co-evolution, and viewed as a partnership that might entail new crossovers between human and machine, electronic literature might be reframed: rather than considering its success or failure as an offshoot of (traditional) literature, based on the division between the literary and literature, the book and the life, it may now be seen as a site where the human–machine dynamics underpinning much of contemporary everyday life (digital exchange) can be explored in new ways partly because here is the site not of their symbolic rehearsal (takes place inside Ishiguro's text) but of their material interaction.[12]

Forms of social power?

If the canonical move made here extends the grounds of literary endeavour, it does so partly by extending what counts as the literary work, or as a literary operation – and although Hayles' move does not equate to Ryan's consideration of ontological metalepsis (the leak into life itself), there are parallels to be

drawn between this and the tighter cognition incursions involved in the cognitive partnership she proposes (the PC rather than the pencil). At any rate the kind of coupling Hayles explores raises questions not only about what might be brought in through such an expansion in traffic – but what might be left behind.

Notably these newly materialised performances, these partnership productions, might raise questions about the location and workings of power. This, avowedly, is an issue for Hayles in this work, but nonetheless is given very little attention. Hayles, in fact, notes that 'complementing studies based on the materiality of digital media' are analyses that 'consider the embodied cultural, social, and ideological contexts in which computation takes place' (2008: 36). It seems acceptable that social reality happens 'somewhere else' (2008: 133), largely perhaps outside of the body–machine loop set up to contain the literary worlds of which Hayles writes. One way in which the project of the digital humanities is problematic might be found in the contradiction here – between ruthless policing of boundaries on the one hand and a geography of expansion and transformation on the other.

Software studies as the expansion of the tactical?

Hayles certainly retains a sense of the literary project and is clearly at the forefront of defining a digital humanities project – even if the human in the work explored above and elsewhere is qualified. Others feel the disciplines within which such concepts are cradled have reached their limits. Neil Badmington, writing on the post-humanities, gives a useful steer on this (see Badmington 2006) as does Matthew Fuller, whose multi-authored *Software Studies/A Lexicon* collection is the final new media programme explored here (Fuller 2008). Fuller's handbook, essentially a canon-builder, begins by setting itself up against the 'cookie cutter' of the arts and humanities, roundly declared incompetent as tools to grapple with the daily fabric of contemporary (highly technologised) working lives.

In fact, the proximate target is media and cultural studies. Fuller's goal is to move beyond the representational fetish of media studies and associated approaches, since – at least as he views them – these approaches can recognise that there are things beyond text, but can get hold only of their shadows.

With the sense that more is needed, Fuller locates the field of software studies as a supplement to literary studies (said to provide some tools, definitions, and concepts) that also draws on 'some of the key standard objects of computer science, programming and software culture' (2008: 1–11). Software studies claims that an approach capable of exploring digital operations, structures, languages and their intersections and connections directly is now required;

the contrast is with approaches aiming to expose the concealed logic of software through examination of the genres and forms it supports – by way of its symptoms perhaps.

The nexus that emerges is distinct from both. Once again, a section of the computational caravan turns off the road, finds a field, and sets up an encampment. So what are its values and what is the attempt?

What I want to suggest here is first that the format of the project *itself* makes a certain taxonomising claim. Designing the project as a *Lexicon*, Fuller avowedly drew on Raymond Williams' *Keywords* (Williams 1976), but it is also useful to think of the *Lexicon* as a List; certainly, if, following Alison Adams' *Lexicon* contribution, the list is understood as a code structure that allows for unfinished business (Adams 2008: 174). Contributors are enjoined to look at what software *patterns*, to attend to its operations and its materiality, and to attend above all to how it speaks and writes. The result is an entry list whose taxonomic categories are once again proto-Borgesian: those tools that are suggestive of connection, those languages that invite retooling, the interface viewed at a particular scale, a codework, a 'rhetorical' codework, 'Codecs', 'CVS', a coding epithet that might imply efficiency and aesthetics ('Elegance'), a disquisition on system event sounds, entries on some of the basic categories at issue including 'Algorithm', 'Language', 'Code' – and a Lev Manovich piece considering the import-export 'business' (Manovich 2008: 119) that constitutes the latter three entries' basic interactions. In different ways these entries tackle software and its operations. Elegance aside, the *Lexicon*, and the work of its contributors, might be compared to Perl perhaps, which it describes as a programming language with a status halfway between assembler and fully natural languages enables a form of coding defined (affectionately) as 'mostly fast, and kind of ugly' (Cox and Ward 2008: 207); a description that gets at the provisional aesthetic of the *Lexicon* and its desire to lash together some useful tools that are capable of doing some work.

In fact, despite the provisional style and apparently modish eclecticism here there is much that marks a coherent and systematic turn. The *Lexicon* lays out a field, provides within it the values to make it operative, and also claims the game – software studies – is worth the salt. The attempt here is the construction of a mode of study that, instead of starting with a recognised form of cultural production (e.g. literature or narrative) and re-materialising it, turns what were once understood as the supporting dimensions of digital culture to the fore, and takes as the central problematic the cultural operations of software, and in particular the relationship between language and code. It is striking that, once considered in this light, many apparently arbitrary and jarring swoops in scale or subject become comprehensible: they operate at a scale, and with the priorities, that software provides.

Formalism and inexactitude?

In the place of re-doubled cognition and new partnerships, here the crux is the tension between the fierce formalism of code and the inexactitude of human practices and of natural language, a tension that lies at the heart of software as a cultural production. This constitutes the key problematic of *Lexicon*. Once again convergence is at issue. This time, however, the aim is to understand how this might operate through an exploration focusing on software: its processes, its actors, its functions, and the respective powers and limits of the modes within which various facets of software act – and interact, since this perspective does not imply a neglect of interaction or a neglect of the question of the location of the working out of the significance of that interaction. What it does do is re-focus the project to re-think, through a newly informed sense of what software is capable of effecting, what actors and what kinds of acts are possible – and perhaps whether it is convergence or its avoidance that might in some way be miraculous.

The field as laid out thus includes at one end Kittler in the *Lexicon* he contributes an entry on 'Code' declaring that 'code – by name and by matter – are what determine us today, and are what we must articulate if only to avoid disappearing underneath them entirely' (Kittler 2008: 40). His argument is that expansion of computerisation into everyday life increasingly 'puts code into the practice of realities' (2008: 45), and does so even as its incommensurability with natural language remains. The implication is that language will be set aside or will cease to matter and that the symptoms of this are already appearing: 'the programme will suddenly run properly when the programmer's head is empty of words' (2008: 46). This produces an insoluble dilemma that might only be resolved by radical means; what these might be is less clear – silencing particular forms of natural language voluntarily perhaps, or finding new ways to speak – both may be suggestive in relation to recent work. (It also produces a strong argument for machinic literacy; only those who can at least get near to such machine talk can understand what is going on, perhaps.) The majority of the contributors to the *Lexicon* are less mordant. Marked contrast to Kittler's fear that natural language will be muted or lost it is asserted by Montfort that source code itself is 'human-read and machine interpreted' (Montfort 2008: 198), so that putting code into the practice of reality does not imply that all human activity moves onto the grounds of the machine or that all human language is overtaken.

Codeworks

In the *Lexicon* the project of software studies might be summed up as an injunction to mind the gap, to explore the relationships between code operations and operations in natural language, to find, exploit, and create gaps for others – and

also to think rigorously not about the packaging of software (the contents, questions of representation – and their 'evils' or 'goods') but its material operations and processes – also perhaps in relation to their evils and goods. It is not surprising then that the codework, a literary production that operates in two languages simultaneously, being both executable and readable, emerges as a sacred object in the *Lexicon*. Codeworks speak twice, once in the lexicon of the computer and once directly to 'us', in a language we can understand. Graham Harwood's *London*, a remixed Perl version of Blake's *London* with its critique of industrialisation, is one example of this genre that is invoked here by Geoff Cox and Adrian Ward (2008: 208). It works by exploring the totalising potentials of computing as a technical proceeding which may, as Harwood puts it, reduce people to data (Harwood cited in Cox and Ward 2008: 207) as the first line – 'Child name if known else undefined' – begins to indicate. The sting in the tail, of course, is that it is software that is employed to speak of this process.

Codeworks, despite being made code, are not industrial code objects. But for Fuller, at least, to destabilise a conventional understanding of the connection between machine and natural language materialised through use and at the point of interaction – which emerges as much from the market as it does from technology itself – is also to destabilise a reading of software's potential as market-given. Fuller's critical starting point, his software studies credo expressed genealogically, is that:

> [A]t the point of software's legal reordering as a separate kind of entity, it became a commodity. ... This ... allows it to circulate in different ways, such as markets, while excluding others ... [but] software has always had a parallel genealogy including the amateur, academic, gratuitous, experimental and free. (Fuller 2008: 3)

If there are ways to read the operations of code (and ways to curate or write or do code) that do not conform to a market logic, this is not because software is ontologically 'free', but because it never has been an uncomplicated progeny of the market, but contains and materialises a series of more complex interactions and contradictions. Fuller's goal perhaps is that, through the revitalising power of his software supplements, it might be possible to trace another route through software's history (outside of/supplementary to the market route), to explore how the process of use (execution of code, interaction with users) produces more than the silenced world as coded output, as Kittler fears it does. For at least some of the contributors here software is techno-cultural politics.

The scale of this project however – the tricky slide from artwork to market, from tactic to strategic gesture – is worth thinking about. Software studies has a critical register which connects it to the earlier and more limited tactical media

project (see e.g. Lovinck and Fuller himself). However, the *Lexicon* certainly takes mainstream formations as its object of study and is thus distinguished from sub-cultural and activist studies of software cultures in scope, range, and ambition. There are interesting ways in which this line is walked. Fuller's computational turn demands a personnel shift, as well as a tighter focus on code. The job requirements for making the grade as a software studies person are possession of a 'two-way intelligence'. Declaring that software 'makes more sense understood transversally' (2008: 10), Fuller argues that the capacity to engage with code-based production and to engage with technicity of software through the 'tools of realist description' requires certain technical skills, alongside skills that come from disciplines at some distance from computer science and the contained project of realised instrumentality it prioritises (2008: 9). Less, perhaps, is required of technology, which is often portrayed here as more innocent than its users, and so, by reverse osmosis (from machine to human) technicians or computer scientists do not necessarily need to demonstrate the responding critical 'bent' in their work to expose various aspects of code's workings. In fact there are markedly fewer of the latter. The contributors, the doubly articulate elite, are for the most part cultural theorists, artists, writers, and humanities scholars. However, even given this unevenness, the *Lexicon* operates through a mixed language of enquiry – though not with a mixed gender bunch.

Partly through these machinations – which enable a mode of expansion – which if they don't replicate, nonetheless find some parallels with *Wired*'s capacity to encompass, in its early years, all hopes – software studies could be read as tactical media's bid for a grander field, and as radically optimistic.

Canonisation: (blessed are the cloud-makers?)

The writing objects explored here all raise questions of procedure and problems of theory in digital media and do so partly at least through processes of categorisation. Which brings me finally back to a very brief consideration not of canonical moves and categorising strategies, but of canonisers and strategisers. And here I return to one of the original ground-makers, Richard Barbrook, who discerned in writings on new media a Californian ideology that faced a European dystopia (Barbrook 1995). This isn't a fair division, but it was a smart one, and, thinking about these canon-formers, there is something of a division between the somewhat de-politicised formalism of some of the key North Americans involved here (Ryan and Hayles) which is in striking contrast to the avowedly critical approaches of (UK-based) Fuller. What Barbrook didn't say at the time, although perhaps it was implicit, was that the dystopian faction had certain difficulty engaging with the materials of that which railed against. To me, the computational turn, taking on board

materiality, critically requires, demands, needs, to retain a critical vision – and retool it.

So, in conclusion, here I have explored some of the dynamics involved in the computational turn, and in particular have focused on questions of borders – and their extension; categorisations – and their work; and canonicalism – and its claims. The moves considered here can be understood as moves to produce new taxonomies of new media. Arising in response to the extant body of work, they break divisions, as well as set up new ones. These categorising gestures (this is literature; this is code) require and invoke particular forms of engagement as appropriate – and disable others. In so doing they may also instigate disciplinary annexation bids – claims for the re-incorporation of what is perceived as new material into older disciplinary areas – or they may strengthen the case for new forms of post-disciplinary engagement.

In particular, consideration of the materiality not only of texts, but of the materialised engagements between bodies and machines that new media affords, might inaugurate new forms literary study – and they would be at some distance from Moretti's distant readings. However, the same dynamics might also signal the unmaking of a particular form of literature and the emergence of what (could be) various forms of a 'beyond text' or 'post'-humanities. This latter may not align with that other abused term the digital humanities. Indeed the fruit of the theoretical work considered in this piece might be that it provokes a demand to re-think, and, in material terms, what that term might entail or require.

Notes

1. Re-mapping as removal: a mode of stripping out. There is something concerning in the appropriation of situationalist tactics for methodological modeling (the instrumentalisation of the *derive*) by those studying human computer interaction, or the taming of (re-framing of) de Certeau's critique of commodification, Henry Jenkins and MIT where activity is valorised as mappable, joining in, making your mark, saying 'where you are at' when all about the opposite: the un-mappable marine immensity of submerged life.
2. It is useful in this context to note that this issue became one that much exercised those involved in Internet research, where the question of defining the in relation to texts or human subjects (raised elegantly by Kate O'Riordan and Liz Bassett for the AoIR in the mid-90s, and returned to recently at the OII), became attached to questions of (research) ethics, more broadly a question that had to be thought ethically Zylinksa.
3. Others agree. For instance Sadie Plant has argued that cultural studies exhibits a form of inter-disciplinarity that confirms rather than breaks boundaries. As a consequence it sets out to legitimate what is already known rather than exploring 'how and to what extent it is possible to think differently' (Plant 1996: 216).
4. This is why the Internet might be dead – as *Wired* recently proclaimed it was.

5. Scepticism about the usefulness of 2.0 is widespread (see e.g. *The Register* for an industry perspective).
6. The use of concepts of discontinuity, rupture, threshold, limit, series, and transformation present all historical analysis not only with questions of procedure, but with theoretical problems. It is these problems that will be studied here (Foucault 1972: 1).
7. Ann Freidberg's account of Windows as architectural components and metaphors, references this work – with the peculiar consequence that Microsoft comes to be central to a modern attempt at a certain re-enchantment of the world. It is the case that Bill Gates, of all people, was struck by the poetry of cables made of glass and sand, capable of carrying light (see *The Road Ahead*, 1996).
8. See also Andy Cameron's writing of the 1990s, which not only registered Cameron's doubts, but also the pessimism of professional multimedia enthusiasts/specialists about the prospects for the development of compelling tales on digital platforms.
9. As a product I.F/Electronic Literature certainly failed, but it also largely failed as a format. My take on this is that content mirrors the failure of material form. I.F. can operate on many digital platforms but it was designed with the closed world of the CD-ROM in mind. In splendid isolation, side-lined from the 'street' vigour of the Web, trapped in a world coded for infotainment, lacking the rigor of earlier movements' symbolic engagements with technology (for instance the modernism of the early twentieth century), and without the close-up 'artisanal' connection with digital material the also essentially avant garde digital productions such as the codework might offer (see below), it is, or at least was, stranded.
10. See, for instance, work by Jenny Sunden, Terry Harpold, and George Landow.
11. For the clones the known secret is that they live to die; for the humans (perhaps the rest of us) it is that they (or we) are medical cannibals.
12. This suggests a way in which larger narrative visualization projects (where the network, and the large-scale view of narrative patterning extends far beyond the end of the discrete text) might be re-articulated with the internal forms its 'dividual' parts take. 'Partner'ship works from two directions.

References

Aarseth, E. (1997), *Cybertext: Perspectives on Ergodic Literature* (Baltimore: Johns Hopkins University Press).
Aarseth, E. (2001), 'Computer Game Studies, Year One', *Game Studies* 1(1): 1–4.
Badmington, N. (2006), 'Posthumanities', in Clare Birchall and Gary Hall (eds), *New Cultural Studies: Adventures in Theory* (Edinburgh: Edinburgh University Press, 260—72).
Barbrook, R., and Cameron, A. (1995), 'The Californian Ideology', *Mute* 3 (Autumn): iv–v.
Bassett, C. (2010), 'Up the Garden Path: or How to get Smart in Public', *Second Nature* 2: 42—61. (http://secondnature.rmit.edu).
Bassett, C. (2007), *The Arc and the Machine* (Manchester: Manchester University Press).
Barbrook, R., and Cameron, A. (1995) 'The Californian Ideology', *Mute*, Issue 3, Autumn, iv-v.
Bassett, C. (2006), 'Cultural Studies and New Media: On Being Less Forgetful', in C. Birchall and G. Hall (eds), *New Cultural Studies, Adventures in Theory* (Edinburgh: Edinburgh University Press, 220–38).

Bassett, E., and O'Riordan, K. (2002), 'Ethics of Internet Research: Contesting the Human Subjects Research Model', *Ethics and Information Technology* 4(3): 233–47.

Bolter, J. D. and Grusin, R. (1999). *Remediation: Understanding New Media* (Cambridge, MA: MIT).

Cameron, A. (1995). 'Dissimulations: The Illusion of Interactivity', *Millennium Film Journal* 28: 32–48. (http//:wmin.ac.uk./media/vb/dissim.html).

Dawson, A. 'Introduction: New Enclosures', *New Formations*: 8–22.

Edwards, N. P. (2001), 'Think Piece – Making History: New Directions in Computer Historiography', *IEEE Annals of the History of Computing* 23(1): 88–94.

Friedberg, A. (2006), *The Virtual Window: From Alberti to Microsoft* (London: MIT Press).

Fuller, M. (2008), *Software Studies: A Lexicon* (London: MIT).

Foucault, M. (1972), *The Archaeology of Knowledge* (London: Routledge).

Galloway, A. (2004), 'Playing the Code: Allegories of Control in Civilization', *Radical Philosophy* 128: 33–40.

Gates, B., Myhrvold, N., and Rinearson, P. (1996), *The Road Ahead* (Harmondsworth: Penguin).

Grau, O. (2007). *Media Art Histories* (London: MIT Press).

Harwood, G. (1997), 'Interview', in B. Graham (ed.), *Serious Games* (London: Barbican Art Gallery, 38—41).

Hayles, N. K. (2008), *Electronic Literature: New Horizons for the Literary* (Notre Dame: Notre Dame Press).

Harwood, G. (1997), 'Interview', in B. Graham (ed.) *Serious Games*, (London, Barbican Art Gallery), 38–41.

Hayles, K. (2009), 'RFID: Human Agency and Meaning in Information Intensive Environments', *Theory Culture and Society* 26(2–3): 47–72.

Hermes, J. (2009), 'Media, Meaning and Everyday Life', in S. Thornham, C. Bassett, and P. Marris (eds), *Media Studies: A Reader*, 3rd edn (Edinburgh: Edinburgh University Press, 514–23).

Jenkins, H. (2004), 'The Cultural Logic of Media Convergence', *International Journal of Cultural Studies* 2004(7): 33–43.

Juul, J. (2001), 'Games Telling Stories? – A Brief Note on Games and Narratives', *Game Studies* 1(1). http://www.gamestudies.org/0101/juul-gts/.

Latour, B. (1996), *Aramis or the Love of Technology,* trans. Catherine Porter (Cambridge: Harvard University Press).

Latour, B. (1992), 'Where are the Missing Masses? Sociology of a Door', Bijker and Law (eds), *Shaping Technology/Building Society: Studies in Sociotechnical Change* (Cambridge, MA: MIT Press, 225–58).

Lister, M. (1995), *The Photographic Image in Digital Culture* (London: Routledge).

Mumford, L. (1946), *Technics and Civilization* (London: Routledge).

Moretti, F. (2009), 'Style, Inc. Reflections on Seven Thousand Titles (British Novels, 1740–1850)', *Critical Inquiry* 36: xx.

Plant, S. (1996), 'The Virtual Complexity of Culture', in Robertson, Mash, and Tickner (eds) *Futurenatural* (London: Routledge, 203–17).

Ryan, M.-L. (2006), *Avatars of Story* (Minnesota: University of Minnesota Press).

Selzer, M. (2009), 'Parlor Games: The Apriorization of the Media Mark Seltzer', *Critical Inquiry* X: 100–34.

Sterne, J. 'MP3 as Cultural Artifact', *New Media and Society* 8(5): 825–42.

Turner, F. (2006), *From Counterculture to Cyberculture: Stuart Brand, the Whole Earth Network, and the Rise of Digital Utopianism* (Chicago: University of Chicago Press).

Thornham, H. (2011), *Ethnographies of the Videogame: Gender, Narrative and Praxis* (London: Palgrave).

Williams, R. (1975), *Television: Technology and Cultural Form* (London: Fontana).

Zielinski, S. (2006), *Deep Time of the Media* (London: MIT Press).

Zylinska, J. (2009), *Bioethics in the Age of New Media* (London: MIT Press).

7
The Esthetics of Hidden Things

Scott Dexter

> '…drawers, chests, wardrobes. What psychology hides behind their locks and keys! They bear within themselves a kind of esthetics of hidden things.' – (Bachelard 1994: xxxvii)

On the slip

Katherine Hayles observes, 'Along with the hierarchical nature of codes goes a dynamic of concealing and revealing that operates in ways that have no parallel in speech and writing' (2005: 54). Hayles alludes to two examples of this dynamic. The first is to the 'essential practice' in software engineering of 'conceal[ing] code with which one is not immediately concerned' (2005: 54). The second example is, well, more revealing: '[R]evealing code when it is appropriate or desired also bestows significant advantage. The "reveal code" command in HTML documents…may illuminate the construction and intent of the work under study' (2005: 54). This essay unfolds in the space between concealing and revealing limned by these two examples.

Hayles' characterisation of revealing code, while generally accurate in its implications, itself conceals a double slip which simultaneously defines and textures my argument. Hayles first slips among hierarchies and layers of code when she locates the command 'in' HTML documents. From the perspective of someone sitting in front of a computer browsing the Web, it may not be clear 'where' this command is. As I browse, using Firefox version 3.6.12 for Ubuntu, I find this command available both in the browser's 'Edit' menu and in the menu which appears when I right-click in a displayed HTML document; the command is also executed when I use the control-u key combination. Is the command 'in' the document? Authors of HTML documents need not expend any extra effort to put this command 'in' their documents: their concern – their place in the hierarchy – is exclusively the content, structure, and behaviour of the document as it will be rendered by a browser application. HTML

authors know that these browser applications provide the dual functionality of displaying an HTML page in a more or less legible manner and also, if the reader wishes, of providing the HTML 'source'. Is the command 'in' the document? It would appear not.

But yet... Hayles knows that, 'One of the advantages of object-oriented languages is bundling code within an object so that the object becomes a more-or-less autonomous unit' (2005: 54). That is, object-oriented programming (of which more below) relies heavily on the metaphor of an 'object', which, roughly, is a collection of data and operations on that data which have been so closely associated (through particular syntactic strategies) as to be understood as a single entity. Firefox itself is written with a number of programming languages; two of the most heavily used (according to SfR Fresh 2010), C++ and Java, are object-oriented. From the perspective (layer) of Firefox programmers, the Firefox code represents an HTML document as an 'object', and with this document object is bundled the Firefox code responsible for displaying the HTML source. Is the command 'in' the document? From the Firefox programmer's perspective, yes. Thus Hayles has slipped an observation from the programmer's layer into a description of experience at the user's layer.

Hayles also slips, simultaneously, among the ever-lubricated layers and hierarchies of desire. For in fact the command in question is not 'reveal codes' but 'view source'. (The phrase 'reveal codes' is more closely associated with the WordPerfect word processor, beloved by many of its users largely because of this feature, which shows exactly how WordPerfect's formatting codes are interpolated among the text and allows them to be moved, deleted, and even themselves edited; see Acklen 2010.) This slip is an easy one to make, isn't it? We believe computers to be full of mysteries which might be revealed, if our desire for revelation is appropriate. We approach them as supplicants, preferring to request (do we truly believe we have the authority to 'command'?) revelation rather than to assert our right to view the source. Why? An accounting of the 'reveal code' dynamic may be part of what Matthew Fuller calls on 'speculative software' to do: 'What characterises speculative work in software is, first, the ability to operate reflexively upon itself and the condition of being software – to go where it is not supposed to go, to look behind the blip; to make visible the dynamics, structures, regimes, and drives of each of the little events which it connects to' (Fuller 2003: 32). Yet, as I aim to show, that which software purports to hide – that which it therefore might be compelled to make visible – is rarely what is actually hidden, is often already visible. To posit the existence of an arena where software is not supposed to go but which contains answers to questions which might be reflexively asked by software itself is to cede much ground indeed, to further mystify. This slip, these layers of desire for mystery, for open secrets, for the yielding of authority, are the primary generators of the esthetic of the hidden which suffuses modern computing.

As Rebecca Schneider reminds us, such slips are familiar and fertile ground for scholarship: 'Blind spots and slips of the tongue have long been granted an important role in excavating meaning' (Schneider 2006: 255). What Hayles slip reveals, I suggest, is that we need the workings of the computer to be hidden from us. In particular, we need the peculiarly human imperatives of the computer to be hidden. The signal defining characteristic of the modern computing device is that its hardware provides very little constraint on what it will do. Most of those constraints are provided instead by code produced by extremely fallible humans – this structure is exactly why ethicist James Moor characterises computers as 'malleable', and loads much ethical complexity onto that term. Yet most accounts of the limits – and potentials – of computing deny, more or less vociferously, the role of the embodied human in realising these limits and potentials.

In order to begin to retrieve this role of the human, in this essay I consider three intersecting arcs of theoretical and technological development within the history of computer science: Alan Turing's formulation, in the mid-1930s, of a theoretical model of a computing machine; the mechanisation of memory; and the rise of object-oriented programming. Each of these trajectories is marked both by a particular tension between the human and the machine and by a particular formation of the 'reveal code' dynamic. To study code is, indeed, to study layers, hierarchies, and the slippery meanings they imperfectly conceal and reveal. Through these interweaving developments I aim to illuminate something of the development of the 'reveal code' dynamic, examining the ways in which 'layers' in code structure and are structured by an esthetic of the hidden which inflects not only how we think about computation but what we are not able to think.

Abstracting the human

A few years ago, when very little had been heard of digital computers, it was possible to elicit much incredulity concerning them, if one mentioned their properties without describing their construction. (Turing 1950: 448)

In 1937 British mathematician Alan Turing published a fundamental result about the limitations of computation, several years before the creation of computing machines with the basic characteristics we today associate with computers (Turing 1937). While this result alone would have been enough to secure Turing's scholarly reputation, his career saw him making similarly significant contributions both to the British war effort by developing techniques for decrypting German communications and to the early development of modern electrical computers. He committed suicide at the age of 42, a year after concluding a year-long course of estrogen therapy which had been administered

being after he had been found guilty of 'gross indecency with a male person' (Hodges 1983).

The argument in Turing's 1937 paper relied on his development of an abstract notion of a computing machine. Turing had at his disposal a number of concrete models of machinic computation from which he could have abstracted, as the idea of mechanical computation already had a rich European history (see Goldstine [1992] for one treatment of the European history of mechanical computing from circa 1600). Yet he chose to abstract not from the various techniques of computation instantiated in these various machines, but rather from another well-developed scientific practice, that of human computation. As documented in David Alan Grier's *When Computers Were Human*, the term 'computer' designated someone who was employed to carry out mathematical computations from as early as 1765, when the British Admiralty funded Nevil Maskelyne to produce a celestial almanac using a staff of five computers (Grier 2005: 29). The practice continued and evolved, variously employing unemployed hairdressers, adolescent boys, women who had graduated college with mathematics degrees, and, near the end, when modern electromechanical computers were rendering human computing offices obsolete, shortly after World War II, 'the dispossessed...those who lacked the financial or social standing to pursue a scientific career....Women..., African Americans, Jews, the Irish, the handicapped, and the merely poor' (Grier 2005: 277).

In the process of developing his abstract computing machine, Turing guides the reader through a remarkably detailed analysis of the activity of a human computer. He begins by grounding the notion of machinic computation in the limits of human capacity: 'We have said that the computable numbers are those whose decimals are calculable by finite means. This requires rather more explicit definition....For the present I shall only say that the justification lies in the fact that the human memory is necessarily limited. We may compare a man in the process of computing a real number to a machine which is only capable of a finite number of conditions' (Turing 1937: 231). This limitation of human memory is overcome, in the case of the human computer, by using writing to augment and stabilise what is remembered: 'Some of the symbols written down will form the sequence of figures which is the decimal of the real number which is being computed. The others are just rough notes to "assist the memory"' (Turing 1937: 231–2). Thus the bulk of what is written in the course of a complex calculation, Turing emphasises, are disposable intermediate figures which only need be written because of the fallibility of human memory. As Jacques Le Goff has observed, this connection between calculation and memory was sedimented in European scientific practice as early as the seventeenth century, when '[t]he arithmetical machine invented by Pascal...added to the *faculty of memory* a *calculative faculty*' (Le Goff 1992: 91).

Turing completed his model of computation by observing, and then mechanising, the human process of computation: 'The behaviour of the [human] computer at any moment is determined by the symbols which he is observing, and his "state of mind" at that moment.... Let us imagine the operations performed by the computer to be split up into "simple operations" which are so elementary that it is not easy to imagine them further divided.... We may now construct a machine to do the work of this computer' (Turing 1937: 249–51).

Through his contributions to the war effort, Turing would become involved in designing and constructing some of the earliest electrical computing machines, machines which were to obscure the human roots of computation both through the Taylorist abstractions inherent in their design and through the eventual engineering of machine components which realised the potential for mechanisation to exceed some limits of human cognitive capacity.

Several years later, in a paper arguably as influential as his 1937 work on the limits of computation, Turing made another gesture towards what, and why, computation might conceal (Turing 1950). In this piece Turing adopts a nearly conversational tone to present some ideas on the question of whether machines might ever be said to think. In his opening gambit, Turing describes a parlour game in which an interrogator is trying to guess the genders of two contestants, a man and a woman, based solely on the nature of their responses to questions. Turing then presents a slightly more fanciful reformulation of this game in which the man/woman binary is replaced by the man/machine binary, and the question becomes whether the machine can fool the interrogator into believing the machine is human (if so, we would say that the machine has 'passed the Turing Test'). Of course concealment is a necessary part of the game, as Turing well recognised: 'The form in which we have set the problem reflects the... condition which prevents the interrogator from seeing or touching the other competitor, or hearing their voices' (Turing 1950: 434). Indeed, the specific technique for so preventing the interrogator from having such bodily knowledge is that 'the answers should be written, or better still, typewritten. The ideal arrangement is to have a teleprinter communicating between the two rooms' (1950: 434). As Tyler Curtain observes, this concealment, this 'neat disarticulation of physical indications of gender from the conditions of judgment about "intelligence"' has the ultimate effect of 'reseating gender firmly within "intelligence" itself' as gender, being made invisible through the mechanism of the test, instead becomes part of the 'world knowledge' any intelligent being should have (Curtain 1997: 142).

Thus, what began, in Turing's writings, as a mechanised simplification of the behaviours of human calculation has become a process by which, it is conceivable, all manner of human behaviours may be emulated. Yet, as Curtain suggests, in the act of assessing the verisimilitude of these emulations,

we necessarily slip as we inject a layer between the behaviours we consider suitable for emulation and the qualities of human-ness by which they are judged.

Memory and security

Memory is the storehouse and guardian of all things. (Cicero, *De Oratore* I, 5)

Turing's treatment of machine computation is by no means the first effort (however abstract) to overcome the limits of human cognition, most especially memory. Indeed, much of the technicisation of information has been aimed at overcoming perceived limitations of human memory and its related faculties. One set of limitations, of course, consists of those attached to human fallibility: capacity, accuracy and speed with information is both 'stored' and 'recalled'. As beautifully documented in Yates' *The Art of Memory* (1966), these were prime concerns of scholars through the medieval and Renaissance eras. A more interesting limitation is the *individuality* of human memory; as Jacques Le Goff points out, 'outside of writing mnesic activity is constant not only in societies without writing, but also in those that have it' (Le Goff 1992: 55). That is, the dynamic connection between individual memory and collective memory must always be tended to. Writing and subsequent technologies have both eased this connection and also made new problems manifest. For example, as Leroi-Gourhan observes, the revolution of the printing press can be understood as a revolution in memory: 'Readers not only obtained access to an enormous collective memory whose entire contents they could not possible register but were also frequently confronted with new material. A process of the exteriorisation of the individual memory then began to take place' (Leroi-Gourhan 1993: 261).

The individuality of memory is likely the root of the ancient and pervasive metaphor of information *storage*. While what we term 'information' has always been understood as ineffable, it has also been understood as something which may be stored – and, more specifically, hidden – through techniques and technologies of memory. As Caesar observed in his account of the Druids in Gaul, the difference in value and utility between writing and memory can be discerned by considering the problem of keeping secrets: while written language was understood to be superior for some purposes, human memory is one of the best repositories for the storage of secrets.

[The Druids] believe that religion forbids these courses to be written down, whereas for almost everything else, both public and private accounts, they use the Greek alphabet. They seem to me to have established this custom for two reasons: because they do not wish to divulge their doctrine, or to see their pupils neglect their memory by relying on writing. (Caesar, *Gallic Wars*, VI, 14, quoted in Le Goff 1992: 57)

In this ancient account, writing was problematic in some applications because it held the potential to expose secrets too broadly; yet in Turing's parlour games, writing – that is, the intervention of a 'teleprinter' between interrogator and contestants – is used to hide the secret 'identity' of the contestants. As we will see, modern technologies of memory substantially conflate the operations of writing and memory, generating multiple layers of anxiety about revelation and concealment.

The storehouse metaphor of memory is not without its critics, of course. Thomas Reid, criticising Locke's adaptation of the storehouse metaphor in *Essay* II.x. 1–2, observed,

> The analogy between memory and a repository…is obvious and is to be found in all languages, it being very natural to express the operations of the mind by images taken from things material. But in philosophy we ought to…view [the mind's operations] naked. When therefore memory is said to be a repository or store-house of ideas where they are laid up when not perceived and again brought forth when they are needed, I take this to be popular and rhetorical and figurative. For [Locke] tells us that when they are not perceived they are nothing and no where, and therefore can neither be laid up in a repository, nor drawn out of it. (Reid 1969: 368–9)

Nonetheless, as information technologies advanced throughout the nineteenth century, the metaphor of storage persisted, so that Charles Babbage was able, without any apparent hesitation, to describe his Analytical Engine as being comprised of

> [a] Store…considered as the place of deposit in which the numbers and quantities given by the…question are originally placed, in which all the intermediate results are provisionally preserved and in which at the termination all the required results are found. (Babbage 1837/1982: 23)

and a 'Mill in which all operations are performed' (Babbage 1837/1982: 19).

As actual computing machines were designed and enhanced after World War II, the dual metaphors of information storage and computer memory as analogue of human memory deepened and further entangled. John von Neumann, writing about the first 'stored program' computer (the EDVAC), described the utility of storing programs by observing, 'The instructions which govern a complicated problem may constitute a considerable material.…This material must be remembered' (von Neumann, 1945/1982, p. 383). Further, describing the computing mechanism of the EDVAC as a whole, von Neumann noted, 'The [central arithmetic unit, central control, and memory] correspond to the associative neurons in the human nervous system' (von Neumann 1945/1982: 384).

But in fact the mechanisation and successive miniaturisation of memory has rendered any perceived correspondence between machine memory and human memory fallacious. As discussed above, the dual role of human memory as protector of secrets and as source of individuation (to some extent, our self-understanding as individuals depends on the uniqueness and privacy of our memories) has long been understood. Mechanical memory, while improving on some limits of human memory, was not designed to guard secrets.

In Turing's abstract computing machine, 'memory' is conceived of as 'a "tape" (the analogue of paper) running through it, and divided into sections (called "squares") each capable of bearing a "symbol". At any moment there is just one square ... which is "in the machine".' (Turing 1937: 231).[1] The rest of the squares are, in principle, open to inspection and even alteration by entities outside the machine; indeed, in a subsequent paper (Turing 1939), Turing developed the notion of a kind of hypercomputation in which his machines were aided by an 'oracle' which was capable of instantaneously computing a function and writing the result on the tape.

Turing's notion of memory as a nominally linear collection of 'squares' which contain 'symbols' continues in heavy use, especially in pedagogical contexts. The 'Guide to Using Memory Diagrams' by Holliday and Luginbuhl (2004) is representative: in a 14-page document, the authors develop and explain a particular system for visualising, in an abstract yet rigorous way, the contents of memory at any point in the execution of a Java program. In this system, as is common, variables – the software analogue to material memory, where values are 'stored' and later retrieved – are represented by rectangles; the interior may contain a value (just as Turing's squares may bear symbols), and the exterior may sport labelling information such as the type of value expected to be stored (a character, or an integer, etc.). These snapshot-diagrams can be concatenated to form a 'memory evolution diagram' which may trace, explain, or document the operations of a program.

Such diagrams entail a complex of claims about the properties of computer memory amounting to a kind of theory of semi-permeability: memory compartments are passively transparent, most especially to the programmer but also to the program itself, yet the contents of these compartments shall only change when the program's instructions decree. But, as I outline below, mechanical memory lives up to none of these expectations.

Any materialisation of memory is certainly more volatile than Turing's abstraction; indeed, as the pioneering designers of computing machines realised, any physical system, such as 'storing electrical charges on a dielectric plate inside a cathode-ray tube' or 'acoustic feed-back delay lines' (Burks et al. 1947/1982: 403), will be inherently unreliable. John von Neumann expressed exactly these concerns regarding the design of the EDVAC: 'Malfunctioning of any device has ... always a finite probability – and for a complicated device and

a long sequence of operations it may not be possible to keep this probability negligible' (von Neumann 1945/1982: 383).

Modern DRAM (dynamic random access memory) technology is no exception to von Neumann's observation; it is remarkably sensitive to a variety of error-inducing conditions. According to a 2009 study, the likelihood of an 'event that leads to the logical state of one or multiple bits being read differently from how they were last written' (Schroeder 2009) is high enough to make memory hardware equipped with 'error correcting codes...crucial for reducing the large number of memory errors to a manageable number of uncorrectable errors'. Specifically, the study observes that computing installations which contain a large number of memory modules are so vulnerable to uncorrectable memory errors (the study reports a 0.22 per cent annual error rate per module) that additional protection mechanisms must be written into the software running on these computers. For example, a 'crash-tolerant application layer [is] indispensable for large-scale server farms' (Schroeder 2009).

If the contents of memory change 'unexpectedly', it is rare for cosmic rays to be named explicitly as the culprit; most computing practitioners are rather more inclined to blame some kind of error elsewhere in the system. Nonetheless, the casual assumption that each program, like an individual human, has an allocation of memory which it 'owns' and controls exclusively is, while completely wrong in many important respects, deeply pervasive to the point of being arguably the single largest source of software 'security' problems. As I show below, much effort has been expended in a quest to graft onto computer memory those desirable characteristics of human memory which were overlooked in the early quest for reliability, capacity, and speed of access. It is this quest to retrofit computer memory with these implicit desiderata which spawned many of the earliest (and deepest) layers underwriting the reveal code dynamic.

The idea of 'hiding' as an engineering strategy emerged in the computing world as both the growing complexity of computing tasks and the increasing heterogeneity of computer programmers and users put pressure on the transparent, permeable qualities of computer memory. In one influential presentation, Butler Lampson described the design of an operating system, Cal-TSS, which, in 1971, was one of the first to take on the challenge of augmenting computer memory. Lampson did not use the term 'hiding' in this paper, emphasising 'protection' instead, but the crucial role of hiding, in a very particular sense of the term, emerges clearly. Lampson begins by acknowledging the growing pressures: 'A considerable amount of bitter experience in the design of operating systems has been accumulated in the last few years, both by the designers of the systems which are currently in use and by those who have been forced to use them' (Lampson 1971: 423). The 'radical changes' which Lampson discusses are focused around 'a very powerful and general protection mechanism'. This mechanism is based on two ideas. The first is that 'an operating system should

be constructed in layers', where the purpose of the lower layers is to re-present the 'bare machine provided by the hardware manufacturer' as a collection of 'user machines' which are allowed to make use of the computer's resources 'in a controlled manner' (Lampson 1971: 423). The second idea is what Lampson calls 'enforced modularity... [in which] interactions between layers or modules can be forced to take place through defined paths only'. In particular, the system is designed so that 'no possible action of a higher layer, whether accidental or malicious, can affect the functioning of a lower one' (Lampson 1971: 424).

The specifics of the implementation of this system are not directly significant; what we have is a system which aims to allocate memory and other system resources to individual computational processes, enforcing this individuation through a programmed layering which both conceals the 'bare machine' and simultaneously blocks any process's effort to see or manipulate either the lower layers or another process's designated resources on the same layer. Of course, while this individuation is naturally occurring in human cognition, in the case of the computer it requires using 'powerful protection' and 'enforced interactions' to guard the vulnerability of the 'bare machine'. While Lampson acknowledges the possibility of 'malicious' action, there is little evidence that computing installations of the 1960s experienced security problems in the modern sense of the term. It is more likely that the system was designed to protect against 'accidental' action, as Cal-TSS was an early example of a 'time-sharing' system, able to serve up to 26 users (who also shared memory!) simultaneously.

A few years later, the Cambridge CAP computer sported many of these features in refined form. The system aimed to provide very tight control over how memory was accessed and utilised: 'The intention is that each module of program which is executed on the CAP shall have access to exactly and only that data which are required for correct functioning of the program. Access to a particular area of memory should never imply access to any other.' Further, computational processes were organised into an explicit hierarchy of privilege: 'The CAP also supports a hierarchical structure of processes, of such a nature that the position of a process in the hierarchy determines the resources available to it' (Needham and Walker 1977: 1).

At roughly the same time, a general notion of 'information hiding' as a programming practice was being developed and articulated by David Parnas, whose 1972 paper gave the first published use of the term 'information hiding'. As Parnas notes, 'The flowchart was a useful abstraction for systems with on the order of 5,000–10,000 instructions, but as we move beyond that it does not appear to be sufficient; something additional is needed' (p. 1056). Instead, Parnas proposes designing programs in such a way that each module 'is characterized by its knowledge of a design decision which it hides from all others. Its interface or definition [is] chosen to reveal as little as possible about its inner workings' (Parnas 1972: 1056). Again, the motivating factor is that the simple

models in place in the earliest days of computing seemed to be succumbing to demands of increased heterogeneity and complexity.

Parnas enumerates the virtues of his mode of program design and decomposition as improved 'changeability', 'independent development', and 'comprehensibility', while Lampson and Needham and Walker emphasise the 'flexibility' and 'reliability' of a system based on protection and layering. Thus, the first efforts to implement 'hiding', which also manifested as 'protection' and, soon, 'security', amounted to strategies for implementing a kind of individuation in which the human capacity to hide knowledge from all others was simulated by layers of software on top of a fundamentally transparent memory.

Although it may seem that systems designers of the 1970s had solved this problem of transparent memory, it continues to be at the core of our contemporary understanding of computer and software security. As the authors of *Building Secure Software*, one of the first compendia of tools and techniques, assert, 'Behind every computer security problem and malicious attack lies a common enemy – bad software' (Viega and McGraw 2002: 1). While Viega and McGraw successfully demonstrate that software may contain an astonishing variety of faulty assumptions about software's users and environments, it turns out that ultimately what 'software security' is trying to prevent is the appearance in memory of data which has either been manipulated by a program other than the one who 'owns' that of memory, or which has properties other than the ones anticipated by the programmer.

Viega and McGraw detail many subtle mechanisms by which an attacker could gain access to and privileges on a computer, but the two most common, and most fundamental, mechanisms rely on being permitted to insert unexpected data (typically, code masquerading as data) in unexpected memory locations. The first is when data is transferred into memory from an input source: '[Some] security vulnerabilities boil down to bad assumptions about trust. Usually, trust problems manifest when taking input of any sort. This is mostly because it is often possible to craft malicious input to have deleterious side effects' (Viega and Mcgraw 2002: 308). The second is known as a 'buffer overflow'; in this scenario, a designated storage area in memory (a 'buffer') is made to hold more data than it has capacity to store, with the result that the overflow is written into adjacent memory locations. Even though this overflow memory space is 'owned' by the same process which owns the buffer, it is relatively straightforward to use this overflow condition to gain extra/illicit system privileges.[2]

Much of the layering which characterises modern computing, then, arises from the yet-unsolved problems of memory. As I will show below, as these layers continue to deepen with the introduction of more expressive, metaphor-driven programming languages, and as these languages debut new strategies to simulate memory which is 'private', exclusively owned and controlled by one 'individual', the urge to treat machine calculations anthropomorphically also rises.

Towards autonomous objects

Instead of a bit-grinding processor raping and plundering data structures, we have a universe of well-behaved objects that courteously ask each other to carry out their various desires. (Ingalls, 1981)

At present, the dominant metaphor for software development is *object-oriented programming* (OOP). This metaphor is dually grounded in technical consider-ations of programming security and effectiveness and in claims about human cognition. Dan Ingalls, one of the core designers of the early object-oriented language Smalltalk, suggests that the object metaphor is based on a fundamen-tal cognitive operation:

> The mind observes a vast universe of experience, both immediate and recorded. ... [I]f one wishes to participate, literally to take a part, in the uni-verse, one must draw distinctions. In so doing one identifies an object in the universe, and simultaneously all the rest becomes not-that-object. ... [W]e can associate a unique identifier with an object and, from that time on, only the mention of that identifier is necessary to refer to the original object. (Ingalls 1981)

While the designers of Smalltalk were strongly motivated by recent develop-ments in the understanding of human cognition (for example, they paid close attention to the work of Piaget, Papert, and Montessori), they were equally motivated by technical challenges, especially those arising from increasing complexity. As Alan Kay, one of the lead developers, explains, they were moti-vated to 'qualitatively improve the efficiency of modeling ... ever more complex dynamic systems', in particular to 'find a better module scheme for complex systems involving hiding of details' (Kay 1993: 3–4).

The metaphor of 'object' was introduced with the 1967 version of the program-ming language Simula. In an autobiographical reflection on the development of Simula, Ole-Johan Dahl, one of its two designers, notes that, 'The most import-ant new concept of Simula 67 is surely the idea of data structures with associated operators ... called objects. ... Clearly, in order to enforce the use of abstract object views, read access to variable attributes would also have to be prevented' (Dahl 2004: 7). The object metaphor, then, offers an explicit structure for determining which parts of memory should be hidden; sustaining the object metaphor requires a high degree of abstraction away from the open memory of the bare machine, so the programming language must offer mechanisms for preventing the 'variable attributes' (i.e. the data) of an object from being read by other objects.

This mechanism was initially only an aspiration: 'A main aspect of security' was the intention that the language would allow programmers to design objects

specifying which data elements would be 'invisible' to other objects except through programmer-defined means; these specifications were to be enforced when the program was translated (compiled) into executable form, with the translator refusing to complete its work if any of the Simula code attempted to transgress the programmer-specified object boundaries. For example, 'In a model containing "customers" and "clerks" the active agent would need access to its own data as well as those of [a "customer" object] during "service"' (Nygaard and Dahl 1981: 448–9). The nature of this concern about security is much more about enforcing the metaphor of the individual than about reining in rogue programmers. Indeed, it is foolish to deploy the information-hiding mechanisms of object-oriented languages towards achieving protection against malicious agents; while a translated program will respect information-hiding boundaries, knowledgeable and motivated programmers could in many cases 'link in' other, less well-behaved translated code and circumvent the compiler's checks (Viega & McGraw 2002: 53).

In Smalltalk, which was influenced in its early stages both by the design of Simula and by the work of Butler Lampson and David Parnas cited above, the idea of 'hiding' is purified to such an extent that it needs not be made explicit: 'The last thing you wanted any programmer to do is mess with internal state even if presented figuratively' (Kay 1993: 25). In Smalltalk, computation is refigured as a recursive conversation among message-passing objects. These objects are ' "shiny" and impervious to attack' (Kay: 20) – nothing about their internal condition is available to other objects, friend or foe, in the computational system.

This anthropomorphic view of programs and computation is one of the most remarkable characteristics of object-oriented programming. Rather than viewing a computational process as a sequence of calculational steps, in which a faint echo of the original human computers may be heard, the object-oriented metaphor posits a model of computation in which objects compute by actively – nearly autonomously – passing messages among themselves. This understanding of computation effectively amounts to a vision of a new social order within computation of 'well-behaved', even 'courteous', objects which act from their 'desires'. As a result of the Smalltalk design process, the vulnerability of the bare machine has finally been completely cocooned, it would seem, by a technological evolution which comes closest yet to providing human-like individuation among a community of computing and communicating processes.

While the 1967 version of Simula was the first language to implement the concept of 'object', the designers' aspirations for security did not explicitly develop into a proto-anthropomorphic perspective until several years later. In Dahl's account, 'There is an important difference, except in trivial cases, between *the inside view* of an object, understood in terms of local variables... and implemented procedures operating on the variables..., and *the outside view*. This difference... underlies much of our program designs from an early time on,

although not usually conscious and certainly not explicitly formulated [until several years later]' (Dahl 2004: 7). Based on this explicit formulation, subsequent versions of Simula compiler included keywords 'hidden' and 'protected' which could be used by the programmer to indicate that selected attributes could not be accessed by other objects.

OOP's anthropomorphic perspective may also arise from its roots in simulation, as Simula was from its very early stages intended to study, through simulation, various systems and processes involving humans: 'the basic concepts of SIMULA [in 1963] were: (1) A system, consisting of a finite and fixed number of *active* components named *stations*, and a finite, but possibly variable number of *passive* components named *customers*' (Nygaard and Dahl 1981: 443).[3]

Nygaard and Dahl (the co-designers of Simula) provide some example code from this early phase of Simula's development, showing the manner in which an air passenger is abstracted into a passive 'customer' component which consumes a random amount of time at the service counter before being sent on either to passport control or payment:

system Airport Departure := arrivals, counter, fee collector, control, lobby;
customer passenger (fee paid) [500]; **Boolean** fee paid;
station counter;

> **begin** accept (passenger) select:
>
> > (first) if none: (exit);
>
> hold (normal (2, 0.2));
>
> route (passenger) to:
>
> (**if** fee paid **then** control **else** fee collector)
>
> end;

station fee collector, etc.

The analogy between the object-based model of computation and a sort of social order deepened with Bjarne Stroustrup's development of the language C++, which drew on some ideas developed in Simula and, more importantly, on Stroustrup's experiences with the Cambridge CAP computer. 'The notions of protection from the Cambridge CAP computer and similar systems – rather than any work in programming languages – inspired the C++ protection mechanisms. ... By default, all information is *private*. Access is granted by declaring a function in the *public* part of a ... declaration, or by specifying a function ... as a *friend*' (Stroustrup 1993: 14; emphasis added). With C++, objects are graced with a potential social life rivalling that of the most hardened computer programmer.

Thus, the reveal/conceal dynamic of code traverses a number of related binaries – hidden/shown, inside/outside, and, ultimately, public/private – as various imperatives provoked their creation. Lamport, and then Stroustrup,

needed to protect the machine from processes which violated the crude individuality marked out in the allocation of memory. For Nygaard and Dahl, the tacit recognition of inside/outside yielded an explicit formulation of 'hidden' only after a mathematical abstraction – paralleling Turing's original abstraction – made clear the nature of the boundary. And in Smalltalk, the emphasis, deriving from both Lamport and from Parnas's characterisation of the utility to programmers of 'information hiding', is on highly abstract communicating objects whose organisation approaches the social. Within each of these binaries is another: the tension between denying and yearning towards the human.

On the slip

> *There will always be more things in a closed, than in an open, box. To verify images kills them, and it is always more enriching to* imagine *than to* experience. *The action of the secret passes continually from the hider of things to the hider of self.* (Bachelard 1994: 88)

If we're lucky, the slip itself may slip from being a momentary enquiry to a mode of enquiry: 'certain moments in our collective thinking have encouraged us to lean toward a rigor that utilizes the slip, a scholarship not only of the slip but on the slip, one that emulates as well as excavates the slip for the ways of knowing a slip might allow' (Schneider 2006: 255). Hayles expresses concern that '[t]he 'reveal code' dynamic helps to create expectations … in which … layered hierarchical structure … reinforces and is reinforced by the worldview of computation' (2005: 55). But a richer 'reveal code dynamic' might become available if we move onto the slip. The meaning of code – that code even *has* meaning – is far from clear: does it not need to interact, as it executes, with humans, or at least data? The view that, 'Finally, a computer program only has one meaning: what it does. … Its entire meaning is its function' (Rosenberger 1997), as articulated by programmer Ellen Ullman, is widely shared by programmers and other scholars. Can the static text of a program, ultimately just a bunch of instructions which might not even qualify as 'text', as it sits awaiting its apotheosis as executing program, have anything meaningful to tell us? Such a question risks opening up 'something diffuse, something slippery, something akin to … hollowness, lack, excess, misfiring, error, or even void' (Schneider 2006: 255).

Actually hiding things in software is hard: this is such a fundamental truth, at least from a technical perspective, that Viega and McGraw enshrine it as 'Principle 8: Remember That Hiding Secrets Is Hard' (2002: 109). Even the tactic of hiding secrets in the pure binary of machine code is doomed to failure, as 'it is very easy to acquire and use reverse-engineering tools that can turn

standard machine code into something much easier to digest...enough effort can reveal any secret you try to hide in your code' (2002: 73).

This, then, is part of the esthetics of the hidden which structures code: to call something 'hidden', either in the imperative mode of code or in the prescriptive mode of engineering practice, is not to hide but to make some other mark. This kind of hiding is not a vertical tactic but a horizontal one; to be hidden-from is to be adjacent-to. Objects may assert their privacy, but to programmers they are still but bare machines – or, at the level of machine code, boundaries between objects dissolve into collective memory. To hide is to stratify through (imperfect) individuation.

Yet, of course, something *is* hidden. Looking 'downward' these layers conceal little perhaps. The keyword 'hidden' is used not only in the (now somewhat archaic) Simula language, but also in the (less archaic) Common Gateway Interface (CGI) for allowing webservers to delegate webpage generation to other applications. Webpages which pass data to a CGI application may contain fields designated as 'hidden'. But 'hidden fields are not meant for security (since anyone can see them), but just for passing session information to and from forms transparently' (Guelich et al. 2000). The hidden is transparent. But looking upward is inconceivable: this is another part of the esthetics of the hidden. The one who says to hide is hidden; 'hidden' denies the one who can see.

Ghosting this essay, hidden to a greater or lesser extent, is Eve Kosofsky Sedgwick, who exhorts us to move beyond fundamentally paranoid reading practices: '[I]t is possible that the very productive critical habits embodied in what Paul Ricoeur memorably called the "hermeneutics of suspicion"...may have made it less rather than more possible to unpack the local, contingent relations between any given piece of knowledge and its narrative/epistemological entailments for the seeker, knower, or teller' (Sedgwick 1997: 4). This hermeneutics demonstrates a strong affinity for guile, concealment, mystification, for code: 'the fundamental category of consciousness is the relation hidden-shown...the distinguishing characteristic...is the general hypothesis concerning both the process of false consciousness and the method of deciphering' (Ricoeur 34–5, qtd in Sedgwick, 1997, p. 5). The relation hidden-shown is an enormously unstable one when it comes to code, though it nonetheless contains remarkable psychological power to inhibit the unpacking of relations between code and its entailments for anyone who seeks it. When we acknowledge the open secrets of code, we find, I suspect, something very queer indeed.

Acknowledgements

I am grateful for the interlocution, and other constructive interventions, of Karl Steel, Mobina Hashmi, Federica Frabetti, and Amy E. Hughes.

Notes

1. As Turing goes on to point out, the machine's memory also inheres, to some extent, in its current state: 'The "scanned symbol" is the only one of which the machine is, so to speak, "directly aware". However, by altering its [state] the machine can effectively remember some of the symbols which it has "seen" (scanned) previously.' (Turing 1937: 231). My focus here, though, is 'recorded' memory.
2. Since the publication of Viega and McGraw's book, other types of security flaws based on memory vulnerabilities have come to light. For example, in 2007, Jonathan Afek and Adi Sharabani produced the first public account (Afek and Sharabani 2007) of a 'dangling pointer' bug which could be used to attack the Microsoft IIS web-server.
3. Nygaard and Dahl anachronistically identify customers as 'objects' in their discussion; the 'network' and 'process' metaphors provided structure during the initial course of the language's design, with 'object' introduced in 1967.

References

Acklen, L. (2010), 'Getting the Most out of Reveal Codes in WordPerfect'. http://www.corel.com/servlet/Satellite/us/en/Content/1153321168468.

Afek, J. and Sharabani, A. (2007), 'Dangling Pointer: Smashing the Pointer for Fun and Profit'. http://www.blackhat.com/presentations/bh-usa-07/Afek/Whitepaper/bh-usa-07-afek-WP.pdf.

Babbage, C. (1837/1982), 'On the Mathematical Powers of the Calculating Engine', in B. Randell (ed.), *The Origins of Digital Computers: Selected Papers*, 3rd edn (Berlin/Heidelberg/New York: Springer-Verlag).

Bachelard, G. (1994), *The Poetics of Space* (Boston: Beacon Press).

Burks, A.W., Goldstine, H. H., and von Neumann, J. (1947/1982), 'Preliminary Discussion of the Logical Design of an Electronic Computing Instrument', in B. Randell (ed.), *The Origins of Digital Computers: Selected Papers*, 3rd edn (Berlin/Heidelberg/New York: Springer-Verlag).

Curtain, T. (1997), 'The "Sinister Fruitiness" of Machines: *Neuromancer*, Internet Sexuality, and the Turing Test', in E. K. Sedgwick (ed.), *Novel Gazing: Queer Readings in Fiction* (Durham, NC: Duke University Press).

Dahl, O. J. (2004), 'The Birth of Object Orientation: The Simula Languages', in . O. Owe, S. Krogdahl, and T. Lyche (eds), *From Object-Orientation to Formal Methods: Essays in Memory of Ole-Johan Dahl,* LNCS 2635 (Berlin/Heidelberg/New York: Springer Verlag, 15–25). http://www.olejohandahl.info/papers/Birth-of-S.pdf

Fuller, M. (2003), *Behind the Blip: Essays on the Culture of Software* (Brooklyn: Autonomedia).

Goldstine, H. H. (1992), *The Computer from Pascal to von Neumann* (Princeton: Princeton University Press).

Grier, D. A. (2005), *When Computers Were Human* (Princeton: Princeton University Press).

Guelich, S., Gundavaram, S., and Birznieks, G. (2000), *CGI Programming with Perl*, 2nd edn. http://docstore.mik.ua/orelly/linux/cgi/index.htm (O'Reilly & Associates).

Hayles, N. K. (2005), *My Mother Was a Computer: Digital Subjects and Literary Texts* (Chicago: University of Chicago Press).

Hodges, A. (1983), *Alan Turing: The Enigma* (New York: Simon & Schuster).

Holliday, M. and Luginbuhl, D. (2004), 'A Guide to Using Memory Diagrams'. http://paws.wcu.edu/holliday/LectureNotes/150/MemoryDiagramGuide.pdf.

Ingalls, D. H. H. (1981), 'Design Principles behind Smalltalk', *BYTE Magazine*, August. http://stephane.ducasse.free.fr/FreeBooks/BlueBookHughes/Design%20Principles%20Behind%20Smalltalk.pdf.

Lampson, B. W. (1971), 'On Reliable and Extendible Operating Systems', *The Fourth Generation: Infotech State of the Art Report 1*, 421–44. http://research.microsoft.com/en-us/um/people/blampson/07-ReliableOS/07-ReliableOSInfotech.pdf.

LeRoi-Gourhan, A. (1993), *Gesture and Speech* (Cambridge, MA: MIT Press).

Kay, A. (1993), 'The Early History of Smalltalk', *ACM SIGPLAN Notices* 28(3): 1–54.

Le Goff, J. (1992), *History and Memory*, trans. Steven Renjdall and Elizabeth Claman (New York: Columbia University Press).

Needham, R. M. and Walker, R. D. H. (1977), 'The Cambridge CAP Computer and Its Protection System', *Proceedings of Sixth ACM Symposium on Operating Systems Principles*, 1–10.

Normand, E. (1996), 'Single Event Upset at Ground Level', *IEEE Transactions on Nuclear Science* 43: 2742–50.

Nygaard, K. and Dahl, O.-J. (1981), 'The History of the SIMULA Languages', in R. Wexelblat (ed.), *History of Programming Languages* (Waltham, MA: Academic Press, Inc.).

Parnas, D. L. (1972), 'On the Criteria to Be Used in Decomposing Systems into Modules', *Communications of the ACM* 15(12): 1053–8.

Reid, T. (1969), *Essay on the Intellectual Powers of Man* (Cambridge, MA: MIT Press).

Rosenberger, S. (1997), 'Elegance and Entropy: Ellen Ullman talks about what makes programmers tick'. http://www.salon.com/technology/feature/1997/10/09/interview/index.html.

Schneider, R. (2006), 'Intermediality, Infelicity, and Scholarship on the Slip', *Theatre Survey* 47(2): 253–60.

Schroeder, B., Pinheiro, E. and Weber, W.-D. (2009), 'DRAM Errors in the Wild: A Large-Scale Field Study', *Sigmetrics/Performance 2009*. http://www.cs.toronto.edu/~bianca/papers/sigmetrics09.pdf.

Sedgwick, E. K. (1997), 'Paranoid Reading and Reparative Reading; or, You're So Paranoid, You Probably Think This Introduction Is about You', in E. K. Sedgwick [ed.], *Novel Gazing: Queer Readings in Fiction* (Durham, NC: Duke University Press).

SfR Fresh. (2010), 'CLOC Analysis of FireFox-4.0b7.source.tar.gz'. http://www.sfr-fresh.com/linux/misc/firefox-4.0b7.source.tar.gz/cloc.html.

Stroustrup, B. (1993), 'A History of C++: 1979–1991', *Proceedings of the ACM History of Programming Languages Conference (HOPL-2)*. http://www.research.att.com/~bs/hopl2.pdf.

Turing, A. (1937), 'On Computable Numbers, with an Application to the Entscheidungsproblem', *Proceedings of the London Mathematical Society* s2–42(1): 230–65.

Turing, A. (1939), 'Systems of Logic Based on Ordinals', *Proceedings of the London Mathematical Society* 45: 161–228.

Turing, A. (1950), 'Computing Machinery and Intelligence', *Mind* 59: 433–60.

Viega, J., and Mcgraw, G. (2002), *Building Secure Software: How to Avoid Security Problems the Right Way* (Boston: Addison Wesley Longman).

von Neumann, J. (1945/1982) 'First Draft of a Report on the EDVAC, Contract No. W-670-ORD-4926' in B. Randell (ed.), *The Origins of Digital Computers: Selected Papers*, 3rd edn (Berlin/Heidelberg/New York: Springer-Verlag).

Yates, F. (1966), *The Art of Memory* (Chicago: The University of Chicago Press).

8
The Meaning and the Mining of Legal Texts

Mireille Hildebrandt

Introduction

Positive law, inscribed in legal texts, entails an authority not inherent in literary texts, generating legal consequences that can have real effects on a person's life and liberty. The interpretation of legal texts, necessarily a normative undertaking, resists the mechanical application of rules, though still requiring a measure of predictability, coherence with other relevant legal norms, and compliance with constitutional safeguards. The present proliferation of legal texts on the Internet (codes, statutes, judgements, treaties, doctrinal treatises) renders the selection of relevant texts and cases next to impossible. We may expect that systems to mine these texts to find arguments that support one's case, as well as expert systems that support the decision-making process of courts, will end up doing much of the work.

This raises the question of the difference between human interpretation and computational pattern-recognition and the issue of whether this matters for the meaning of law. Possibly data mining will produce patterns that disclose habits of the minds of judges and legislators that would have otherwise gone unnoticed (possibly reinforcing the argument of the 'legal realists' at the beginning of the 20th century). Also, after the data analysis it will still be up to the judge to decide how to interpret the results of data-mining operations or up to the prosecution which patterns to engage in the construction of evidence (requiring a hermeneutics of computational patterns instead of texts). My focus in this paper concerns the fact that the mining process necessarily disambiguates the legal texts in order to transform them into a machine-readable data set, while the algorithms used for the analysis embody a strategy that will co-determine the outcome of the patterns. There is a major due process concern here to the extent that these patterns are invisible to the naked human eye and will not be contestable in a court of law, due to their hidden complexity and computational nature.

This chapter aims to explain what is at stake in the computational turn with regard to legal texts. I will start with a discussion of the meaning of law, highlighting its embodiment in the technologies of the script, and the hermeneutic implications this has for legal expertise and for legal certainty. Next, I will briefly investigate to what extent the law can be understood in terms of calculation and measurement, to prepare for an analysis of pattern recognition as a tool to mine the overload of legal texts. Various methods to automate legal interpretation will be discussed, such as production rules, case-based reasoners, neural nets, alternative logic-based systems and their combination. I will explain and emphasise the significance of the normative bias that informs law in a constitutional democracy, raising the issue of how this bias can be sustained or reinvented with the use of data-mining technologies. Acknowledging that pattern recognition by machines will not replace interpretation but require lawyers to interpret the findings of machine learning and other techniques of not-reading, I will discuss the recommendations that Sculley and Pasanek developed with regard to the assumptions of data-mining schemes. Their recommendations seem pivotal for legal practitioners and researchers, providing a measure of protection against unwarranted deference to hegemonic legal knowledge systems. Finally I will relate this to the notion of due process, seeking ways to un-hide the complexity involved in data-mining operations, in order to open the results of computational 'knowledge' to the scrutiny of lawyers, legislators and citizens.

The meaning of law

Legal scholarship and legal science

It is interesting to note that legal *scholars* often think of law as part of the humanities (Dworkin 1991; White 1990), whereas others – who prefer to call themselves legal *scientists* – lay claim to law as part the social sciences (Ulen 2002). In fact, the attribution to either domain can have serious consequences, for instance in the Netherlands where legal research grant applications must be submitted to the social science department of the national agency for the funding of scientific research (NWO). The decision on funding legal research is thus made by a jury consisting mostly of psychologists and other empirical scientists, many of whom believe in the priority of quantitative methods and all of whom seem engrossed in a methodological granularity that is atypical for legal research.

The primacy of text and the anticipation of legal effect

The *practice* of law, however, seems engrossed in a hermeneutical approach to legal texts, being simultaneously confronted with the ambiguity that is inherent in natural language and with the need for legal certainty (Dworkin 1982).[1]

According to a hermeneutical legal approach, interpretation and context deter-
mine the meaning of the applicable legal text with regard to the case at hand,
while the meaning of the case at hand is determined by the relevant legal text.
This circle is not necessarily vicious, nor can it be avoided by stipulating that
interpretation is forbidden. For instance the Roman Emperor Justinian pro-
hibited commentaries when he 'enacted' what has later been called the *Corpus
Iuris* of Roman law, but the attempt failed even during his own reign (Glenn
2007: 138; Merryman 2007: 58). Though the circularity of the interpretation of
a legal case and that of the relevant legal text is unavoidable and, in fact, pro-
ductive, it does highlight the tension between norm and decision, raising the
question to what extent a norm is reinterpreted and changed due to a decision
on its application and to what extent a decision is constrained by the norm that
is expected to regulate it. Legal theory has some awareness that decisions often
posit the norm that rules them. We could start quoting Wittgenstein (2009)
and Taylor (1995) here, on what it means to follow a rule, or immerse ourselves
in the debate between renowned legal philosophers like Schmitt (2005), Kelsen
(2005), and Radbruch (1950) on the priority of normativity or decisionism.
In times of emergency these debates can be enlightening, for instance when
privacy and security are opposed as incompatible social goods, demanding
unrestricted discretionary powers to monitor citizens and to intervene in their
lives unhindered by constitutional legal norms (Hildebrandt 2010; Lyon 2007).
These debates are interesting and may be relevant for our topic, particularly
where the computational turn in the humanities launches an entirely new
field of questions and issues. In fact the process of interpretation is *confronted
with* and may even be *replaced by* computational processes of pattern recogni-
tion. One could, for example, venture the question of whether computational
machines are better at making decisions in case of an emergency – having
more powers to compute and being less hindered by emotional or subjective
bias.[2] In this chapter I will focus on the difference between interpreting text
and interpreting the results of data mining, but I want to emphasise that in the
case of legal texts interpretations may have legal effect and thus always antici-
pate decision-making.

Legal effect and the sources of the law

Before further enquiring into the meaning of the mining of legal texts, I want
to draw the reader's attention to an important legal notion, namely that of
'the sources of the law'. A source in this sense is not a mere resource or heur-
istic, but constitutes a restricted set of binding written and unwritten legal
materials. Generally speaking, in a modern legal system, the sources of the law
can be summed up as codes and statutes, court judgements, legally binding
international treaties, doctrinal treatises, and legal principles. The restricted
concept of 'the sources of the law' relates to the need for a final establishment

of legal consequences. The legal adage of *litis finiri oportet* states that the legal struggle should come to an end, implying that at some point legal certainty is a good in itself, despite the fact that one can disagree about the justice of the outcome (Radbruch 1950; Leawoods 2000).[3] To achieve closure in a legal setting, the arguments that can be used are limited to those grounded in the authoritative legal sources. The legal norms 'mined' from these sources must be interpreted in a way that guarantees the overall coherence of the legal system as well as their compliance with constitutional safeguards. As one may guess, the assumption of coherence and constitutional compliance cannot be understood as something to be taken for granted. Rather, this assumption is a productive one that requires lawyers ever and again to taste and turn different interpretations of the facts of the case and of the relevant legal norm, until they have a 'solution' that fits and adjusts the system in a manner consistent with what Montesquieu once called 'the spirit of the laws'.[4]

The normativity of legal texts

Legal texts thus entail an authority not inherent in literary texts, enabling them to generate legal effect, entailing major consequences for a person's life and liberty. Their interpretation is necessarily a normative undertaking, in the sense of defying a mere mechanical application of legal rules. The normativity of this undertaking must, however, not be confused with moralism. It rather refers to what Dworkin (1991) has called the integrity of the law, which goes one step further than mere consistency. Whereas consistency can be understood as defined by the logic of non-contradiction, integrity adds a measure of discretion that is typical for judgement, as compared to mere application, though in the legal context this discretion cannot be used in an arbitrary fashion. Dworkin argues that judgement must be exercised by 'mining' the principles and policies that implicitly inform the relevant body of law, and he claims that such principles signify the moral dimension of the law. Though this position has raised many critiques (e.g. Fish 1987) it does at least aim to avoid the Scylla and Charybdis of mechanistic logic, subjectivist voluntarism, and neutral instrumentalism. In a constitutional democracy law is more and less than logic; it cannot be equated with arbitrary decisionism and must avoid being a mere instrument of those in authority. The need for re-iterant textual interpretation, that is, the close reading of codes and cases within the 'interpretive community' (Fish 1987) of professional lawyers, induces what has recently been coined as slow reading (Carr 2010; Miedema 2009), the mindful hesitation about the correct application of the law by the courts (Latour 2010), as well as the agonistic or adversarial structure of the legal process. All this nourishes a legal tradition that values practical wisdom based on human experience over mere logical rigor (Holmes 1991: 1); it prompts the inter-subjective tasting and testing of legal opinion and thereby establishes the legal profession as a

buffer between those in authority and those held to account by the law. In a sense, the autonomy of the law thus depends on the distantiation brought about by the need to interpret the proliferating mass of legal texts (Ricoeur and Thompsom 1981; Geisler 1985).

Not-reading of legal texts

This raises the question of how data-mining operations on legal texts could contribute to our understanding of the law. Will they provide the final proof of what legal realists and critical legal studies have claimed all along: that the interpretation of legal texts is far more subjective, arbitrary, and/or related to power struggles than legal scholars like to assume (Kennedy 2004)? Will it uncover correlations between whatever a judge had for breakfast and the outcome of his decision-making process, or will it uncover correlations between the vested interests of the ruling class and the content of the law? Or will it correlate attributes of particular cases with their outcome, thus providing a new type of legal certainty, based on a statistical prognosis of what courts will decide? Oliver Wendell Holmes (renowned legal realist and U.S. Supreme Court justice) contended that 'the prophecies of what the courts will do in fact, and nothing more pretentious, are what I mean by the law' (Holmes 1897: 461). Will the anticipation he alludes to be brought to perfection by the data mining of court verdicts? Or might it be that Holmes' pragmatism was closer to a hermeneutic understanding of law than some would have it?

Measurabilities

How does the law cope with measurability? Can we measure the lawfulness or even the justice of a verdict? Is causality a matter of either/or, or must we accept gradations of some action being the cause of an event? Could data mining reveal a granularity of wrongfulness, instead of merely judging an action to be wrongful under the circumstances of the case? Is culpability a matter of yes/no, or must we develop machine-readable criteria to calculate the precise extent of a person's guilt? Can punishment be calculated in precise measure to the causality, wrongfulness, and culpability of an action? Or rather should we calculate the type and measure of punishment in accordance with its effectiveness, as inferred from data-mining operations on the fusion of databases containing verdicts with data bases containing the post-conviction behaviours of offenders (recidivism)? Actuarial justice practices have sprung up during the past decades, pretending that such calculations provide reliable knowledge (Feeley and Simon 1994). Interesting debates have erupted about the attribution of tort liability for toxic waste or occupational diseases where only epidemiological inferences are available, providing evidence in probabilistic terms that cannot be pinned down to individual cases (Poulter 1993; Custers 2004).

Similarly, criticism has been formulated of actuarial knowledge claims used in the fields of policing (determining who should be monitored) and sentencing (determining who is calculated to be unresponsive to any form of treatment) (Harcourt 2007). One may even expect that cognitive science – also in the thrift of a computational turn – will at some point produce knowledge claims as to the measure of freedom a person has to comply with the law, taking into account her calculated brain behaviours and/or morphology (Libet, Freeman, and Sutherland 1999).

Debates on the issue of determinism (as claimed by some cognitive scientists) and voluntarism (the assumed foundation of criminal liability) proliferate (Morse 2008). Both compatibilists – who consider the whole debate the result of a category mistake – and incompatibilists – who often reject scientistic determinism on the mere ground that it would be undesirable – claim final solutions to such existential problems as to whether responsibility presumes freedom or whether, on the contrary, a measure of freedom is born from being forced to give an account of oneself (Butler 2005).

What strikes me as an important concern here is the question of what it means to translate the flux of real-life events into discrete silicon inscriptions, as well as the question of what actually happens when such discrete inscriptions are manipulated to generate patterns in data bases. Could the visualisation – another translation – of data-mining processes (e.g. dynamically, also showing the development and transformation of the patterns mined) help us to come to terms with the meaning and significance of these patterns? Maybe such visualisation requires a novel hermeneutics, for example building on a semiotics that does not equate a sign with a letter, acknowledging different ways of 'reading' texts, images, movements, and life events.

From hermeneutics to pattern recognition?

The mining of legal texts: a plurality of methods and their assumptions

Let us now return to the issue of proliferating legal texts and the need to involve machine-learning technologies to select relevant texts or to predict the outcome of a case. In a salient overview of legal-knowledge-based systems, Aikenhead (1995) discussed attempts to automate legal reasoning on the basis of artificial intelligence (AI).[5] He distinguished between using production rules, case-based reasoners, neural nets, and fuzzy, deontic, and non-monotonic logic-based systems.

Production rules

With regard to production rules, Aikenhead finds that they try to capture legal reasoning in terms of the application of 'the rules stored in the system, by satisfying the clauses of the production rules', which boils down to a naive

understanding of legal reasoning, 'only subscribed to by extreme legal positivists' (1995). The problem is how the systems determine whether a case falls within the scope of a rule, what the system will do if no rule seems to apply, and what happens if multiple rules apply that apparently lead to different incompatible outcomes.

Case-based reasoners

Case-based reasoners do not depend on pre-existing rules but argue from previous solutions to new situations, providing 'an "argument" as to why the solution should occur, highlight weak points... and indicate what likely responses the opposition will raise'. Here the problem is that the systems must be capable of determining that different cases are similar enough to apply analogous reasoning, which is the baseline of case-based reasoners. To solve this problem the case must be broken down into pre-defined 'factors' that can be compared across different cases to calculate their similarity. In pre-defining these 'factors' the designers of the system will have to disambiguate the various aspects of cases, after which all subsequent cases will have to be reduced to compilations of precisely these factors. Aikenhead speaks of 'only a crude approximation of analogical reasoning'.

Neural nets

Neural nets do better in the sense that they are capable of pattern recognition in a less deterministic manner. Whereas case-based reasoners depend on classifications defined by the designer of the system, neural nets will come up with the classifications on the basis of, for example, clustering of text fragments, allowing the user to train the system to recognise relevant segments and sequences. Here the disadvantage is that the neural net cannot explain or justify its outcome, since the process of generating an outcome is basically a black box.

Alternative logic-based systems

The alternative logic-based systems, building on fuzzy, deontic, and defeasible or non-monotonic logic, had not been sufficiently explored as yet (in 1995), but seem to suffer from similar problems as those described above. To achieve any kind of result the relevant legal texts (case law, statutes) must be translated into machine-readable data, split up and/or tagged to allow their manipulation. This splitting assumes a qualification of parts (sentences, words, phrases, interpunction) that is not obvious.

Combined mining methods

Presently various methods have been combined to achieve better results, for instance neural nets with fuzzy logic (Hollatz 1999). Methods such as

unsupervised neural networks for clustering of similar texts within an archive of legal texts supposedly provide self-organising maps capable of classifying legal documents, based on automatic analysis of text corpora and semi-automatic generation of document descriptions (Merkl and Schweighofer 1997). Natural language processing (NLP) techniques to perform linguistic annotation using XML-based tools and a combination of rule-based and statistical methods are used to correlate between linguistic features of sentences in legal texts and the argumentative roles they play. This provides for automatic summarisation of legal texts (Grover, Hachey, et al. 2003). Case-based reasoning architectures are used to enhance the relevance of jurisprudence research in databases of legal decisions (Grover, Hachey et al. 2003). Combinations of case-based reasoning and extracting information from legal texts provide somewhat successful predictions of the outcome of cases based on similar facts. This allows computer systems to 'support reasoning by analogy, presenting alternative reasonable arguments, and generating testable legal predictions' (Ashley and Brüninghaus 2009: 126).

The significance of a constitutive normative bias

Aikenhead notes that in human society 'any similarity perceived between situations depends on the context in which the situations are viewed', while an analogy also depends on 'moulding the analogy made in a direction desired for the outcome of an argument'. He observes that

> The way that an analogy is manipulated depends on its context, on one's viewpoint and the outcome that one wants to achieve. ... In this sense, similarities, dissimilarities, classifications and thus the existence of analogies is made and not found.

As the French would say: '*les faits sont faits*'. This is an important observation. It confirms crucial findings in cognitive science about our 'bounded rationality' (Kahneman 2003) and the impact of emotion on sound decision-making (Damasio 2003). *Bien étonnés de se trouver ensemble,*[6] these findings seem to align with long-standing insights within continental philosophy about the illusionary nature of the liberal human subject (Butler 2005; Hildebrandt 2011). Our thoughts and actions are constrained by inferences that play out below the threshold of consciousness, beyond the grasp of rational calculations. Such findings and insights, however, do not necessarily imply that autonomy is an illusion or that we must admit to being irrational machines. Quite the contrary, they highlight the productive nature of a normative bias and the need to reflect and review our normative inclinations as part of a fragile but all the more important dimension of human society. Bias, in this light, is not something to be overcome, but a touchstone that should be under scrutiny to fine-tune or even disrupt the direction it implies. This scrutiny, in turn, must

not be understood as entailing an objectivist view from nowhere, but neither must it be downplayed as a subjectivist illusion. Legal practice has developed ways and means to scrutinise the normative bias of constitutional democracy, notably by producing a measure of legal certainty in the face of reiterant contestation. Legal interpretation will therefore require a multiplicity of overlapping methods to flesh out various types of bias, in order to prevent hegemonic claims to 'objective' findings. The point is not to get lost in sterile debates on subjectivism but to acknowledge the normative underpinnings of law in a constitutional democracy without taking them for granted.

Distant reading and not-reading: reinventing normative bias

Data mining of legal texts in order to classify them for instant retrieval, analogous reasoning, or prediction seems to require distant reading (Moretti 2005) in the sense of the not-reading of legal texts (Clement, Steger, et al. 2008). Clearly the focus here is not on mere information retrieval, based on simple indexing on the basis of word frequency, which has been around for many decades. Instead we are concerned with software machines capable of detecting patterns in legal texts that should help practicing lawyers to argue their case or to help legal scholars to develop, attune, or reject doctrinal theories about specific legal issues. Rather than painstakingly reading one's way into a mass of individual cases to see how codes and statutes are interpreted, helped by legal treatises on the relevant legal doctrine, the developers of the inference machines discussed above hope that they will at some point provide a more immediate oversight regarding whatever may be the factual and legal issues at stake.

 My question is how such a computational overview differs from the hands-on close reading of legal texts that has informed the legal profession ever since the script and especially the printing press took over from orality (Collins and Skover 1992; Eisenstein 2005; Glenn 2004; Hildebrandt 2008; Ong 1982). Assuming that data mining of legal texts will be a tool to select which cases or codes must be read in more detail, we must investigate what difference the process of 'not-reading' makes to the subsequent reading of texts deemed relevant by the knowledge discovery in databases (KDD) expert system. With the upsurge of printed material in the fifteenth to seventeenth centuries, the legal profession developed a monopoly on the interpretation of legal texts. This monopoly in fact contributed to the relative autonomy of the law in relation to both morality and politics (Berman 1983; Koschaker 1997). In the context of modern legal systems the practice of law involves the elaboration and maintenance of a normative bias that negotiates the often competing demands of legal certainty, justice, and the purposiveness of the law (Radbruch 1950; Leawoods 2000). Lawyers are used to this negotiation, aimed at creating and sustaining the coherence and integrity of the legal system and this aim stands for a kind of normative bias on which modern law depends. Further enquiry is warranted into how pattern recognition relates

to this normative bias. To what extent will KDD expose gross inconsistencies, hidden and unjustified discrimination, and previously invisible ineffectiveness, whereas traditional legal practice obfuscates inconsistencies, injustice, and counterproductive patterns by 'reading' patterns into the chain of decisions that realign them in the direction of legal certainty, equality, and purposiveness? Does machine learning imply that the normative bias of modern law is integrated in the process of knowledge discovery? Or must we instead believe that KDD in itself should be neutral, whereas the interpretation of its results will 'add' the required normative test? Will there perhaps be invisible – possibly unintended – biases based on the assumptions that are inevitably embodied in the algorithms that generate the patterns. Most importantly, the mining of legal texts confronts us with the issue of how we (lawyers, legislators, and citizens) may get our finger behind those assumptions, especially if they are protected as trade secrets or by intellectual property rights?[7]

... and back?

In a salient article on 'Meaning and Mining: the Impact of Implicit Assumptions in Data Mining for the Humanities' – that inspired the title of this paper – Sculley and Pasanek (2008) discuss some of the assumptions that inform data-mining schemes. Notably they point out that: (1) machine learning assumes that the distribution of the probabilistic behaviour of a data set does not change over time, whereas much of the work done in the humanities is based on small samples that do not pretend such fixed distribution (focusing on change and ambiguity rather than invariance over the course of time); (2) machine learning assumes a well-defined hypothesis space because otherwise generalisation to novel data would not work, (3) for machine learning to come up with valid predictions or discoveries the data that are being mined must be well represented, avoiding inadequate simplifications, distortions, or procedural artefacts; (4) machine learning may assume that there is one best algorithm to achieve the one best interpretation of the data, but this is never the case in practice, as demonstrated by the 'No Free Lunch Theorem' (which says there is no data-mining method without an experimenter bias).[8] To illustrate their point they develop a series of data-mining strategies to test Lakoff's claim about there being a correlation between the use of metaphor and political affiliation, both via various types of hypothesis testing (supervised learning methods) and via various types of clustering (unsupervised learning methods). They conclude that:

> Where we had hoped to explain or understand those larger structures within which an individual text has meaning in the first place, we find ourselves acting once again as interpreters. The confusion matrix, authored in part by

the classifier, is a new text, albeit a strange sort of texts, one that sends us back to those text it purports to be about. (*idem* 2008: 12).

In fact they continue:

> Machine learning delivers new texts – trees, graphs, and scatter-grams – that are not any easier to make sense of than the original texts used to make them. The critic who is not concerned to establish the deep structure of a genre or validate a correlation between metaphor and ideology, will delight in the proliferation of unstable, ambiguous texts. The referral of meaning from one computer-generated instance to the next is fully Derridean. (*idem* 2008: 17).

This seems a very apt pointer for the meaning and mining of legal text. Instead of taking the 'trees, graphs, and scatter-grams' of KDD that can be mined from legal texts at face value or discarding them as irrelevant, the results of automated analysis could invite legal scholars to reconsider their established opinion, to uproot their preconceptions, and to engage with novel ambiguities. To achieve this Sculley and Pasanek provide five recommendations for Best Practice, which could serve as an appetiser to develop similar constraints for the data mining of legal texts. First, the collaborative effort of computer engineers and lawyers who sit down together to mine legal data bases should focus on making their assumptions about the scope, function and meaning of the relevant legal texts explicit. Second, they should use multiple representations and methodologies, thus providing for a plurality of mining strategies that will most probably result in destabilising any monopoly on the interpretation of the legal domain. Third, all trials should be reported instead of 'cherry-picking' those results that confirm the experimenters' bias. As they suggest, at some point failed experiments can reveal more than supposedly successful ones. This is particularly important in a legal setting, because the legal framework of constitutional democracy should prevent individual outliers and minority positions from being overruled by dominant frames of interpretation. Fourth, in a legal setting the public interest requires transparency about the data and the methods used to make the data-mining operations verifiable by other joint ventures of lawyers and software engineers. This connects to their fifth recommendation, regarding the peer review of the methodologies used. The historical artifact of a legal system that is relatively autonomous in regard to both morality and politics and safeguarded by an independent judiciary, has been nourished by an active class of legal scholars and practitioners willing to test and contest the claimed truth of mainstream legal doctrine. Only a similarly detailed and agonistic scrutiny of the results of data-mining operations can sustain the fragile negotiations of the rule of law.

Legal scrutiny, due process, and visual analytics

Scrutinising the mining strategies of legal practitioners can be seen as an important contribution to due process. Due process, in the narrow sense, derives from the U.S. Constitution that grants citizens the right not 'to be deprived of life, liberty, or property without due process of law' (fifth and fourteenth amendments). The European Convention of Human Rights (ECHR) has a similar right to a fair trial in article 6. In this narrow sense due process regards citizens' rights of contestation in case of governmental interference with fundamental rights such as property (civil law) and liberty (criminal law). In relation to the mining of legal text, due process would signify the effective right to contest a specific interpretation of the law (Citron 2007). For such a right to be effective in the era of not-reading of legal texts, lawyers should develop a *curiosity for* and a *serious interest in* the 'intestines' of the data-mining process. To the extent that KDD technologies will be used to determine the substance of legal obligations, this kind of scrutiny should indeed become part of a lawyer's professional and academic training.

There is also another due process concern, which regards a citizen's understanding of how her actions will be interpreted in a court of law and her right to contest the determination of guilt or liability in court. Though our legal systems – especially in a continental setting where jury trials are not the standard way to hold court – depend heavily on the expertise of legal counsel, I believe that the legitimacy as well as the effectiveness of the legal process also depends on a party's capacity to understand how she is being judged. To grasp the standards against which her actions are measured, a citizen too must be empowered to 'read' and scrutinise the data-mining techniques that co-determined the outcome of her case.

Even if autonomous legal knowledge systems are not presently used to argue a case, we may expect something like that to happen in the not-too-distant future. One way of disclosing how the mining of legal texts has influenced the reasoning of the courts could be to employ some form of visual analytics (Pike, Stasko, et al. 2009). If such techniques can for instance present a dynamic visual display of jurisprudential developments citizens can be invited to participate in the scrutiny of knowledge construction technologies that could have a substantial legal effect on their lives. This might offer an attractive way of not-reading 'the path of the law' (Holmes 1897), enabling a demonstration of how different algorithms will yield alternative 'paths'.

Concluding remarks

Though dreams of artificial agents that replace our human judges have not come true, a variety of legal knowledge systems is emerging, capable of pattern

recognition in the mass of proliferating legal texts. Considering the amount of legal texts that will be available online, we may expect an urgent need for techniques that provide summaries, cluster similar cases or codes, deliver classifications of relevant factual and legal elements, or predict the outcome of new cases with some measure of accuracy. Though lawyers may embrace or resist such automation for a number of good and bad reasons, the domain of what was once called jurimetrics should not be left to those fond of calculating, formal logic, and computer science. Those using these systems (practicing lawyers, legal scholars) should be provided with the means to interpret the results and to contest their relevance and validity, while those who will be affected by the outcome of these automations should be provided with the interfaces that allow them to scrutinise and contest these outcomes.

Sculley and Pasanek formulated a set of five recommendations for a critical appraisal of the data mining of literary texts. These recommendations could be further developed and adapted to the context of legal texts. First, assumptions about the scope, function, and meaning of the relevant legal texts should be made explicit. Second, a multiplicity of representations and methodologies must be used to prevent the appearance of objectivity that is so often attached to computing. Third, when developing a legal knowledge system all trials should be reported, whether they confirm or refute a designer's original expectations. Fourth, the public interest requires transparency about the data and the methods used. Fifth, a sustained dialogue about different mining methods should enrich doctrinal debates. I would add a sixth recommendation that requires legal theory and legal and political philosophy to engage with the implications of the not-reading of legal texts. Instead of deferring to data scientists or resisting any kind of automation, there is an urgent need for research into the epistemological, practical and political implications of different types of mining methods.

Notes

1. Cf. Latour (2010) on the practice of the law, based on his intriguing ethnography of the French Conseil d'Etat. Though he would probably avoid terms like hermeneutics, his account, for example, highlights the crucial role played by the file in a legal procedure that is deeply immersed within the French civil law tradition. On the role of the file see also Vismann (2008).
2. Cognitive psychology has recently found that whereas consciously we are no match for the computational powers of machines to solve complex puzzles, unconsciously we do a much better job (Dijksterhuis 2006). This is thought to be due to the need for emotional bias as a precondition for sound decision-making (Damasio 2003) and due to our unconscious capacities to develop shortcuts to effective behaviours (Gigerenzer 2007).
3. This need for closure is typical for modern legal systems. In societies without a state the absence of a monopoly on violence pre-empts such closure, requiring negotiations

and mediation to settle a dispute and to prevent, for example, revenge or feud. Cf. Glenn (2007: chap. 3), Berman (1983: chap.1), Salas (1992: 60–67).

4. Montesquieu (1912, I.3): 'I have not separated the political from the civil institutions, as I do not pretend to treat of laws, but of their spirit; and as this spirit consists in the various relations which the laws may bear to different objects, it is not so much my business to follow the natural order of laws as that of these relations and objects'. This may require a Herculean effort (Dworkin 1991, Leenes 1998) and according to some authors it presupposes the 'one right answer thesis' (see also Dickson 2010).

5. Aikenhead observes that these kinds of systems have often been developed for the purpose of automating legal reasoning, hoping to develop machines that can deter-mine legal solutions. He notes that although no such automation has been achieved, AI techniques are valuable for automating various office tasks as well as 'in providing insights about the nature of law'. See similarly Solum (1991). Relevant caveats for automated justice can be found in Gutwirth (1993) and Citron (2007).

6. Surprised to find themselves together.

7. In principle a business that develops legal knowledge systems can keep the source code of the software a secret or protect it by means of copyright or patent, depend-ing on the relevant jurisdiction. This implies that the appliance is a black box for the user, who may easily be persuaded that the resulting legal opinion is based on 'sound' statistical evidence.

8. See http://www.no-free-lunch.org/ for an overview of 'no free lunch theorems'. Cf. Giraud-Carrier and Provost (2005).

References

Aikenhead, M. (1995), 'Legal Knowledge-Based Systems: Some Observations on the Future', *Web Journal of Current Legal Issues*. http://webjcli.ncl.ac.uk/articles2/aiken2.html.

Ashley, K., and Brüninghaus, S. (2009), 'Automatically classifying case texts and predict-ing outcomes', *Artificial Intelligence and Law* 17(2): 125–165.

Berman, H. J. (1983), *Law and Revolution: The Formation of the Western Legal Tradition* (Cambridge, MA and London: Harvard University Press).

Butler, J. (2005), *Giving an Account of Oneself*, 1st edn (New York: Fordham University Press).

Carr, N. (2010), *The Shallows: What the Internet Is Doing to Our Brains* (New York: W. W. Norton).

Clement, T. S., et al. (2009), 'How Not to Read a Million Books', paper presented at the Seminar on the History of the Book, Rutgers University, New Brunswick, NJ, 5 March 5 ==2009, available at: http://www3.isrl.illinois.edu/~unsworth/hownot2read.rutgers. html.

Citron, C. K. (2007), 'Technological due process', *Washington University Law Review* 85: 1249–313.

Collins, R., and Skover, D. (1992), 'Paratexts', *Stanford Law Review* 44: 509–52.

Custers, B. (2004), *The Power of Knowledge: Ethical, Legal, and Technological Aspects of Data Mining and Group Profiling in Epidemiology* (Nijmegen, NL: Wolf Legal Publishers).

Damasio, A. R. (2003), *Looking for Spinoza: Joy, Sorrow, and the Feeling Brain* (Orlando, FL: Harcourt).

Dickson, J. (Spring 2010 Edition) 'Interpretation and Coherence in Legal Reasoning', in *The Stanford Encyclopedia of Philosophy*, available at http://plato.stanford.edu/archives/ spr2010/entries/legal-reas-interpret/.

Dijksterhuis, A., and van Olden, Z. (2006), 'On the Benefits of Thinking Unconsciously: Unconscious Thought Can Increase Post-Choice Satisfaction', *Journal of Experimental Social Psychology* 42: 627–31.

Dworkin, R. (1982), 'Law as Interpretation', *Texas Law Review* 60: 527–50.

R. Dworkin (1991), *Law's Empire* (Glasgow: Fontana).

Eisenstein, E. (2005), *The Printing Revolution in Early Modern Europe,* 2nd edn (Cambridge/New York, Cambridge University Press).

Feeley M., and Simon, J. (1994), 'Actuarial Justice: The Emerging New Criminal Law' in D. Nelken (ed.), *The Futures of Criminology* (London: Sage), 173–201.

Fish, S. (1987), 'Still Wrong after All These Years', *Law and Philosophy* 6: 401–18.

Geisler, D. M. (1985), 'Modern Interpretation Theory and Competitive Forensics: Understanding Hermeneutic Text', *The National Forensic Journal* III: 71–9.

Gigerenzer, G. (2007), *Gut Feelings: The Intelligence of the Unconscious* (New York: Viking).

Giraud-Carrier, C., and Provost, F. (2005), 'Toward a Justification of Meta-Learning: Is the No Free Lunch Theorem a Show-Stopper?' in *Proceedings of the ICML Workshop on Meta-Learning* (Bonn), 9–16, available at http://dml.cs.byu.edu/~cgc/pubs/ICML2005WS.pdf.

Glenn, H. P. (2007), *Legal Traditions of the World*, 3rd edn (Oxford: Oxford University Press).

Grover, C., Hachey, B., and Korycinski, C. (2003), 'Summarising Legal Texts: Sentential Tense and Argumentative Roles', in *Proceedings of the HLT-NAACL 03 on Text Summarization Workshop – Volume 5* (Morristown, NJ: Association for Computational Linguistics).

Gutwirth, S. (1993), 'Waarhedenpluralisme, recht en juridische expertsystemen. Een verkenning', in R. de Corte (ed.), *Automatisering van de juridische besluitvorming* (Ghent, BE: Mys & Breesch): 125–48.

Harcourt, B. E. (2007), *Against Prediction: Profiling, Policing, and Punishing in an Actuarial Age* (Chicago: University of Chicago Press).

Hildebrandt, M. (2008), 'A Vision of Ambient Law', in R. Brownsword and K. Yeung (eds), *Regulating Technologies: Legal Futures, Regulatory Frames and Technological Fixes* (Oxford: Hart Publishing).

M. Hildebrandt (2010), 'The Indeterminacy of an Emergency: Challenges to Criminal Jurisdiction in Constitutional Democracy', *Criminal Law and Philosophy* 4(2), 161–181.

M. Hildebrandt (2011), 'Autonomic and Autonomous "Thinking": Preconditions for Criminal Accountability', in: M. Hildebrandt and A. Rouvroy, Law, Human Agency and Autonomic Computing. The Philosophy of Law Meets the Philosophy of Technology (Abingdon: Routledge).

Hollatz, J. (1999), 'Analogy Making in Legal Reasoning with Neural Networks and Fuzzy Logic', *Artificial Intelligence and Law* 7: 289–301.

Holmes, O. W. (1897), 'The Path of the Law', *Harvard Law Review* 10(8): 457–78.

O.W. Holmes ([1881] 1991), *The Common Law* (New York: Dover Publications).

Kahneman, D. (2003), 'Maps of Bounded Rationality: Psychology for Behavioral Economics', *The American Economic Review* 93: 1449–75.

Kelsen, H. (2005), *Pure Theory of Law* (Clark, NJ, Lawbook Exchange).

Kennedy, D. (2004), 'The Disenchantment of Logically Formal Legal Rationality, or Max Weber's Sociology in the Genealogy of the Contemporary Mode of Western Legal Thought', *Hastings Law Journal* 555: 1031–76.

Koschaker, P. (1966), *Europa und das römische Recht,* 4th edn (Munich-Berlin).

Leawoods, H. (2000), 'Gustav Radbruch: An Extraordinary Legal Philosopher', *Journal of Law and Policy* 2: 489–516.

Libet, B., Freeman, A., and Sutherland, K. (1999), *The Volitional Brain: Towards a Neuroscience of Free Will* [Journal of Consciousness Studies] (Thorverton, UK: Imprint Academic).

Lyon, D. (2007), 'Surveillance, Security and Social Sorting', *International Criminal Justice Review* 17: 161–70

Merkl, D. and Schweighofer, E. (1997), 'En Route to Data Mining in Legal Text Corpora: Clustering, Neural Computation, and International Treaties', in *Proceedings of the Eighth International Workshop on Database and Expert Systems Applications* (IEEE): 465–70.

Merryman, J. H., and Pérez-Perdomo, R. (2007), *The Civil Law Tradition: An Introduction to the Legal Systems of Europe and Latin America* 3rd edn (Stanford, CA: Stanford University Press).

Miedema, J. (2009), *Slow Reading* (Duluth, MN: Litwin Books).

Montesquieu, C. de Secondat, Nugent, T., and Prichard, J. V. (1912), *The Spirit of the Laws,* 2 vols (New York/London: Appleton).

Moretti, F. (2005), *Graphs, Maps, Trees: Abstract Models for a Literary History* (London: Verso).

Morse, S. J. (2008), 'Determinism and the Death of Folk Psychology: Two Challenges to Responsibility from Neuroscience', *Minnesota Journal of Law Science & Technology* 9: 1–35.

Ong, W. (1982), *Orality and Literacy: The Technologizing of the Word* (London/New York: Methuen).

Pike, W. A., et al. (2009), 'The Science of Interaction', *Information Visualization* 8: 263–74.

Poulter, S. R. (1993), 'Science and Toxic Torts: Is There a Rational Solution to the Problem Of Causation?' *High Technology Law Journal* 7: 189.

Radbruch, G. (1950), *Rechtsphilosophie*, Erik Wolf, ed. (Stuttgart: Koehler).

Ricœur, P., and Thompson, J. B. (1981), *Hermeneutics and the Human Sciences: Essays on Language, Action, and Interpretation* (Cambridge, UK/New York/Paris: Cambridge University Press).

Salas, D. (1992), *Du procès pénal. Eléments pour une théorie interdisciplinaire du procès* (Paris: Presses Universitaires de France).

Schmitt, C. (2005), *Political Theology: Four Chapters on the Concept of Sovereignty* (Chicago: University of Chicago Press).

Sculley, D., and Pasanek, B. M. (2008), 'Meaning and Mining: The Impact of Implicit Assumptions in Data Mining for the Humanities', *Literary and Linguistic Computing* 23(4): 409–24.

Solum, L. B. (1992) 'Legal personhood for artificial intelligences', *North Carolina Law Review* 70: 1231–87.

Taylor, C. (1995), 'To Follow a Rule' in *idem, Philosophical Arguments* (Cambridge, MA: Harvard University Press), 165–81.

Ulen, T. S. (2002), 'A Nobel Prize in Legal Science: Theory, Empirical Work, and the Scientific Method in the Study of Law', *University of Illinois Law Review*: 875—920.

White, J. B. (1990), *Justice as Translation: An Essay in Cultural and Legal Criticism* (Chicago: University of Chicago Press).

Vismann, C., and Winthrop-Young, G. (2008), *Files: Law and Media Technology* (Stanford, CA: Stanford University Press).

Wittgenstein, L., et al. (2009), *Philosophical Investigations* (Malden, MA: Wiley-Blackwell).

9
Have the Humanities Always Been Digital? For an Understanding of the 'Digital Humanities' in the Context of Originary Technicity

Federica Frabetti

This chapter is situated at the margins of what has become known as 'digital humanities', that is, a discipline that applies computational methods of investigation to literary texts. Its aim is to suggest a new, somewhat different take on the relationship between the humanities and digitality by putting forward the following proposition: if the digital humanities encompass the study of software, writing and code, then they need to critically investigate the role of digitality in constituting the very concepts of the 'humanities' and the human. In other words, I want to suggest that a deep understanding of the mutual co-constitution of technology and the human is needed as an essential part of any work undertaken within the digital humanities. I will draw on the concept of 'originary technicity' (Stiegler 1998, 2009; Derrida 1976, 1994; Beardsworth 1995, 1996) and on my own recent research into software as a form of writing – research that can be considered part of the (also emerging) field of Software Studies/Code Studies – to demonstrate how a deconstructive reading of software and code can shed light on the mutual co-constitution of the digital and the human. I will also investigate what consequences such a reading can have – not just for the 'humanities' and for media and cultural studies but also for the very concept of disciplinarity.

I look at the emerging field of the digital humanities from what might be considered somehow a marginal perspective. The digital humanities are generally understood as embracing all those scholarly activities that involve using techniques and methodologies drawn from computer science (image processing, data visualisation, network analysis) to produce new ways of understanding and approaching humanities texts. The disciplinary boundaries of the digital humanities are sometimes broadened to include the practices of writing about

digital media and technology as well as being engaged in processes of digital media production (e.g. developing new media theory, creating interactive electronic literature, building online databases and wikis). And yet, my aim with this chapter is to suggest a new, somewhat different take on the relationship between the humanities and digitality by putting forward the following proposition: if the digital humanities encompass the study of software, writing, and code, then they need to critically investigate the role of digitality in constituting the very concepts of the 'humanities' and the human. In other words, I want to suggest that a deep understanding of the mutual co-constitution of technology (including digital technology) and the human is needed as an essential part of any work undertaken within the digital humanities.

With the expression 'the mutual co-constitution of technology and the human', I am referring to the alternative, non-Aristotelian tradition of thought on technology that starts with Martin Heidegger and includes Jacques Derrida (1976, 1994) and Bernard Stiegler (1998, 2009), among others. Timothy Clark (2000) calls this the tradition of 'originary technicity' – a term he borrows from Richard Beardsworth (1996). These thinkers have deeply criticised the Aristotelian concept of technology as a tool (something that humans deploy for their own ends), by observing how the human itself is always already constituted in relation to its own technologies (be they a stone implement, language, writing, or the digital computer). It could be said that the term 'originary technicity' assumes a paradoxical character only if one remains within the instrumental understanding of technology; if technology were instrumental, it could not be originary – that is, constitutive of the human. Thus the concept of 'originary technicity' resists the utilitarian conception of technology. The thinkers of 'originary technicity' point out that technology is actually constitutive of knowledge, culture, and even philosophy, since, by providing the support for the inscription of memory, it allows for transcendence and therefore for thought.

Thus, by emphasising the mutual co-constitution of the human and the technical, I mean to suggest that the digital humanities need to engage with the concept of the 'digital' at a much deeper level than the instrumental one. Surely, the digital is not something that can just be added to the field of the humanities as we know it. On the contrary, the pivotal role that technology (including digital technology) plays in the very constitution of the human must be acknowledged. In turn, such an acknowledgement could open the way to a better understanding of digitality itself. In fact, one must be reminded at this point that the digital, as well as what is referred to as 'digital technologies' or 'new technologies', is not well understood yet. Indeed, the main problem with new technologies is that they exhibit – in Stiegler's words – a 'deep opacity' (Stiegler 1998: 21). As Stiegler maintains, 'we do not immediately understand what is being played out in technics, nor what is being profoundly transformed

therein, even though we unceasingly have to make decisions regarding tech-nics, the consequences of which are felt to escape us more and more' (1998: 21).[1] I suggest that we need to start tackling the opacity of new technologies in order to develop political thinking about them. Furthermore, I want to argue that the digital humanities are the most promising academic field in which to engage in a radical reflection on the nature of the digital from a cultural and political point of view. Let me now expand on this point by looking briefly at the place of new technologies and digitality in today's academic debate.

The reflection on the digital has been the focus of rather established areas such as digital (or new) media studies, and of media studies in a broader sense, for more than a decade. Since digital media are perceived as characterised by a certain invisibility and ubiquity, many scholars in the field have been led to wonder whether a global picture of 'digital media' as a concept and a discipline is possible at all. In that light, software has been positioned as a 'minimal char-acteristic' of digital media. Thus there has been a surge of interest in software in the academic environment, for instance in the emergent fields of software studies and code studies.

Nevertheless, to think that technology has only recently emerged as a sig-nificant issue in media and cultural studies would be a mistake.[2] In fact, I want to emphasise here that technology (in its broadest sense) has been present in media and cultural studies from the start, as a constitutional concept. The intertwining between the concepts of 'medium' and 'technology' dates back to what some define as the 'foundational' debate between Raymond Williams and Marshall McLuhan (Lister 2003: 74). While a detailed discussion of this debate would divert us from the main focus of this chapter, it must be noticed that in his work McLuhan was predominantly concerned with the technological nature of the media, while Williams emphasised the fact that technology was always socially and culturally shaped. At the risk of a certain oversimplifica-tion, we can say that British media and cultural studies have to a large extent been informed by Williams' side of the argument – and has thus focused its attention on the cultural and social formations surrounding technology, while rejecting the ghost of 'technological determinism', and frequently dismissing any overt attention paid to technology itself as 'McLuhanite' (Lister 2003: 73). Yet technology has entered the field of media and cultural studies precisely because of McLuhan's insistence on its role as an agent of change.

One must be reminded at this point that, in the perspective of media and cultural studies, to study technology 'culturally' means to follow the trajectory of a particular 'technological object' (generally understood as a technological product), and to explore 'how it is represented, what social identities are associ-ated with it, how it is produced and consumed, and what mechanisms regulate its distribution and use' (DuGay 1997: 3). Such an analysis concentrates on 'meaning', and on the way in which a technological object is made meaningful.

Meaning is understood as not arising from the technological object 'itself', but from the way it is represented in the discourses surrounding it. By being brought into meaning, the technological object is constituted as a 'cultural artefact' (1997: 10). Thus, meaning emerges as intrinsic to the definition of 'culture' deployed by media and cultural studies. This is the case in Williams' classical definition of culture as a 'description of a particular way of life', and of cultural analysis as 'the clarification of the meanings and values implicit and explicit in particular ways of life' (Williams 1961: 57), as well as in a more recent understanding of 'culture' as 'circulation of meanings' (a formulation that takes into account that diverse, often contested meanings are produced, shared, and communicated within different social groups, and that they generally reflect the play of powers in society) (Hall 1997; DuGay et al. 1997).

When approaching new technologies, media and cultural studies have therefore predominantly focused on the intertwined processes of production, reception, and consumption; that is, on the discourses and practices of new technologies' producers and users. From this perspective, even a technological object as 'mysterious' as software is addressed by asking how it has been made into a significant cultural object. For instance, in his 2003 article on software, Adrian Mackenzie demonstrates the relevance of software as a topic of study essentially by examining the new social and cultural formations that surround it (Mackenzie 2003). An analogous claim is made by Lev Manovich in his recent book, *Software Takes Command* (2008). In this book Manovich argues that media studies have not yet investigated 'software itself', and advances a proposal for a new field of study that he names 'software studies'. Manovich actually claims to have been the first to have used the term in 1999. He goes on to propose a 'canon' for software studies that includes Marshall McLuhan, Robert Innis, Matthew Fuller, Katherine Hayles, Alexander Galloway, and Friedrich Kittler, among others. However, when he speaks of 'software itself', Manovich is adamant that 'software' does not mean 'code' – that is, computer programs. For him, software studies should focus on software as a cultural object – or, in Manovich's own term, as 'another dimension in the space of culture' (Manovich 2008: 4). Software becomes 'culturally visible' only when it becomes visual – namely, 'a medium' and therefore 'the new engine of culture' (2008: 4).

Although I recognise that the above perspective remains very important and politically meaningful for the cultural study of technology, I suggest that it should be supplemented by an alternative, or I would even hesitantly say more 'direct', investigation of technology – although I will raise questions for this notion of 'directness' later on. In other words, in order to understand the role that new technologies play in our lives and the world as a whole, we also need to shift the focus of analysis from the practices and discourses *concerning* them to a thorough investigation of how new technologies *work*, and, in particular,

of how software *works* and of what it *does*. Let me now explain how such an investigation of software can be undertaken.

By arguing for the importance of such an investigation, I do not mean that a 'direct observation' of software is possible. I am well aware that any relationship we can entertain with software is always mediated, and that software might well be 'unobservable'. In fact, I intend to take away all the implications of 'directness' that the concept of 'demystifying' or 'engaging with' software may bring with it. I am particularly aware that software has never been univocally defined by any disciplinary field (including technical ones) and that it takes different forms in different contexts.[3]

To give but one example, let me start from a rather widely accepted definition of software as the totality of all computer programs as well as all the written texts related to computer programs. This definition constitutes the conceptual foundation of software engineering, a technical discipline born in the late 1960s to help programmers design software cost-effectively. Software engineering describes software development as an advanced writing technique that translates a text or a group of texts written in natural languages (namely, the requirements specifications of the software 'system') into a binary text or group of texts (the executable computer programs), through a step-by-step process of gradual refinement (Brooks 1995; Humphrey 1989; Sommerville 1995). As Professor of Software Engineering at St Andrews University Ian Sommerville explains, 'software engineers model parts of the real world in software. These models are large, abstract, and complex so they must be made visible in documents such as system designs, user manuals, and so on. Producing these documents is as much part of the software engineering process as programming' (Sommerville 1995: 4).

This formulation shows that 'software' does not only mean 'computer programs'. A comprehensive definition of software also includes the whole of technical literature related to computer programs, including methodological studies on how to design computer programs – that is, including software engineering literature itself. I consider such an inclusive definition of software particularly promising for a cultural analysis of software because it allows me to make an essential move – that of transforming the problem of engaging with software into the problem of reading it. This definition of software enables me to ask to what extent and in what way software can be described as legible. Moreover, since software engineering is concerned with the methodologies for writing software, it is also possible to ask to what extent and in what way software can actually be seen as a form of writing. Such a re-formulation makes it possible to take the textual nature of software seriously. In this context, concepts such as 'reading', 'writing', 'document', and 'text' are no mere metaphors. Rather, they are software engineering's privileged mode of dealing with software as a technical object. It could even be argued that in the discipline of software engineering software's technicity is dealt with as a form of writing.

As a first step it is important to note that, in order to investigate software's readability and to attempt to read it, the concept of reading itself needs to be problematised. In fact, if we accept that software presents itself as a distinctive form of writing, we need to be aware that it consequently invites a distinctive form of reading. But to read software as conforming to the strategies it enforces upon its reader would mean to read it like a computer professional would; that is, in order to make it function *as software*. What I want to argue here is that reading software on its own terms is not equal to reading it functionally. Moreover, I want to suggest that a promising strategy for reading software can be developed by drawing on Jacques Derrida's concept of 'deconstruction'. However controversial and uncertain a definition of 'deconstruction' might be, I am essentially taking it up here as a way of stepping outside of a conceptual system while simultaneously continuing to use its concepts and demonstrating their limitations (Derrida 1980). 'Deconstruction' in this sense aims at 'undoing, decomposing, desedimenting' a conceptual system, not in order to destroy it but in order to understand how it has been constituted (Derrida 1985).[4] According to Derrida, in every conceptual system we can detect a concept that is actually unthinkable within the conceptual structure of the system itself – therefore, it has to be excluded by the system, or, rather, it must remain unthought to allow the system to exist. A deconstructive reading of software therefore asks: what is it that has to remain unthought within the conceptual structure of software?[5] In Derrida's words (1980), such a reading looks for a point of 'opacity', for a concept that escapes the foundations of the system in which it is nevertheless located and for which it remains unthinkable. It looks for a point where the conceptual system that constitutes software 'undoes itself'.[6] For this reason, a deconstructive reading of software is the opposite of a functional reading. For a computer professional, the point where the system 'undoes itself' is a malfunction, something that needs to be fixed. From the perspective of deconstruction, in turn, it is a point of revelation, in which the conceptual system underlying software is clarified. Actually, I want to suggest that Derrida's point of 'opacity' is also simultaneously the locus where Stiegler's 'opacity' disappears; that is, where technology allows us to see how it has been constituted. Being able to put into question at a fundamental level the premises on which a given conception of technology rests would prove particularly important when making decisions about it, and would expand our capacity for thinking and using technology politically, not just instrumentally.

Let me consider briefly some of the consequences that this examination of software might have for the way in which media and cultural studies deals with new technologies, as well as for the digital humanities as a field. As a first step, it is important to notice how recent strands of software and code studies aim at reading code with the instruments of close reading (as it is

performed in the study of literature) and with a view to unmask the ideological presuppositions at work in code. Thus, for instance, in a recent paper titled 'Disrupting Heteronormative Codes: When Cylons in Slash Goggles Ogle Anna Kournikova', Mark Marino argues that, by reading code, we can uncover the heteronormative assumptions at work in the functioning of a virus (a worm, in fact) called AnnaKournikova, which in 2000–2001 managed to infect hundreds of thousands of computers by offering illicit pictures of the famous tennis star (Marino 2010). The worm spread as an email whose subject line read as 'Here you have!' It carried a JPEG attachment which was in fact a piece of malware written in Visual Basic Script – that is, dangerous code which infected the computer when the recipient of the email clicked on the attachment. With an audacious and promising move, Marino reads the AnnaKournikova code as the inscription of heterosexual desire and the ideology of heteronormativity.

Although I find this perspective of much significance for the study of software and code, I also want to suggest that it should be complemented by a problematisation of the conceptual structure of software *as such* – that is, by a deconstructive reading of software aimed at understanding in what way software and code have taken the form they have today. To return to the example I have discussed above, an analysis of the emergence of the discipline of software engineering at the end of the 1960s would need to take into account how software was understood as a process of material inscription that continuously opened up and reaffirmed the boundaries between what was then named 'software', 'writing', and 'code'. Software engineering established itself as a discipline through an attempt to control the constitutive fallibility of software-based technology. Such fallibility – that is, the unexpected consequences inherent in software – was dealt with through the organisation and linearisation of the time of software development – and this, in turn, was pursued through the writing of 'documents' (requirements specifications, design documentation, computer programs). Software engineering also understood software as the 'solution' to pre-existent 'problems' or 'needs' present in society, therefore advancing an instrumental understanding of software. However, both the linearisation of time and the understanding of software as a tool were continuously undone by the unexpected consequences brought about by software – which consequently had to be excluded and controlled in order for software to reach a point of stability. At the same time, such unexpected consequences remained necessary to software's development (Frabetti 2009).

Importantly, when I pay such close attention to the conceptualisation of software as writing, I do not mean to argue that software *is* a form of writing – at least, not 'writing' in any historical sense of the word (or what Derrida would call 'writing in the narrow sense'). On the contrary, I want to argue that, in historically specific circumstances, 'software' has been constituted in relation with (historically specific) concepts of language and writing that must be

investigated in their historical singularity. Even more importantly, it must be kept in mind that these observations are not automatically valid for *all* software. Every instance of software needs to be studied per se, and problematised accordingly. What is more, the opacity of software cannot be dispelled merely through an analysis of what software 'really is' – for instance by saying that software is 'really' just hardware (Kittler 1995), or by unmasking the economical interests behind it, or by contrasting the theory of software against the personal self-accounts of programmers (Fuller 2003). Rather, one must acknowledge that software is *always* both conceptualised according to what Katherine Hayles (2005) has called a metaphysical framework *and* capable of escaping it – and the singular points of opacity of singular instances of software need to be brought to light. (Or, as Derrida would have it, the process of deconstruction needs to be carried out.)[7]

To conclude, let me go back to the importance of such conceptualisation of software for the field of the digital humanitites. What I want to suggest here is that a deconstructive reading of software (and of digitality) will enable us to do more than just uncover the conceptual presuppositions that preside over the constitution of software itself. In fact, such an investigation will have a much larger influence on our way of conceptualising what counts as 'academic knowledge', especially in the humanities. To understand this point better, not only must one be reminded that new technologies change the form of academic knowledge through new practices of scholarly communication and publication as well as shifting its focus, but that the study of digitality has eventually become a 'legitimate' area of academic research. Furthermore, as Gary Hall points out in his book, *Culture in Bits* (Hall 2002: 111), new technologies change the very nature and content of academic knowledge. In a famous passage, Jacques Derrida wondered about the influence of specific technologies of communication (such as print media and postal services) on the field of psychoanalysis by asking 'what [would psychoanalysis have become] if Freud had had e-mail?' (Derrida 1996). If we acknowledge that available technology has a formative influence on the construction of knowledge, then a reflection on new technologies implies a reflection on the nature of academic knowledge itself.

But, paradoxically, 'we cannot rely merely on the modern "disciplinary" methods and frameworks of knowledge in order to think and interpret the transformative effect new technology is having on our culture, since it is precisely these methods and frameworks that new technology requires us to rethink' (Hall 2002: 128). A critical attitude towards the concept of disciplinarity becomes necessary here. The digital humanities should pursue a deep self-reflexivity in order to keep its own disciplinarity and commitment open. Perhaps this self-reflexivity would be enabled by the establishment of a productive relationship between the digital humanities and deconstruction (understood here, first of all, as a problematising reading that would

permanently question some of the fundamental premises of the digital humanties themselves).

To conclude, I propose a reconceptualisation of the digital humanities as a field that can and should try to understand the digital in terms other than, on the one hand, the technical ones and, on the other hand, the ones (typical of media and cultural studies, and also to some extent of software and code studies) related to the dynamics of production, circulation, and consumption. Such an understanding must be pursued through a close, even intimate, engagement with digitality and with software itself. To what extent and in what way this intimacy can be achieved and how software can be made available for examination remains one of the main problems of the digital humanities. Taking into account possible difficulties resulting from the working of mediation in our engagement with technology as well as technology's opacity and its constitutive, if unacknowledged, role in the formation of both human and academic knowledge, I argue that such an engagement is essential if the digital humanities are to take new technologies seriously, and to think of them in a way that affects – and that does not separate – cultural understanding and political practice.

Notes

1. We can provisionally assume here that the word 'technics' (belonging to Stiegler's partially Heideggerian philosophical vocabulary) indicates in this context contemporary technology, and therefore includes what I am referring to here as 'new technologies'.
2. With the formulation 'media and cultural studies' I mean to highlight that the reflection on new technologies is positioned at the intersection of the academic traditions of cultural studies and media studies.
3. For instance, a computer program written in a programming language and printed on a piece of paper is software. When such a program is executed by a computer machine, it is no longer visible, although it might remain accessible through changes in the status of the machine (such as the blinking of lights, or the flowing of characters on a screen) – and it is still defined as software.
4. In 'Structure, Sign, and Play in the Discourse of the Human Sciences' (1980), while reminding us that his concept of deconstruction was developed in dialogue with structuralist thought, Derrida speaks of 'structure' rather than of conceptual systems, or of systems of thought. Even though it is not possible to discuss this point in depth here, I would like to point out how, in the context of that essay, 'structure' hints at as complex a formation as, for instance, the ensemble of concepts underlying social sciences, or even the whole of Western philosophy.
5. I am making an assumption here – namely that software is a conceptual system as much as it is a form of writing and a material object. In fact, the investigation of these multiple modes of existence of software is precisely what is at stake in my analysis.
6. According to Derrida, deconstruction is not a methodology, in the sense that it is not a set of immutable rules that can be applied to any object of analysis – because

the very concepts of 'rule', of 'object' and of 'subject' of analysis themselves belong to a conceptual system (broadly speaking, they belong to the Western tradition of thought), and therefore are subject to deconstruction too. As a result, 'deconstruction' is something that 'happens' within a conceptual system, rather than a methodology. It can be said that any conceptual system is always in deconstruction, because it unavoidably reaches a point where it unties or disassembles its own presuppositions. On the other hand, since it is perfectly possible to remain oblivious to the permanent occurrence of deconstruction, there is a need for us to actively 'perform' it, that is to make its permanent occurrence visible. In this sense deconstruction is also a productive, creative process.

7. Thus, I want to suggest here that software studies and code studies do not need to make a knowledge claim with regard to what software *is* (and perhaps neither do digital humanities). They should rather ask what software *does* – and, with a view to that, investigate historically specific (or rather, singular) instances of software in order to show how software works. Such investigation would probably bring to the fore the fact that the conceptualisation of software is always problematic, since in every singular understanding of software there are points of opacity. In other words, parts of the conceptual system which structures software have to remain unthought in order for software to exist.

References

Beardsworth, R. (1995), 'From a Genealogy of Matter to a Politics of Memory: Stiegler's Thinking of Technics', *Tekhnema* 2: non-pag. http://tekhnema.free.fr/2Beardsworth. htm.

Beardsworth, R. (1996), *Derrida and the Political* (New York: Routledge).

Brooks, F. P. (1995), *The Mythical Man-Month: Essays on Software Engineering, 20th Anniversary Edition.* (Reading, MA: Addison-Wesley).

Clark, T. (2000), 'Deconstruction and Technology', in N. Royle (ed.), *Deconstructions: A User's Guide* (Basingstoke: Palgrave, 238–57).

Derrida, J. (1976), *Of Grammatology* (Baltimore: The Johns Hopkins University Press).

Derrida, J. (1980), 'Structure, Sign, and Play in the Discourse of the Human Sciences', in *Writing and Difference*, (London: Routledge, 278–94).

Derrida, J. (1985), 'Letter to a Japanese Friend', in R. Bernasconi & D. Wood (eds), *Derrida and Différance* (Warwick: Parousia Press: 1–5).

Derrida, J. (1987), *The Post Card: From Socrates to Freud and Beyond* (Chicago: University of Chicago Press).

Derrida, J. (1994), *Specters of Marx: The State of the Debt, the Work of Mourning, and the New International* (New York and London: Routledge).

Derrida, J. (1996), *Archive Fever: A Freudian Impression* (Chicago: University of Chicago Press).

DuGay, P., et al. (1997), *Doing Cultural Studies: The Story of the Sony Walkman* (London: Sage/The Open University).

Frabetti, F. (2009), 'Does It Work? The Unforeseeable Consequences of Quasi-Failing Technology', '*Creative Media*', *Culture Machine*, E-journal, Special issue, vol. 11.

Fuller, M. (2003), *Behind the Blip: Essays on the Culture of Software* (New York: Autonomedia).

Galloway, A. (2004), *Protocol: How Control Exists after Decentralization* (Cambridge, MA: MIT Press).

Hall, G. (2002), *Culture in Bits: The Monstrous Future of Theory* (London and New York: Continuum).

Hall, S. (ed.) (1997), *Representation: Cultural Representations and Signifying Practices* (London: Sage/The Open University).

Hayles, K. N. (2005), *My Mother Was a Computer: Digital Subjects and Literary Texts* (Chicago: University of Chicago Press).

Humphrey, W. (1989), *Managing the Software Process* (Harlow: Addison-Wesley).

Kittler, F. A. (1995), 'There Is No Software', *CTheory*: non-pag. http://www.ctheory.net/articles.aspx?id=74.

Lister, M., et al. (2003), *New Media: A Critical Introduction* (London and New York: Routledge).

Mackenzie, A. (2003), 'The Problem of Computer Code: Leviathan or Common Power?', non-pag. http://www.lancs.ac.uk/staff/mackenza/papers/code-leviathan.pdf.

Manovich, L. (2008), *Software Takes Command*. http://lab.softwarestudies.com/2008/11/softbook.html.

Marino, M. (2010), 'Disrupting Heteronormative Codes: When Cylons in Slash Goggles Ogle Anna Kournikova', DAC 09, Talk/Oral Presentation, Refereed Paper, UC Irvine, CA, DAC, 2009–2010.

Sommerville, I. (1995), *Software Engineering* (Harlow: Addison-Wesley).

Stiegler, B. (1998), *Technics and Time, 1: The Fault of Epimetheus* (Stanford, CA: Stanford University Press).

Stiegler, B. (2009), *Technics and Time, 2: Disorientation* (Stanford, CA: Stanford University Press).

Williams, R. (1961), *The Long Revolution* (Harmondsworth: Penguin).

10
Present, Not Voting: Digital Humanities in the Panopticon

Melissa Terras

1 Introduction

In November 2009 I was approached by the conference organising committee for the Digital Humanities Conference 2010, to be held in July at King's College London. In a deviation from previous conferences, the committee had decided that, for the first time, instead of getting someone external to the community to talk about semi-related research areas, they would ask an early career scholar from well within the discipline to present the closing plenary. Would I consider giving the speech?

The email squirmed in my inbox for a few days as I considered the invitation. While surprised and honoured, I was aware of the perils of presenting a plenary at the most important international conference in my field: should things backfire it could be disastrous for my reputation and relatively young research career. Many of those in the audience would be close colleagues; some would be very good friends. I was aware that, in a conference hall that holds 250 people, there would be 249 other people who were more than qualified to stand up for an hour and say what they currently thought of the digital humanities (not to mention the other 200 folks expected to register for the conference who could be watching from the streaming lecture theatre). This was not a conference I could walk away from and forget a ruinous, hour-long presentation failure.

Additionally, I was very aware that the rules of giving plenary speeches have changed as rapidly as the information environment over the last few years. I remember a plenary at ALLC/ACH (as the conference was then known) ten or so years ago where the eminent speaker read a chapter of their book, never looking up at the audience once, and with no concession given for the change of presentational mode: 'As I said on page 39. ... As I will discuss in chapter five. ...' Nowadays, given that I would be recorded and broadcast online, that type of academic behaviour is unacceptable. So I knew I would be incredibly nervous. As well as being <nervous>, I was aware that I would be #nervous: as

soon as I started to speak, many of those in attendance would tweet comments about what I'd said online, even though I had not really begun.

However, this idea of surveillance and being watched and judged gave me the seed of the subject I could talk about in the plenary. Digital humanities faces many issues in the current financial and educational climate, not least the fact that we need to demonstrate our usefulness and relevance at a time of cutbacks and economic stringency. I believe that those in the digital humanities have to be more aware of our history, impact, and identity if the discipline is to continue to flourish in tighter economic climes, and that unless we maintain and establish a more professional attitude towards our scholarly outputs we will remain 'present, not voting' within the academy. I could frame this discussion in regard to an individual project at University College London: Transcribe Bentham, demonstrating the practical and theoretical aspects of digital humanities research, while providing a nice introduction to the competitive relationship between my own institution, University College London, and its neighbour just a mile down the road where the conference would be held. Furthermore, I had been following many of those in the digital humanities closely on Twitter, wondering what I could possibly say; I could use voices from the community to back up and reify the conclusions I was coming to. I replied to the email. I would do the talk.

1.1 Background

University College London (http://www.ucl.ac.uk/) and King's College London (http://www.kcl.ac.uk) were both founder members of the University of London in 1836 (Harte 1986; University of London 2010), and the two universities have an interesting, competitive history. UCL was set up as a secular educational establishment, letting in anyone who could pay the fees (such as Gandhi. And women (Harte 1979; Harte and North 1991), whereas King's was set up as an Anglican church–based institution, in reaction to the 'Great Godless of Gower Street' threatening to allow education to all just up the road. The two institutions have remained locked in friendly – but sometimes fierce – competitive mode ever since. A recent Provost's newsletter from UCL ran with a headline that UCL had beaten King's in the women's rugby varsity match 22–0 (Grant 2010). On the academic front, we are often competing for the same staff, students, grants, even facilities. UCL has recently established its Centre for Digital Humanities (http://www.ucl.ac.uk/dh/), which forms a competitive alternative to the teaching and research that has been established at King's Centre for Computing in the Humanities (soon to be the Department of Digital Humanities, http://www.kcl.ac.uk/schools/humanities/depts/cch). And so it goes on.

We're proud at UCL of the different nature of our university. As opposed to King's, we will never have a theology department, and do not provide a

place of worship on campus. Much of the founding principles of UCL were influenced by the jurist, philosopher, and legal and social reformer, Jeremy Bentham, who believed in equality, animal rights, utilitarianism, and welfarism (http://www.ucl.ac.uk/Bentham-Project/). UCL special collections host 60,000 folios of Bentham's letters and manuscripts, many of which have not been transcribed. Upon his death, Bentham's skeleton was preserved as an 'Auto-icon' (a very obvious snub to those who believed in religion and the need for a Christian funeral) which now sits, dressed in his favourite outfit, in the cloisters at UCL. There is an oft-repeated story that Bentham's body is wheeled into Senate meetings, although he is noted in the minutes as 'Present, not Voting' (Bentham Project 2009).

In early colour photos, you can still see Bentham's real preserved head at the base of the Auto-Icon. However, Bentham's head has been stored in Special Collections ever since 1975, when (the story goes) students from King's stole it, merrily kicked it around the quad, and then held it for ransom. Friendly competition, indeed.

One of Bentham's main interests was penal reform, and he is perhaps most famous for his design of the Panopticon, a prison which allowed jailors to observe (*-opticon*) all (*pan-*) prisoners without the incarcerated being able to tell whether they were being watched. This psychologically, and physically, brutal prison was never built, but the concept has lived on as metaphor, influencing a wide range of artists, writers, and theorists, including George Orwell (who worked in room 101 of Senate House, in between UCL and King's, and would have been well aware of Jeremy Bentham's work) and Foucault (1975). Indeed, the Panopticon can be taken as a metaphor for Western society, and, increasingly, online communication, particularly social media (Katz and Rice 2002). Every time you tweet, do you know who is paying attention? What audience are you performing for, and can you be sure you are in control of how your actions are viewed and used?

This chapter will cover three main areas: the Transcribe Bentham project, an innovative crowdsourcing project which aims to aid in making Bentham's archive at UCL accessible. The project is presented here as a type of digital humanities resource that can objectively demonstrate the changes that are occurring in our field at the moment. Second, current issues in digital humanities will be framed in regard to the Transcribe Bentham project and the wider digital humanities community. Friendly competition is not so friendly just now. There are tough times ahead for academia, given the current financial crisis and promised austerity measures. What can we learn from the areas highlighted by this discussion of digital humanities, and what can we do better as a field, so those who are looking at us (and believe me, managers and administrators and financial experts are looking at us) can visibly see our impact, our relevance, and our value? Finally, a to-do list will be

presented for practitioners within the digital humanities in response to these emergent issues.

2 Transcribe Bentham

Transcribe Bentham is a one-year, Arts and Humanities Research Council–funded project, housed under the auspices of the Bentham Project at UCL (http://www.ucl.ac.uk/Bentham-Project/). The Bentham Project aims to produce new editions of the scholarship of Jeremy Bentham, and so far 12 volumes of Bentham's correspondence have been published, plus various collections of his work on jurisprudence and legal matters (http://www.ucl.ac.uk/Bentham-Project/Publications/index.htm). However, there is much more work to be done to make his writings more accessible, and to provide transcripts of the materials therein. Although a previous grant from the AHRC from 2003 to 2006 has allowed for the completion of a catalogue of the manuscripts held within UCL (http://www.benthampapers.ucl.ac.uk/), and transcriptions have been completed of some 10,000 folios (currently stored in MS Word), there are many hours of work that need to be invested in reading, transcribing, labelling, and making accessible the works of this interdisciplinary historical figure if they are to be analysed, consulted, and utilised by scholars across the various disciplines interested in Bentham's writings.

Crowdsourcing – the harnessing of online activity to aid in large-scale projects that require human cognition – is becoming of interest to those in the library, museum, and cultural heritage industries, as institutions seek ways to publicly engage their online communities, as well as aid in creating useful and usable digital resources (Holley 2010). As one of the first cultural and heritage projects to apply crowdsourcing to a non-trivial task, UCL's Bentham Project launched the 'Transcribe Bentham' initiative, an ambitious, open source, participatory online environment which is being developed to aid in transcribing 10,000 folios of Bentham's handwritten documents (http://www.ucl.ac.uk/transcribe-bentham/). Formally launched in September 2010, this experimental initiative aims to engage with individuals such as schoolchildren, amateur historians, and other interested parties who can provide time to help us read Bentham's manuscripts. The integration of user communities is key to the success of the project, and an additional project remit is to monitor the success of trying to engage the wider community with such documentary material: will we get high-quality, trustworthy transcriptions as a result of this work? Will people be interested in volunteering their time and effort to read the (poor) handwriting of a great philosopher? What technical and pragmatic difficulties will we run into? How can we monitor success in a crowdsourced environment?

At the time of writing, one month since the launch of Transcribe Bentham, we have over 200 registered users, and over 200 'finished' transcriptions that

have been locked down as final within the system, with many more partially underway. There are a few dedicated transcribers, who aim to do at least one manuscript a day for the duration of the project – which should mean we end up with a tally of thousands of transcribed texts by the end of the project. Letters and publicity materials have just been sent to 500 schools within London, and the project has received high levels of publicity across a variety of online and offline media (http://www.ucl.ac.uk/transcribe-bentham/publicity/) which, we hope, will continue to swell the transcriber numbers. We are closely watching user logs of the system, and will report back in due course. One of the questions we have to face is how many transcriptions equate to value for money for an endeavour such as this? At what stage can we say 'this has been successful'?

Stepping back a little, one of the other things that is interesting about the Bentham Project, and the Transcribe Bentham initiative, is that it demonstrates neatly the progression of digital humanities in historical manuscript–based projects. The Bentham Project has been primarily occupied with print output, gaining a Web presence in the mid-1990s, then an online database of the Bentham archive in the early twentieth century, and is now carrying out a moderately large-scale digitisation project to scan in Bentham's writings for Transcribe Bentham. In addition, the Bentham Project has gone from a simple Web page, to interactive Web 2.0 environment, from MS Word to TEI-encoded XML texts, and from relatively inward-looking academic project to an outward-facing, community-building exercise. We can peer at digital humanities through this one project, and see the transformative aspects that technologies have had on our working practices, and the practices of those working in the historical domain.

3 Transcribe Bentham, and emerging issues in DH

Rather than concentrating on crowdsourcing itself, I thought it would be more useful to point out to those involved in the digital humanities community some of the emergent issues that I have found myself tackling while engaging in the Transcribe Bentham project. It's certainly true that for every project that you work on you learn new things about the field, and over the past year various aspects of DH research and issues that concern the DH community have raised their head. I will back these issues up with some observations of what has been happening in the DH community, through conversations that others have been having on Twitter. A lot of these issues are becoming more visible within DH, so I'm going to quote the individuals within the community on those.

3.1 Our dependence on primary sources;
our dependence on modern technology

I've never felt more of a jack of all trades, master of none than when working on Transcribe Bentham. Let's be clear – the Bentham Project belongs to Professor

Philip Schofield, who has been working on it for over 25 years (http://www. ucl.ac.uk/laws/academics/profiles/index.shtml?schofield). I was just drafted in to help bridge the gap between primary sources, dedicated scholars, and new technology. On the one hand, I'm utterly dependent on scholars who know less than I about IT, and more than I about their subject domain, to make an academic contribution. On the other hand, I'm utterly dependent on some programmers who have had the funding and time to work up the ideas we have for TB into a complex (but seemingly simple) working environment for transcribing documents in just a few months. I'd be lost without access to historical knowledge and source material, but I'd be lost without access to new, online cutting-edge technologies.

This is something I see repeated across the digital humanities. When Ray Siemens tweets 'Among many highlights of an excellent week, holding a well-read copy of Thynne's 1532 Chaucer, as well as an iPad...' we understand the joy (Siemens 2010). When Brian Croxall tweets 'Gah, can't get online at this hotel' (Croxall 2010) we feel his frustration at being cut off from a service and an environment which is becoming as essential to us as running water or oxygen. When Bethany Nowviskie tweets 'Dreamed last night that my #DH2010 poster was a set of flexible, give away, interactive touchscreens. Maybe not too far in the future' (Nowviskie 2010) we nod in recognition, and go, yeah...that would be cool...let me Google that and see if they exist....We exist in a parallel state where we are looking towards humanities research, and computational technology, which can be immensely rewarding, and great fun. I'm really enjoying working on Transcribe Bentham. I really enjoy the duality of DH research (as long as I can get online when I want).

3.2 Legacy data

However, as well as working with historical documents (or artefacts, etc.), it's becoming increasingly common within the digital humanities that we have to work with historical digital documents – or legacy data – left over from the not-so-distant past, in different formats and structures that need to be brought into current thinking on best practice with digital data. This can take immense amounts of work. Converting 10,000 transcribed Bentham documents from MS Word to TEI-compliant XML, with any granularity of markup, is not a trivial task. Linking these transcripts with the records currently held in the online database, and then UCL's library record system (to deal with usability and sustainability issues) is not a trivial task. Linking existing transcriptions with any digitised images of the writings which exist is not a trivial task. Transcribe Bentham, then, is dealing with sorting its own ducks into a row, as well as undertaking new and novel research.

Most of us understand this, and we understand just how much work (and cost) is involved in continually ensuring we are maintaining and updating our

work and our records to make sure that our digital resources can continue to be used. So we understand that a seemingly simple tweet by Tom Elliott saying 'more BAtlas legacy data added to Pleiades today, courtesy of @sgillies http://bit.ly/dBuYFg' (Elliott 2010) belies an incredible amount of work to ensure to convert and maintain an existing resource. As well as looking forward to the future, and new technologies, we DH practitioners must be our own archivists.

3.3 Sustainability

Which brings me to the thorny issue of sustainability. We hope with Transcribe Bentham that the project will continue far beyond its one-year remit, but there are some decisions we have to make. Will the user forums, and user contributions, continue to be monitored and moderated if we can't afford a staff member to do so? Will the wiki get locked down at the close of funding or will we leave it to its own devices, becoming an online free-for-all? We are at the stage, in a one-year project, where we already need to be applying for future funding, before we have even got anything to demonstrate that it's worth continuing our funding (and there is no guarantee in the current climate that any funding will be forthcoming; see below). But we are lucky in Transcribe Bentham – its father project, the Bentham Project, will continue, whatever happens, under the watchful auspices of Philip Schofield. So when Dan Cohen is quoted by Shane Landrum, in a tweet that reminds us 'Being a labour of love is often the best sustainability model' (Landrum 2010) we understand what that means. Sustainability is an area of huge concern for the DH community, and is going to become more so as financial issues get more complex.

3.4 Digital identity

Transcribe Bentham is going to live or die by its digital identity and digital presence. It doesn't have any equivalent in the offline world. It is what it is: an online place to hang out and help Transcribe some documents, should that take your fancy. To be a success, then, our functionality, digital presence, and digital identity need to be absolutely perfect. Ironically, I've never worked on a digital humanities project before where the digital presence mattered so much, and I've come to realise that we all should be taking our digital identity and digital presence a lot more seriously. It's not enough just to whack up a website and say 'that'll do, now back to writing books'. If we are going to be in the business of producing digital resources, we have to be able to excel at producing digital resources, and be conscious of our digital identity and digital presence.

We are lucky at Transcribe Bentham to have gained the input of one of my PhD students, Rudolf Ammann (@rkammann) who is also a gifted graphic designer. He has taken it upon himself to whip both UCL Centre for Digital Humanities, and Transcribe Bentham, into online shape, while designing logos

for us which are both fitting, useful, and memorable. We're being careful with TB to roll our presence out over Twitter and Facebook to try to encourage interaction. We hope that someone will be watching.

Suddenly it matters in a way that didn't matter before, if people are looking at our website and our resource. I believe that digital presence and digital identity is becoming more important to digital humanities as a discipline. So when Amanda French jokily tweets 'I feel like I got a rejection letter yesterday from @DHNow when too few RTed my "binary hero" post http://bit.ly/aKpBiX' (French 2010) we understand the complexity of interacting in the new digital environment: we want the discourse, and want the attention (and if you don't know what DHNow is, you should be reading it every day: http://digitalhumanitiesnow.org/). Likewise when Matt Kirschenbaum tweets 'Has Twitter done more as DH infrastructure than any dedicated effort to date?' and this is immediately re-tweeted by Tim Sherratt with an addendum '[For me it has!]' (Sherratt 2010) we understand the possibilities that are afforded with new modes of online communication. How we can harness this properly for Transcribe Bentham remains to be seen – but we are at least aware we need to make the effort.

3.5 Embracing the random, embracing the open

There are large differences between producing a perfect (or near as perfect as can be) print edition of Bentham's letters, and learning to deal with the various levels of quality of input we are getting with Transcribe Bentham. There are large differences between working in a close-knit group of scholars to working with the general public. There are also differences in producing online editions and sources which you are willing to open up to other uses – and one of the things we want to do with Transcribe Bentham is to provide access to the resulting XML files so that others can re-use the information (via Web services, etc.). The hosting and transcription environment we are developing will be open source, so that others can use it. And this sea change, from working in small groups to really reaching out to users, is something we have to embrace and learn to work with. We also have to give up on ideas of absolute perfection, and go for broader projects, embracing input from a wider audience, and the chaos that ensues. So we understand when Dan Cohen tweets 'Another leitmotif I'm sensing: as academics, we need to get over our obsession w/ perfect, singular, finished, editorial vols' (Cohen 2010). Let's see what happens if we embrace this.

3.6 Impact

I only realised recently that my automatic reaction to getting involved with the Transcribe Bentham project was 'How can I get some output from this that counts for me?' We wrote into the grant bid a period of user-testing and

feedback, and one of the reasons is to get a few almost-guaranteed publications out of the project, looking at the success – or not! – of crowdsourcing in cultural heritage projects (and, indeed, a chapter in a book such as this). With some academic outputs built into the grant, we can go and play online, and not have to worry too much about how creating an open source tool, or reaching out to a potential audience of thousands, will 'count' in the academic world. No matter how successful Transcribe Bentham, no matter how many new texts we transcribe, the 'impact' will be felt in the same usual way – through publications. This is nonsense, but it's part of the academic game, and is becoming of increasing frustration to those working in the digital humanities. It's not enough to make something that is successful and interesting and well-used: you have to write a paper about it that gets published in the Journal of Successful Academic Stuff to make that line on your CV count, and to justify your time spent on the project. So we understand the frustration felt by Stephen Ramsay when he puts a mini-documentary online which goes as viral as things really get in the digital humanities, viewed by thousands of people, which will have no real impact on his career (Ramsay 2010a). 'I've published some print articles. Funny thing though: None of them were read by 2000 people in the space of 2 weeks...had their titles printed on t-shirts, or resulted in dozens of emails from adoring fans. So why am I writing journal articles again?...Oh wait, nevermind, my department doesn't count movies' (Ramsay 2010b, 2010c, 2010d).

3.7 Routes to jobs

Should those hired in digital humanities projects to do technical work have a PhD in digital humanities – even if the tasks in the role are service-level (such as marking up TEI) and don't require that academic training? I'm willing to admit that Transcribe Bentham walked right into the storm with this issue when our job adverts for our two RAs went live. We advertised for two postdocs: one with a historical background who had experience working in the Bentham studies area, and one with TEI chops to help us with the back end of the system. We specified that we wanted PhDs because of the changed rules in employment at universities in the United Kingdom (well, at least those involved in the common pay framework (Universities and College Union 2004)); if we had advertised for posts at non-PhD level, we wouldn't have been able to employ someone with a PhD, even if they wanted to work for less money, because of the spine point system. So we advertise for two postdocs, and if someone good comes through without a PhD, we can employ them on a lower rate. But we forgot to mention that applications from those without a PhD may also be considered. Cue much online discussion in various forums.

 We should all understand this frustration. Dot Porter (@leoba) said, on Facebook rather than Twitter, 'I get annoyed when I read job postings for

positions that require a PhD, and then read the job description and can't figure out why. Maybe I'm sensitive, not having a PhD? Is a PhD really required for one to take part in the digital humanities these days, even in supporting (non-research) roles?' (Porter 2010).

This is becoming a real issue in digital humanities. There is no clear route to an academic job, and no clear route to a PhD, and there are a lot of people at a high level in the field who do not have PhDs. Yet, increasingly, we expect the younger intake to have undertaken postgraduate study, and then to work in service-level roles (partly because there are few academic jobs). It remains to be seen how we can address this. For Transcribe Bentham, we changed the advert to make it clear we accepted applications from non-PhDs. In the end we did appoint two postdocs, but at least we made it clear that people had the option to apply for a job where, ostensibly, you didn't need a PhD, just the skill set, to undertake the task properly.

3.8 Young scholars

This problem of employment and career and progression taps into a general frustration for young scholars. It can be hard to get a foothold, and hard to get a job (not just in digital humanities; in the United Kingdom over 10 per cent of those with degrees are currently unemployed. It's a tough time to be coming out of university, PhD or no PhD [BBC News 2010]). Perhaps it was always difficult to make the transition from academic student to academic Academic, but Twitter amplifies the issues that are facing young scholars in the field trying to make headway. I was very aware when hiring for Transcribe Bentham that there were some very good candidates out there who just weren't getting a break (the person who came in second in the interview, and who we would have employed instantly had we had two historical postdoc positions, later told me that he had had over 20 interviews, but we were the first people to give him any feedback. Luckily, we have since managed to find money to employ him at the Bentham Project). We shouldn't forget the pressure young scholars are under (at a time when we are complaining of the financial pressures that paid academics are under) and how difficult it can be for them on both a professional and personal level. It saddens me to read tweets like this one from Ryan Cordell saying 'Just wrote a tough email withdrawing from #DH2010. Even if I got a bursary, I just couldn't swing it in the same summer as our move #sigh'. (Cordell 2010).

3.9 Economic downturn

Which brings me to the next doom-and-gloom point. When Brett Bobley tweets 'Two weeks ago, no one in my kid's school had Silly Bandz; now they all wear them. How come higher ed never moves that fast?' (Bobley 2010) we all chuckle at the thought of the academy as being a reactive, immediate institution.

It takes a few years for the impact of outside events to trickle down. It's only now that the economic downturn is starting to hit higher education. In the United Kingdom, cuts over the next few years are predicted to be anything between 25 per cent to 40 per cent, depending on what leak or rumour or governmental minister you believe (and, indeed, the Browne report on a 'sustainable future for higher education in England' threatens 80 per cent cuts in teaching finance for the arts, humanities, and social sciences [Browne 2010]). These are uncertain times for research, and teaching, and for institutions, and for individuals, and for projects. We don't know if there will be money to even apply for to continue the research and application in the Transcribe Bentham project. We don't know, even if we submit an application, that the funding council won't suddenly reject *all* applications due to their funding cuts. We don't know how to make an economic case for projects in the arts, humanities, heritage, and culture, so that when panjandrums and apparatchiks are deciding which swinging cut to make next, we can display our relevance, our impact, the point of our existence, and why people should keep writing the cheques. These are uncertain times. How this is affecting digital humanities is slowly beginning to be played out.

3.10 Money, the humanities, and job security

I felt that it would be morally wrong of me to speak at a conference at King's College London that had the word humanities in the title and not broach the subject of what had happened in the 2009–2010 academic year with the threat of redundancy for all humanities academics at King's. Palaeography is a subject close to my heart, and, as @DrGnosis tweeted during the opening speech of #DH2010, 'I weep for Palaeography' (@DrGnosis 2010). I also like to think that had any one of the 420 other registered conference attendees from the digital humanities community been asked to give the plenary speech they would have had the courage to raise this issue. But I was a guest at the conference and did not want to be rude or impolite. So I'll repeat what was tweeted by John Theibault: 'There's going to be a bit of a pall over dh2010 because of all that's gone on with KCL' (Theibault 2010). I recommend that if you do not understand what I am talking about, then read about it, and understand how little respect was given to humanities academics at King's from their own management (Pears 2010). I suggest you hope that your own management have not been taking notes, and do not proceed in a similar fashion, for what hope is there then for the humanities?

It's very difficult for those in the humanities to make the economic case for their existence (British Academy 2004; Arts and Humanities Research Council 2009), and that is what we are expected to do in the current climate. We need to be able to explain why projects like Transcribe Bentham are relevant, and important, and useful. Those in the humanities are historically bad at doing this, and those in DH are no different. But DH is different from traditional

humanities research; we should be able to articulate the transferable skill set that comes with DH research that can educate and influence a wide range of culture, heritage, creative, and even business processes. On the downside, projects like Transcribe Bentham are more expensive than paying one individual scholar for a year to write their scholarly tome on, say, Byzantine Sigillography; the digital equivalent will require researchers, computer programmers, computer kit, digitisation costs, and so forth. To ensure that the digital humanities are funded at the time when funding is being withdrawn from the humanities, we need to be prepared, and to articulate and explain why what we do is important, and relevant.

3.11 Fears for the future

Of course it's not just the humanities that are in a perilous financial state: in the United Kingdom, it's the whole education sector. At King's, it's not just humanities that have been cut, but also the engineering faculty. Profitable groups from disciplines such as computer science have been poached wholesale by other universities (not so friendly competition now, is it?). And this is a pattern we are seeing across the universities in the United Kingdom. We're all scared – for the continuation of our projects (such as Transcribe Bentham); for our students; for our young scholars on temporary contracts; for our 'research profile' (whatever that may mean); and for our own jobs. We understand the implicit horror in a tweet such as that from Simon Tanner saying 'England next? Plan to close smaller #Welsh #Universities broadly welcomed by #education professionals. http://bit.ly/dxWBsj #HE #wales' (Tanner 2010).

 If we think that no one is watching us and making value judgements about our community, our research, our relevance, and our output, then we are misguided. It's not just other scholars who are paying attention, but those who hold the purse strings – who often have no choice but to make brutal cuts. The humanities are one of the easiest targets, given scholars' reluctance or inability to make the case for themselves. I'm reminded of a phrase from Orwell's *1984*, and what happened to society when under the horrific pressure and surveillance within. Allow me to paraphrase: if we are not prepared, and if we are not careful, these cuts will be 'a boot stamping on the face of the humanities, forever'. I remember very clearly that at the end of an upbeat DH2009 Neil Fraistat (@fraistat) stood up and said, 'The digital humanities have arrived!' But in 2010, the place we have arrived at is a changed, pessimistic, dystopian educational landscape.

4 Digital humanities in the Panopticon

So let us pretend that we are someone from outside our community, watching the goings-on in academia and making value judgements, and financial

judgements, about our discipline and field. How does digital humanities itself hold up when under scrutiny? How do we fair with the crucial aspects of Digital Identity, Impact, and Sustainability?

The answer is: not very well. From the outside looking in, we seem amateur. We should know and understand best, amongst many academic fields, how important it is to maintain and sustain our digital presence and our community. But at the time of this writing, our Web presence, across the associations, sucks. The ACH website says it was last updated in 2003 (http://www.ach.org/). The ALLC website is a paean to unnecessary white space (http://www.allc.org/). SDH/SEMI is not so bad, but has its own problems with navigation and presentation (I'm including it here so as not to leave out a whole association: http://www.sdh-semi.org/) – but the ADHO website is a prime example of what happens when wikis are not wiki-ed (http://digitalhumanities.org/). These are our outward faces. These are our representations of the field. We've been slow to embrace other social media and new technologies when we are the field that is supposed to show how it is done.

The associations have recently taken this on board. There is a lot of hard work going on behind the scenes on all accounts. A wireframe of the new ADHO site, which should be up and running shortly, demonstrates that we are moving into the twenty-first century, finally. What's interesting is the big empty space for a mission statement, and a definition of the field (which we at DH don't have yet). We need to take our digital presence more seriously, and to embrace the potentials that we all know about, but haven't pitched in to help represent for the discipline.

What about impact? We've been historically bad at articulating our relevance and our successes and our impact beyond our immediate community (and sometimes within our immediate community; it surprised me recently when a leading scholar in the field was told, via Twitter, of the role the DH community had in the formulation of XML). We're bad at knowing our own history, as a discipline, and having examples listed off the top of our heads of why our research community is required in today's academe.

As for sustainability, we should know best among many humanities fields of the importance of preservation of our discipline's heritage. Yet it's only been recently that scholars in the field have started to note the disappearance of abstracts from previous conferences, websites which have disappeared overnight, the fact we don't have, and can't locate, a complete back run of the journals printed by the associations. For example, we don't have any of the image files included in the ALLC/ACH 2000 abstract book. We need to look after our heritage; no one else will. A few people are working behind the scenes to try to build up digital copies of our discipline's history, and hopefully over the next year or so we'll see this available online. We need to be leading the way in the humanities for publishing and maintaining and sustaining our discipline, to

demonstrate that, yes, we really do know what we are talking about. At the moment, it looks like we don't.

Why does all this matter? I bring you back to the title of my talk, 'Present, Not Voting: Digital Humanities in the Panopticon'. Our community matters (although, heck, a lot of you are not voting: for the ACH and ALLC elections in 2010, turnout was around 30 per cent. We need new blood in the associations. We need people who are not just prepared to whine but prepared to roll up their sleeves and do things to improve our associations, our community, and our presence in academia.) But the fact of the matter remains: if we do not treat our research presence seriously, if we are not prepared to stick up for digital humanities, if we are not prepared to demonstrate our relevance and our excellence and our achievements, then the status of those working within DH (including the relevance of digital scholarship, and how it is treated by those in the humanities) will not improve, and we'll be as impotent as we have ever been. We should be demonstrating excellence and cohesion and strength in numbers. We should be prepared, as best we can, for whatever is coming next in the financial downturn, and in academia. If we self-identify as digital humanists – and I presume many of those at the conference reading this text would – then we need to articulate what that means, and what's the point of our community. It's the only way to prepare for what is coming.

5 Homework

So far, doom and gloom. But we are a community who are full of people who like to do things, and make things, and achieve things. There are plenty of practical things we can do to ensure both the continuation of our individual careers, our individual projects (such as Transcribe Bentham), our centres, and our teaching.

For the individual, we can be prepared by having at the tip of our tongue what we do and why we matter and why we should be supported and why DH makes sense. (Those definitions of DH must be personal, and must vary, but how many of us, when asked to explain DH, go 'well, its kinda the intersection of...' – and you lost them at kinda). We need to think about the impact of our work, and why it is relevant. When asked, or queried, about this (either in a personal or professional setting) we should *know*. It really doesn't hurt to have learned a little about the background of our field, and its impact, and its successes, so we can throw in a few 'for examples' of when the blue-sky nature of research pays off, and for when the application of our research in the wider community works, and for some major problems that need to be solved about digital culture and use and tools and why we are the people to do it.

Individuals can find support in networks of scholars, and become active in communities (both DH and individual subject organisations); there is strength

in numbers. Individuals can take their digital identity seriously – let's show other scholars and other disciplines how best to proceed. We need to learn to play the academic game with regard to publications, though, and ensure all of our wonderful whizz-bangy tools are equally followed up with research papers in important places, which is the only way with which to maintain and improve our academic credentials at present. Individuals can promote and be the advocates for DH, and for DH-based research. We can also ensure that we support younger cohorts and students and young scholars who are just entering our field; it's our role to be ambassadors for DH in every way we can.

For those individuals who do have some management sway and some management clout, there is also plenty that can be done to push forward the digital humanities agenda within departments and institutions. More support and kudos can be given to digital scholarship and digital outputs within the humanities, and this becomes something that can be raised and pushed within institutional committee structures, to ensure they count for hiring and promotion and tenure. (Indeed, established devoted tenure track posts for digital humanities scholars may be something those in institutions that offer tenure could work towards). Issues of funding and employment for young scholars in the discipline should be watched out for, including the PhD and hiring/ qualification issue, but this is something that can be tackled through careful, watchful leadership. My main advice to those in DH management, though, would be to ensure that you fully embed your activities within institutional infrastructures: become indispensable. Get involved with academic departments and service areas. Provide advisory services and engage with as wide a spectrum of people within your institution as you can. Be ready to defend your staff and your projects in the current financial climate, and be forewarned.

There is also strength in numbers in management, in local, regional, national, and international communities. Collaborations should be entered into, rather than competition, to further imbed projects and people into the wider academic field. Strategies and policies should be developed to deal with the coming hardships that face us.

From an institutional point of view, building up a centralised record of all the individuals and projects involved in DH within an institution can facilitate new research, and build on existing strengths to make it clear where new research opportunities may lie. I would suggest that DH centres should integrate closely with library systems (and iSchools). Institutions can also support digital outputs being counted as research in the internal promotion of individual scholars. The establishment of teaching programs (such as the new UCL Centre for Digital Humanities MA in Digital Humanities, http://www.ucl.ac.uk/dh/courses/mamsc) provides essential training for young scholars entering our field, and institutions should look to the opportunities that exist in providing this graduate-level training which is sorely needed in our field.

Institutions can also encourage collaboration with other institutions, and provide facilities, for example, for visiting scholars, to encourage cross-fertilisation of teaching and research ideas.

The ADHO organisations can also do plenty to maintain and support research, teaching, and the DH community. Our digital presence should be (and is being) sorted out as a matter of urgency. Within those digital resources, ADHO and its constituent organisations should provide the community with the ammunition that is necessary to defend DH as a relevant, useful, successful research field. Information about the successes of DH can be pushed, including projects and initiatives that have been important to both our and other communities. The value and impact of DH can be documented and presented. A register of good projects can also be maintained. Best practice in the running of projects and centres can be encouraged, and advice given to those who need it in all matters DH. Collaboration should be fostered, and the associations should continue the work they are doing in supporting young scholars. If anyone has any further ideas, then please do contact the associations. They are there to help you.

My suggestions for funding agencies are relatively succinct; I am not sure how much leeway they have in providing funds at the moment, although it is worth saying that certain funders (more than others) have been and are being very supportive to DH, and are engaged with and listening to our community. We need financial support, both to carry out blue-sky research, and to build DH infrastructures. Funding agencies can also help with the sustainability of projects, and in wrapping up and archiving projects. They can aid, encourage, and facilitate collaboration and graduate research. Considering the large investment that has been made in DH, particularly over the past 10 to 15 years, it makes sense for them to continue supporting us to ensure our research comes to fruition, although we are all very aware of the changed financial academic world in which we live.

6 Conclusion

This chapter was a general overview of what I planned to say at DH2010, although the spoken plenary digresses from the written record in places. It is an honest tour of what DH means to me, and some of the issues with which DH is presented at the moment. It has been necessarily negative in places. I hope I have left you with the feeling that there is proactive activity which we, as individuals, departments, institutions, organisations, and agencies can take to further entrench ourselves in the humanities pantheon and to demonstrate that we really are indispensible to the humanities, and to the academy.

It's worth saying a few words on what the impact of the plenary was: I briefly became a hashtag on Twitter as the DH community discussed what I

had said (I mounted the original text of the keynote immediately after the speech at http://melissaterras.blogspot.com/2010/07/dh2010-plenary-present-not-voting.html, and the video of the speech can be viewed at http://www.arts-humanities.net/video/dh2010_keynote_melissa_terras_present_not_voting_digital_humanities_panopticon). Over a thousand people have now viewed the speech online, which also was featured twice in the *Times Higher Education Supplement* (Cunnane 2010; Mroz 2010), and has even been translated into Japanese (Kodama 2010). Many individuals took the time to contact me about their own experiences, and offer their support. There has been some inevitable snark: some scholars from King's did not like that I brought up the redundancy program at King's; they had expected that I would use the time to say something placid and non-confrontational. I argue that if you have the opportunity, you should use it constructively.

I don't know what is going to happen with Transcribe Bentham, whether the project itself will be a success, or whether we'll still have a funded project to talk about in even six month's time, but for me it is part of the learning curve to distil and understand how our current research aims fit into the current academic framework. One thing I do know is that Jeremy Bentham would have loved the fact that a picture of his manky embalmed head had been broadcast on a giant screen at King's College London (especially when involved with a speech that raises issues about KCL!). I enjoyed having the chance to talk through my thoughts about Transcribe Bentham, and the digital humanities in general. I look forward to the plenaries in the following years at the digital humanities conferences, and I hope relatively young scholars continue to ruffle a few feathers. See you on Twitter (@melissaterras), in the Panopticon.

References

Arts and Humanities Research Council (2009), 'Leading the World: The Economic Impact of UK Arts and Humanities Research'. http://www.ahrc.ac.uk/About/Policy/Documents/leadingtheworld.pdf. Date accessed 12 October 2010.

@DrGnosis. (2010), Tweet, 4:10 p.m., 7 July 2010.

BBC News (2010), '"One in 10" UK Graduates Unemployed', 1 July 2010. http://www.bbc.co.uk/news/mobile/10477551. Date accessed 12 October 2010.

Bentham Project (2009), 'The Auto-Icon'. http://www.ucl.ac.uk/Bentham-Project/Faqs/auto_icon.htm. Date accessed 12 October 2010.

Bobley, B. (2010), Tweet, 2:53 a.m., 17 June 2010. http://twitter.com/brettbobley/status/16353177883. Date accessed 12 October 2010.

British Academy (2004), '"That Full Complement of Riches": The Contributions of the Arts, Humanities and Social Sciences to the Nation's Wealth'. http://www.britac.ac.uk/policy/full-complement-riches.cfm. Date accessed 12 October 2010.

Browne, J. (2010), 'Securing a Sustainable Future for Higher Education. An Independent Review of Higher Education Funding and Student Finance'. 12 October 2010. www.independent.gov.uk/browne-report. Date accessed 12 October 2010.

Cohen, D. (2010), Tweet, 6:13 p.m., 26 March 2010. http://twitter.com/dancohen/status/11102790690. Date accessed 12 October 2010.

Cordell, R. (2010), Tweet, 12:25 p.m., 29 March 2010. http://twitter.com/ryancordell/status/11244268587. Date accessed 12 October 2010.

Croxall, B. (2010), Tweet, 9:54 p.m., 23 May 2010. http://twitter.com/briancroxall/status/14578266190. Date accessed 12 October 2010.

Cunnane, S. (2010), 'As a Discipline, We Suck Online', report on DH2010 Keynote in *Times Higher Education*, 15 July 2010. http://www.timeshighereducation.co.uk/story.asp?sectioncode=26&storycode=412549&c=1. Date accessed 12 October 2010.

Elliott, T. (2010), Tweet, 4:06 p.m., 24 June 2010. http://twitter.com/paregorios/status/16935662168. Date accessed 12 October 2010.

Foucault, Michel (1975), *Discipline and Punish: The Birth of the Prison* (New York: Random House).

French, A. (2010), Tweet, 4:22 p.m., 21 April 2010. http://twitter.com/amandafrench/status/12582195866. Date accessed 12 October 2010.

Grant, M. (2010), *Provost's Newsletter*, 29 March 2010. (London: University College London). Available at http://digitool-b.lib.ucl.ac.uk:8881/R/U6QRH22V7VJVGGSI6GS7YSH8YG2XIIKMALKR53LCPQC42YJJ9H-00795?func=results-jump-full&set_entry=000025&set_number=000160&base=GEN01. Date accessed 12 October 2010.

Harte, N. (1979), 'The Admission of Women to University College, London : A Centenary Lecture'. Pamphlet (London: University College London).

Harte, N. (1986), *The University of London 1836–1986: An Illustrated History* (London: Athlone).

Harte, N., and North, J. (1991), *The World of UCL, 1828–1990* (London: University College London).

Holley, R. (2010), 'Crowdsourcing: How and Why Should Libraries Do It?' *D-Lib Magazine* March/April 2010, 16(3): 4. http://www.dlib.org/dlib/march10/holley/03holley.html. Date accessed 12 October 2010.

Katz, J. E. and Rice, R. E. (2002), *Social Consequences of Internet Use: Access, Involvement, and Interaction* (Cambridge, MA: MIT Press).

Kodama, S. (2010), *Translation of Present, Not Voting: Digital Humanities in the Panopticon*. Available at http://www.dhii.jp/dh/dh2010/DH2010_Plenary_trans_by_kodama.html. Date accessed 12 October 2010.

Landrum, S. (2010), Tweet, 9:45 p.m. 15 April 2010. http://twitter.com/cliotropic/status/12243330614. Date accessed 12 October 2010.

Mroz, A. (2010), 'Leader: Members-Only Code Is Outdated'. Report on DH2010 Keynote in *Times Higher Education*, 15 July 2010. http://www.timeshighereducation.co.uk/story.asp?storycode=412539. Date accessed 12 October 2010.

Nowviskie, B. (2010), Tweet, 11:59 a.m. 29 June 2010. http://twitter.com/nowviskie/status/17324005264. Date accessed 12 October 2010.

Pears, I. (2010), 'The Palaeographer and the Managers: A Tale of Modern Times'. Future Thoughts Blog. http://boonery.blogspot.com/2010/02/palaeographer-and-managers-tale-of.html. 27 February 2010. Date accessed 12 October 2010.

Porter, D. (2010), Facebook Status Update, 18 February 2010, 15:37.

Ramsay, S. (2010a), 'Algorithms Are Thoughts, Chainsaws Are Tools'. http://vimeo.com/9790850. Date accessed 12 October 2010.

Ramsay, S. (2010b), Tweet, 8:10 p.m. 15 March 2010. http://twitter.com/sramsay/status/10532995569. Date accessed 12 October 2010.

Ramsay, S. (2010c), Tweet, 8:12 p.m. 15 March 2010. http://twitter.com/sramsay/status/10533053354. Date accessed 12 October 2010.

Ramsay, S. (2010d), Tweet, 8:13 p.m. 15 March 2010. http://twitter.com/sramsay/status/10533079350. Date accessed 12 October 2010.

Sherratt, T. (2010), Tweet, 2:21 p.m. 4 July 2010. http://twitter.com/wragge/status/17719837474. Date accessed 12 October 2010.

Siemens, R. (2010), Tweet, 4:33 a.m. 30 April 2010. http://twitter.com/RayS6/status/13108171972. Date accessed 12 October 2010.

Tanner, S. (2010), Tweet, 8:03 a.m. 30 June 2010. http://twitter.com/SimonTanner/status/17396576778. Date accessed 12 October 2010.

Theibault, J. (2010), Tweet, 2:43 a.m. 19 June 2010. http://twitter.com/jtheibault/status/16512576778. Date accessed 12 October 2010.

Universities and College Union (2004), 'HE Pay Framework Agreement'. *Pay and Conditions*. http://www.ucu.org.uk/index.cfm?articleid=1922. Date accessed 12 October 2010.

University of London (2010), 'About University of London: A Brief History'. http://www.london.ac.uk/history.html. Date accessed 12 October 2010.

11
Analysis Tool or Research Methodology: Is There an Epistemology for Patterns?

Dan Dixon

Introduction

Intuition and pattern recognition are, consciously or unconsciously, used across all realms of rigorous enquiry, from both hard and soft sciences to the humanities, as well as in more applied disciplines. In fact, it could almost be said to be the one common factor in all their approaches to knowledge generation. In many disciplines pattern recognition is often dismissed as merely a means of achieving inspiration or getting that first hunch along the route of enquiry. However in the digital humanities it can sometimes seem that the search for patterns can be an end in itself.

The digital humanities seem to be very concerned with patterns, and across many works the concept conflates the ideas of shape, graph, structure, and repetition. Browsing through the literature, the term pattern appears, and tends to be used in a very unproblematic manner. In many cases it is used to mean a wide variety of different relationships in the data, massively dependent on the project and the researcher. They can be used to discuss the shapes that emerge in graphs, the statistical accounts of data sets, or the emergence of relationships that to that point had been unseen.

In the narrower definition of humanities computing (Svensson 2009), using computational and data-driven approaches to reinterpret texts, it is usually new structures that are sought. These are ones that would not be readily apparent to a human reader and require the brute force, or transformation, that computational methods bring which are usually difficult, boring, or physically improbable for human researchers to carry out. However, the problem is that the term 'structure' comes with a century of baggage from structuralism and it is difficult to escape the connotations that go with it. It would seem that pattern is often used as a new term with an optimistic hope that it has none of the baggage that

structure does. Patterns come up as a shorthand for the shapes and structures that are spotted by human researchers from the information returned by computational processes. But the nature of what patterns are and their status as an epistemological object has been ignored.

Even beyond the digital humanities there is no rigorous philosophical approach to the concept of patterns (Resnik 1999). There is a long tradition of thinking about structure, relationships, difference, repetition, and similarity, but nothing specifically about the idea of the pattern, especially if this is to be treated as a special epistemological concept. It is strange that given our human propensity for pattern recognition, and the continual reliance on the concept across all disciplines, that we have not developed a deeper philosophical investigation of patterns themselves.

This chapter is not intended to be that rigorous philosophical investigation of the idea of the pattern, but instead to present some practical perspectives on the nature of patterns, pattern recognition, and the limits of knowledge that we can expect using patterns as a method of analysis. There is a massive body of work across the twentieth century that is either explicitly or implicitly based on the idea of structure, relations, and patterns. This is a burgeoning topic that needs attention, and this chapter can do no more then scratch the surface. It is intended to be a pragmatic attempt to raise some of the questions that would allow the use of patterns as a justifiable knowledge generation and validation technique. However, many of these issues are very substantive and reach further into old questions in epistemology than even the concept of patterns do by themselves.

The main argument in this chapter is that the study and use of a particular approach to patterns has had much success in interventionist or normative types of enquiry, namely design and action research. In these situations, due to the contextual nature of the knowledge, value judgements in relationship to their utility can be made rather than abstract and generalisable truth judgements on the nature of the patterns. Based on this theoretical background, patterns can be justified as part of the process of enquiry in any type of research, but not by themselves as an end; they are part of the process, not the product.

This approach to patterns can apply across many of the clusters of practice that appear in the diverse and quite different areas or typologies of what is coming to be called digital humanities, but this idea is more relevant in some areas than others. Tara McPherson (2009) outlines three quite different areas of development of digital humanities. First there is the relatively established field of humanities computing, which focuses on using computers and information technology to create tools, infrastructure, standards, and collections. Then there are the blogging humanities, which use networked media, and the possibilities of the Internet for collaboration to undertake its projects. Finally there are what McPherson calls the multimodal humanities, which bring together

scholarly tools, databases, networked writing, and peer-to-peer commentary, often using the technologies and tools that they are themselves studying.

While each have a different purpose for using computers and the Internet as part of their research, they each understand the underlying technical capability required and the transformation effect of applying technology to very traditional approaches to the centuries-old tradition of the humanities. It is in the first type outlined above, the computational humanities, that this discussion of patterns arises and is of most relevance. It is where computing is applied to the transformation analysis of individual texts in all mediums, or of meta-textual analysis of archives made possible through digitisation, metadata, and databases.

Outline

This chapter is broken down into five further sections and concludes with many open questions about the nature of patterns, their uses, and how they can be justified.

The first section will briefly explore the nature of pattern recognition from a psychological perspective, focusing on a viewpoint from cognitive psychology. Our capability to find patterns is a fundamental part of our sensory and thinking processes.

Next there is brief outline of the occurrence of patterns in systems theory–influenced research and I present the idea that patterns are emergent, repeated, observable phenomena that can be used to understand the underlying systems.

Then there is a discussion of how these patterns can be located epistemologically within a continuum of knowledge creation, from scientific enquiry through to action research.

Which leads on to Charles Sander Pierce's concept of abduction and scientific process. The psychological condition of apophenia, the pathological tendency to spot patterns where there are none, is presented as a contrasting principle to the useful process of abduction.

Finally an instrumental epistemology is proposed that puts patterns in as part of the process, not the product of the process. This is supported by discussing the wider nature of scientific process and comparing it to action research, while asking where digital humanities projects can, or should, be located in this framework.

Psychology and patterns

Pattern recognition, or stimulus equivalence, is a fundamental capability of all animals, but is still difficult for psychology to fully explain. It is a core

function of information processing and part of all our sensory stimulus. However, it is not a simple phenomena and psychologists are still divided on how it functions. Although it is recognised that the entire neurophysiological and psychological pathway between sense organ and the higher brain function is involved, researchers are still split on where the most vital aspect of the process occurs (Kalat 2009).

In the early twentieth century gestalt psychologists were very interested in pattern recognition as part of their work on perception, and their gestalt principles all describe various forms of pattern recognition and shape matching (Enns 2005). These principles such as *prägnanz*, the tendency to selectively perceive symmetry and order, or reification, where shapes are inferred from incomplete data, are all forms, or categories, of pattern recognition. However, as they observed, pattern recognition was not one single, simple phenomenon, so they created these categories of visual conditions under which patterns and shapes would be perceived or mentally completed.

Currently pattern recognition is a large and active part of cognitive psychology, a theoretical approach which is very concerned with information processing. It was possibly even one of the first questions raised in this field (Juola 1979). Cognitive psychology is also very closely linked to computer science, and research on biologically based pattern recognition is often then applied to computer-based sensory experiments and insights from computer vision are applied to human psychology experiments.

Within cognitive psychology there are two main competing theories for how pattern recognition works: template matching and feature analysis (Neisser 2005). In template matching the stimulus is compared to a mental model, or template, that is based on past experience and represents the shape or structure in memory. The shape is somehow held in memory as a complete, holistic structure. This template is able to be applied even in situations where the shape has been rotated, enlarged, or transformed. In feature analysis, the visual stimulus is broken down into key features and then the relationships between these key features or pattern are compared to features in memory. Where there is a connection between similar sets of key features, a pattern is recognised.

Two main points derive from this. Firstly, from the gestalt theory, that patterns and shapes are constructed from quite different visual stimuli. When we perceive, we can see similar shapes and patterns in quite different data visualisations. This means that care needs to be taken when comparing patterns across different texts, data sets, and visualisations. We are very good at spotting possible patterns, but not necessarily in being able to use these as objects for comparisons in and of themselves. The second point is that pattern recognition can be seen as matching the incoming visual stimuli to existing mental models. This means we tend to see patterns and structures that we have already

encountered. This means that we cannot spot patterns we haven't encountered before, and have a tendency to seek out patterns or structures that we have seen before, and possibly even to see patterns where there are none – the concept of apophenia as discussed below.

Much of the research carried out in pattern recognition is in the area of visual patterns because this is our richest sensory input. Much of the recent work in the field of digital humanities is in attempting to create new visualisations of existing texts, using the capabilities that computers give us to create new, transformational representations. The role of different senses in spotting patterns in data has not been very well explored and this is an area that could be open to more explorative or playful approaches to finding new shapes and patterns in data.

Patterns and systems

Now I turn towards a discussion of some key examples of the use of patterns within research influenced by systems theory. This starts with Gregory Bateson's multidisciplinary work and then moves on to Christopher Alexander and his influence on design and design research. Through this I propose a more formal definition of patterns based on the work of Alexander: that patterns are repeated shapes and structures which are the observable features of an underlying system.

The concept of patterns recurs throughout the interlinked fields of systems theory, cybernetics, complexity, systems, and information theory. Systems theory is a late-twentieth-century concept that has had a major impact across many disciplines, from the humanities to the hard sciences. It developed from the cybernetic thinking that emerged from the interdisciplinary Macy Conferences in the late 1940s, which included, but were not limited to, anthropologists, computer scientists, sociologists, and mathematicians. However, many of the participants of these conferences had been working on these system concepts for some time before meeting after World War II.

The common feature of all these systems-based approaches to patterns is that repeated, physically observable features are recognised as emergent and convergent principles that reveal underlying forces and processes.

One of the earliest discussions of patterns, in a systems-theory light, appears to be from Gregory Bateson (2000),[1] one of the key participants in the Macy Conferences. During some of his wildly freewheeling classes he would sometimes pull a dead crab out of a bag and ask students to describe the structures before them. He would ask his class to think about the reasons why the crab had various forms of symmetry and similarity. Why were the pincers the same size as each other, or why were the legs and pincers similar? What purpose could they deduce from looking at the structure of the crab?

In the 1940s Bateson was primarily working in the field of anthropology and was examining culture. He was working on creating structures of relationships between what he called 'bits of culture', and he was looking for patterns in these structures of relationship. His approach differed from the existing symbolic and linguistic doctrine of structuralism; what he was doing might have been more akin to what we would now call social network analysis. The patterns he was spotting were commonalities in relationship structures within a culture or across different cultures. Later in his multidisciplinary career he would start to look for common patterns across wildly different systems, that is, between zoology and psychology (Bateson 1988). These patterns are common structures that occur in the human and natural world, and are represented in various forms that cut across, or transcend, academic disciplines. He called these common structures 'meta-patterns' and called for a 'meta-science' to study these. Being a truly multidisciplinary thinker, he called for a multi- or transdisciplinary approach to looking at common patterns wherever they occurred, in whatever material and in whatever discipline.

Although Bateson's call has never really been answered, it is not the case that he has been completely ignored. His thinking on meta-patterns has been recently resurrected by the ecologist Tyler Volk, who intends them as a way of unifying knowledge and enquiry in science and humanities (Volk 1996; Volk et al. 2007). Although these principles are meant to apply across all disciplines they do tend to be very naturalistic and inspired by the physical world.

Examples of these Bateson/Volk meta-patterns are universal concepts that span disciplinary explanations, for example the meta-pattern *spheres*, where roundness occurs in a wide variety of scales and places, and where there is a tendency towards a spherical shape in three-dimensional space-filling networks. The *sphere* is a pattern that minimises surface area by volume, has no stress points, and is approached, but never perfectly reached, in physical objects like stars, animal skulls, or fruit. A second meta-pattern is the principle of *Binaries*, which features in concepts such as electrical charge, bilateral symmetry and structural linguistics. A final example is *Sheets*, such as leaves, flatworms, and wings, which maximise surface area, can be flexible, and are able to capture other matter.

Although Volk is carrying on the tradition of Bateson, he is not unique among ecologists. Patterns and structures in the overall system, rather than the individual objects, are the important thing for ecologists. This applies to biological ecology and also to where ecological principles are applied to other fields, such as media ecology:

> Ecologists focus more on dynamic systems in which one part is always multiply connected, acting by virtue of those connections, and always variable,

such that it can be regarded as a pattern rather than simply as object. (Fuller 2005)

Most recently a thread of pattern thinking has been popularised via Software Engineering and Interface Design. This can be traced back to Christopher Alexander's *Timeless Way of Building* (Alexander 1979), which uses patterns as a design methodology for democratising architecture and urban planning. Alexander is a self-professed systems thinker and architect, and it is reasonable to assume that he was aware of Bateson's meta-patterns as well as Buckminster Fuller's discussion of patterns in architecture (Fuller 2005). Contemporary uses of patterns in this tradition cover fields such as pedagogy, ubiquitous computing, mobile social software, moderation, wiki creation, computer supported cooperative work, and game design (Dixon 2009).

Christopher Alexander was using patterns as a way to identify and replicate living spaces that had what he called *the Quality*, which is perhaps more appropriately described as habitability; that is that they efficiently and enjoyably support everyday human social, cultural, and physical processes. Although he was cataloguing and recording physical structures, he was interested in a system of social and psychological forces that underpinned day-to-day life. He saw livable, habitable buildings as representing good approaches to managing the space of everyday life. Habitable urban and architectural features were ones that represented a balancing of underlying social, cultural, and physical forces.

This balance of forces is maybe most evident in his larger-scale patterns for regions and towns, for example in 'city country fingers' the forces being balanced are urbanisation, the need to be near work and infrastructure, while wanting to be close to nature, as well as his prescient predictions about very current issues, like lowering food miles (Alexander 1979). In the 'scattered work' pattern, the forces at work are issues such as work–life balance, education, transport, noise, and pollution (Alexander et al. 1978: 21). These are also apparent on a much smaller scale when he talks about the physical forces involved in 'column connections' (Alexander et al. 1978: 1068) or the infrastructure demands in 'duct space' (Alexander et al. 1978: 1076). Generally though, the forces are more human, like the need for sleep, work, or food.

At the heart of all these pattern-based approaches is a systems view of the world, and in particular one based on a complex systems approach. These complex systems of culture, mathematics, or physics are inherently difficult to understand and any attempt to rigorously describe or model them will fail to capture the completeness of the system. This obviously raises many problems for academic enquiry into these areas, and is especially problematic when study of these systems is intended for normative purposes or some form of timely intervention is the desired outcome.

The patterns, or recurring structures, that each of these approaches describe are the emergent features that are easy to perceive and recognise. They are stable emergent structures of the underlying systems that all of the researchers above are actually trying to access. The pattern is a means to an end – a design tool, not the design.

The study of patterns is therefore a morphology of these structures, not just for their own sake, but to analyse the underlying forces, the network structure, or the system that is actually of primary concern. They are a means of gaining a useful and timely understanding of a complex system through examining the evolutionary balancing of the forces that created the patterns without having to have a complete, and fundamentally impossible, understanding of the systems that self-balance those forces (Dixon 2009).

These patterns may be multiple steps removed. Alexander catalogues the patterns of buildings to get at the systems of human habitation. The common structures of 'undesigned' houses show the physical systems of building, which reveal the social systems of human habitation. Bateson and Volk link together the various systems in the natural world, from organisms to ecologies to astrophysics.

All of the systems discussed above change over time, even if it is only very slowly. In these examples the systems that create these patterns tend to evolve or self-organise in some manner, although these evolutionary processes do not necessarily have to be entirely natural and, especially so in the architectural example, must also be socially and politically determined. However, the common feature of patterns in these approaches is that they are the common structural forms that emerge from this natural, or partially natural, evolutionary complexity. They are the shapes that repeat themselves because they are, as Alexander would say, optimal solutions to common problems (Alexander 1979).

The main benefit of using patterns as a method for system understanding is that one does not have to model the overall system in any way, or create abstract interpretations. The patterns provide an intermediary stage for analysis, as well as signposted routes into the most important parts of the system. They are an empirical result, observed in situ, emerging directly from the systems being examined. Thus they can be used as a way to understand the underlying forces and processes of the system.

These patterns are not an abstraction or a model for the system. The activity of observing, collecting, categorising, and analysing these types of pattern is not like modelling or trying to replicate the system, it is an empirical process.

Having outlined what patterns are, here are some things they are not. They are not models of the system; they are structural representations of elements within them. They are not metaphors or analogies for emergent properties of a system; they are physically present and not re-interpreted. Neither are they

maps, graphs, or diagrams of an entire system; they are descriptions of emergent features of those systems. They are not created; they are documented and described.

Given that patterns are common structural elements that identify localised evolutionary sweet spots, how do we go about identifying what these structural elements should look like in new fields of study? This is easy when we think about architecture, or the physical world, but what about history, culture studies, or politics? What are the telltale structures for those systems and how might we create software that helps us surface those structures?

Epistemic orientation

The next step point is the relationship between the concept of a pattern and the way that it can be validated as a epistemic construct. Locating the digital humanities among the variety of approaches to knowledge generation and reflexively understanding the forces which push it around is important.

There are a range of different approaches to knowledge generation that can be mapped onto a continuum determined by their level of normativity and the degree of contextuality versus generality. This relationship between the various forms of enquiry is outlined in Table 11.1. At one end of the spectrum the natural, or hard, sciences attempt to take a detached position to enquiry and seek universal facts or truths. At the other end of the spectrum are interventionist projects, where the knowledge generated can only be assumed to work in the context in which it was discovered and on the project that it is being used. With methodologies such as action or design research, generalisations beyond the task and situation at hand are difficult to perform or justify. The knowledge may only be valid at that point in time for the very reason that the researchers will be actively effecting change and modifying the field of research. Interpretative enquiry sits somewhere in the middle, trying to make generalisable knowledge claims based on context and relativity, but always being in a position of having to make value judgements based on subjective relationship to the area of study (Aakhus and Jackson 2005).

While this is a gross simplification of all these areas, it does provide a platform for understanding the relationships between them and a handy way to

Table 11.1 Continuum of knowledge from applied to abstract

	Goal	Normativity	Abstraction
Positivist/Empiricist Natural science	Describe	Detached	Universal
Humanities	Critique	Normative & involved	Contextual
Action Research Design as research	Design	Intervention	Situated

fit research along these two scales of normativity and abstraction. This spectrum also doesn't hold up for all ways of viewing or describing these three approaches, and the epistemic basis for all three can be justified in very different ways, but it is a helpful abstraction.

An issue with humanities computing is that researchers often appear to be dragged towards more scientific interpretations and methods for their research. This could be because there is a researcher bias towards these methods. Many people involved in projects are computer scientists, or those capable of working in this field. Therefore there will be those more familiar with such research methods and attracted to modes of enquiry and the knowledge claims that one can make from these processes. Another possibility for a drift towards the scientific could be the nature of the tools and results themselves (Sculley and Pasanek 2008). The production of data, the visualisation approaches, and the mechanisms for their production have more in common with the hard sciences. So it is only natural that there is some possible confusion and questioning of the borderline between interpretative humanities and the descriptive and explanatory approaches of hard science (Raben 2007).

The patterns presented by Bateson and Volk come from scientific tradition, and Bateson was surely not naively calling for a meta-science of meta-patterns. He intended meta-patterns to be studied as a science, and Volk's work, especially his position in a scientific discipline, further cements the meta-patterns approach as scientific.

The architectural, software, and interface patterns influenced by Alexander's work fit into the bottom level of Table 11.1, in the fields of Action Research and Intervention. Patterns identified and used can be judged on their practical effectiveness in making actual change, rather than needing to be generalised and tested for validity on a more universal scale. The correctness of patterns is therefore within the scope of the project or activity, and needs only be valid for the participants.

As such there has been a recent growth in pattern-based enquiry following the Alexandrian thread. His use of patterns is intentionally grounded in design; he is first and foremost an architect, and although he did publish a collection of his patterns, he claimed that they were not complete and not necessarily right.[2] His process of using patterns was intended to identify a new pattern language for each project, including patterns that might be very particular for the type of building project he was working on. So a psychiatric hospital would draw on a different set of patterns than that of a college campus. There might be some things in common, but there would also be many special cases that would apply only to that type of project. Additionally, as the process is participant-driven, they were expected to research, document, analyse, and use new patterns (Alexander 1979). Thus each new project would have a contextual pattern language created and explored specifically for itself.

The other aspect of the Alexandrian method is that the patterns are not intended to be considered or used separately; they are, as he describes them, a language. Patterns in this sense are not a static set of knowledge, but instead a process; a design tool, not a design (Dixon 2009). In this sense it is worth noting that there seem to be parallels to explore in the relationship between structuralist linguistics and Alexander's approach. However, one of the key differences is that Alexandrian patterns are cataloguing the emergent physical patterns, and structuralism is looking at the repetition of the underlying relationships in language.

Patterns become a tool, rather than a product of a research process. They are useful contextually within the process, and can be validated within the context of the project and against the other methods being used. There is still the problem of identifying useful and valid patterns, because not every shape or structure seen is useful or valid, and it is very easy to see patterns where there are none and end up in the realms of apophenia and numerological digressions.

This leads to Peirce's Pragmatic framework for science and knowledge creation. This is a framework where scientific research is wrapped in a historical or genealogical framework that at a wider scale looks surprisingly similar to action research. The concept of patterns falls outside the accepted low-level frameworks of scientific research, but very much falls into the type of abductive reasoning that Peirce describes as the way ideas and inspiration are found in the natural sciences.

Abduction and apophenia

The principle of abduction was proposed by Charles Sanders Peirce, the founder of pragmatism, as a formalisation of the hunches, guesses, and intuition that help the natural sciences. He discussed it as a third, necessary but ignored, part of the logical scientific process, along with the traditional forms of deduction and induction (Burch 2010). Abduction is the method by which hypotheses are created or discovered; induction and deduction are the methods by which they are proven.

Abductive reasoning is, simply put, the spotting of patterns and relationships in sets of data. Pattern recognition as a process exists within the context of any form of enquiry even without specifically foregrounding the notion of patterns. Seeing patterns, or abductive reasoning, is a necessary part of the scientific or critical process and is used across all disciplines. However by itself it is not valid, and patterns spotted by hunches and intuition need to be validated or the process can degenerate into mere apophenia.

Abduction was the third type of reasoning that Peirce formalised, along with deduction and induction. In deduction a premise is reached by purely logical,

a priori reasoning: *A* therefore *B*, and *B* therefore *C*, leading to *A* therefore *C*. Induction is the principle of repeated testing. If *B* follows from *A* in all observed cases, then that would be a good theory for all cases in the future.

Abductive reasoning is different in that no logical or empirical connection is required, merely spotting patterns in the data. The results of abduction, however, are not necessarily logically or scientifically coherent; they need to be properly tested, either deductively or inductively, or both. This three-step process of abductive hypothesis forming, deductive theory construction, and inductive empirical testing was the basis of Peirce's three-part iterative scientific process. This process has been actively adopted by many interventionist-driven processes of enquiry, which I will discuss more in the next section.

If abduction is seeing patterns where there are patterns and creating the correct interpretation, then apophenia is its natural foil. Apophenia is the experience of seeing connections and patterns where there are none and ascribing excessive meaning to these situations. This is the experience that leads to such things as conspiracy theory and numerology.[3] The concept, first put forward by Klaus Conrad as a description of psychosis, has become a broader description of the same experience in sane individuals (Dansey 2008). Although working from the same principles as abduction, in that it is fitting a pattern of connections to a random set of data, the experience is one that is not validated through either deductive or inductive reasoning. In fact, in cases of mental illness the individuals will stick vehemently to their abductive reasoning and will remain unconvinced by deductive or inductive reasoning. It is pattern recognition gone wrong, seeing only the pattern expected, no matter what data leads to it. In using patterns as a tool, or form of enquiry, it becomes the opposite of abduction. It is false hypotheses based on incorrect patterns.[4]

Another aspect of pattern recognition is the difference between natural, evolutionary patterns and designed patterns. When I say natural and evolutionary, I am getting at processes that may be, solely or in a mix, physical, biological, social, psychological, technical, and political, of sufficient complexity and occurring over a long period of time. Compare these to designed situations, and structures created with conscious agency, and we get very different types of patterns. Additionally, if the process of identifying the patterns is one where the data is significantly changed and, consciously or unconsciously, agency is effected on that data, then the resulting patterns also show the effects of that agency. The patterns will now be designed, not discovered; artefacts of observation. Whereas apophenia discovers anti-patterns with no validation, design can retro-engineer patterns into an pre-selected normative model.

So the process of spotting, discovering, or finding patterns requires both care to not break them by moulding the data to fit preconceptions as well as not being over-zealous in finding meaning where there is none. And in all cases being able to perform some form of deductive or inductive reasoning to

validate the pattern's existence. Rather than a theory for what patterns are then, a methodology for using patterns that fits with Peirce's three-part method, is what is needed.

An interventionist epistemological basis

If a robust methodology for the use of patterns in any discipline is required, and patterns have been used effectively in interventionist methodologies, then it would be sensible to examine the theory behind an established field like action research. Action research is not chosen at random; it is an area where there has been a great deal of work on justifying the techniques, results, and knowledge generated. As a practice it is far removed from positivist science and regularly has had to defend its practices against often antagonistic opposition. So action researchers have developed a rigorous process and epistemological stance to deal with these debates and objections:

> Action research aims to contribute both to the practical concerns of people in an immediate problematic situation and to the goals of social science by joint collaboration within a mutually acceptable framework. (Rapoport 1970)

Design research is a much more recent discipline and doesn't have the tradition of justifying itself using this kind of theoretical approach, but all forms of interventionist research could be justified using the theoretical background of action research.

Through examining a research methodology like action research and contrasting it with traditional science, a starting point for an epistemology of patterns could be extrapolated and applied to both interpretative and scientific endeavours. Based on the Peircean approach we can use patterns as a formalisation of the abductive part of the process.

Action research academics in many ways do position themselves very consciously in opposition to scientific research. They describe action research as favouring:

- Understanding over explanation
- Making things happen over prediction
- Conjecture over deduction/induction
- Engagement over detachment
- Action over contemplation

According to action research, positivist science has many deficiencies in generating knowledge for solving problems. The way the natural sciences are

epistemologically constructed doesn't specifically seek to solve human problems. Action research, however, is intended to be a problem-solving methodology. It can also base its legitimacy as a science on strong philosophical traditions that are different from traditional positivist science. The viewpoints of the following interconnected philosophies are core: Marx's praxis; hermeneutics; existentialism; pragmatism; process philosophy; and phenomenology (Susman and Evered 1978).

Marx wanted philosophy to be a practical activity and the philosopher to take a critical position in the world. His practice of philosophy is intended to change the world, and, in doing that, one is also personally changed. The idea of the hermeneutic circle is that there is no knowledge without presuppositions, that interpretation is historically re-shaped, and different interpretations can freely co-exist. Existentialism brings individual choice, empowerment, and the possibility for action to the researcher. It makes researchers consciously aware of their connections and involvement in the world. Phenomenology points to the importance of the immediate subjective experience rather than distant objective science; our experience, viewpoint, and understanding as human beings are as important as factual knowledge gained through abstracting away from our unique viewpoint.

Possibly most relevant for this discussion though are the historically interlinked traditions of pragmatism and process philosophy. These both present non-traditional epistemologies where knowledge can only be understood through how it comes about, not in an ahistorical and abstract manner.

Process philosophy puts *things* in the background and focuses on the doing of learning, understanding, or researching; the practice is important, not the product. The processes are complex and made up of many stages or phases; they have a temporal element and there is a structure or shape to them. So it is an underlying philosophy for dynamic systems, naturally supporting change over time, and the concept of evolution (Rescher 2009). Via the pragmatic philosophy of Pierce, James, and Dewey, we get the iterative learning/research cycle (usually known as the Kolb cycle) and the idea that there is no ultimate positivist truth, that the truth of anything can only be judged in how useful it is contextually to the individual (Hookway 2010).

Most of these underlying assumptions are contrary to traditional science, which assumes its methods are value-neutral, that people are only ever objects of enquiry; it eliminates the role of history in the knowledge-generation process and assumes that there can be a denotative language to describe it (Susman and Evered 1978).

However, in a wider context, the practice of science and technology does function like instrumental modes of enquiry (Stephens et al. 2009). At the micro level science uses traditional scientific technique, but on the larger scale, good scientific practice looks like it is wrapped in action research. Iterative

cycles of abductive reasoning are followed by deductive or inductive thinking, leading to rational and justifiable discoveries. The cycles continue with the abductive reasoning informed by previous cycles of enquiry; knowledge being built upon and inspired by rounds of abductive reasoning, intuition, and the practical concerns of doing science.

What this means is that patterns can be used as a valid part of any scientific process, but not necessarily as a scientific product. Pattern recognition, or a refined framework of patterns, such as Alexander's, can be used as a method to obtain inspiration and point the researcher in new directions. In this case it is easy to justify the use of patterns as part of this cycle rather than an output of the process, as, say, a scientific fact might be an output. They have a validity and a usefulness within the context of the scientific enquiry but cannot be abstractly justified outside that process.

So far the discussion in this section has been concerned with linking scientific research to action research. The two ends of the spectrum of normativity and abstraction are presented in Table 11.1. Partly this is because the literature seeks to show the relationship and linkages between action research's very practical, human, and engaged research, and the objective, distanced natural sciences. Partly, because through showing that this applies to scientific research, it can also be applied to the humanities, which sit within the continuum between these two seemingly opposed research epistemologies. Which leaves us able to justify the use of patterns, either as the simple recognition of shapes and structures already familiar to us, or through the more systemic approach of emergent, repeated structures.

Conclusion and further questions

This chapter is intended to raise more questions than it answers and to question the use of patterns as an epistemological object. It proposes the idea that patterns are a valid part of the process of enquiry, or a way to seek inspiration. This places the concept within the background epistemology of pragmatism, where the overall validity can be demonstrated via its usefulness. However, this is an incredibly general approach and provides a very practical and pragmatic, in the usual sense of the word, approach to discussing patterns.

There is a great deal of space to develop this idea of patterns further and see if there is something more to it than just pattern recognition, abduction, and intuition. Maybe there are generalisable approaches, or a methodology that can be developed. Patterns in their current uses appear to be various types of repeated structural forms, though this does raise questions about the commonality of these forms and the relationships between them across disciplines. What are the patterns for fields such as history, media studies, or linguistics?

Would patterns identified in individual texts replicate, and why would they do this?

Just as Bateson called for a meta-science of meta-patterns, is there, or could there be, a meta-humanities concerned with these patterns? Though as soon as these sorts of questions are raised it appears to be replicating exactly the same academic discussion that spawned the formalist and structuralist movements of the early twentieth century. Perhaps the time has come for the pendulum to swing back so that this style of thinking is again fashionable or there is a full cyclic revolution back to the same concerns that sparked off structuralism. Perhaps the transformational tools, techniques, and collaborations are now available that could give us new insights based on just such a formal approach.

Though a point worth making is that whereas structuralism was seeking to understand the hidden conceptual structures behind culture, much of the contemporary work in humanities computing is to actually make patterns in data apparent through various forms of information visualisation. There is a much higher level of importance placed on visual perception, and actually seeing shapes in the data. Which raises the question of whether we are seeking patterns where none exist, or creating them ourselves through the software and information artefacts that are made as part of the research process. If the process is one where the data is massaged until either the visualisations or statistics do tell us something, are we just practising the humanities' equivalent of numerology? Are we designing patterns where none existed in the first place and is there is an unavoidable tendency towards apophenia instead of pattern recognition?

At its heart, humanities computing is about turning a text into a system (or, depending on one's point of view, exposing an already existent system) and then performing new types of analysis. It is interesting that the concept and term 'pattern' comes up in a variety of systems theory fields. The earliest problems in cybernetics and information theory were concerned with patterns; in fact their definition of information was based in pattern as opposed to randomness. Pattern recognition is important in cognitive psychology as a key problem in mental information processing and cognitive psychology is predicated on a systems and informational model of the human mind. Now it makes its appearance in the digital humanities as a term used to describe a wide variety of interpretations of data, statistics, and structure. All of these disciplines are heavily predicated on the underlying concepts of the system and information, and now the digital humanities are as well because of their link to computer science and the use of digital forms of data. Patterns, information, and systems are highly interlinked and heavily self-referential concepts that have developed over the last 50 years.

At this point it is worth also raising the question as to the nature of these systems. How are these systems conceived; is there is a fundamental difference

between patterns of connections versus patterns in emergent physical, psychological, social, or political structures? The approach to patterns and systems described by both Alexander and Bateson is one based on the assumption that the underlying systems are evolutionary and not designed. If we are imposing systems on texts or archives, do we have the same kind of evolutionary context that are required to justify the emergence of patterns as systemic sweet spots?

It is also worth considering researchers' conscious or unconscious intentions when they digitise and systematise texts. Alexandrian patterns are emergent, repeated shapes or structures that don't necessarily indicate, or give a full understanding of the underlying systems or forces that create them. They are an empirical, descriptive, and documentary approach, not a theoretical one, whereas modelling is inherently abstract and theoretical. Suppositions, strategies, and connections can be made, but principally these are untestable until modelling or experimentation can take place. When most of the systems we are talking about are either large scale, or part of very human and non-replicable forces, it means that controlled experimentation is impossible. Of course, located and normative experiments, such as those that action research routinely carry out, are very possible, and are the only real option in many of these situations. Which means patterns could be useful as a way of understanding the balances of forces or local structure, but not a method or a route to model or describe the whole underlying system.

As said in the introduction, many of these are far-ranging questions that concern not only the concept of patterns, but also the interrelated concepts of information, systems, and epistemology. These are not easy questions to answer. However, it is straightforward to say that, as the study of systems and information has been steadily increasing in importance over the last century, and that patterns appear to regularly crop up in this genealogy of research, the study of patterns is going to also be of increasing importance, both in the digital humanities and beyond.

Notes

1. *Steps to an Ecology of Mind* was first published in 1972, but includes essays written over Bateson's lifetime. The chapter, 'Experiments in Thinking About Observed Ethnological Material', originally a paper presented in 1940, is the first place to outline his pattern-influenced thinking.
2. In publishing his list of patterns, and also publishing it before his process, he created a de facto standard for an architectural pattern language. It would probably have been better to communicate the process by keeping the list secret and making other practitioners go through the hard work of documenting and understanding the patterns. This tends to be the problem with pattern languages, that they end up being treated as merely collections of best practice or rules for practitioners in the discipline, rather than a living, dynamic language to be consciously re-interpreted by lay participants on each new project.

3. These cultural practices based on apophenia assume the mantle of science or pseudo-science through circular reasoning and self-justification.
4. There is an correlation between the idea of apophenia and the posthuman replacement of floating signifiers which Katherine Hayles proposes (1999). Flickering meanings of pattern and randomness in the constant information overload of the posthuman age would point to us all too often experiencing apophenia and never getting the chance to validate our patterns. We never necessarily know if our patterns are 'right' and all too often conspiracy theories and paranoid delusions invade our interpretations, lending a madness to the everyday.

References

Aakhus, M. & Jackson, S. (2005), 'Technology, Interaction, and Design', *Handbook of Language and Social Interaction* (Mahwah, NJ: Lawrence Erlbaum, 411–36).

Alexander, C. (1979), *The Timeless Way of Building* (New York: Oxford University Press USA).

Bateson, G. (1988), *Mind and Nature* (Toronto: Bantam Books).

Bateson, G. (2000), *Steps to an Ecology of Mind: Collected Essays in Anthropology, Psychiatry, Evolution and Epistemology* (Chicago: Chicago University Press).

Burch, R. (2010), 'Charles Sanders Peirce', in E. Zalta (ed.), *The Stanford Encyclopedia of Philosophy* (Spring 2010 edition). Available: http://plato.stanford.edu/archives/spr2010/entries/peirce/ [10 Nov 2010].

Dansey, N. (2008), 'Facilitating Apophenia to Augment the Experience of Pervasive Games', *Breaking the Magic Circle* (Tampere, FI: University of Tampere).

Dixon, D. (2009), 'Pattern Languages for CMC Design', in B. Whitworth and A. De Moor (eds) *Handbook of Research on Socio-Technical Design and Social Networking Systems* (Hershey, PA: IGI Global, 402–415).

Enns, J. T. (2005), 'Perception, Gestalt Principles of', in Lynn Nadel (ed.), *Encyclopedia of Cognitive Science* (Hoboken, NJ: Wiley).

Fuller, M. (2005), *Media Ecologies: Materialist Energies in Art and Technoculture* (Cambridge, MA: MIT Press).

Hayles, N. K. (1999), *How We Became Posthuman: Virtual Bodies in Cybernetics, Literature, and Informatics* (Chicago: University of Chicago Press).

Hookway, C. (2010), 'Pragmatism', in E. Zalta (ed.), *The Stanford Encyclopedia of Philosophy* (Spring 2010 edition). Available: http://plato.stanford.edu/archives/spr2010/entries/pragmatism/ [10 Nov 2010].

Juola, J. F. (1979), 'Pattern Recognition', In R. Lachman et al. (eds), *Cognitive Psychology and Information Processing: An Introduction* (Hove, UK: Psychology Press).

Kalat, J. W. (2009), *Biological Psychology* (Florence, KY: Wadsworth Publishing Co. Inc.)

McPherson, T. (2009), 'Introduction: Media Studies and the Digital Humanities', *Cinema Journal* 48: 119–23.

Neisser, U. (2005), 'Pattern Recognition.' In D. A. Balota and E. J. Marsh (eds.), *Cognitive Psychology: Key Readings* (New York: Psychology Press).

Raben, J. (2007), 'Introducing Issues in Humanities Computing', *Digital Humanities Quarterly* 1.

Rapoport, R. N. (1970), 'Three Dilemmas in Action Research', *Human Relations* 23: 499.

Rescher, N. (2009), 'Process Philosophy', in E. Zalta (ed.), *The Stanford Encyclopedia of Philosophy* (Winter 2009 edition). Available: http://plato.stanford.edu/archives/win2009/entries/process-philosophy/ [30 Jan 2010].

Resnik, M. D. (1999), *Mathematics as a Science of Patterns* (Oxford: Oxford University Press).

Sculley, D. and Pasanek, B. M. (2008), 'Meaning and Mining: The Impact of Implicit Assumptions in Data Mining for the Humanities', *Literary and Linguistic Computing* 23: 409.

Stephens, J., Barton, J. and Haslett, T. (2009), 'Action Research: Its History and Relationship to Scientific Methodology', *Systemic Practice and Action Research* 22: 463–74.

Susman, G. I. and Evered, R. D. (1978), 'An Assessment of the Scientific Merits of Action Research', *Administrative Science Quarterly* 23: 582–603.

Svensson, P. (2009), 'Humanities Computing as Digital Humanities', *Digital Humanities Quarterly* 3.

Volk, T. (1996), *Metapatterns: Across Space, Time and Mind* (New York: Columbia University Press).

Volk, T., Bloom, J. W. and Richards, J. (2007), 'Toward a Science of Metapatterns: Building upon Bateson's Foundation', *Kybernetes* 36: 1070–80.

12
Do Computers Dream of Cinema? Film Data for Computer Analysis and Visualisation

Adelheid Heftberger

I don't know if cybernetic measurements of novel-rhythms have already been made, I would find them enlightening; and if there were any, I would like to compare 'War and Peace' and 'Raskolnikov', would like to see these two samples together. If you x-rayed them, materialised them, they would maybe both produce fantastic graphs as by-products of literature. Boiled down to one formula – another comparison between Tolstoy and Dostoyevsky: Tolstoy is in his shortest novel still lengthy, Dostoyevsky breathless until complete breathlessness.[1]

– Heinrich Böll

1 The digital formalism project

Digital Formalism was a three-year project, which started in 2007 and ended this summer. It was a joint effort of archivists, film scholars, and computer scientists. The project partners were the Austrian Film Museum, the Department for Theater, Film, and Media Studies at the University of Vienna, and the Interactive Media Systems Group at the Vienna University of Technology. Our aim was to gain new insight into the work of the Russian director Dziga Vertov, who is famous for his highly formalised style of filmmaking, with its spatiotemporal structures and montage patterns that follow complex rules and artistic principles. To do this we went right back to the film material itself, as it survives presently, and analysed it frame by frame. A combination of automated and manual analysis was carried out and the results were compared to see if automated analysis could serve a valuable role in the study of not only Vertov's cinema but cinema in general. The original material provided by the Austrian Film Museum[2] was 35mm, black-and-white film prints, which are intended to be played at non-standard

210

frame rates of 18 to 20 frames per second. Most of the seven films we looked at are silent. The films were scanned frame –by frame in order to obtain a digital image sequence for each film (one image per frame in PAL resolution). The frame-by-frame digitisation avoids the introduction of interpolated frames, which are usually inserted during the telecine process when transferring silent films at a subjectively 'correct' speed to PAL video (which has a fixed, standard frame rate of 25fps). A low-resolution AVI file was produced to run on a PC. In this way it is a digital version of the actual film reel and the work on the computer with the file is very close to working on a viewing table, where you can navigate step by step (frame by frame) through the film. After this process, the films were annotated manually using Anvil – a free software for annotating digital video (Figure 12.1).[3] It provides a graphical user interface for creating annotation elements on temporal, hierarchical, completely user-defined layers. The data is stored in XML files, which can be transferred via Matlab into Excel-Sheets.

The initial reason for the manual annotation was to be able to provide a ground truth for the automated analysis. Our colleagues from the Technical University wrote algorithms initially for dealing with relatively simple tasks such as the detection of shot boundaries and intertitles, later tackling more complex tasks like motion tracking, image composition, pattern recognition, and film comparison. We defined descriptive tracks as well as so-called interpretive tracks, because clearly the interests of the project partners and also of

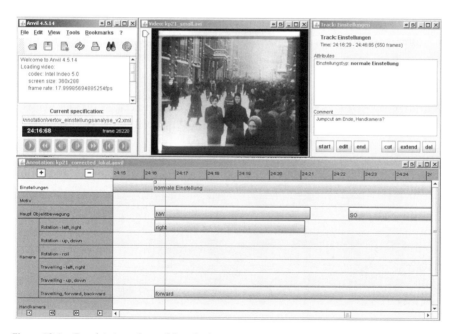

Figure 12.1 Graphic interface of Anvil; the categories were developed within the project

the individual researchers are different. By descriptive tracks we mean formal criteria like types of shots, camera movement, optical perspective, or material-based criteria like cue marks or reel changes. The interpretive tracks include semantic units or temporal units.

The first results were published in January 2010[4] and the Austrian Film Museum published a DVD containing two rare films by Dziga Vertov, accompanied by new scores written by Michael Nyman.[5] The challenges arose from the theoretical background (Russian Formalism), the different scholarly methods, and the film material itself.

2 From the viewing table to a filmic structure

First of all, Russian Formalism was a quite short-lived movement, which was oppressed already in 1930, a relatively few years after its emergence around 1915, and before it could fully develop. Putting it very simply, the Soviet regime could not tolerate practices and schools in the arts, which were more interested in form than in content. Moreover the initial field of study in Russian Formalism was literature and only later did formalist scholars turn their attention to film.[6] Thus trying to find a stringent method or a scientific practice for an empirical analysis which can be applied to computer programmes for automated analysis doesn't yield useful results. Another challenge within the work flow of the Digital Formalism project was to find a common language between humanities and natural sciences. While the terminology was handled in a pragmatic and narrowly defined way by one discipline, a broader view was preferred by another. This is especially crucial when it comes to technical terms and the different 'working vocabularies'. From an archival perspective, for example, it is quite clear that a film consists of different printing generations, that different copies of the same film exist in different archives and these can be in bad shape or even incomplete due to the treatment they sometimes underwent for practical or political reasons. Also it turned out that automated analysis still has its limitations, even when it is applied for comparatively simple procedures like, for example, shot detection. This is due to the condition

Figure 12.2 Three adjoining shots, frame grabs taken from *A Sixth Part of the World* (SU, 1926)

of the source material (films from the 1920s and 1930s) and even more to the 'filmic playfulness' of Dziga Vertov himself. He used dissolves, multiple exposures, and trick sequences extensively (Figure 12.2) .

To understand and to be able to ask what it is that we want to see in Vertov's films from computer analysis, I suggest that the method must include going back to the film prints and Vertov's own writings, thereby taking into consideration the historical context. Already in 1927 Kyrill Shutko warns of formalist scholars who do not take into consideration the fact that film is born as a collective work and its structure is based also on technical conditions:

> Under no circumstances may one forget, whilst conducting one's theoretical excursions into the realm of historical cinema, that film production is not a divinely inspired, creative process but rather represents the result of financial, economic and social calculations – sophisticated right down to even the most minute details – which are realised through exceedingly complex technical procedures.[7]

Filmmakers sometimes give very detailed descriptions of their practices and their work. Dziga Vertov was one of them and his own writings give insight into how he wanted to structure his movies and film production in the Soviet Union in general. Going back to the viewing table in the archive, watching a film over and over again and making close readings may enable the researchers to discover a structure beneath its surface (Figure 12.3). Only then can we ask ourselves: does it make sense to consider the 'Vertov Structures' in the whole corpus of his works, in one key-work, in single sequences of one film, or even in the movement between the frames – the famous Vertov-Interval? (Figure 12.3)[8]

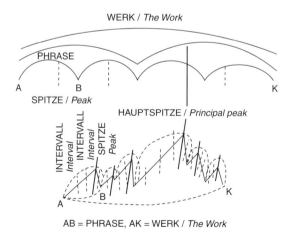

Figure 12.3 Diagram illustrating Vertov's article, dated 1922[9]

Let me put the key questions in a broader context: what cinematic elements are central to an analysis concerned with the involvement of the senses in cinematic perception? Which of these elements can be expressed in a form that can be retrieved automatically with digital tools? How can computer-based methods work together with manual annotation or where do they *have* to? How can we visualise the huge quantities of data produced from the manual annotation? And how can visualisation show us a hidden structure within formally very challenging films, so that humans cannot possibly oversee it by simply watching the film?

3 Visualisation

I will be using the very general term 'visualisation' to mean any kind of visual representation of the structure of a film, be it on a timeline or other kinds of graphical representations. Other issues derive from being provided with charts and graphs later on. A crucial question is, for example: how can visualisations contribute to a new input within film studies? While I will not be able to give a fully satisfying answer – it is a work in progress and much more research needs still to be done – I'd still like to present two collaborations with international partners, both well known for their work. They also represent for me the two main roads which can be taken for visualising empirical data collected from manual annotations or computer programmes. While Lev Manovich deals with large amounts of data, mostly filtered from Internet sources, Yuri Tsivian serves as an example of how film scholars can start using visualisations for very specific hypotheses concerning single films or sequences within certain films.

3.1 Cinemetrics

The film scholar and film historian Yuri Tsivian created an online meeting point for everybody interested in the formal analysis of film, where each is invited to contribute to the fast-growing database. As he himself states on his website: 'Much like martial arts, or like poetry and music, cinema is the art of timing. This explains why, early on, filmmakers such as Abel Gance or Dziga Vertov in the 1920s or as Peter Kubelka or Kurt Kren in the 1960s not only counted frames when editing, but also drew elaborate diagrams and colour charts in order to visualise the rhythm of their future film. This also explains why a number of scholars interested in the history of film style (Barry Salt in England, David Bordwell and Kristin Thompson in the United States or Charles O'Brien in Canada) count shots and time film lengths to calculate the average shot lengths of the films and/or use these data in their study'.[10] On the other hand, Vlada Petric, a Vertov studies pioneer, in the 1980s already analysed Vertov's most experimental film, *Man with a Movie Camera* (SU, 1929), listing

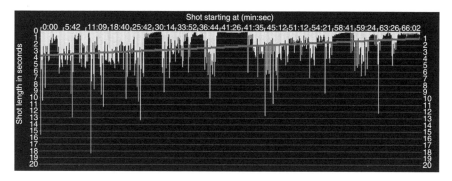

Figure 12.4 Graph taken from Cinemetrics, *Man with a Movie Camera* (SU, 1929). The y-axis represents the length of the shot in frames, the x-axis is the timeline

and describing each individual shot, noting the point of view, angle, composition, and motives by hand.[11] The usual process on Cinemetrics is to download a small program, created by Gunars Civjans, which can be used to count cuts manually and save them directly into the online database. The contribution from the project had to be more accurate than that: we needed exact, frame-based shot boundaries, because Vertov's *Man with a Movie Camera*, the film we submitted first, includes many, integral one-frame shots and one of the fundamentals of the Digital Formalism project was to operate on a single-frame level. Some of our data (for example the manual shot detection with Start and End Frames) was therefore transferred into the Cinemetrics database using Excel Sheets, and thus producing a graph (Figure 12.4) in which one can see a formal structure, a skeleton, of the film.

A very lively discussion on the historic reel changes (with each reel during this time measuring approximately 300 meters and where one reel equals approximately 15 minutes depending on projection speed) and their importance to the structure of the film took place over several months by Yuri Tsivian, Barbara Wurm, and myself.[12] Parts of it were also published in book form.[13]

3.2 Visualisations by Lev Manovich

Our collaboration with Lev Manovich and his Software Studies Institute turned out to be a very fruitful one. Relying on both manual annotation and automated analysis, visualisations in different forms were created – mostly for Vertov's lesser known film, *The Eleventh Year* (SU, 1928). All of them can be found on a flickr site[14] and some of them were featured on the aforementioned DVD publication. Manovich and his co-workers experimented with both self-written programmes and with existing visualisation tools that existed as freeware. In our collaboration we started out with the most basic parameters (Shots), following in a way Tsivian's approach, and then moved on to combining these

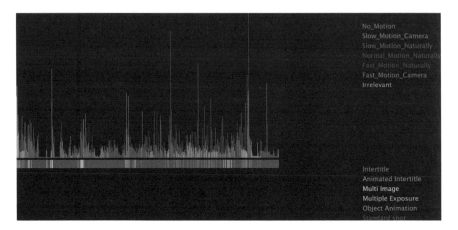

Figure 12.5 The Eleventh Year (SU, 1928). Visualisation combining two types of shot categories. A single bar is one shot; the bar colour is a shot type (Standard Shot, Intertitle, etc.). In the upper graph, the bar's length represents the shot duration. The shot order is left to right

data sets with other manually annotated parameters like 'Types of Shots' and 'Motion Types' (Figure 12.5).

In the next, somewhat more advanced, visual representation of a film structure, the visual information (the image frames) is visible (Figure 12.6). Apart from being a very graphic chart, depicting the content of the shots, this information can be used as data (like light/shade distribution) in other software.

In the last example the graph is divided by the five film reels. Each frame is displayed here, with the shot length to be found under the image. In this way we can immediately see how the montage changes in certain parts and speeds up particularly towards the end of the film, a practise used by Vertov in almost every one of his films.

4 Problems of automated analysis

A next, logical step would be to include statistics in further analysis. That way, when we ask questions – like how to combine several parameters in one chart or what should be annotated – we can bring in statistics in order to prove our hypotheses and see if correlations can be found to back up presumptions. For a first attempt, see the discussion carried out over Cinemetrics where a hypothesis on the connection between movement within the shot and the shot lengths was enunciated. This leads to the fascinating and broad topic of montage and editing.[15] Clearly computer analysis and manual annotation should go hand in hand here. One of several reasons for this is that

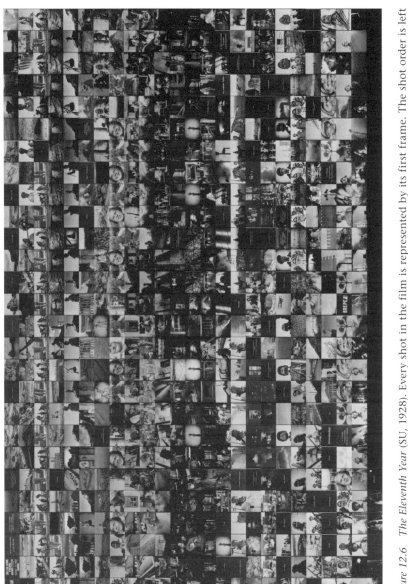

Figure 12.6 The Eleventh Year (SU, 1928). Every shot in the film is represented by its first frame. The shot order is left to right and top to bottom

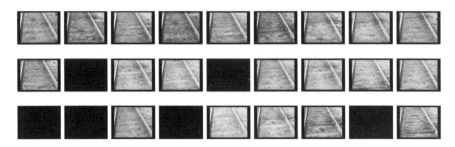

Figure 12.7 Frame grabs taken from *Man with a Movie Camera* (SU, 1929)

whenever semantics (image content) comes in, software is not able to detect and annotate it. There are also technical problems, however. During the project it turned out, and I'd like to be contradicted here, that, for example, face recognition does not yet work satisfactorily, especially if the source material is of comparatively bad quality. Another issue is the identification of motifs should we want to analyse how Vertov used them to create rhythmic structures. It makes a big difference if the same shot was re-used, if the motif is the same but only the framing or angle is different, or if we look for some kind of semantic similarity. Automated motion tracking cannot distinguish camera movement from object movement within the frame, shot recognition is still a problem for computer programs ... the list could go on. For all these reasons the results stemming from computer analysis have to be discussed by film scholars and/or archivists (see Figure 12.7). If montage sequences are detected where black frames are used, was it due to the printing process at that time or was it an artistic device used intentionally by Vertov to try to create a stroboscopic effect?

The way I see it, the most useful path to follow is a combination of manual and automated annotation and analysis. Using video files solely from Internet sources bears the danger of having lost all archival and material traces (reel changes, splices, etc.) in the process of digitisation. Yet without this important information on the history of early films it is very difficult, if not impossible, to understand the structure of these works.

The benefits of visualisations can be manifold and I'd like to suggest three possible fields: Film History, Film Studies, Archival Studies. We can research the influence of technical innovations, like sound or colour in film, and their influence on film style (as Barry Salt does in his work). We can look at the change of shot lengths over time or in different countries. Furthermore we can try to find evidence of how politics – in our case a totalitarian system in the Soviet Union – manifests itself in filmic works, for example, cases where filmmakers were forced to re-cut their work or where they could find ways to

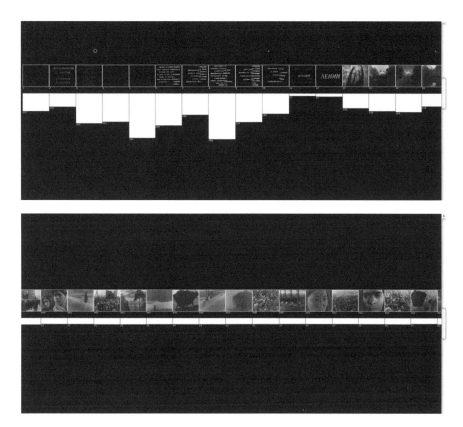

Figures 12.8 and *12.9* Frame grabs taken from *Three Songs about Lenin* (SU, 1934). Every shot of the film is represented by its first frame; the length of a bar below the image corresponds to shot duration. The number under each image is the shot number and the number under each bar is the shot length in frames

make films according to their artistic beliefs in times when there could only be one doctrine – that of socialist realism. In Vertov's case, a form of subversive protest against this stylistic and political programme can be noted in his montage. Among scholars the prevailing view is that Vertov ceased his experimental method of filmmaking and formal style in the early 1930s, shortly after his avant-garde masterpiece, *Man with Movie Camera*. I, however, have tried to use visualisation to show that in my opinion Vertov continued to use this style of editing – albeit in a more subtle way – in his film *Three Songs about Lenin* (SU, 1934). Due to its topic more than anything else (Lenin was as popular as ever then), this film was the director's most famous one in the Soviet Union. Nonetheless, it is still considered a very uninteresting one in terms of montage. A closer analysis of the annotated data and the following visualisation shows

evidence of the fact that Vertov still experimented (Figures 12.8 and 12.9). This is something which can escape one's eye very easily upon first viewing. What should be demonstrated here is that after a conventional opening with titles and first shots, a very formally structured sequence appears in the middle of the film.

However, there are other fields where human minds are needed to discuss and interpret data, be it manually annotated or computer generated. So far automated analysis still functions in quite a simple way when it comes to the analysis of genres or semantic units. The structure of changes in brightness, usually aided by sound, indicate certain genres. For avant-garde films or for a general discussion about genre, it is not that easy and human input is needed. Another issue in film studies would be how to extract an artistic signature of a director, how can we define it, and are there ways to make it more visible? As regards Vertov and his specific ways of filmmaking, we can use shot recognition to find out more about his way of working with the film material. Proposals by Vertov to Soviet officials still exist, where he pleads for the installation of a film-shot library, an idea he shared with other like-minded individuals – though each gave it a different name. Vertov used *author's filmothek* (Figure 12.10), while Viktor Shklovsky simply used *filmothek* and Boris Kazansky speaks of a *kadrothek* (from the Russian word *kadr* for shot).[16] The idea is basically the same and clearly derives from Vertov's beginnings as a professional filmmaker when he worked in the central Soviet newsreel department in Moscow.

From an archival point of view, the project proved especially interesting. Films have always existed in different versions and formats and different copies are held by archives all over the world. How and at what time parts went missing mostly cannot be traced anymore. For example, we know of at least two films by Vertov where the whole last reel is missing and believed lost. For restoration purposes, whole copies of films could be digitised and compared with other sources using computer software.

So, in the end, what is the contribution of computer science not only to this particular project but also more generally to film studies or the humanities? The possibility to *see* what can otherwise escape our eyes, to save time in data mining, and ideally be even more accurate than human annotators. In film studies especially this claim makes sense because the media is a very complex one, judging from the production process and the amount of diverse data that can be found and analysed. It is not surprising that filmmakers have always used techniques and methodologies to organise their work, be it a big Hollywood production where the process had to be carefully planned and storyboards had to be drawn or the work of an avant-garde filmmaker, who drew a chart for his or her metric film. The visualisation of filmic data from shooting up to editing has always been essential for directors and

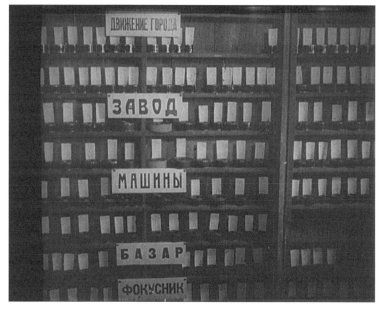

Figure 12.10 Author's Filmothek. Frame grabs taken from *Man with a Movie Camera* (SU, 1929). The labels on the shelves say: movement of the city, factory, cars, bazaar, magician. We can see that all the shots are ordered here according to topic

cinematographers and now we can go back to their own writings or draw-ings to compare the films with the texts and thus maybe understand more about their way of working. While literary theory and other disciplines in the humanities have developed scientific approaches closer to an empirical method (formalism and structuralism shared a belief in 'objective' data with natural sciences, for example), film studies interestingly still lacks this trad-ition. Therefore it is not surprising that attempts were increasingly made to introduce a very 'text-based' analysis of the filmic work. Two of the lead-ing proponents of this method are David Bordwell and Kristin Thompson. Film contains large amounts of data, which automated analysis and visual-isation can extract to help scholars see micro- or macro-structures within films. Even if Lev Manovich's method of data mining makes sense in many cases (if we remember the example of all the *Time* magazine covers from the beginning up to today combined in a single image), for our specific interests one of the most important things in my opinion is to develop useful categor-ies beforehand. That can only be done with a wide knowledge of the Russian filmmaker, knowledge of film history in general, expertise in film analysis, and an archival background. In that way we have the best chance to get use-ful results to answer our questions and can analyse the visual representations created from our data. The last step in this process – the analysis of the graphs and visualisations – leads back again to the starting point: an evaluation of our parameters and the form of the visualisation. Both routes (Manovich's and Tsivian's) have their advantages, whether we start with specific questions and try to visualise them in order to help us find the answers we are looking for, or if we extract data first and then try to see patterns.[17] But these deci-sions can still only be made by the research team and the project group itself, always according to the topic and interests.

All frame grabs courtesy of the Austrian Film Museum, Vienna.

Visualisations by Lev Manovich/Software Studies Initiative, UCSD.

Notes

1. Heinrich Böll, 'Annäherungsversuch. Nachwort zu Tolstois Roman "Krieg und Frieden"', pp. 163–87, in *Neue politische und literarische Schriften* (Cologne: Kiepenheuer und Witsch, 1973, pp. 175–76). Author's translation.
2. The Austrian Film Museum holds one of the biggest collections of films, acquired from different sources since 1968, and film-related materials, donated by Vertov's widow Elizaveta Svilova in the 1960s and 1970s. Parts of the collection were pub-lished in: Thomas Tode and Barbara Wurm (eds), *Dziga Vertov. Die Vertov-Sammlung im Österreichischen Filmmuseum.* ('The Vertov Collection at the Austrian Film Museum') (Vienna: Synema – Gesellschaft für Film und Medien, 2006). See also the Online Catalogue at www.filmmuseum.at.

3. The Annotation Software used was developed in 2003 by Michael Kipp (Graduate College for Cognitive Science) and the German Research Center for Artificial Intelligence (DKFI). See www.anvil-software.de.
4. Klemens Gruber, Barbara Wurm, Vera Kropf (eds), *Digital Formalism. Die kalkulierten Bilder des Dziga Vertov* (Vienna, Cologne, Weimar: Maske & Kothurn, Issue 55, No. 3, 2009).
5. Dziga Vertov, *Šestaja čast' mira / Odinnadcatyj*, Edition Filmmuseum, Munich 2010 [DVD Publication].
6. The film theoretical texts by the Russian formalists were published under the title *Poetika kino* in 1927 in Moscow and Leningrad.
7. Kyrill Shutko, 'Vorwort', in: W. Beilenhoff (ed.), *Poetica Kino. Theorie und Praxis des Films im russischen Formalismus* (Frankfurt am Main: Suhrkamp, 2005, pp. 3–9). [AU: FULL CITE FOR "BEILENHOFF" OK?] Translated from the German by Oliver Hanley.
8. See also the article by Adelheid Heftberger, Michael Loebenstein, Georg Wasner, 'Auf Spurensuche im Archiv. Ein Arbeitsbericht,' in: Gruber, Wurm, and Kropf, *Digital Formalism,* p. 137.
9. Translated and published in Tode, Wurm 2006, p. 172.
10. See www.cinemetrics.lv.
11. See Vlada Petric's profound work on *Man with a Movie Camera*: Vlada Petric, *Constructivism in Film – A Cinematic Analysis: The Man with the Movie Camera* (Cambridge: Cambridge University Press, 1993).
12. See http://www.cinemetrics.lv/movie.php?movie_ID=1780.
13. See also the article by Adelheid Heftberger, Yuri Tsivian, Matteo Lepore, 'Man with a Movie Camera (SU 1929) under the lens of Cinemetrics', in: Gruber, Wurm, and Kropf, *Digital Formalism*, 61.
14. See http://www.flickr.com/photos/culturevis/sets/72157622608431194/.
15. See also the article by Barbara Wurm, 'Vertov Digital. Numerisch-graphische Verfahren der formalen Analyse', in: Gruber, Wurm, Kropf, *Digital Formalism*, p. 15.
16. See Viktor Shklovsky, 'Die Temperatur des Kinos', p.274–277, in: Beilenhoff, W. Beilenhoff (ed.), *Poetica Kino. Theorie und Praxis des Films im russischen Formalismus* (Frankfurt am Main: Suhrkamp, 2005, pp. 274–77). Also Boris Kazansky, 'Die Natur des Films', p. 113, in: Beilenhoff, *Poetica Kino*, p. 113.
17. See also Dan Dixon's (University of the West of England) research on patterns, an interesting presentation of which was made during the 'Computational Turn' workshop at Swansea University, March 2010.

13
The Feminist Critique: Mapping Controversy in Wikipedia

Morgan Currie

Introduction

Research on Wikipedia often compares its articles to print references such as the *Encyclopaedia Britannica*, a resource historically associated with depoliticised content, neutrality, and the desire to catalogue the external world objectively. Yet Wikipedia, the free-content, openly editable, online encyclopedia, evolves out of a process whereby multiple perspectives, motives, compromises, and protocols determine the present version of an article. Using controversy as an epistemological device, can we explore Wikipedia to map editors' concerns around an issue? Can we observe how the mechanics of controversy regulation affect the quality of an article?

To begin one should ask how to pinpoint controversy and its resolution on a site that is updated several times every second. What methods can we use to trace a dispute through to its (temporary) resolution and to observe the changes in an article's content, form, and wider-linked ecology?

This chapter starts by examining past research on the editorial accuracy of articles on Wikipedia, at the expense of exploring Wikipedia as a socially and technically mediated process. Instead, one can argue that controversy and discussion are critical for an article's development in a participatory platform. Next, the chapter works towards a definition of controversy using Actor Network Theory and applies this specifically to Wikipedia's own protocols and technologies for consensus editing. Finally, this chapter provides methods for isolating and visualising instances of controversy in order to assess its role both in a network and across an article's editing history; it will investigate ways to track and graphically display controversy and resolution using the Feminism article and its larger network as a case study.

This research reveals the complex dynamism of Wikipedia and the need for new analyses when determining the quality or maturity of its articles. Wikipedia is not a static tome but a collaborative process, continually modifying within

a digital environment. An article can evolve precisely from conflict between editors who disagree, and it may achieve its current state only after years of development. This chapter proposes a variety of methods to map and visualise these dynamics.[1]

Wikipedia as a source of quality information: prior studies

Wikipedia began on 15 January 2001 as an experimental side-project related to an earlier online encyclopedia, Nupedia. Nupedia's articles were written by experts and received approval only after a peer review process, fact-checking, and editing (Nupedia 2010). Taking a less conventional approach, Wikipedia employed the wiki as its fundamental building block. A wiki is a server software that allows collaborative editing of both content and the organisation of contributions; it can track an article's status, archive an individual's edits, provide platforms for discussion, and store every version of an article ever edited on its editing history page (Wiki.org 2010). The wiki software enables anyone so inclined to author or edit any article. At the time of this writing there are 3,149,493 articles on Wikipedia, and 358,025,347 edits by 11,343,470 users in 260 languages, easily making it the largest reference source today (Wikipedia 2010a).

As an online reference, Wikipedia itself advises its readers of its formal strengths and weaknesses: unlike paper resources, which are updated by experts over months or years, Wikipedia's software has a low bar for entry and allows continual updates within seconds. But it cautions that unlike print encyclopaedias, articles mature over time. Older articles exhibit more balanced and comprehensive information. A reader is more likely to find un-encyclopaedic information and vandalism in younger articles, as new contributors are likely to be less familiar with Wikipedia's three core policies that form the threshold for any contribution on Wikipedia: verifiability by citing reliable sources; no original research, including personal analysis or opinions; and neutral point of view, or a fair, unbiased presentation of multiple perspectives on an issue (Wikipedia 2010b, 2010c, 2010d, 2010e).

Studies of Wikipedia have demonstrated the growth of new contributors on Wikipedia since its inception. Aniket Kittur and colleagues, for example, presented a study at the ACM Conference on Human Factors in Computing Systems that found that while administrators once comprised 60 per cent of editing activity, at the time of the study that amount had declined to 10 per cent, making way for a majority of new and anonymous writers (Kittur 2007). Assessing content contributions, writer and programmer Aaron Swartz conducted a study in 2006 that counted letter additions per editor to a selection of articles; his results reveal that while a small number of dedicated volunteers make a majority of the edits, so-called outsiders provide the bulk of the writing (Swartz 2006).

Several theorists have speculated about the grave consequences of an immensely popularly reference resource built primarily by amateurs. Writer Andrew Keen, for instance, calls Wikipedia 'intellectually disorienting and misleading' for its lack of rigorous, editorial oversight. He accuses it of destabilising institutions that have traditionally safeguarded knowledge, such as the academy's peer review process (Keen 2008). To explore this line of argumentation, political scientist George Bragues analysed six articles on well-known philosophers to test if Wikipedia is an inferior resource for academics. While his team found no serious errors, significant portions of the philosopher's theories were omitted; the problem 'was more of omission than commission'. He concludes that while Wikipedia's non-certified authors managed to capture over half of each article's essential points, academic sources still prevailed by qualitative and quantitative measures (Bragues 2009: 152). The threat of amateurism has been cited as a direct deterrent to future quality. In a paper on open source communities and Wikipedia, Andrew George of the University of Virginia expresses concern that too many editors contributing slander or incorrect information present 'a faceless world of less-informed objectors [who] may make their effort seem not worth it, thus depriving Wikipedia users of their scholarship' (George 2007: 18). He fears that anonymous dilettantism could drive off dedicated editors and academics who could make substantive contributions.

Alternatively, other studies find Wikipedia's collaboratively edited articles surprisingly accurate. In a report by IBM researcher Dave Kushal and colleagues' introducing history-flow software, the authors analysed how quickly Wikipedia's contributors reverted or sanitised vandalism, bias, and obscenity, finding that obscene comments were reverted in an impressive medium time of 1.7 minutes, while article deletions took longer, at 90.4 minutes. They attribute these corrections to vigilant editors (Kushal 2004). Studies have similarly explored Wikipedia's robustness against false information, such as communications professor Alex Halavais's research that inserted 13 inaccuracies into as many articles. He reported that they were corrected within minutes (Halavais 2004). Another study by information specialist Thomas Chesney invited 258 research staff to evaluate two articles each, one in their domain of expertise and one random article. Articles in the experts' fields were overall considered highly accurate, though 13 per cent of the articles contained mistakes (Chesney 2006). More famously, in 2005 *Nature* conducted a study using *Encyclopaedia Britannica* as a bar for Wikipedia entries. Experts examined 42 scientific articles to determine which resource had greater levels of accuracy; the findings gave *Britannica* only a negligibly greater percentage of accuracy (Giles 2005).

Media theorists Helen Nissenbaum and Yochai Benkler go further to applaud Wikipedia for overturning traditional sociological notions of collaboration. Whereas social cooperation was formerly perceived as the result of a

geographically close community sharing common social norms and goals, on Wikipedia a global, far-flung group of anonymous editors engage in open discussion. Editors find consensus through 'user-run quasi-formal mediation and arbitration, rather than on mechanical control of behavior' (Nissenbaum 2006: 397). This 'commons-based peer production' perspective therefore emphasises a consensus-building process over the quality of an article's current version as a foundation for Wikipedia's success.

Yet the focus on unmonitored peer production also ignores Wikipedia's many fine-grained technical and managerial controls. In a study by new media theorists Sabine Niederer and José Van Dijck, the authors take issue with this claim that Wikipedia is mechanically unmediated, writing, 'the increasing openness of Wikipedia to inexperienced users is *made possible* by a sophisticated technomanagerial system, which facilitates collaboration on various levels. Without the implementation of this strict hierarchical content management system, Wikipedia would most likely have become a chaotic experiment' (Niederer 2010: 6). Niederer and Van Dijck demonstrate that technical and managerial protocols, what they call 'technicity of content', are also a part of the ongoing construction of an article.

For instance, elected administrators, or sysops, have special overriding privileges that allow them to delete and restore articles, protect articles against revisions, and block editors entirely. Beyond vigilant editors, there are computer programs ('bots', short for software robots) designed to detect and remove malignant or unverified content, errors, or messy code. So while making a mistake or deliberate error on Wikipedia is easy, there are technical measures in place to monitor and adjust content within seconds. It is for this reason, as Niederer and Van Dijck point out, that Halavais's errors were easily corrected by Wikipedians and their tools.

This chapter agrees that a study of Wikipedia should shift focus from isolated product to dynamic socio-technical process, departing from studies applied to analogue counterparts such as print encyclopaedias. Research that assesses articles for accuracy and comprehensiveness too often glosses over the fact that articles are constructed over time and on another medium entirely. Wikipedia is a unique reference source precisely because its software exposes its history; it has what Richard Rogers calls an 'in-built reflection or reflexivity', as its versioning history and analytics can show how an entry was constructed – a trait missing from most finished, printed work (Rogers 2009: 28).

The social and technical processes that construct Wikipedia can be highly useful for research. Andrew Lih, for instance, studied the development of articles over time through metadata, specifically information gathered from editing history pages, to set metrics for each article's reputation. He uses two measures for reputed quality: rigor, or the number of edits for an article, since 'more editing cycles on an article provides for a deeper treatment of the subject

or more scrutiny of the content'; and diversity, or the total number of unique users, both anonymous and registered, because 'With more editors, there are more voices and different points of view for a given subject'. He concludes that Wikipedia benefits precisely from participation and 'more users making their impression by scrutinizing or contributing to content' (Lih 2004: 19). Kushal et al., as well, created software to visualise the editing activity over time, in order to pinpoint moments of highest activity for further discursive analysis (Kushal 2004).

This chapter builds upon methodologies that emphasise editing process by focusing on Wikipedia's social and technical protocols for managing controversy; it presents a variety of ways to trace how conflict and consensus emerges as editors from various perspectives, localities, and motives work together to define a topic. This chapter proposes that by following the heatedness of a debate across an article's internal topology or wider ecology, one can possibly use Wikipedia to highlight societal concerns, as article revisions often reflect current sociopolitical and cultural conditions. In turn, topics of controversy within articles and across an article ecosystem provide a rich place to evaluate how human and non-human actors affect the quality or maturity of an article over time.

Defining controversy

Tommaso Venturini provides a basic but useful definition for controversy: '[c]ontroversies begin when actors discover that they cannot ignore each other and controversies end when actors manage to work out a solid compromise to live together. Anything between these two extremes can be called a controversy' (Venturini 2010: 261).

To unpack such a deceptively simple, intuitive definition, Venturini describes Bruno Latour's methods of controversy-mapping, developed by Actor-Network Theory (ANT). According to ANT, a dispute is a contestation between an assortment of actors, both human and non-human, that breaks down and transforms long-held assumptions or aggregates. Controversies open up 'black boxes' and shake the foundational assumption of things as well as ideas that would otherwise be taken for granted. Black boxes may be religious institutions, technological designs, or scientific principles; they are held together by a 'cosmos' of common beliefs made natural through symbolic exchange. Controversy not only opens black boxes up to discussion, but it also constructs them; it is the prerequisite state before one cosmos of belief prevails over another, or until actors temporarily reach an impasse (Venturini 2010: 267).

Cartographers understand that any perspective, no matter its methodological rigor, will be biased. So rather than pursue one theoretical or methodological path when observing a controversy, cartographers should jettison any presumptions about observed subjects and consider as many viewpoints as

possible. Such multifaceted perspectives allow one to find what Latour terms 'second-degree objectivity'. Rather than distinguishing a single philosophy or scientific method on the path to attaining a neutral point of view, second-degree objectivity actively looks for and employs a variegated spectrum of subjectivities (Venturini 2010: 270). Seeking a variety of presumptions and dis-agreements about a phenomenon (typical of a controversy) allows an observer a more nuanced observational perch; any resulting order is an effect brought about by heterogeneity. One finds the complexity beneath the surface, and realises that the isolated product is inseparable from the processes that natu-ralised its coherence.

But how does one locate a controversy? Venturini provides five pointers:

- 'Controversies involve all kind of actors', not only humans 'but also natural and biological elements, industrial and artistic products, institutional and economic institutions, scientific and technical artifacts and so on and so forth' (Venturini 2010: 261).
- Controversies display the social in its most dynamic form. Social entities that once seemed indissoluble break apart, and new alliances are formed.
- Controversies are reduction-resistant. 'In controversies, actors tend to disagree on pretty much anything, included their disagreement itself' (Venturini 2010: 262).
- Controversies are debated. They bring assumed or unnoticed objects back into discussion.
- Controversies are conflicts. That is, a coherent worldview is shattered by conflicting viewpoints.

The observational method of ANT, and particularly the state of second-degree objectivity, supports Wikipedia's tenet that mature articles achieve greater NPOV precisely because they have more editors and hence more points of view. Controversy-mapping also echoes Lih's findings that rigor and diversity improve an article's reputation over time. The diverse actors on Wikipedia are encouraged to find common ground through exploring the perspectives of others, and the synthesis could result in greater quality.

Wikipedia's page, 'Writing for the Opponent', is an exemplar of this tenet: 'Note that writing for the opponent does not necessarily mean one believes the opposite of opponents' POV. The writer may be unsure what position he wants to take, or simply have no opinion on the matter. What matters is that you try to "walk a mile in their shoes" and on this occasion, not judge them' (Wikipedia 2010f). Thus articles that have several editors, rather than the ones that lie fallow and unquestioned by readers, are more likely to develop towards the ideal of Wikipedia's core principles. Controversy can be an important set-ting where this synthesising work becomes visible.

A Wikipedia-specific approach to observing controversy

In order to apply ANT's controversy-mapping to Wikipedia, it is important to examine some of Wikipedia's own protocols for handling controversy. When disagreements arise, for instance, editors will frequently use 'talk' pages to arbitrate matters prior to making an edit and to make a space where they may debate very different opinions on what constitutes the protocols governing Wikipedia. The talk page is also a useful resource since Wikipedia's 'three-revert rule' prohibits an editor from making more than three reverts within a 24-hour period or else be temporarily blocked, preventing 'edit warring' (Wikipedia 2010g, 2010h).

Wikipedia also has an in-built archiving system that records all previous edits of a page and makes it simple to revert to an earlier version. The edit history is a log of each change made to the article throughout its entire lifetime; it includes metadata such as time, date, username information and whether an edit is a 'revert' back to a previous edition. It can also include editors' notes explaining why the edit was made. The archived versions of a page are available to users via a 'page history' link. This system ensures that poor editing causes no permanent damage and serves as a record of past additions, deletions, and misuse. Wikipedians can also flag articles with warning templates if articles are not properly cited, have few in-links, or exhibit signs of bias and partiality. Finally, the last line of defense in a debate is an appeal to an actor with hierarchical privileges, as when a system operator blocks a user.[2]

With these mechanisms in mind, Venturini's pointers for locating controversy are all applicable to Wikipedia. Regarding point one, controversies involve human and non-human actors; a researcher examines not only discussion between editors, but also looks at how wiki software, bots, admin hierarchy, and the wider architecture and mechanical nature of the Web affect disputes. This basic point of ANT also reflects an awareness of Wikipedia's technicity of content as defined above.

Point four directs us to look for signs of debate; on Wikipedia, this unfolds through clusters of editing activity on an article's history edit pages or its discussion page. Point five declares that controversies are conflicts, often corresponding to moments when two editors form very different opinions on what constitutes the protocols governing Wikipedia. An example of this type of dispute occurred when editors contested the posting of the Jyllands-Posten cartoon of Muhammad on a Wikipedia page about the cartoon itself. To settle the debate, Wikipedia's policies around censorship came under discussion.[3]

Point two, that entities once seeming indissoluble break apart, can be observed with the phenomenon of forking as defined by Joseph Reagle (Reagle 2008). Forking is the ability for a dissatisfied constituent of a discussion to copy and relocate elsewhere to continue working on its content; it enables

growth, since a new page 'splinters off' a larger article and gives way to a larger ecology of links surrounding an issue. Forking also satisfies tenet three: controversial issues expand the points under discussion, rather than reduce them. Controversies give rise to – or eliminate – content, headings, and new articles altogether (Rogers 2009).

Also useful for our purposes, Venturini's definition explains what controversy is not. Vandalism on Wikipedia, for instance, is usually anonymous and short-lived; debate does not normally take place between the vandal and the rest of the community. Additionally, a person who directly flouts Wikipedia's rules of NPOV and engages in 'flame wars', Internet-slang for deliberately hostile interactions on the Web, is not engaging in real debate (Wikipedia 2010i). More typically, a controversy on Wikipedia arises when a contribution contests the notions Wikipedians hold about foundational principles themselves, such as NPOV and verifiability.

Methods

Sample

For analysis, this case study explores Wikipedia's article on Feminism, an article that began on 26 December 2001, and can be considered relatively 'mature' due to its age and dense editing history. Additionally, feminism is a historically controversial issue, beginning (according to Wikipedia's own definition) as a primarily political approach to improving women's status in society through equal rights and legal protection. With regard to more contemporary feminist issues, women have cited instances of rampant sexism in online communities. According to Reagle, Wikipedia itself is not exempt from such accusations. In 2006 an all-female splinter group of wiki-editors formed WikiChix, a mailing list intended for women only. They cited 'systemic gender bias in Wikipedia' as the group's justification (Reagle 2008).[4] This chapter investigates if debates about the definition and contemporary relevance of the political movement are visible on the editing history pages.

Procedures: Macroscopic

Rather than grafting older methodologies onto the online medium, I deployed several Web-based tools for researching societal controversy diagnostics on Wikipedia (Rogers 2009).[5] This chapter also focuses less on discourse, as archived for instance on an article's discussion pages, than on analytical data. The Digital Methods Initiative's Wikipedia Edit Scraper and Localizer Tool, for instance, creates a spreadsheet of an article's entire editing history data to date, including the dates of all additions and deletions, the user who made them, and any comments they cited for their change.[6] Metadata can also be compiled from articles' 'revision history statistics', a list created by

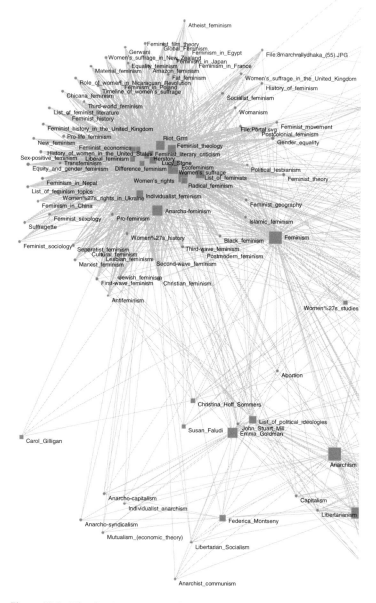

Atheist_feminism
Feminist_film_theory
Gerwani
Global_Feminism
Feminism_in_Egypt
File:8marchrallydhaka_(55).JPG
Women's_suffrage_in_New_Zealand
Feminism_in_Japan
Feminism_in_France
Equality_feminism
Material_feminism
Amazon_feminism
Fat_feminism
Women's_suffrage_in_the_United_Kingdom
Role_of_women_in_Nicaraguan_Revolution
History_of_feminism
Feminism_in_Poland
Timeline_of_women's_suffrage
Chicana_feminism
Socialist_feminism
Third-world_feminism
Womanism
List_of_feminist_literature
Feminist_history
Feminist_movement
Feminist_history_in_the_United_Kingdom
Postcolonial_feminism
Pro-life_feminism
Riot_Grrrl
File:Portal.svg
New_feminism
Gender_equality
Feminist_economics
Feminist_theology
History_of_women_in_the_United_States
Feminist_literary_criticism
Sex-positive_feminism
Herstory
Transfeminism
Lucy_Stone
Equity_and_gender_feminism
Difference_feminism
Ecofeminism
Political_lesbianism
Women's_suffrage
List_of_feminists
Feminism_in_Nepal
Women's_rights
Radical_feminism
Feminist_theory
List_of_feminism_topics
Individualist_feminism
Women%27s_rights_in_Ukraine
Feminist_geography
Feminism_in_China
Anarcha-feminism
Feminist_sexology
Pro-feminism
Islamic_feminism
Suffragette
Feminist_sociology
Women%27s_history
Third-wave_feminism
Black_feminism
Feminism
Separatist_feminism
Postmodern_feminism
Cultural_feminism
Lesbian_feminism
Second-wave_feminism
Marxist_feminism
Jewish_feminism
First-wave_feminism
Christian_feminism
Antifeminism
Women%27s_studies

Abortion

Christina_Hoff_Sommers
List_of_political_ideologies
Susan_Faludi
John_Stuart_Mill
Emma_Goldman
Carol_Gilligan

Anarchism

Anarcho-capitalism
Capitalism
Individualist_anarchism
Libertarianism
Anarcho-syndicalism
Federica_Montseny
Mutualism_(economic_theory)
Libertarian_Socialism
Anarchist_communism

Figure 13.1 The feminism network

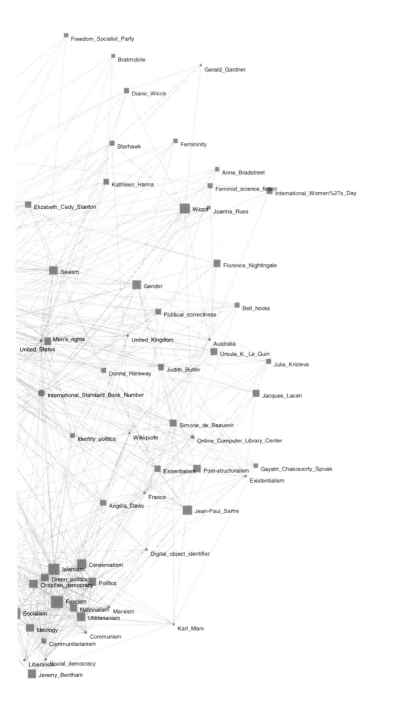

Freedom_Socialist_Party

Bratmobile

Gerald_Gardner

Dianic_Wicca

Starhawk Femininity

Anne_Bradstreet

Kathleen_Hanna Feminist_science_fiction International_Women%27s_Day

Elizabeth_Cady_Stanton Wicca Joanna_Russ

Florence_Nightingale

Sexism

Gender Bell_hooks

Political_correctness

Men's_rights United_Kingdom Australia

United_States Ursula_K._Le_Guin

Julia_Kristeva

Donna_Haraway Judith_Butler

Jacques_Lacan

International_Standard_Book_Number

Simone_de_Beauvoir

Identity_politics Wikiquote Online_Computer_Library_Center

Essentialism Post-structuralism Gayatri_Chakravorty_Spivak

Existentialism

France

Angela_Davis Jean-Paul_Sartre

Digital_object_identifier

Islamism Conservatism

Green_politics Politics
Christian_democracy

Fascism
Socialism Nationalism Marxism
Utilitarianism

Ideology Karl_Marx

Communism
Communitarianism

Liberalism Social_democracy
Jeremy_Bentham

Figure 13.2 Network topology, editors and article activity: scaled to ratio of edits per total months of editing since article's origin

Wikipedia of all editors in order of their number of edits that includes the dates of a user's first and latest edits, and provides links to all editors' user pages.

This case study's approach is multifold. First it maps the placement of issues over the wider Feminism article ecology, taking a macroscopic approach to determine if actors' debates are concentrated in different articles at different times over the network. Using a link analysis to map Feminism's network, one can determine articles that were highly linked to Feminism and see where the most editing activity occurred across each; additionally one can look at how this activity occurred over time, to discover whether debates moved from one article to another. Additionally, one can trace the issue commitments of top Wikipedia contributors, as well as bots, across the Feminism network. Do editors work on several articles at once, or do they more often concentrate activity in certain articles? Could such clusters of editing activity over time reveal the way debates move or concentrate across the larger ecology?[7]

A map of Feminism's wider ecology (Figure 13.1) was created by scraping the Feminism page using the Wikipedia Network Analysis Tool to reveal

Editor	Feminism	History of Feminism	Women's Suffrage	Women's Rights	Radical Feminism	Ecofeminism	Men's Rights	Antifeminism	Sex-Positive Feminism	Men and Feminism	Liberal Feminism	Cultural Feminism	Anarcha-Feminism	Feminist Theology	Marxist Feminism
Cailil	701	91	22	60	10	14	35			18	3	16	2		1
Catamorphism	120				10			15	28						
SmackBot¬†(bot)	32	13	10	7	15	2	18	12	6	10	4	3	2	3	2
Dysprosia	97	2			6		9			1					
Binksternet	27	6	60		4									2	
Bremskraft	68					4	7				20				
ClueBot¬†(bot)	43	2	32	6	2			4	3	2					1
JCDenton2052	19	20		5	9	4		6	3	14	5	5		1	2
VoluntarySlave	14	8		7	14			23	4		1	3	2		3
Owen					2	43		3	1		1	1	14		2
AntiVandalBot	16			15	1			3							1
AnnaAniston	17				7			3				7			
Sardanaphalus		3			2	3		2		2	2	2	2	4	2
Taranet		3									1			18	1
VoABot II	11		8		2			2							
Rjwilmsi	10	6								3	1				
Blackcats	10				2	2		3							
Dakinijones					2	5		2		1	1	1	1		1
Cerberus of elyssia					2						1	1	1		1
Cantaire87											1	2	1		1
YurikBot¬†(bot)					2						1	1			1

Figure 13.3 Top editors and their issues: numerals indicate number of edits per article

bi-directional links within Wikipedia. The results were then visualised with the software ReseauLu.[8] The data on the editing activity of 14 articles most strongly linked to the Feminism network (Figure 13.2) was gathered by running each article's URL through the Digital Methods Initiative's Wikipedia Edit Scraper and Localizer Tool, which outputs a spreadsheet of data about an article's edits to date. The total number of edits in each article was visualised with Digital Methods Initiative's Dorling Map Tool.[9]

A third chart shows the scraped editing activity over time in five articles in the Feminism ecology, visualised using bubble charts made by a Nodebox image generation script. The final chart reveals the top 21 editors across 15 articles of the Feminism network, according to data gathered from 'revision history statistics' of each article, a list of all editors in order of their number

Figure 13.4 Network topology, bots and article activity: scaled to ratio of edits per total months of bot maintenance since article's origin

of edits. These results were also visualised by a Nodebox image generation script (Figure 13.3).[10] Finally, the scraped editing activity revealed bot activity across the feminism network, tallied as a percentage of total editing activity in the article and visualised using Digital Methods Initiative's Dorling Map Tool (Figure 13.4).

Procedures: Microscopic

The second part of analysis takes a microscopic approach, diving into the editing history of the Feminism article to determine the levels of activity under certain headings and by editors over time.[11] This analysis is divided into two main narratives: the first examines Feminism's two highest peaks of activity and analyses these spikes according to the most heavily edited headings and the editors involved. Do editing peaks indicate controversy? What can editing peaks tell us about the heatedness of users' concerns, and how can we analyse the reason for the peak's abatement? Did the content of the article change heavily as a result of these debates? And where did the main editors go after the peaks subsided?

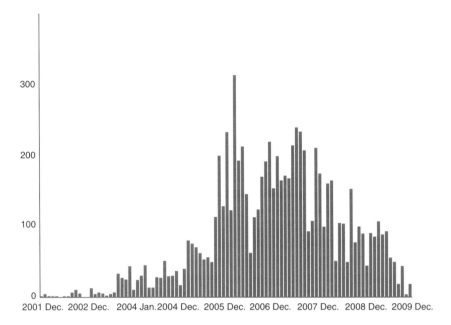

Figure 13.5 Two peaks in feminism's editing history

To show editors and their issues in the two peaks, the number of edits over each month from November 2001 to November 2010 were tallied and visual-ised in a bar graph of editing activity in order to find top editing peaks (Figure 13.5).[12] Top headings (mentioned more than ten times) and their occurrence for both peaks were visualised with Digital Methods Initiative's Dorling Map Tool (Figure 13.6). To show editor activity over time, the revision history statistics for Feminism were queried to gather the top 50 editors and scrape Feminism's history, and then to isolate the dates of all editing activity of the top 50 edi-tors from 2001 to 2010. Results of all edits by top editors were first visualised in a bubble chart by making an image-generation script for Nodebox.[13] Next, results were isolated to only those edits six months before and after peak one and peak two.

The second microscopic narrative follows a heading, 'Criticisms of Feminism' that exhibited a high amount of editing activity until splitting into two new headings, 'pro-feminism' and 'anti-feminism', on 9 August 2007. The history of the headers 'anti-feminism' and 'pro-feminism' reveals that these were cre-ated out of several 'Criticism'-related headers, and after the split no 'Criticism'-related headers reappeared. This analysis asks if the split in the heading can be viewed as dispute resolution, looking first at editing activity before and after the split, and second at where the primary editors in the 'Criticisms' section went after the split.[14]

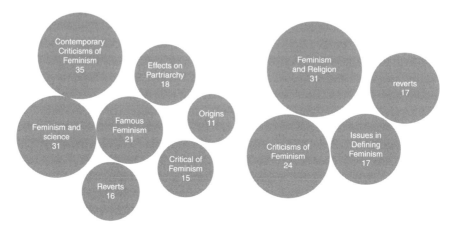

Figure 13.6 Users' top issues and number of reverts in two peaks

For this section, actor dispersal was revealed after the split by a scrape of revision history of the 'Feminism', 'Anti-feminism', and 'Pro-feminism' pages using the 'Wikipedia edit scraper and IP localizer' tool. By querying the word 'criticism' within scraped results, one can isolate all prior labels concerning this heading and see how the heading changed over time. By isolating the edits within the Feminism page to 'Anti-feminism', 'Pro-feminism', and related 'Criticism' headers, the main actors within the 'Criticism' section were revealed by tallying the number of their edits (above five edits). One can also compare the main actors of the 'Criticism'-related headers to the actors of the 'Pro-feminism' and 'Anti-feminism' page to determine if the editors jumped to these pages. The results were visualised with bubble lines (Figure 13.7). Finally, the key words 'Pro-feminism' and 'Anti-feminism' showed if any changes occurred in the headings as well.

Findings

The macroscopic view: feminism and the wider ecology

The macroscopic investigation asks generally if one can trace controversies across articles in the same article ecology, considering both editing activity and editors' issues. First, findings show that the darkest cluster of articles that link to the Feminism article also appear in Feminism's Discussion Template, which makes sense as Feminism is a series header organising several other concepts and subsections from its page; this cluster is a clear example of standardisation on Wikipedia as users create indexes of relationships around a topic. A commonly linked JPEG file in the network, for instance, is the image on the discussion template. On the bottom left-hand corner is a cluster of political 'isms'

Editor dispersal

(heading/page)

	Criticism	Pro-feminism	Anti-feminism	Anti-fem page	Pro-fem page
(editors)	Ashmoo (13)		Ashmoo (1)		
	66.41.212.231 (10)				
	Anacapa (38)				
	Cailil (9)	Cailil (6)	Cailil (11)		Cailil (3)
	Catamorphism (17)			Catamorphism (15)	
	NeoAspara (15)			NeoAspara (64)	

Figure 13.7 Main editor dispersal after the split, numerals indicate number of edits by editors with +5 edits

(Socialism, Capitalism, Libertarianism, etc.), and on the right-hand side is a cluster of theorists in the vein of women's studies and identity politics (Simon de Beauvior, Angela Davis, Judith Butler, etc.). In this reading, Feminism has relevance for theorists and to politics, in line with its definition as both a cultural and a political movement.

Next, data on the activity distribution of 14 articles most strongly linked to the Feminism network (Figure 13.2), shows that editing is unevenly distributed, with Feminism receiving the highest ratio of edits over time, as expected. It is interesting to note that Anti-feminism receives the third-highest ratio of edits

after Women's Suffrage, and more than Women's Rights; also, Men's Rights has a larger ratio of edits than Women's Rights and the same ratio of edits to History of Feminism.

Regarding editing activity over time, in Feminism and four closely linked articles, there is no general pattern linking article age to editing activity. Cultural feminism's activity remains relatively low throughout its history and has abated in the last few years. In contrast, Anarcha-feminism exhibits levels of recent interest. Anti-feminism, Women's Suffrage, and Radical Feminism have a stable amount of editing after a peak around 2006. Women's Rights declined in activity from a peak in 2006, while Feminism has declined significantly since peaks of high activity between 2005 and 2007 (these peaks are explored in more depth below), possibly indicating consensus around controversial issues.[15]

Significantly, there does seem to be a pattern across articles, as all articles, excepting Anarcha-feminism, received the highest amount of edits to date between 2005 and 2007. One could posit that editing interest in a primary article leads to more activity in linked articles, a possible sign of controversy travelling across the ecology.

In data regarding the topology, the top 21 editors across 15 articles of the Feminism network (Figure 13.4), one sees that Cailil (a systems operator, or 'sysop'), Catamorphism, Bremskraft, and Dyspropria all rank high due to heavy editing in the Feminism article. Other editors have made small contributions to several articles in the ecology, such as JCDenton2052, VoluntarySlave, Owen, and Sardanaphalus. In contrast, Binksternet, Own, and Taranet exhibit particular interests and do not participate in the general articles. Three of the top editors are bots; Smackbot is the only editor contributing to all articles.

With regard to bot activity (Figure 13.5), the findings corroborate prior research that shows bot dependency does not generally correspond with an article's levels of activity (Gerlitz 2009). Indeed, Feminism and Anti-feminism, articles with high activity, have a relatively low percentage of bot maintenance. Bot activity here is not an indicator of controversy.

The microscopic view: two narratives in the feminism topology

Narrative one: the two peaks

This narrative asks if one can locate a controversy by focusing on periods of greatest activity in an article's editing history. A bar graph of number of edits over time in Feminism (Figure 13.7) shows that the highest amount of activity occurred in March 2006 and July 2007.

(It is important to note that for both narratives, issues were localised by sorting the Feminism scrape's 'comments' section, then analysed according to prevalence of Table of Content headings listed as keywords in the 'comments' column. One problem with this method is that the comments do not specify

bot activity or reverts in relation to a heading. Thus, if the Table of Contents heading was not mentioned in the comment of the edit, it was not included in the results. A more thorough study might include these important elements, though gathering such information would require visiting each edited page's URL separately to pinpoint the location of a revert or bot edit, a laborious and time-consuming task).

To analyse the first peak, editing history from February to April 2006 (peak month plus months before and after) was sorted by key words in 'comments'; results show that the Table of Content section, 'Criticisms of Feminism', received the most edits, 35 – further confirming extreme interest in this section of the article – and 'Feminism and Science' received the second most edits, followed by 'Famous Feminists', 'Effects on Patriarchy', 'Critical of Feminism', and 'Origins'.

For the period of peak number two, June to August 2007, issues of most concern still include 'Criticisms of Feminism'; activity also ensued within 'Feminism and Religion', a new Table of Contents heading that was introduced in July and expands upon the subheading 'Effect on Religion'. A main actor here is Bremskraft, who, like Anacapa, edited only during a brief period, with 68 edits over July and August 2007 primarily under 'Feminism and Religion'. Interestingly, there is also much activity in the heading 'Issues Defining Feminism', a section devoted to the problematic nature of the term itself. Also, in the last month of the period, August 2007, no single heading received more than ten edits, demonstrating that much of the previous month's concerns had abated. Instead, the high amount of activity can be attributed to Cailil the Sysop. Cailil made 110 edits this month, 47 per cent of the total, most of them minor edits over several headings in the article.

One user, Anacapa, made 59 edits this period, 19 in 'Contemporary Criticisms' alone, accounting for 54 per cent of activity in this heading over the period. Anacapa also edited in two other popular headings, 'Critical of Feminism' and 'Famous Feminists'. This amount of work, even in a concentrated period of time, gives Anacapa status as the third-highest contributor to Feminism since its inception (Toolserver.org 2010). A visualisation of all user activity in Feminism since its beginnings shows Anacapa's large amount of activity in this period, followed immediately by an increase in other users' activity. Therefore, it is reasonable to attribute this spike primarily to this user. A chart of the top 100 users in Feminism during this peak shows that Anacapa made most of his edits during this peak, then left the discussion only to return once more to make 15 edits in May 2007 (Figure 13.7). He was blocked on 1 June 2007 after a charge by another user, Durova[16] (Wikipedia 2010).

Narrative two: the heading split

This narrative asks if there is a method to pinpoint controversy and its closure within an article by tracing a particularly active Table of Contents heading

in the Feminism article. It specifically examines if the split of the heading 'Criticisms of Feminism' into 'Pro-feminism' and 'Anti-feminism' sections resulted in consensus. The data includes activity, user topology, and heading changes over time.

First, regarding activity, 68 edits were made in the 'Criticisms' section of the Feminism article six months before the split, while only 12 edits were made in the 'Anti-feminism' section and three edits in the 'Pro-feminism' section six months after the split. This decline in activity could indicate that controversy indeed abated after the split (Figure 13.5).

Second, investigating the Table of Contents specifically, the heading for the 'Criticisms' section was unstable over the years, with seven changes from its introduction on November 2005 until the split on 9 August 2007. In contrast, there is no indication that the 'Pro-feminism' and 'Anti-feminism' headings have changed since they were introduced. One can argue that headline constancy is another indicator of consensus.

Finally, regarding editor placement, results show that 'Anti-feminism' has 22 editors total since it began over two years ago, and 'Pro-feminism' has five. 'Criticisms', on the other hand, had 122 editors over its almost six years of history, a significant ratio of editors compared to the new headings. Of the seven highly involved actors (more than five edits) in the 'Criticisms' section (Figure 13.6), three continued editing in the 'Anti-feminism' section and one (Cailil the Sysop) in the 'Pro-feminism' section. Two of the main actors jumped from 'Criticisms' to 'Anti-feminism' within Feminism. One jumped to the article Anti-feminism and one to the Pro-feminism article. According to the personal Wikipedia activity of the users, two of the original actors, Anacapa (who also is seen as an actor in the first narrative) and Plonkeroo, have been banned from Wikipedia altogether (Wikipedia 2010j, 2010k). Results show that the main editors largely dispersed after the split of 'Criticism' into 'Anti-' and 'Pro-'; one can argue this also shows consensus around an issue that received large amounts of edits prior to the split.

Discussion

In the macroscopic analysis comparing activity and users across Feminism's wider ecology, four potential relationships become apparent. First, many of the articles in the network have the same name as Table of Content headings within the Feminism article; one could read this as a universalism and particularism typical of identity politics, wherein topics under the same umbrella (the Feminism article) also have their own identity as a discreet article. Second, there is also data supporting the existence of a community of editors who show interest across several articles, including a highly invested sysop, Cailil, who

has exercised his or her admin status to block users – an example of Wikipedia's managerial protocols at work. Third, spikes of editing in the main article, Feminism, between 2005 and 2007 seem to trickle to the rest in the ecology, a possible indicator of one article's controversy migrating to others in the network. Finally, a high amount of editing activity in the page Anti-feminism and Men's Rights possibly shows us Wikipedians' interest in identity politics, particularly defining views that might be antithetical to feminist goals (a theory also supported by the high activity in Feminism's 'Criticisms of Feminism' heading).

In the first microscopic narrative, two peaks, one can make a few key observations. In the first peak, an edit war ensued between one user, Anacapa, and other editors. Because Anacapa was later blocked, the spike in activity could be considered a 'flame war' rather than a controversy proper as defined by Venturini. Instead of discussing the evolution of content, wherein editors would debate if Anacapa's edits achieve NPOV and add value to the heading 'Criticisms of Feminism' (though the consensus was that he did not), the discussion became more about how to handle Anacapa him- or herself.[17] The result is a clear example of Wikipedia's hierarchical protocols at work, since an administrator proscribed the content of an article by blocking Anacapa entirely. Yet so-called flame wars can also affect the content of an article; a version of the page at the end of the editing period reveals that Anacapa's edits led to the creation of a counter-defensive heading, 'Response to Criticisms of Feminism' (Wikipedia 2010o).

In the second peak, two characteristics are significant. First, the creation of a new heading, 'Feminism and Religion', led to a spike in edits, reflecting that additions often generate editing interest and contesting points of view. By referring to the editing history pages at the end of the period, one could make the case that 'real debate' ensued in this section, as editors worked to create content according to Wikipedia citation standards.[18] Second, this period marks the beginnings of Cailil's role as a 'groundskeeper' performing mostly minor edits (and a few major edits; in fact, two months after the peak Cailil created the split in 'Criticisms of Feminism' discussed above, which further drove down activity). The evidence of Wikipedia's managerial hierarchy can be seen in how Cailil's edits correspond with a decline in overall editing. One can assume either that the groundskeeper protects the page from more flame wars, or that the sysop's overriding privileges maintain stability by vigilant oversight of content. Either way, the data shows that the Feminism page has remained relatively stable after these years of dispute.

In the second narrative in the microscopic investigation of Feminism, in the heading split one sees that Table of Content headings can serve as a device for mapping controversy diffusion. By tracing headings and actors, the data

shows that a section of controversy abated when a heading split within the article. This demonstrates how controversy management results in new structures and articulations around an issue: from 'Criticisms of Feminism' to two new sections that give equal weight to both sides of the issue, 'Anti-feminism' and 'Pro-feminism'. Also worth noting is that 'Criticisms of Feminism' had 1,264 words on 1 February 2006 (the beginning of the first peak) but by 31 August 2007 (end of the second peak) was relegated to the two new sections at the bottom of the article, with a combined total of only 331 words. One can trace a distinct decline in interest in this issue that continues to the time of this writing.

Conclusion

This case study presents a variety of methods for mapping controversies both within an article and throughout its network. These methods reveal which issues are most important to the editors and also unearth complex dynamics that affect the content itself. The resulting data demonstrates that controversy management plays a part in an article's creation and maturity, with regard both to content and structure, as wiki software enables controversy to fold into the production process. Scholarship that focuses on consensus may overlook the role that controversy and dispute play in highlighting and refining heated topics.

 This chapter concludes that an article should be considered an ongoing process from which one can map certain issues of interest and debate for Wikipedians, as well as assess the maturity of an article over time. While this dynamism makes it difficult for researchers to isolate and follow conflict, metadata such as article age, number of editors, number of edits, links within an ecology, comments, and activity on the discussion page are important metrics indicating an article's trustworthiness. Further studies could use similar methods to chart dispute in articles embroiled in real-time debate, such as during political elections, by tracking users and their issues as edit wars unfold and observing how this does (or doesn't) affect Wikipedia's content.

Design credits

Michael Stevenson, Figure 13.1; Drew Davis, Figures 13.4, 13.7; Kimberley Spreeuwenberg, Figures 13.6 and 13.7.

A very special thanks to

Drew Davis, Sabine Niederer, Richard Rogers, Kimberley Spreeuwenberg, and Michael Stevenson.

Notes

1. The research for this article was conducted with the Digital Methods Initiative course taught by Richard Rogers at the University of Amsterdam (2010). For more information on using Wikipedia to map controversy, see 'Wikipedia as a Space for Controversy', a session of the DMI summer school taught by Sabine Niederer on 6–10 July 2009. Documentation and slideshow can be found at http://wiki.digital-methods.net/Dmi/WikipediaAsASpaceOfControversy. Date accessed 10 January 2010.
2. A list of Wikipedia templates: http://en.wikipedia.org/wiki/MediaWiki_custom_ messages. Date accessed 10 January 2010.
3. The Baghdad Museum made a 335-page archive of the discussion around the cartoon, because it 'reveals the mechanics of the clash of civilizations' (Simmons, 2006). The cartoon was online as of the time of this writing: http://en.wikipedia. org/wiki/Jyllands-Posten_Muhammad_cartoons_controversy. Date accessed 10 January 2010.
4. The Wikichix list moved its hosting from Wikimedia, after it declined to endorse exclusive discrimination (Reagle 2008).
5. 'Digital methods' is a term for medium-specific methods for web research coined by Richard Rogers (2009). Digital methods concentrates on finding research opportunities that would have been improbable or impossible without the Internet.
6. The Wikipedia Edit Scraper was created by the Digital Methods Initiative, http://wiki.digitalmethods.net/Dmi/ToolWikipediaEditsScraperAndIPLocalizer. Date accessed 3 January 2010.
7. Methods for the first part of the analysis, mapping the wider network, follow those first applied by Gerlitz et al., 'Place of Issues (According to Editors and Their Edits)', Digital Methods Initiative. http://wiki.digitalmethods.net/Dmi/ThePlaceOfIssues, July 2009. Date accessed 10 January 2010.
8. The Wikipedia Network Analysis Tool was created by the Digital Methods Initiative. http://lab.erikborra.net/cvs/wikipediaNetwork/index.php. Date accessed 4 January 2010.
9. The Dorling Map was created by the Digital Methods Initiative: research and analysis by Richard Rogers, Sabine Niederer, Zachary Deveraux, and Bram Nijhof, design by Auke Touwslager. http://wiki.digitalmethods.net/Dmi/NetworkedContent. Date accessed 4 August 2010.
10. Nodebox software can be accessed at http://nodebox.net/code/index.php/Home. Last accessed 4 August 2010.
11. Methods for the second part of the analysis, mapping the Feminism article, follow those developed with Kimberley Spreeuwenberg for the Digital Methods Course at the University of Amsterdam (2010).
12. 'Many Eyes' Data Visualization Tool is offered by IBM. http://manyeyes.alphaworks. ibm.com/manyeyes/.
13. Bubble lines were created by the Digital Methods Initiative. http://tools.issuecrawler. net/beta/bubbleline/. Last accessed 4 January 2010.
14. 'Criticisms of Feminism' was introduced on 8 November 2005, three years after the Feminism article began. When the Sysop Cailil split 'Criticisms' into two new headings inside the article – 'Anti-feminism' and 'Pro-feminism' – she or he wrote, *'introducing rewritten content – Anti-feminism (Pro-feminism summary to follow when it's referenced).'* http://en.wikipedia.org/w/index.php?title=Feminism&action=history. Date accessed 10 January 2010.

15. Feminism edits declined in 2003 with the creation of Anarcha-feminism, possible indication of a fork. Data however shows this isn't the case; the editors in Anarcha-feminism were not previously editing in Feminism. No forking could be detected from the data at hand.

16. Durova worked with Cailil the Sysop to investigate Anacapa's overall activity. She cites this comment by Anacapa as the reason for the block: 'If you have genuine POV concerns please offer them. Otherwise please spend your time tackling the truly ugly personal cheap shots that people use against people like me who bring in content that counters the credulous content that prevails on a Maoist Mob rule encyclopedia.' Durova writes 'I have blocked this account indefinitely for this edit entitled 'Libelous warning' after a lengthy investigation, conducted mostly by Cailil, that Anacapa is a long-term disruptive editor at feminism-related subjects and probable sockpuppeteer who violates WP:NPOV, WP:NOR, WP:AGF, and generally responds aggressively to anyone who points out that this user's behavior exceeds the bounds of site standards.'

17. See discussion page on blocking Anacapa: http://en.wikipedia.org/w/index.php?title=Wikipedia:Community_sanction_noticeboard&oldid=136135960.Last accessed 10 January 2010. This page provides the entire community discussion around whether or not to block this user.

18. Examples of the exchange between Bremskraft and Cailil: 'Bremskraft, I think you're getting somewhere with those references – good job![5] Personally I would be inclined to remove the "Religions inspired by feminism" sub-section.' And 'Cailil, thank you for your always thoughtful responses. Here is the problem with trying to source American conservative religious organizations in general: what appears to be a "non reliable" source is simply a primary source.' http://en.wikipedia.org/w/index.php?title=Talk:Feminism&oldid=154594558. Date accessed 10 January 2010.

Bibliography

Brauges, G. (2009), 'Wiki-Philosophizing in a Marketplace of Ideas: Evaluating Wikipedia's Entries on Seven Great Minds', *Media Tropes E-Journal* II(1): 117–58.

Chesney, T. (2006), 'An Empirical Examination of Wikipedia's Credibility', *First Monday* 11 (November). http://firstmonday.org/issues/issue11_11/chesney/.

Digital Methods Initiative (2008), 'Digital Methods Wiki'. http://www.digitalmethods.net. Date accessed 9 January 2010.

Gerlitz, C., and Stevenson, M. (2008), 'The Place of Issues – According to Editors and Their Edits', *Digital Methods Wiki*. http://wiki.digitalmethods.net/Dmi/NetworkedContent. Date accessed 19 January 2010.

George, A. (2007), 'Avoiding Tragedy in the Wiki-Commons', *Virginia Journal of Law and Technology* 12(8), Fall.

Kittur, A., et al. (2007), 'Power of the Few vs. Wisdom of the Crowd: Wikipedia and the Rise of the Bourgeoisie', Alt.CHI at CHI 2007; 28 April–3 May 2007; San Jose, CA.

Kushal, D., Wattenberg, M., and Viegas, F. B. (2004), 'Studying Cooperation and Conflict between Authors with History Flow Visualizations', *CHI Journal* April: 24–29.

Lih, A. (2004), 'Wikipedia as Participatory Journalism: Reliable Sources? Metrics for Evaluating Collaborative Media as a News Resource', Paper presented to the 5th International Symposium on Online Journalism, University of Texas at Austin. Retrieved 19 October 2006, from http://jm http://jmsc.hku.hk/faculty/alih/publications/utaustin-2004-wikipedia-rc2.pdf. Date accessed 10 January 2010.

Niederer, S. and van Dijck, J. (2010), 'Wisdom of the Crowd or Technicity of Content? Wikipedia as a Socio-Technical System', *New Media & Society,* first published on 7 July 2010 doi:10.1177/1461444810365297.

Nissenbaum, H., and Benkler, Y. (2006), 'Commons-Based Peer Production and Virtue', *The Journal of Political Philosophy* 14(4): 394–419.

Nupedia archive (2010), http://web.archive.org/web/*/www.nupedia.com/main.shtml. Date accessed 10 January 2010.

Reagle, J. (2008), 'In Good Faith: Wikipedia and the Pursuit of the Universal Encyclopedia', PhD dissertation, New York University: 70–102.

Rogers, R. (2009), *The End of the Virtual: Digital Methods* (Amsterdam: Vossiuspers UvA).

Simmons, J. (ed.) (2006), 'The Wikipedia Mohammed Cartoons Debate: A War of Ideas. Iraq Museum International'. http://www.baghdadmuseum.org/wikipedia/wmcd03_060215. pdf.

Toolserver.org (2010), http://toolserver.org/~daniel/WikiSense/Contributors.php? wikilang=en&wikifam=.wikipedia.org&grouped=on&page=Feminism. Date accessed 10 January 2010.

Venturini, T. (2010), 'Diving in Magma: How to Explore Controversies with Actor-Network Theory', *Public Understanding of Science* 19(3): 258–73.

Wiki.org (2010), 'What is Wiki'. http://wiki.org/wiki.cgi?WhatIsWiki. Date accessed 9 January 2010.

Wikipedia (2010a), 'About Wikipedia'. http://en.wikipedia.org/wiki/Wikipedia:About. Date accessed 9 January 2010.

Wikipedia (2010j), 'Anacapa User Page'. http://en.wikipedia.org/wiki/User:Anacapa. Date accessed 3 December 2009.

Wikipedia (2010l), 'Community Sanction Board'. http://en.wikipedia.org/w/index. php?title=Wikipedia:Community_sanction_noticeboard&oldid=136135960. Date accessed 10 January 2010.

Wikipedia (2010h), 'Edit Warring'. http://en.wikipedia.org/wiki/Edit_warring. Date accessed 10 January 2010.

Wikipedia, 'Feminism Talk Page'. http://en.wikipedia.org/w/index.php?title=Talk:Feminism&oldid=154594558. Date accessed 10 January 2010.

Wikipedia (2010m), 'Feminism Edit History 1 February 2006'. http://en.wikipedia.org/w/index.php?title=Feminism&oldid=154829063. Date accessed 10 January 2010.

Wikpedia (2010n), 'Feminism Edit History 31 August 2007'. http://en.wikipedia.org/w/index.php?title=Feminism&oldid=37622595. Date accessed 10 January 2010.

Wikipedia (2010o), 'Feminism Edit History 30 April 2006'. http://en.wikipedia.org/w/index.php?title=Feminism&oldid=50939405. Date accessed 10 January 2010.

Wikipedia (2010i), 'Flame War'. http://en.wikipedia.org/wiki/Flame_war. Date accessed 10 January 2010.

Wikipedia (2010d), 'Neutral Point of View'. http://en.wikipedia.org/wiki/Wikipedia: Neutral_point_of_view. Date accessed 26 March 2009.

Wikipedia (2010c), 'No Original Research'. http://en.wikipedia.org/wiki/Wikipedia:No_ original_research. Date accessed 26 March 2009.

Wikipedia (2010k), 'Plonkeroo User Page'. http://en.wikipedia.org/wiki/User:Plonkeroo. Date accessed 3 December 2009.

Wikipedia (2010e), 'Reliability of Wikipedia'. http://en.wikipedia.org/wiki/Reliability_ of_Wikipedia. Date accessed 7 January 2010.

Wikipedia (2009), 'Revision History of Feminism'. http://en.wikipedia.org/w/index.php ?title=Feminism&action=history. Date accessed 3 December 2009.

Wikipedia (2010), 'Revision History of Antifeminism'. http://en.wikipedia.org/w/index.php?title=Antifeminism&action=history. Date accessed 3 December 2009.

Wikipedia (2010), 'Revision History Pro-feminism. http://en.wikipedia.org/w/index.php?title=Pro-feminism&action=history. Date accessed 3 December 2009.

Wikipedia (2010g), 'The Three Revert Rules'. http://en.wikipedia.org/wiki/The_Three_revert_rule#The_three-revert_rule. Date accessed 10 January 2010.

Wikipedia (2010b), 'Verifiability'. http://en.wikipedia.org/wiki/Wikipedia:Verifiability. Date accessed 26 March 2009.

Wikipedia (2010f), 'Writing for the Opponent'. http://en.wikipedia.org/wiki/Wikipedia:Writing_for_the_opponent. Date accessed 10 January 2010.

14
How to Compare One Million Images?

Lev Manovich

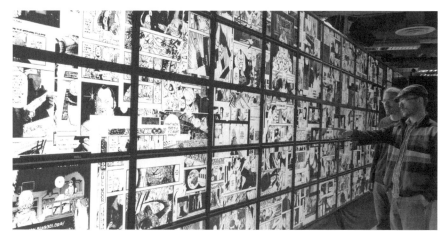

Figure 14.1 Exploring one million manga pages on the 287 megapixel HIPerSpace (The Highly Interactive Parallelized Display Space) at Calit2, San Diego. HIPerSpace offers 35,840 x 8,000 pixels resolution (287 megapixels) on 31.8 foot wide and 7.5 foot tall display wall made from 70 30-inch monitors

Introduction

The description of joint NEH/NSF Digging into Data competition (2009) organised by Office of Digital Humanities at the National Endowment of Humanities (the U.S. federal agency which funds humanities research) opens with these questions: 'How does the notion of scale affect humanities and social science research? Now that scholars have access to huge repositories of digitised data – far more than they could read in a lifetime – what does that mean for research?' A year later, an article in the *New York Times* (16 November 2010) stated: 'The next big idea in language, history and the arts? Data.'

While digitised archives of historical documents certainly represent a jump in scale in comparison to traditionally small corpora used by humanists, researchers and critics interested in contemporary culture have an even larger challenge. With the notable exception of Google Books, the size of digital historical archives pales in comparison to the quantity of digital media created by contemporary cultural producers and consumers – designs, motion graphics, websites, blogs, YouTube videos, photos on Flickr, Facebook postings, Twitter messages, and other types of professional and participatory media. This quantitative change is at least as important as the other fundamental effects of the political, technological, and social processes that start after the end of the Cold War (for instance, free long-distance multimedia communication). In an earlier article I described this in the following way:

> The exponential growth of a number of both non-professional and professional media producers over the last decade has created a fundamentally new cultural situation and a challenge to our normal ways of tracking and studying culture. Hundreds of millions of people are routinely creating and sharing cultural content – blogs, photos, videos, online comments and discussions, and so forth.

> At the same time, the rapid growth of professional educational and cultural institutions in many newly globalised countries, along with the instant availability of cultural news over the Web and ubiquity of media and design software, has also dramatically increased the number of culture professionals who participate in global cultural production and discussions.

> Before, cultural theorists and historians could generate theories and histories based on small data sets (for instance, 'Italian Renaissance', 'classical Hollywood cinema', 'post-modernism', etc.) But how can we track 'global digital cultures', with their billions of cultural objects, and hundreds of millions of contributors? Before you could write about culture by following what was going on in a small number of world capitals and schools. But how can we follow the developments in tens of thousands of cities and educational institutions? (Manovich 2009).

While the availability of large digitised collections of humanities data certainly creates the case for humanists to use computational tools, the rise of social media and globalisation of professional culture leave us no other choice. But how can we explore patterns and relations between sets of photographs, designs, or video which may number in the hundreds of thousands, millions, or billions? (By summer 2010, Facebook contained 48 billion photos; deviantArt. com, the leading site for non-professional art, housed 100 million submissions; coroflot.com, a site used by professional designers, had 200,000 portfolios.)

In 2007 we have set up a new lab called Software Studies Initiative (http:// www.softwarestudies.com) at the University of California, San Diego (UCSD)

and the California Institute for Telecommunication and Information (Calit2) to address these challenges. We developed a number of methods and techniques for the analysis and visualisation of large sets of images, video, and interactive visual media. This article describes our key method which consists of two parts: 1) automatic digital image analysis that generates numerical descriptions of various visual characteristics of the images; 2) visualisations that show the complete image set organised by these characteristics.

We have already successfully applied this method for researching many types of visual media: comics, Web comics, video games, virtual worlds, video, films, cartoons, motion graphics, print magazines, paintings, and photographs. Examples include 167,000 images from Art Now Flickr group, 100 hours of *Kingdom Hearts* video game play, and 20,000 pages of *Science* and *Popular Science* magazines (1872–1922). (For more details and other projects, see the digital humanities section of our lab blog http://www.softwarestudies.com; you can also find our visualisations on YouTube and Flickr at http://www.flickr.com/photos/culturevis/collections/).

To test how this method would work with larger datasets, in the fall 2009 we downloaded the complete runs of 883 different manga series from the most popular website for 'scanlations', OneManga.com. (Scanlation is a manga which was originally published in Japan and then was digitised and translated by fans.) We obtained all pages available for these series along with the user-assigned tags indicating the genres and intended audiences for them (see Douglass, Huber, and Manovich, *Understanding Scanlation*).

The resulting data set contains 1,074,790 manga pages. Each page is in the form of a JPEG image; average image resolution is 850 x 1150 pixels. We used our custom digital image processing software to measure a number of visual features of every page (shading, presence of fine details, texture properties) using supercomputers at the National Energy Research Scientific Computing Center (NERSC). (A 'feature' is the common term in digital image processing; it refers to a numerical description of some image property.)

In this chapter we use the challenge of working with this set of one million manga pages to motivate the need for a computational approach for the exploration of collections of such size, and to explain our particular method that combines digital image analysis and a novel visualisation technique.

Any reflection on culture begins with an informal comparison between multiple objects in order to understand their similarities and differences. For instance, if we want our analysis to properly reflect the range of graphical techniques used today by manga artists across thousands of manga books, millions of pages, and tens of millions of individual panels, we need to be able to examine details of individual images and to find patterns of difference and similarity across large numbers of images. To do this, we need a mechanism that would allow us to precisely compare sets of images of any size – from a few dozen to millions. We discuss how our method, which combines automatic digital image analysis and media visualisation, addresses these requirements.

How to compare one million images?

Today, a typical publication in the humanities is based on the detailed examination of a small number of artifacts (which, depending on the field, can be literary texts, TV programmes, films, video games, etc.). Of course this does not mean that the author only considered these artifacts in isolation. Usually the detailed analysis of these artifacts is performed against the larger horizon – the knowledge of the wider cultural field(s) which is acquired both directly (for instance, watching films) or indirectly (for instance, reading publications in film studies). But how reliable or complete is this background knowledge? For instance, to continue with the example of cinema, IMDb (www.imdb.com) contains information for over half a million films produced since the beginning of cinema; how many of them were seen by academic film scholars and film critics? (The same database lists 1,137,074 TV episodes as of summer 2001 [see IMDb Database Statistics]).

The fact that using tiny samples has been a default method of humanities until now does not mean that we should keep using it forever. If Google can analyse billions of Web pages and over a trillion links several times each day, we should be able to do better than simply consider a handful of artifacts and generalise from them – even if we don't have the same resources. The key reason for the huge infrastructure maintained by Google is the need to index the Web in real time; in the case of cultural analysis, we don't have the same requirements, so we should be able to analyse large cultural data sets with much smaller computer resources. Indeed, today computer scientists who study online social media typically capture and analyse dozens or hundreds of millions of separate objects – photos, Twitter updates, blog posts, and so on – with very small resources. (See Cha et al., 'I Tube, You Tube, Everybody Tubes'; Crandall et al., 'Mapping the World's Photos'; Kwak et al., 'What is Twitter?').

Having at our disposal very large cultural data sets which can be analysed automatically with computers and explored using interactive interfaces and visualisation opens up new possibilities. These possibilities can potentially transform our understanding of cultures in many important ways. Instead of being fuzzy and blurred, our horizon (knowledge of a cultural field as whole) can become razor sharp and at the same time acquire a new depth (being able to sort and cluster millions of artifacts along multiple dimensions). This would enrich our understanding of any single artifact because we would see it in relation to precisely delineated larger patterns. It would also allow us to make more confident statements about the field at large. Perhaps most importantly it will erase the distinction between the precision of 'close reading' and imprecision of a 'zoomed out' view' – between a detailed understanding of a few works and very approximate ideas about the field as a whole which we normally form by mentally interpolating between a small number of facts and artifacts we study.

It will also erase the separation between 'close reading' (detailed analysis of small parts of texts) and Franco Moretti's 'distant reading' (as it is commonly understood – which is not the same as how Moretti defines it (see his *Conjectures on World Literature*, 2000): analysis of large-scale patterns in the development of entire genres, literary production of whole countries, and the like, using a whole novel as an atom of analysis (for instance, counting a number of novels in different genres published over a historical period). Rather than choosing one scale of analysis, we would be able to easily traverse between all them at will, observing patterns at any scale.

Any automatic computational analysis of large samples of human cultures will have many limitations of its own, and therefore it will not replace human intuition and experience. However, while we should keep in mind these various limitations, the opportunities that it offers are still immense. For example, having access to a million manga pages should allow us, in principle, to pretty reliably map the full spectrum of graphical possibilities used by contemporary commercial Japanese manga artists. Such a mapping would also allow us to understand which manga series are most typical and which are most unique stylistically; to find all series where graphical language significantly changes over time (today all top series have been running for a number of years); to investigate if shorter series and longer series have different patterns; to separate the artists who significantly vary their graphical languages from series to series from the artists who do not; and so on. We also would be able to take any hypothesis or observation we may make while informally looking through a small sample of images – for instance, we may observe that the manga aimed at different genders and age groups has distinct graphical languages – and see if it holds across our whole set.

But how can we accomplish this in practice? How can we possibly compare one million manga pages?

What eyes can't see

1. Let us start by selecting only two manga pages from our data set and examining them directly without any software tools. We will take these pages from the *One Piece* and *Vampire Knight* series. The first is one of the best-selling and top-rated *shounen* (teenage boys) manga; the second is among the top *shoujo* (teenage girls) manga (Figures 14.2 and 14.3).

We can certainly note many kinds of stylistic distinctions by comparing these two pages. For instance, we may observe that a page from *Vampire Knight* contains dramatic diagonal angles created by both panel divisions and lines inside the panels, the full palette of grey tones from white to grey to black, the large black letters representing sounds and contributing additional visual energy. In contrast, the page from *One Piece* has very little shading; the lines

Figure 14.2 Sample page from *Vampire Knight*

have curves; the panels are neat rectangles. However, how do we know if these stylistic distinctions hold for all of the 10,562 *One Piece* pages and 1,423 *Vampire Knight* pages which we have available? Similarly, if we want to talk about a graphical style of an artist who may have produced tens of thousands of pages across dozens of titles, would selecting and examining a few dozen pages be sufficient? And what if we want to compare all *shounen* and *shoujo* manga in our data set? How many pages should we pull out from each of these categories to reach authoritative conclusions about the possible difference in their graphical languages?

If we only examine a small number of images from a much larger image set at random, we can't be certain that our observations will hold across the complete set. For example, in the case of our one million pages collection (which itself is only a sample of all manga being published commercially), 100 pages is 0.0001% of all available pages. We don't have any reason to believe that whatever we may observe in these 100 pages is typical of our manga set as a whole.

Thus, *the first problem with using our native perception to compare images in order to notice differences and similarities is that this approach does not scale.* If we only examine a small selection of manga pages, this does not qualify us to make general statements about the graphical style of 'best-selling manga', '*shounen*

Figure 14.3 Sample page from *One Piece*. According to the OneManga.com June 2010 list of top 50 series titles accessed by site users, *One Piece* was number 2, while *Vampire Knight* was number 13. According to www.icv2.com, during Q3 2010, *One Piece* was number 2 in Japan, and *Vampire Knight* was number 4. The difference in the *Vampire Knight* ranking is likely to reflect different proportions of male/female manga readers inside and outside of Japan

manga', or even of a single long-running series such as *Hajime no Ippo* (15,978 pages in our data set.)

Examining only a small sample of a larger image set also precludes us from understanding detailed patterns of change and evolution. To illustrate this, we pulled out three pages from a best-selling *One Piece* manga (see Figure 14.5). The pages come from chapters 5, 200, and 400. The series started in 1997; approximately 600 chapters were published by the end of 2010, with new chapters appearing weekly. Thus, the time passed between chapter 5 and chapter 400 is approximately eight years; during these periods, the artists created over 7,000 pages. (Our data source did not have exact information on publication dates of every chapter, and that's why we have to estimate them in this way.) As we can immediately see by comparing these three pages, the graphical language of *One Piece* apparently changed significantly during these eight years – but *how* did it change? Was it a gradual transition, a series of abrupt changes, or some other temporal pattern? Unless we have a

Figure 14.4 10,461 scanlation pages from *One Piece* which were available on OneManga. com in the fall 2009, organised by sequence of publication (left to right, top to bottom). This composite image (we call such images 'montages') includes special pages inserted by scanlation groups (some of them appear as dark black squares when you look at a small version of the visualisation)

Note: To fit all pages in a rectangular grid, some of the pages were cropped.

mechanism to compare a much larger number of pages, we can't answer this question.

In this example, it will be beneficial to pull out a larger set of sample pages using some systematic procedure. For example, we can select every hundredth page to get a better idea of how series' visual language is changing over time. This approach can also be applied for comparing different manga series. For instance, we could take every two-hundredth page of *Naruto* and every two-hundredth page of *One Piece*. (*Naruto* is the most popular manga series around the world today.) Since our data set contains approximately 10,000 pages for each of these series, we would end up with 50 pages for each. We could then examine these 100 pages in order to describe the differences between the styles of the two series. Or, if our series is not very long, we can use a different procedure. We can select one page from each chapter of a series and then use such sets of pages to compare series to each other.

Figure 14.5 Sample pages from *One Piece* manga series drawn from the chapters 5, 200, and 400

However, such an approach will fail if the style within each chapter *varies*. The pages we may select using our sampling procedure may not properly reflect all these variations. This is a fundamental problem with the idea of selecting a number of 'representative pages' and only working with this smaller set.

For instance, consider all pages from one of *Abara*'s chapters (see Figure 14.6). Which page in each chapter best represents its style? Regardless of which page we select to stand in for the whole chapter, it will not adequately convey the stylistic variations across all the pages. Some pages consist mostly of black-and-white areas, with little texture; other pages have lots of shading and use mostly grey; still others combine panels in both styles.

Of course, if we are using a computer to browse our image set, we are no longer limited to pulling out a small sample of images for close examination. Modern operating systems (OS) such as Windows, Mac OS, iOS, and Android, image organiser and viewer software such as Google's Picasa and Apple's iPhoto, and Web photo-sharing services such as Photobucket and Flickr all provide the options to browse through lots of images. So if we, for example, add all 10,461 *One Piece* pages to iPhoto, we can pan, zooming in and out at will, quickly moving between individual images and the whole set.

This should help us to notice additional visual differences and affinities across large sets of images beyond whose picked up by a close analysis of a small sample. Unfortunately, the display modes offered by existing consumer software and Web services are rather inflexible. Typically, the only modes available are a slide show and an image grid. Moreover, usually the images can be sorted by only a few parameters such as uploaded dates, or names, and the user can't easily change the order in which images are displayed. In order to display images in a different order, you have to first to assign new keyword(s)

to every image. This prevents spontaneous discovery of interesting patterns in an image set. Instead of re-organising images along different dimensions and quickly trying different possibilities, a user would have to know first the exact order in which to display images.

Of course, if our image set has some very obvious patterns – let's say it consists of images in three distinct styles only – these limited browsing modes and fixed order would still be sufficient, and we will easily notice these patterns. But such cases are exceptions rather than the norm. (While Picasso worked in a number of dramatically different styles, this is not typical.)

An alternative to examining a set of images informally – regardless of whether we are looking formally at a few, or use software to browse through many – is to systematically describe each using a number of terms, and then analyse the distributions of these terms. In the humanities, this process is called 'annotation'. A researcher defines a dictionary of descriptive terms and then tags all images (or film shots, transitions between comic frames, or any other visual objects). A parallel to the popular practice of users tagging media objects in social media sites (think of tags in Flickr), or adding keywords to one's blog post is obvious – however, while users are free to add any keywords they want, in academic studies researchers typically employ 'closed vocabularies' where a set of terms is defined beforehand. Once all images are annotated, we can look at all the images that have particular tags; we can plot and compare the tag frequencies and other statistical descriptions. For instance, if we annotate manga pages using a set of tags describing visual style, we can then compare how often each stylistic feature was used for *shounen* vs. *shoujo* pages.

Barry Salt pioneered the use of this method to study visual media. He annotated all shots in the first 30 minutes of a few hundred twentieth-century feature films using a number of characteristics: shot scale, camera movement, and angle of shot. Salt used a small number of categories for each characteristic. For example, possible camera movement types were pan, tilt, pan with tilt, track, and so forth (Barry Salt's Database). He also recorded shot duration (Salt, *The Statistical Style Analysis*; *Film Style and Technology*.) Salt then used descriptive statistics measures and graphs to analyse this data. In his very influential book, *Understanding Comics* (1993), Scott McLoud employed a similar method to compare the visual language of Japanese manga and comics from the West. He annotated types of transitions between frames in a number of manga and comic books, and then used histograms to visually explore the data.

Communication and media studies fields have a similar method called 'content analysis'. If humanists usually are concerned with works of a particular author(s), communication researchers typically employ content analysis to analyse representations in mass media, and, more recently, user-generated content. Therefore, they more carefully determine their samples; they also employ multiple people to 'code' (the term used in content analysis to refer to annotation)

media material, and then calculate the degree of agreement between the results of different coders. Here are a couple of recent applications of this method: Herring, Scheidt, Kouper, and Wright analysed the content of 457 randomly selected blogs collected at roughly six-month intervals between 2003 and 2004 'to assess the extent to which the characteristics of blogs themselves remained stable or changed during this active period'. Williams, Martins, Consalvo, and Ivory analysed characters in 150 video games; the total of 8,572 characters were coded to 'answer questions about their representations of gender, race and age in comparison to the US population'.

This method is more powerful than informal examination of media, but it suffers from the same problem – it does not scale to massive data sets. McLoud, for instance, only annotated a small number of comic books and manga titles. Would he obtain the same results with a much larger set – such as our collection of one million manga pages? And even if his results were confirmed, what about all possible exceptions? To find them, we need to tag every page.

Let us say we have a trained viewer who can examine a manga page and select the relevant tags. If this viewer spends one minute for each page and works eight hours per day, it would take almost six years to annotate one million pages.

(Recently, it became possible to use crowdsourcing in order to speed up this process. Since we cannot expect every person to have the same judgements about visual form or to use tags in the same way, researchers use statistical techniques to calculate consistency between the judgements of all participating workers, and to disregard low quality results. However, this approach has a fundamental limitation – like any other attempt to describe images using natural languages, it is much better at capturing image content than form. We discuss this in more detail below.)

Summary: When we examine only a small subset of a large image set, our sample may not be representative of the whole set; it may not properly reflect all variations in a set; and we may not be able to study gradual changes over time.

2. So what if we assume that our data set contains not a million images, but only a hundred? Not that the problem of scale goes away, but is it sufficient to use our eyes only? No. *The second problem with using our eyes is that we are not very good at registering subtle differences between images.* If you are confronted with a small number of images that have substantial differences, your brain can easily organise these images according to their visual differences. (Here I am not concerned with differences in content, which are easy to see, but with the differences in visual language.) This means being able to separate them into groups, rank them according to one or more kinds of visual characteristics, notice the outliers (images which stand out from the rest), and complete other tasks. For instance, we have no problem separating a set of paintings by Piet Mondrian and Theo van Doesburg into two groups corresponding to the

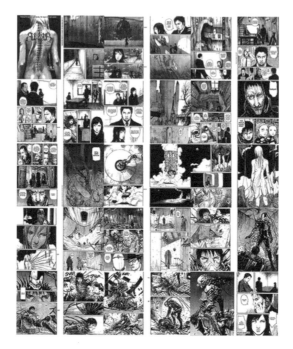

Figure 14.6 A chapter from *Abara* manga by Tsutomu Nihei

works of each artist. Mondrian uses exclusively horizontal and vertical line orientations, while van Doesburg only uses diagonals. These properties clearly mark Mondrian's and van Doesburg's paintings as belonging to two distinct classes.

But with a large number of images, which have smaller differences, we can no longer perform these tasks. The following example illustrates this Figures 14.6 and 14.7. The first composite image contains all pages from one chapter of *Abara* by Tsutomu Nihei. The second composite image contains all pages from one chapter of *BioMega* by the same artist. Do *Abara* and *BioMega* share the same style, or do they have subtle but important differences (besides the size of the panels)? For example, does one title have more stylistic variety than the other? Which page in each title is the most unusual stylistically? Even with this small number of manga pages, these questions are already impossible to answer.

Summary: Even with a small image sample, we may not be able to notice small visual differences between images.

3. *Abara* and *BioMega* have only a few hundred pages each. Out of 883 manga series in our collection, 297 series contain over 1,000 pages, while a number of series have more than 10,000 pages each. If we have difficulty comparing only a few dozen pages from *Abara* and *BioMega*, how can we possibly do this with manga series which are much longer?

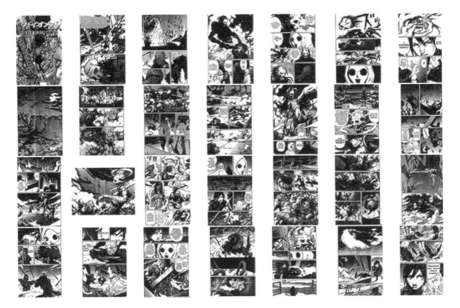

Figure 14.7 A chapter from *BioMega* manga by Tsutomu Nihei

Annotation/content analysis methods will not help here. To use them, we need to have enough tags to comprehensively describe visual characteristics of manga. However, creating a vocabulary which we can use to label all types of visual differences in manga – or in any other form of visual culture – is problematic by itself. We do not have enough words in our natural languages to adequately describe visual characteristics of *even a single manga image* – let alone all other kinds of human-created images. Consider a sample page from *Vampire Knight*. Can we describe all variations in background textures in its four panels? Or the differences between the rendering of hair in each of these panels?

This is *the third problem* with studying visual art, visual culture, and visual media using traditional humanities approaches. Regardless of the methodologies and theories being employed in a given case, all of them use one representational system (a natural language) to describe another (images). But, as the last example shows, we will not be able to give names to all of the variations of textures, compositions, lines, and shapes used even in a single chapter of *Abara*, let alone one million manga pages. We can proceed with traditional approaches so long as we limit ourselves to discussing manga iconography and other distinct visual elements which have standardised shapes and meanings: water drops signifying stress, throbbing veins signifying anger, and so forth. But if we actually want to start discussing a range of graphical and compositional

possibilities used across manga, we need a new kind of instrument. This fundamental limitation applies to all other visual forms developed by human beings, be they paintings, drawings, photographs, graphic designs, Web pages, visual interfaces, animations, and so forth.

Summary: Natural languages do not allow us to properly describe all visual characteristics of images, or name all their possible variations.

Method: digital image processing + visualisation

To address these challenges, we developed a set of methods and techniques, which together we call Cultural Analytics. The key idea of cultural analytics is the use of visualisation to explore large sets of images and video. These visualisations can use existing metadata (for example, publication dates or author names) and also new metadata added by researchers via annotation or coding. However, as we already discussed, adding tags or other annotations manually has serious limitations: our natural visual system can't notice subtle visual differences between a large number of images, and our natural languages do not have terms to describe all visual characteristics of images, or name their possible variations.

To overcome these limitations, our core method uses digital image processing and a new type of visualisation. This section describes this method, and the next sections apply it to progressively larger numbers of images drawn from our one million manga data set. (For the description of other visualisation methods we are using, see Manovich 2010.)

The method involves two steps:

1. We use *digital image processing* to automatically measure a number of visual characteristics (i.e., features) of our images. In this process, visual qualities are mapped into numbers. (In computer science, this step is often referred to as 'feature extraction'.) For example, in the case of grey tones measured on a 0–255 scale, black may be represented as 0, white as 255, and 50% grey as 127.5. The examples of dimensions that can be measured include contrast, presence of texture and fine details, number of lines and their curvature, number and type of edges, and characteristics of every shape. In the case of colour images, we can also measure the colours of all pixels (hue, saturation, brightness), determine most frequently used colours, and also calculate various image statistics for each colour component separately.

Typically, such measurements produce many numbers for each visual dimension of an image. For instance, every pixel will have its greyscale value. If we measure orientations of all lines in an image, we will end with a separate number for every line. In order to be able to compare multiple images with one another along particular dimensions, it is convenient to use the averages of the measurements on each dimension.

For example, if we are interested in greyscale values, we add values of all pixels and divide them by the number of pixels. In the case of line orientations, we similarly add angles of all lines and divide them by the number of lines.

Besides simple average (i.e., mean), we can also use other types of descriptive statistics to summarise image characteristics such as various representations of central tendency such as median and mode and representations of data dispersion such as variance, histograms, and so forth.

2. We create 2D visualisations that position the images according to the averages of their feature values. For example, we may use horizontal dimension to represent brightness values, and vertical dimension to represent saturation values. The average values of image features calculated by software in step 1 became image coordinates in a 2D space. In this way, *the differences between images along a particular visual dimension are translated into their positions in space –* something that the human visual system can read very well.

Combination of digital image analysis and visualisation makes it possible to bypass the problem which haunted visual semiotics in particular, and all human descriptions of the visual in general: the inability of language to adequately represent all variations which images can contain. For instance, even if we use hundreds of words for colours, images can show millions of colour variations. And colour is not the worst case; for other dimensions such as texture or line character, the terms provided by natural languages are much more limited.

In other words, our senses are able to register a much larger set of values on any analog dimension – loudness, pitch, brightness, colour, motion, orientation, size, and so forth. – than our languages have words for. This makes sense because language has developed much later evolutionarily to supplement the senses. Language divides the continuous world into larger discrete categories that make possible abstract reasoning, metaphors, and other unique capacities. It is not designed to exactly map the wealth of our sensory experience into another representational system.

So if we can't rely on a natural language to capture what our senses can register – and we can't rely on the senses because, as we discussed in the previous section, they are not able to register very subtle differences between images, or other cultural artifacts – how can we talk about visual culture and visual media?

Our approach is to use visualisation as a new descriptive system. In other words, we *describe images with images*. In doing this, we are taking advantage of the ability of images to register subtle differences on any visual dimension.

While we utilise a variety of visualisation techniques, the core technique used by our method is a *scatter plot*, that is, a 2D visual representation that uses Cartesian coordinates to display two sets of numerical values describing some data. In our case, each element of a data set is an image, and the two values that determine its position in a plot are two measured visual qualities, such as average saturation and average brightness.

Equally often we use *line graphs* where the X-axis represents the dates the images were created (or their positions in a narrative sequence such as a comic book), and the Y-axis represents some measured value (such as average saturation).

Along with regular scatter plots and line graphs, we also use a new visualisation technique which we call *image plot*. A normal scatter plot and a line graph display the data as points and lines. An *image plot* superimposes images over data points in a graph (see visualisations below for examples).

Note that our method does not imply that we are getting rid of discrete categories completely. Rather, instead of being limited to a few provided by language, we can now define as many as we need. Example: let's say that we want to describe greyscale levels in an image. We use software to read pixel values from an image file, and calculate an average value. This average is then used to position the image in the visualisation along X- or Y-axis.

If pixel values fall within a 0–255 scale (as they do in common 8-bit or 24-bit image formats), and we round off the average, we will have 256 separate categories for greyscale. They don't have separate names. But they work – they allow us to compare multiple images in terms of their greyscale values. We are, of course, not limited to 256 categories – if we want, we can use 10, 100, 1000, 10,000, and so forth.

(Technical details: We also use more advanced visualisation techniques such as scatter plot matrix and parallel coordinates, and multivariate data analysis techniques such as PCA, cluster analysis, etc. However, since the concepts of a multi-dimensional feature space and dimension reduction are more abstract, in this chapter all our examples are 2D visualisations where each axis corresponds to a single feature such as average brightness, or metadata which was collected along with the data – such as a position of a page within the sequence of all pages in a Web comics title.)

While the technique we call 'image plots' has been described in a number of articles in Computer Science (Peters, MultiMatch), it has not been made available in any graphing or visualisation application. Our lab developed free software to create image plots; we use this software in all our projects, and also distribute it as open source (Software Studies Initiative, ImagePlot). The software runs on regular Windows, Mac, and Lunix desktops and laptops. Together with Gravity Lab at California Institute for Telecommunication and Information (Calit2), we also developed an interactive software that can generate image plots which can contain thousands of images in real time on scalable tiled displays (Yamaoka et al., 2011).

Visualising *Abara* and *Noise* (474 Pages)

Having introduced our method – visualising images in a scatter plot form according to quantitative descriptions of their visual properties measured

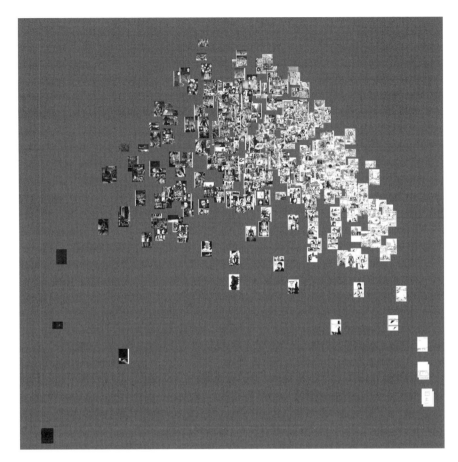

Figure 14.8 *Abara* pages. Artist: Tsutomu Nihei

X-axis = standard deviation of greyscale values of all pixels in a page.
Y-axis = entropy calculated over greyscale values of all pixels in a page.

with digital image processing techniques – let's now apply this method to our manga data set.

To make our visualisation examples easier to follow, we will use the same two visual features throughout. The first feature is a standard deviation of greyscale values of all pixels in an image. Standard deviation is a commonly used measure of variability. It shows how much the data is dispersed around the average. If an image has a big range of greyscale values, it will have large standard deviation. If an image employs only a few greyscale values, its standard deviation will be small.

The second feature is entropy. In information theory, the concept of entropy was developed by Claude E. Shannon in his famous 1948 paper,

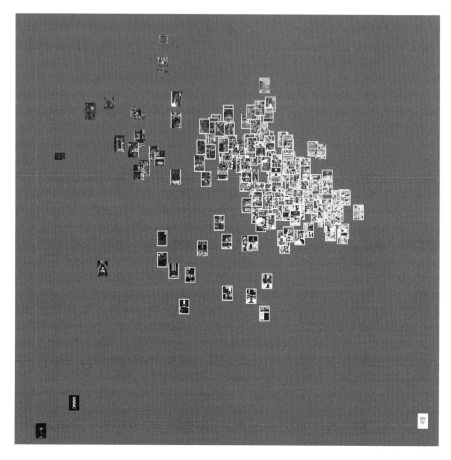

Figure 14.9 NOISE pages. Artist: Tsutomu Nihei

X-axis = standard deviation of greyscale values of all pixels in a page.
Y-axis = entropy calculated over greyscale values of all pixels in a page.

'A Mathematical Theory of Communication'. Entropy describes the degree of uncertainty in the data – that is, how difficult or how easy it is to predict the unknown data values given the values we already know. If an image consists of a few monochrome areas, its entropy will be low. In contrast, if an image has lots of texture and details, and its colours (or greyscale values in the case of black-and-white images) vary significantly from place to place, its entropy will be high.

In the following examples, we will map standard deviation values to X-axis, and entropy values to Y-axis. We will start by creating image plots of *Abara* and *Noise* pages. The first title has 291 pages; the second has 183 pages.

(This count includes all pages which were available for these titles on OneManga. com, including title and credit pages.)

As can be seen, standard deviation (X-axis) and entropy (Y-axis) measurements indeed correspond to perceptually meaningful visual characteristics of manga pages. The pages with low entropy values are situated in the bottom part of a plot. They consist of a small number of flat areas, with minimum detail and no texture. The pages with high entropy values situated in the top part of a plot are the opposite: they have lots of detail and texture. On a horizontal dimension, the pages that only employ a few greyscale values are on the left; the pages that have the range of values are in the middle; and the pages that only have white and black are on the right.

To be able to compare the range of standard deviation and entropy values in both titles, we can plot the data using standard scatter plots, and put the two plots side by side (*Abara* is on the left; *NOISE* is on the right).

These visualisations of the two titles make answering the questions we asked earlier easy. Does one title has more stylistic variety than the other? Yes, *Abara*'s style varies much more than *NOISE* style: the points on the left plot are more dispersed than the points on the right plot. Which page in each title is the most unusual stylistically? Each plot reveals a number of outliers – that is, points that stand out from the rest. (Of course, we should keep in mind that the two measurements we are using in these plots – standard deviation and entropy – only capture some dimensions of a visual style. If we use other features, different pages may stand out as outliers.)

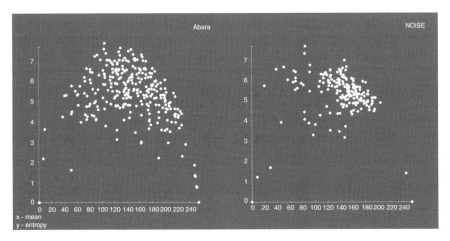

Figure 14.10 *Abara* pages (left) and *NOISE* pages (right). Artist: Tsutomu Nihei

X-axis = standard deviation of greyscale values of all pixels in a page.
Y-axis = entropy calculated over greyscale values of all pixels in a page.

Visualising temporal changes

Manga is a sequential art. To understand if and how visual style in a title varies over the sequence of its chapters and individual pages, we can generate image plots where X-axis represents a page's position in a sequence, and Y-axis uses some visual feature. If we do this for two titles, we can then compare how they vary in time in relation to this feature.

When we make image plots using this approach, they can become very long. For example, let's say we want to graph a sequence of 10,000 images and make each image 100 pixels wide. Such visualisation will be 10,000 x 100 = 1,000,000 pixels wide. To address this problem, our visualisations of feature films represent each shot by a single frame. You can find examples of such plots we made for whole films on our Flickr gallery. Here we will use image plots for shorter titles, and traditional line graphs that represent each page by a point for longer titles. (A line graph does not have to use lines to connect the data. The difference between a line graph and a scatter plot is that the former assumes that data values mapped onto X-axis are separated by the same interval, that is, 1, 2, 3, ... A scatter plot does not make this assumption.)

The next two visualisations compare Abara and NOISE stylistic development on low detail/texture – high detail/texture dimension represented by entropy values.

In both titles, entropy values change over time. The pattern of these changes in *NOISE* can be described as a linear slight shift downward. The pattern in *Abara* is more complex. It can be characterised as a horizontal line, followed by a curve which first goes down and then goes up.

The two temporal patterns also have an interesting structural similarity. In each graph, the range between the top and bottom points (i.e.. the difference between their values on Y-axis) gradually increases. This means that stylistically the pages are at first are pretty similar, but become more varied over time. (Again, keep in mind that we are describing only one stylistic dimension.)

Figure 14.11 Abara pages
X-axis = page sequential position in the title (left to right).
Y-axis = entropy calculated over greyscale values of all pixels in a page.

Figure 14.12 NOISE pages

X-axis = page sequential position in the title (left to right).
Y-axis = entropy calculated over greyscale values of all pixels in a page.

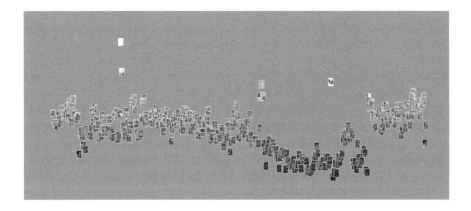

Figure 14.13 342 consecutive pages of the Web comic *Freakangels* (2008–2009)

X-axis = page publication order.
Y-axis = mean of greyscale values of all pixels in a page. Greyscale value = (R value + G value + B value) / 3.

To illustrate interesting temporal patterns that can be revealed using such line graphs of feature values, we will go outside of our one million manga pages for the next example. We will look at the Web comic *Freakangels*. Our data set consists of 342 consecutive pages published over 15 months (2008 to 2009) in six-page chapters appearing weekly. Like in previous graphs, we use Y-axis to represent a single visual feature, and reserve X-axis for page publication order.

In our visualization (Figure 14.13) Y position of each page is determined by the mean (average) of the greyscale values of all pixels in the page.

Despite the weekly intervals that separate the six-page episodes of *Freakangels*, visualisation shows that visual values of the pages are remarkably consistent. For the larger part of the publication period, the changes in brightness follow a smooth curve (the same applies to hue and saturation if we plot them). While

the overall change from light to dark images corresponds to the development of the story from day to night, the fact that the brightness shifts very gradually and systematically over many months is a genuine discovery. Visualisation reveals this unexpected pattern and allows us to see the exact shape of the curve.

Visualising *Naruto* and *One Piece* (17,782 Pages)

We will next compare some of the most popular manga series: *Naruto* (1999–) and *One Piece* (1997–). These titles are rated number 1 and number 3 among OneManga.com global readers. When we downloaded the pages from OneManga.com in fall 2009, the first series had been published continuously for ten years, and the second had been published for twelve years. Accordingly, our download contained 8,037 *Naruto* pages and 9,745 *One Piece* pages.

The following visualisations compare these 9,745 *One Piece* pages and 8,037 *Naruto* pages. Again, the pages are organised according to standard deviation (X-axis) and entropy (Y-axis) measurements. (Both statistics are calculated using all pixels' brightness values in a page.)

First we plot the data using scatter plots; each page is represented by a point.

As in the previous examples, the pages in the upper right have lots of detail and texture. The pages with the highest contrast are on the right, while pages with the least contrast are on the left.

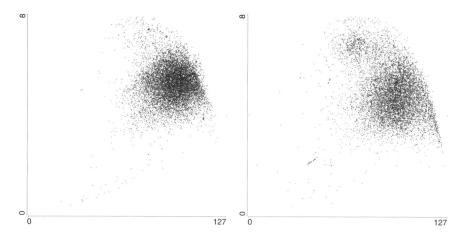

Figure 14.14 Left: 9,745 *One Piece* pages, Right: 8,037 *Naruto* pages
Each page is represented by a point.
X-axis = standard deviation of greyscale values of all pixels in a page.
Y-axis = entropy calculated over greyscale values of all pixels in a page.

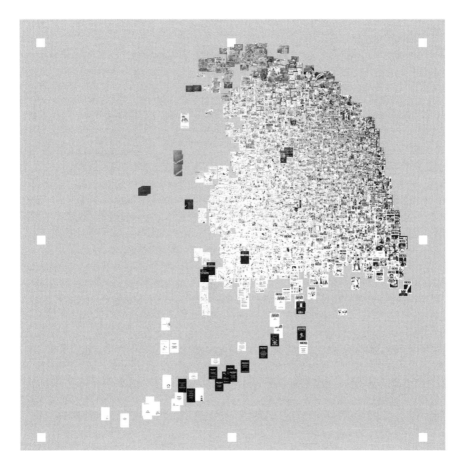

Figure 14.15 9,745 *One Piece* pages.
X-axis = standard deviation of greyscale values of all pixels in a page.
Y-axis = entropy calculated over greyscale values of all pixels in a page.

Projecting sample pages from the two series into the same coordinate space helps us to better understand the similarities and the differences between their graphical languages. The visualisations show that along the two visual dimensions used, the distinctions between the languages of the two series are quantitative rather than qualitative. That is, the 'point cloud' of *Naruto* pages significantly overlaps with the 'point cloud' of *One Piece* pages along both the horizontal and the vertical axes.

Both series cover a large range of graphical possibilities: from simple black-and-white pages with minimal detail and texture (lower part of each visualisation) to the highly detailed and textured (top part). But the centre of *One Piece* point cloud is slightly higher than the centre of *Naruto* point

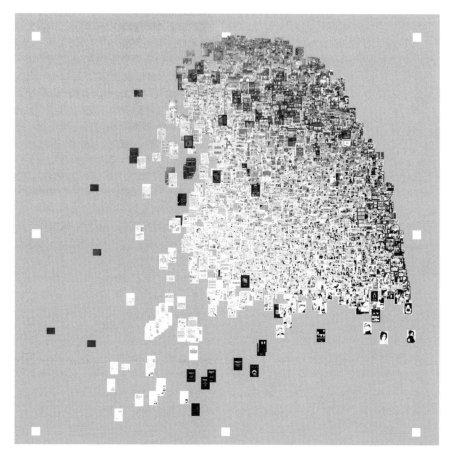

Figure 14.16 8,037 *Naruto* pages

X-axis = standard deviation of greyscale values of all pixels in a page.
Y-axis = entropy calculated over greyscale values of all pixels in a page.

cloud. This means that *One Piece* has more pages that have more textures and details.

Visualisations also reveal the significant differences in the graphical variability between the two series. *Naruto*'s 'point cloud' is much more disperse than *One Piece* 'point cloud' both on horizontal and vertical dimensions. This indicates that *Naruto*'s visual language is more diverse than the visual language of *One Piece*. (We already saw a similar difference when we compared *Abara* and *NOISE* – but now we are seeing this in a much larger data set.)

We can also examine the stylistic development of these long series over the time of publication in the same way used for much shorter *Abara* and *Noise*.

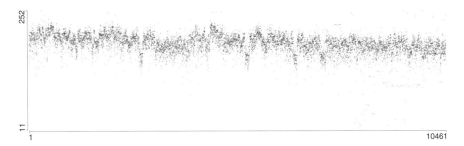

Figure 14.17 9,745 *One Piece* pages

X-axis = page position in publication order (left to right).
Y-axis = mean of greyscale values of all pixels in a page.

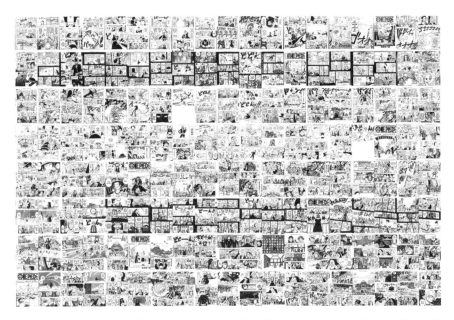

Figure 14.18 A close-up of the complete set of *One Piece* pages arranged in a grid in publication order (left to right, top to bottom)

Figure 14.17 plots 9,745 *One Piece* pages left to right in the order of publication; the vertical position is determined by page brightness mean.

Since we now dealing with thousands of pages in 562 weekly chapters published over 12 years, we can discuss temporal patterns at number of scales. On the scale of years, *One Piece* mean values gradually drift over the whole time period. Within this overall almost linear pattern, we see periodic rises and falls that reverse direction anywhere between 7 and 13 months. Thus, we get the answer to the question we asked earlier when we compared three sample pages

drawn from the fifth, two-hundredth, and four-hundredth chapters – *how* does the visual language of *One Piece* change over time?

The visualisation also shows how some patterns may not be visible if we only use a small number of pages. The three pages we looked at earlier missed the periodic drops in brightness values we can see when we plot all pages. The dips correspond to the parts of the narrative which place the panels over black background, as can be seen in the close-up of the earlier montage of all *One Piece* pages (Figure 14.18).

Visualising complete manga image set (1,074,790 Pages)

We can now finally provide an answer to the question in the chapter's title: how to see one million images? Using the same measurements and axes assignments (X-axis = standard deviation: Y-axis = entropy) as we did in the plots of individual titles and series, we visualise our complete set of one million pages (Figure 14.19). (Of course we can also organise this image set in many other ways using many other measurements – this is just one possible mapping.)

One million pages cover the space of graphical possibilities more broadly and with more density than *Naruto* or *One Piece* alone. In between the four graphical extremes corresponding to the left, right, top, and bottom edges of the pages 'cloud', we find every possible intermediate graphic variation. This suggests that manga's graphic language should be understood as a continuous variable.

This, in turn, suggests that the very concept of *style* as it is normally used may become problematic when we consider very large cultural data sets. The concept assumes that we can partition a set of works into a small number of discrete categories. However, if we find a very large set of variations with very small differences between them (such as in this case of one million manga pages), it is no longer possible to use this model. Instead, it is better to use visualisation and/or mathematical models to describe the space of possible and realised variations.

The fact that image plots of a one million manga pages data set make us question the very basic concept of humanities and cultural criticism is at least as important as any particular discoveries we can make about this data set. It illustrates how computational analysis of massive cultural data sets can transform our theoretical and methodological paradigms used to understand cultural processes.

Defamiliarisation with computers

Our methodology relies on standard techniques of digital image analysis which started to be developed already in the second part of the 1950s and are now everywhere – in digital cameras, image-editing software such as Photoshop,

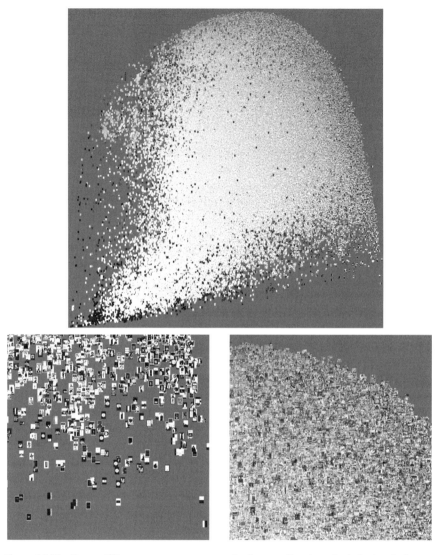

Figure 14.19 One million manga pages organised according to selected visual characteristics

Top image: complete visualisation.
Bottom image: close-up of the bottom part (left) and a close-up part (right).
X-axis = standard deviation of greyscale values of all pixels in a page.
Y-axis = entropy calculated over greyscale values of all pixels in a page.

Notes:
1) Some of the pages – such as all covers – are in colour. However, in order to be able to fit all images into a single large image (the original is 44,000 x 44,000 pixels – scaled to 10,000 x 10,000 for posting to Flickr), we rendered everything in greyscale.
2) Because pages are rendered on top of each other, you don't actually see one million distinct pages – rather, the visualisation shows a distribution of all pages with typical examples appearing on the top.

automated factories, medical imaging, and all science fields which use images as sources of data (from astronomy to biology). However, when we adopt these techniques as tools for cultural research, we should be clear about how they analyse images and what it means in general to see through computer 'eyes'. Since this chapter is focused on motivating and explaining our method in general terms, we would only make one observation. When we look at images normally, we experience all their visual dimensions at once. When we separate these dimensions using digital image analysis and visualisation, we break this gestalt experience. Being able to examine a set of images along a singular visual dimension is a powerful mechanism of defamiliarisation ('ostranenie') – a device for seeing what we could have not noticed previously. If avant-garde photographers, designers, and filmmakers of the 1920s such as Rodchenko, Moholy-Nagy, Eisenstein, and Vertov were defamiliarising the standard perception of visible reality using diagonal framing and unusual points of view, now we can use software to defamaliarise our perceptions of visual and media cultures.

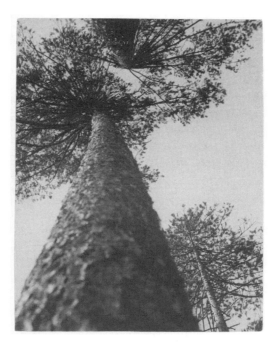

Figure 14.20 Alexander Rodchenko, Pine Trees in Pushkin Park, 1927 (gelatin silver print)

Acknowledgements

Software Studies Initiative research reported in this article was made possible by the generous support provided by California Institute for Telecommunication and Information (Calit2), Center for Research in Computing and the Arts at UCSD (CRCA), and Chancellor Office of University of California, San Diego (UCSD). The development of the custom digital image analysis software and the processing of manga image set on supercomputers at the National Energy Research Scientific Computing Center (NERSC) was funded by Humanities High Performance Computing Award 'Visualizing Patterns in Databases of Cultural Images and Video' (NEH/DOE, 2009). The development of ImagePlot software was funded by a Digital Startup level II grant (NEH, 2010).

Credits

The visualisations and data analysis and visualisation tools developed by Software Studies Initiative are the result of systematic collaborations between the key lab members: Lev Manovich, Jeremy Douglass, William Huber, and Tara Zepel. HyperSpace software for interactive media visualisation was developed by So Yamaoka (Gravity lab, Calit2). Batch image processing tools were developed by Sunsern Cheamanunkul (PhD student, Computer Science and Engineering Department, UCSD).

References

Salt, B. (1974), 'The Statistical Style Analysis of Motion Pictures', *Film Quarterly* 28(1): 13–22.

Salt, B. (1992), *Film Style and Technology: History and Analysis* (London: Starword).

Cha, M. et al. (2007), 'I Tube, You Tube, Everybody Tubes: Analyzing the World's Largest User Generated Content Video System'. 2007 ACM Internet Measurement Conference. Web. Accessed 17 July 2011. http://an.kaist.ac.kr/traces/papers/imc131-cha.pdf.

Cinemetrics.lv. Barry Salt's Database. Web. Accessed 17 July 2011. http://www.cinemetrics.lv/satltdb.php#cm.

Crandall, D. J. et al. (2009), 'Mapping the World's Photos'. 18th International Conference on World Wide Web, 2009. Web. Accessed 17 July 2011. www.cs.cornell.edu/~dph/papers/photomap-www09.pdf.

Douglass, J., Huber, W., and Manovich, L. (2011), 'Understanding Scanlation: How to Read One Million Fan-Translated Manga Pages'. *Image and Narrative* 12(1): 190–228. Brussels. Web. http://lab.softwarestudies.com/2010/11/one-million-manga-pages.html.

Herring, S. et al. (2006), 'A Longitudinal Content Analysis of Weblogs: 2003–2004', *Blogging, Citizenship and the Future of Media* (London: Routledge).

IMDb. *IMDb Database Statistics*. Web. Accessed 17 July 2011. http://www.imdb.com/stats.

Kwak, H. et al. (2010) 'What is Twitter, a Social Network or a News Media?' The 19th International Conference on World Wide Web, 2010. Web. Accessed 17 July 2011. an.kaist.ac.kr/~haewoon/papers/2010-www-twitter.pdf.

Software Studies Initiative (2011), ImagePlot. Open source software for visualization of large image and video collections. Web. http://lab.softwarestudies.com/p/imageplot.html/

McLoud, S. (1993) *Understanding Comics: The Invisible Art* (Northampton, MA: Kitchen Sink Press).

Manovich, L. (2009), 'Cultural Analytics: Visualising Cultural Patterns in the Era of "More Media"', *Domus* Spring 2009. Web. http://lab.softwarestudies.com/2009/06/publications.html#CA_Publications.

Manovich, L. (2010), 'Media Visualization: Visual Techniques for Exploring Large Media Collections', In K. Gates (ed.), *Media Studies Futures* (Blackwell, forthcoming 2012). Accessed 17 July 2011. Web. http://manovich.net/DOCS/media_visualization.2011.pdf.

Moretti, F. (2000) 'Conjectures on World Literature', *New Left Review* 1 (2000): 55–67. Accessed 17 July 2011. Web. http://www.newleftreview.org/A2094.

Peters, C. (ed.) (2006), *MultiMatch: Technology-Enhanced Learning and Access to Cultural Heritage*. D1.1.3 – State of the Art report section. Accessed 17 July 2011. Web. http://www.multimatch.eu/docs/publicdels/D1.1.2.pdf.

Williams, D. et al. (2009), 'The Virtual Census: Representations of Gender, Race and Age in Video Games', *New Media & Society* 11: 815–34.

Yamaoka, S. et al. (2011), 'Cultural Analytics in Large-Scale Visualization Environments', submitted to *Computer Graphics Forum*.

15
Cultures of Formalisation: Towards an Encounter between Humanities and Computing

Joris van Zundert, Smiljana Antonijevic, Anne Beaulieu, Karina van Dalen-Oskam, Douwe Zeldenrust, and Tara L. Andrews

Introduction

The past three decades have seen several waves of interest in developing cross-overs between academic research and computing; molecular biology is often cited as the prime exemplar of 'what computation can do for a field'. The humanities and social sciences have also been the terrain of such interactions, at times through bottom-up collaborations, and at times through concerted policy-driven efforts (Wouters and Beaulieu 2006). The main developments vary across national contexts and disciplines. In our local context (in the Netherlands), we can roughly identify the following waves: the 'history and computing' and 'literature and computing' efforts of the 1970s and 1980s; the collaboratory and infrastructure discussions of the last decade; the current efforts at developing computational humanities, and recent emphasis on virtual research environments (VREs) of which Alfalab[1] can be regarded as an example.

Efforts to introduce computational methods typically involve collaborative work between scholars and engineers and the combination of their complementary skills and expertise. Along the lines of Traweek (1988) and Knorr-Cetina (1999), we consider such collaborations as encounters between 'epistemic cultures', that is to say, particular combinations of meanings, material arrangements, and practices that organise an area of scholarly work. In this chapter we focus specifically on formalisation, and we use an analytic metaphor, 'cultures of formalisation', as a means to highlight the epistemic variety underpinning formalisation practices in different epistemic cultures. We argue that critical reflection on formalisation practices is important for any computational program to succeed, and that this is of particular importance in the humanities domain – foremost because experience shows that rigid prescriptive heuristics

and mandatory explicit formalisations, if uncritically imposed from a computational paradigm, generally do not 'land well' in different humanities research communities. While both computational sciences and humanities can be intrinsically characterised by their epistemological and methodological openness to complexity and uncertainty, their sensibilities as to what is acceptable in terms of heterogeneity of method and approaches often do not overlap. By conceptualising and describing cultures of formalisation in the humanities, we can also identify aspects of research that could be better supported if suitable and compatible computing approaches are developed. An approach that stresses cultures of formalisation can therefore also enrich the computing research agenda, and contribute to more symmetrical and constructive interactions between various stakeholders in computational humanities.

From these initial observations, our exploration takes on three forms. First, we propose to look more closely at formalisation and to question whether it is a singular concept. Second, we ask whether formalisation is also an aspect of research in the humanities, even without (necessarily) thinking of it as driven by computation, and we present four case studies that help us explore that question. Finally, we consider how our analysis enriches what can be understood by formalisation, and what kind of light it throws on the encounter between computing and humanities. In the final section we consider how our explorations and findings influenced developments within Alfalab.

What is formalisation in humanities computing?

Formalisation is highly recognisable as a basic principle underpinning the logic of computation. This has led to the perception that any computational approach in the humanities should be rooted in formalisation as well. Repeated failed attempts at deploying computational approaches in the humanities have then been attributed to the lack of formalisation, and, in the worst cases, even the lack of apprehension of formalisation by humanities scholars. Indeed, at first blush it may seem evident that formalisation of humanities research heuristics and hermeneutics is closely tied to the rise in computational efforts. But it is a fallacy to posit that formalisation is a new development in humanities, driven solely by computation. In music theory, for instance, a trend toward formalisation has been present since the 1960s, prompting an increased interest of computer scientists and psychologists in musicology, rather than the other way round (Honing 2006). Such examples support our argument that formalisation is not a newly emerging element in humanities research and, moreover, that methods of formalisation can facilitate interdisciplinary scholarship. Rather than simply a necessary and straightforward condition for computation, formalisation is a rich and productive concept to think about computation, the humanities, and their encounters.

If formalisation is a key component of humanities computing, what form does it take? As noted above, there is a strong tendency in computing to emphasise the importance of formalisation in order to deploy computational approaches – that is to say, to point to the need to explicitly define properties of research objects. Yet we also find formalisation in other aspects of computing in humanities research. Data-sharing also demands formalisation: formalisation of notions of authorship and ownership of data; the formalisation of research methods; and the formalisation of annotations (see Arzberger et al. 2004; Beaulieu 2003). Formalisation is therefore far from a homogeneous standard of quality. It is not an elusive status of epistemic purity to be attained by research objects before they can be 'computed'. So why does formalisation seem to come to the forefront so prominently in the context of interactions between humanities and computing?

One of the probable reasons is that encounters between different fields tend to throw difference into relief. The need to explain, to make explicit what one does and how, will tend to highlight processes of articulation, which are related to formalisation. But, while formalisation has been around implicitly in humanities research, making certain kinds of formalisation explicit through the use of computational methods appears as an almost hostile act within some of the humanities domains. We posit that this is because the kind of formalisation that is put forward as a necessary condition for computing is *only one kind of formalisation*, currently dominant in computing but far from universal across research domains. By paying attention to this mismatch in kinds of formalisation, we can see the underlying reasons for resistance or, as is more often the case, indifference, of scholars to computational tools that are proposed.

In order to illustrate these points, we now turn to four examples of formalisation in different humanities domains. These case studies show the distinct approaches, modes, and realisations of formalisations that exist and emerge in various humanities projects taking a computational turn.

Case studies

Our case studies are pursued in the framework of Alfalab and in various institutions inside and outside the Royal Netherlands Academy of Arts and Sciences, including the Virtual Knowledge Studio for the Humanities and Social Sciences and the University of Oxford. Alfalab functions as a meeting point for these various endeavours, enabling encounters that, in turn, can foster critical reflection on our respective projects.

Hypothesising history

In the preparatory phase of research Joris van Zundert and Tara Andrews are carrying through, the objective is to explore the possibilities of computationally

inferring and visualising the hypothesis dependency structure that underlies argumentation in historical interpretation.

Historical reconstruction, particularly for medieval periods, rests on scraps of evidence, surmises about its quality and biases, and attempts to fit it into a framework of what we think we know. Elaborate hypotheses must be built to explain our evidence, many of which require intricate argumentation that depends on other hypotheses. These feats of historical analysis can be deeply impressive and thorough (e.g. Dédéyan 2003) but at the same time very dangerous. How can historians assess the full extent of the impact of a new piece of evidence, such as evidence of a market economy found in an area 'known' to have suffered a 'dark age', when it challenges assumptions that have been part of the basis for our understanding of the entire period (cf. Auzépy 2007)? As 'generations' of interpretation build layer upon layer of hypotheses, the complete supportive structure of hypotheses becomes too complex to 'compute' fully, even for the finest minds. Problems of contradictory interpretation due to conflicting structures of hypothesis within one and the same synthesis are a demonstrable result of this complexity.

Our work is therefore a supportive analytical task. It seeks to infer explicitly the relations between hypotheses and to evaluate the internal consistence of the hypothesis dependency trees. This task could be a very valuable addition to the method of aggregative argumentation and interpretation, which is at the core of research heuristics in historical studies. It is also a task that could be highly facilitated through a computational approach. For instance, analysis techniques like topic maps (cf. Bock 2009) and/or rhetorical structure theory (cf. Mann 1986) can readily be applied to describe or visualise argument dependency trees. However, to be able to apply these techniques, we need specific forms of hypothesis and argument formalisation, both of which can be viewed as complex tasks of data curation. We need to be able to capture the hypothetical argumentation in a way that is both simple to apply and unambiguous to a dependency-computing algorithm. Unfortunately, such means of expressing argumentative structure are still a rather abstract form. Instead of taking the form of the original text, the argumentative structure is represented in the form of a series of symbols capturing the argumentative statements and the formalised relations between those statements.

Relevant to the subject of this chapter is the preliminary observation that the process of formalisation and the knowledge of logic involved seem to be non-tangible and actually rather inhospitable to researchers in the field of history. Formalisation of both argumentative structure and the 'surface structure', that is, the very personal idiolect and style of the argumentative text, evokes feelings of 'meddling' with the core capacity, competence, method, and techniques of the researchers. From the computational perspective, however, these formalisations are merely descriptive, and they serve no other purpose than to

compute and visualise the prior hypotheses upon which an argument depends, empowering the researcher to self-evaluate and infer the soundness of argument. At the same time, it is self-evident that the process of transcribing an argument structure from painstakingly stylised idiolect into a computable form is an alienating process for the researcher, not least because idiolect is arguably one of the strongest identifiers of 'self' there is. This is why formalisation in this case creates the risk of resistance and distrust within the targeted research community (historians, in general, and Byzantinists, in the prototype phase of the research, in particular). Furthermore, in order to make formalisation a useful activity, historians need to trust formalisation and not perceive it as an alienating research practice. This will only be achieved if formalisation does not appear as an intrusive process and daunting activity for those researchers. This could be accomplished, for example, by utilising – or even creating – much higher-order computing languages than usually applied. However, this requires computational engineers to recognise form and representation as important factors in establishing trust and enabling unobtrusive formalisation.

The onymic landscape

Names are so common in our daily lives that we tend to overlook them. Still, names are often a cause for laughter, teasing, and – worse – discrimination. Expecting parents take an enormous amount of time and energy in deciding how to name their child. Individuals sometimes change their own names. And, occasionally, names of cities or streets are changed. Such examples show that names are more than just tools for discriminating or referencing entities. Their very characteristics make names a subtle stylistic tool in literary texts too. Often an author can create an idea or certain expectations of a character in a story just by mentioning a name. Tension can be created by mistakes in names, or by the introduction of aliases, which are only solved at the appropriate time (from the storyteller's point of view). Names can imply a geographical and/or social background of characters. In the case described here, Karina van Dalen-Oskam aims to analyse the usage and functions of names in literary texts from a comparative point of view, that is, between texts, oeuvres, genres, time periods, and even languages (Van Dalen-Oskam 2005). The first results of the research will become available in 2011.

The study of names in literature is a sub-discipline of onomastics (name studies). Until recently, research in literary onomastics was very eclectic, only pointing out 'significant' names in a literary work and describing their role in the text(s). About a decade ago, scholars started to emphasise the need to look at all the names in a text (or oeuvre, or genre, etc.) and to analyse the so-called onymic landscape. Only with such an analysis can we be sure which names are really significant and have an extra role in the plot of the story, as motive- or theme-bearing stylistic elements.

This, however, is easier said than done. It takes too much time for one researcher to reconnoiter a large onymic landscape. This has to be done by many scholars, and they need to approach their data in a comparable way in order to make their 'mapping' useful for each other. There are no useful software tools yet for this type of work, which is why creating such tools is part of the Alfalab endeavour. It may seem that names are easy to find in texts, and that usage of tools such as those for named entity recognition and classification (NERC) could make such research very easy. But this is not the case. Tools for NERC usually focus on one language only, and for that language on just a few text types, mainly texts from specific topic areas or from newspapers. Even then, the maximum success rate only occasionally exceeds 80 per cent (Sekine and Ranchhod 2009). Literary texts contain many sorts of name types, so several NERC tools would have to be applied before getting a result that still needs a lot of manual cleaning up.

The comparative literary onomastic research Van Dalen-Oskam conducts will look into the frequency and function of names occurring in literary texts. It will also observe the ratio of types of names (e.g. personal first and family names, place names, etc.). To enable comparative analysis, scholars working on different texts will have to follow the same rules. This of course constitutes a kind of formalisation. A deceptively simple challenge, the formalisation of identifiable properties of names and their uses, is in fact a cumbersome task. For example, the most common names in literary texts are personal names. These can be divided into first names, bynames, and surnames. Scholars will usually agree on what category a name belongs to, but what to do with classical names such as Julius Caesar? Julius was not a first name and Caesar not a family name. We can agree about 'Jesus' being a name, but what about 'God'? The second most frequent name type, place names, is also relatively easy to agree on. But is Niagara Falls a location (so a place name) or an object? Several other categories are denoted as being names in theory, for example, currencies and time indications, or as names in one usage while not in another (van Langendonck 2007). But such categories are probably not very relevant to a literary analysis of the texts. And on top of that, scholars would need extensive training before being able to spot these correctly. So these will be excluded from the comparative literary onomastic research. Part of this project therefore involves finding the right degree of formalisation, to do justice to the research goals at hand, to make use of the potential of tools to support comparative analysis, and to maintain the feasibility of the endeavour.

Microtoponymy

Microtoponym is a term used for names of small to very small entities in both natural and human-made landscape. Imagine, for example, a small field called

'the Gallows'. It may very well be that the name is not even formally designated in any land registry but is only known and used by the local population. Such microtoponyms are part of the object of research and formalisation in yet another pilot of the Alfalab project, called GISLab. This specific exploratory research is interested in applications of Geographical Information Systems (GIS) as a suitable platform for humanities research.

Within the broad spectrum of the humanities, the study of onomastic variation, and in particular the study of place names, or toponymy, may come across as a very specialised niche. But microtoponyms are actually of interest to historians, historical geographers and archaeologists, among others. In the Netherlands, researchers from different disciplines agree that having the Meertens Institute collection, which contains more than 170,000 microtoponyms and their geospatial parameters digitally available, would facilitate and open up new avenues of research in various subjects (Zeldenrust 2005).

Regarding the topic of this chapter, it is useful to point out that in the process of digitising and utilising a legacy consisting of 170,000 physical index cards, systematically recording toponyms and their metadata, formalisation indeed does play a role on several levels: determining functional requirements of the GIS by interviews and studying prior work; development and implementation; and so on. However, the microtoponym case study is less about formalisation in the sense of making heuristics explicit. It is more about formalisation at the level of the objects of research, which, through being formalised and situated in a digital context, can offer new research possibilities.

The following example may serve to clarify the previous statement. In the Dutch context, Schönfeld's book, *Veldnamen in Nederland,* or *Microtoponyms in the Netherlands* (Schönfeld 1950), provides a usable starting point for onomasticians concerned with microtoponyms. However, although Schönfeld's work is still a standard in its field, it was written in 1949, long before anyone envisioned a field called computational humanities. The computational approach and interdisciplinary character of the microtoponym virtual research environment (VRE) that will be established through Alfalab could enhance the present onomastic community and create a new interdisciplinary one. Therefore, an a priori focus on descriptive or prescriptive formalisation based on recognised yet superseded theory would potentially hinder the exploration of new and cross-disciplinary possibilities. On the other hand, explicit generic formalisation would also be hard to achieve. For example, since the visual aspects of a GIS specifically allow researchers to make their own interpretations of certain maps *separately* from other researchers' interpretations, their actual method of interpretation can remain fully implicit. The advantages of formalisation in this case have to do with opening up the possibilities for interacting with microtoponyms as digital objects in a VRE.

The empirical image

This case study concerns the use of Flickr as used by researchers who explore graffiti and street art.[2] The case study focuses on the constitution of Flickr as a resource and means of interaction between researchers and empirical material. In every field there is an accepted way of constituting one's object of research, and this aspect of research is a key dimension of epistemic cultures.

Best known as a photo-sharing platform, Flickr can also be used to build a personal archive of photos, to browse material uploaded by (un)known others, or to engage in a wide variety of activities around photos. Flickr has several features of 'ongoing sociability' (Fuller 2003) typically associated with social networking sites. It enables users to represent themselves and to articulate links to other users and the content they upload. Furthermore, Flickr, like other social networking platforms, makes use of traces generated by use of the system and its content, a defining feature of Web 2.0 applications.

The researchers studied in this case are mostly (visual) sociologists or anthropologists, who focus on urban and/or material culture. Among the huge variety of photos on Flickr, urban photography and the documentation of urban life is a prevalent theme (Petersen 2009). All of the researchers use photography as part of their research practices, which they define as 'fieldwork'. Through interviews, email exchanges, analysis of articles and other output, and the researchers' use (or, in one case, vehement non-use) of Flickr, this case study is able to characterise how Flickr is used in relation to empirical material in the researchers' work.

Researchers use Flickr as a source to throw further light on material they have gathered in their fieldwork, by connecting different bits of empirical material. This use resembles searching, browsing, and 'googling' on the Web, but more specifically in relation to visual material and to street culture, for which Flickr is an especially good source. Visual material is also notoriously under-served by search engines, which are oriented to textual, (and even ASCII) material.

This use of Flickr depends on the presence of material from huge numbers of contributors, and, significantly, on the use of recognisable tags or labels. Tagging and labelling subtend formalisation of content, meaning, or significance of aspects of images. While often done without much conscious effort, the seemingly banal gestures of tagging and labelling are important practices that facilitate the constitution of Flickr material as empirical sources. Consider that most of these researchers have very strong feelings about the use of captions for their photos, and condemn these as parasitic textual practices that undermine the narrative power of the visual material. Yet all of them assign titles and tags to their photos on Flickr. These are usually summary, but, nevertheless, they label the photo with a transcription of the 'tag' text (i.e. the 'name' of the writer of a graffiti or artist). Locations are also often used as tags. This labour in turn enables Flickr to function as a searchable

source. Tagging is a recursive practice in these settings: one can deliberately use popular tags for one's photos in order to generate 'views'. This recursive aspect shapes the constitution of categories and modes of organisation of this material.

This case study illustrates how visual material is made usable through formalisations that involve textual labels, which are useful to some extent for researchers – and certainly interesting as an emergent phenomenon. But this reliance on textuality is far from desirable for some researchers (Beaulieu, de Rijcke and van Heur 2012). Visual formalisations that do not rely on text would highlight different aspects of this empirical material for researchers. This is a case that suggests how computational approaches might be developed to better serve researchers' needs in relation to their empirical material. Possibilities to formalise image data in ways other than textual labelling, and to make them empirically useful to humanities researchers, would be a valuable contribution of a computational approach.

Conclusion

If any computational humanities program is to succeed, the policymakers, organisers, and implementers of such programs should take into account how formalisation is put forth and what is understood by formalisation. We have presented four cases that show the highly varied modes and realisations of formalisation in humanities research. The case of van Zundert and Andrews ('Hypothesising history') predominantly focuses on technical and cultural aspects in formalising properties of a research object. The research of van Dalen ('The onymic landscape') draws attention to the formalisation of the heuristics of a specific research domain. Zeldenrust ('Microtoponymy') demonstrates that formalisation can lead to more freedom, not less. Finally, the case of Beaulieu ('The empirical image') calls attention to emergent formalisation as a driver for the development of a computational approach, rather than the other way round, thereby tapping into the creative potential created by reversing the dominant dynamic. These different modes of formalisation are connected to, but not singularly driven by, current computational practices. Formalisation manifests itself as a multi-faceted, multi-directional and multi-motivated complex of activities, not as a simple, unitary principle underlying computational approach.

The case studies presented in this chapter also illustrate that formalisation can be supported by computation, if we recognise formalisation as an integral part of humanities practice and not as a feature driven only by computation. Such an understanding can be used to align technology and tool development efforts more usefully to the needs and ambitions of researchers. Furthermore, by recognising and articulating different modes of formalisation, computational

science can enrich its own research agenda, further expanding its ambitions in terms of what computation can mean.

Furthermore, if we identify and describe 'cultures of formalisation', researchers will have a more explicit means to recognise practices of formalisation in their own and other humanities domains. In other words, researchers will be able to 'look over the walls' and identify both implicit and explicit formalisation practices in different humanities domains. Such a recognition of different modes of formalisation would enable researchers to interact with each other's modes, allowing them to cross-fertilise different knowledge domains. From there, a community or network of researchers could develop to enhance and to foster awareness of formalisation practices as a value-added means for the humanities.

Finally, in examining promises and challenges of computational methods in general and formalisation in particular, two points should be taken into account. First of all, the ongoing computational 'waves' and 'turns' should not steer the research community away from maintaining and promoting the traditions of humanities in contemporary scholarship. Computational humanities should be unequivocally recognised as only one stream of contemporary humanities research. Perpetuating claims about potency and ubiquity of computational methods, while regarding non-computational scholarship as conservative, creates resistance towards methodological and epistemological innovation. Such claims also obscure the fact that not all questions in humanities research can and should be approached by way of some unified computational analysis. The variety of cultures of formalisation illustrated in this chapter highlights that there is no single golden road to computation.

Secondly, an interplay among computation, formalisation, and humanities should not be light-heartedly considered as yet another way of doing humanities research. Such an interplay is rather more about cognition than about method (cf. Brey 2005): 'when the computer functions as an enhancement of human cognition … human and computer are best regarded as a single cognitive unit, a hybrid cognitive system that is part human, part artificial, in which two semi-autonomous information-processing systems cooperate in performing cognitive tasks' (Brey 2005: 392). Understanding the cognitive interplay of computational systems and human users is important for analysis of formalisation in humanities research. The 'computational turn' does not involve 'just' a specific formalisation of research hermeneutics; it possibly also involves a specific formalisation of the research thought process. However, the community of computational humanists seems to shy away from such a view, and instead seems to specifically highlight methodological and epistemological aspects of formalisation. Yet recognising the cognitive and affective aspects of scholarship (Antonijevic, Dormans, and Wyatt 2012) could help us understand some of the reasons for the resistance towards computational methods that

still prevails. Such an understanding would also help acknowledge scholars' right to not compute, and to decide which turn to take.

Epilogues: connecting cultures of formalisation

The main conclusion of our case studies is that any computational humanities program that is to succeed should take into account how formalisation is put forth, and what is understood by formalisation in the various subfields of the humanities. The cases studies demonstrated wide epistemic variety in humanities research, and, subsequently, the co-existence of diverse formalisation practices in the humanities disciplines. In this final section, we document how we have endeavoured to put the insights presented in the chapter into practice.

The case studies presented in this chapter are all linked to the Alfalab project (http://alfalablog.knaw.nl/), and this is not coincidental. One of the objectives of Alfalab has been to foster interdisciplinary collaboration, foremost by developing and applying computational means suited to research interests of the research settings involved. However, fostering interdisciplinary collaboration might be a goal more easily set than achieved. An implicit consequence of such interdisciplinary efforts is that various epistemic cultures will meet and will need to interact within a project. This has been the case in Alfalab. There we have become aware of methodological and epistemological differences among researchers involved in the project, and of the need for explicit attention for such differences and for flexibility in shaping the project. As a result, we adapted the implementation of Alfalab. It was initially envisioned as a generic Web-based humanities laboratory – a computational infrastructure project, within which a variety of generic tools and databases would be available (Van Zundert 2009). In this sense, the initial plans for Alfalab could be compared to those underlying other humanities-oriented infrastructural initiatives, such as Project Bamboo (Bamboo 2011), DARIAH (Dariah 2011), and CLARIN (Clarin 2011). These projects primarily aim for shared digital infrastructures, as an explicit pre-condition for the successful application of computational approaches in the humanities. However, the research partners in Alfalab realised that developing a shared infrastructure could not, by itself, bring about interdisciplinary or collaborative research. Alfalab needed a way to connect more closely the common digital infrastructure and particular research questions posed by involved research communities. In order to achieve this, we adopted the concept of tailored virtual research environments (VREs).

In Alfalab, a virtual research environment came to be defined as a set of tools tailored to facilitate a specific research workflow over a distributed digital infrastructure that transcends institutional borders (Zeldenrust 2010). In current digital humanities practice, a VRE typically combines three types of digital

tools. The first type comprises digital communication facilities such as mailing lists, wikis, RSS feeds, video, and chat functions. The second type, used alongside the first, enables researchers to access and/or create data within a VRE. Third, a VRE will likely offer tools to analyse digital research data, and possibly to visualise the results of analyses (Early Modern 2011).

Although some of the VREs are quite generic, others opt to adapt to the research of the research communities involved. Such specific tailoring of a virtual research environment usually derives from the recognition that different epistemic cultures apply different methodologies, heuristics, and epistemological approaches. In Alfalab, we found that offering the same, generic infrastructure to all of the researchers included in the project did not facilitate successful integration and implementation of computational methods. Again, infrastructure was a prerequisite, but in itself it could not sustain a vibrant research community focused on using digital resources to engage with a certain research topic. Such engagement could only result from digital resources that served the specific purpose of the researchers involved, and that corresponded to the epistemological and methodological approaches of those researchers.

For that reason, Alfalab has chosen to opt for more differentiated, rather than generic, computational approaches. We have created three demonstrator virtual research environments targeted at three specific research approaches pursued by networks of researchers. The resulting three VREs are TextLab, GISLab, and LifeLab. TextLab is built around text-oriented research. It comprises a text transcription tool to capture digitally the text of physical documents that cannot be digitised by automated means such as optical character recognition. The tool has elaborate facilities to structure, comment, index, and publish digital editions of text sources. GISLab is a VRE geared towards curation and analysis of geospatial data. It involves, among other features, a Web-based facility to pinpoint locations in old maps onto a modern geospatial grid, hence relating historical geospatial information to current reference points. LifeLab opens up census and life course data from a variety of databases to the use of, for example, scholars interested in historical life course analysis and historical economics. Currently, LifeLab does this by making it possible to select datasets for specific variables out of the whole collection. These specific datasets can then be analysed, for example, with statistical means.

Around all three demonstrator projects, Alfalab has organised workshops and is providing various forms of documentation. These serve to familiarise targeted researchers with tasks and workflows that can be achieved by combining Web-based and other digital tools. Workshops also serve to tailor the tools and workflows more closely to the needs of researchers involved.

Last but not least, an expertise group called InterfaceLab has been developed in the course of Alfalab. The work of the InterfaceLab has been to ensure that, as much as possible, VREs were developed through effective

collaboration between humanities researchers, computer scientists, and science and technology studies experts. Collaboration across these epistemic cultures did not occur spontaneously or effortlessly. The InterfaceLab has developed and deployed a variety of strategies to stimulate and enhance this collaborative work among researchers in Alfalab and to support the interactions with the digital humanities community and potential users. Among these are the development of shared understandings of research agendas, of data/tool coupling, and of researchers' needs when working in digital settings. These are detailed on the Alfalab portal, and in various publications – indeed, the analysis in this chapter is an illustration of the kind of work stimulated and supported by this part of the project. Through these sustained interactions in Alfalab, mutual learning and sharing of experiences has taken place. The success of Alfalab can therefore be traced to the expertise of participants in their respective field, to the feedback cycles implemented by the InterfaceLab, and to the ongoing stimulation of critical reflection on the processes of translations going on within the project. As such, the outcomes of Alfalab are equally the mechanisms for interaction set up in and around the project as well as the specific VREs developed.

Alfalab has endeavoured to develop digital resources that not only acknowledged specific research needs, but also recognised different epistemic cultures and types of formalisation applied by those research communities. The project thus incorporated lessons learned from the case studies presented in this chapter, and was able to put forward digital resources useful for specific research groups. However, this did not mean that the goal of fostering interdisciplinary collaboration was also realised. Acknowledging the variety of methods and epistemologies involved in Alfalab helped us to recognise that more generic computational approaches would not suit our purposes. But did it also enable us to identify successful properties for interdisciplinary digital collaboration?

Comparing different heuristics and epistemic approaches among partners involved in the Alfalab project provided an insight that it would be very hard to come up with an easy solution, or natural 'fit', for facilitating interdisciplinary collaboration within a VRE. But reflecting upon those heuristics explicitly and in a comparative manner also revealed certain commonalities in concepts and workflows. It became obvious that, if the project was to offer a successful route to interdisciplinary digital resources and collaboration, we should target those commonalities and try to create shared digital functionalities on the basis of these.

One such commonality appears to be the concept of annotation. Researchers involved across a range of different disciplines represented in the project seem to value annotation. The specific forms of annotation may be different (recall the tension between textual and visual material in the Flickr case study above) but the basic concept is not; for the scholars involved, annotation is the act

of enriching or interpreting research data. In TextLab, this might result in textual notes explicitly related to certain text fragments. In GISLab, annotation could imply identifying certain locations with registered microtoponyms. In other words, the 'act of annotation' can be regarded as a common interface among researchers involved in the project. Although formalisation in these different research settings may differ, the concept of annotation travels across epistemic communities. From the information science viewpoint, such concepts can be useful handles for leveraging computational approaches. For Alfalab annotation was one of the axes along which its interdisciplinary digital infrastructure could be built. We have therefore cross-referenced annotations across the three demonstrator virtual research environments. For this purpose a fourth demonstrator was conceptualised as a cross-demonstrator annotation discovery tool. The implementation of this demonstrator will consist of a repository that harvests annotations from the 'back ends' of the other three demonstrators. Annotations will then be categorised, and a user interface for exploration of these annotations will be provided. The implementation is modeled after the principles of the Open Annotation Collaboration (OAC 2011) and Linked Data initiatives (Linked Data 2011). Currently, this annotation exploration demonstrator is a centralised and snapshot-based tool for data discovery. Ideally this will become a real-time active annotation alerting system. In future developments, we hope that, for instance, a researcher who annotates 'Amsterdam' in a text in TextLab might be alerted that GISLab contains annotations on 'Amsterdam' from the same period as the text's publication year.

The current results achieved in Alfalab show how recognition and careful consideration of differences in cultures of formalisation can facilitate development of useful and applicable digital resources for humanities research. Analysis and reflection on such cultures pre-empts the risk of naive strategies for pushing technology to unreceptive researchers. Such reflections can also lead to the identification of conceptual commonalities across different sets of research heuristics that appear to be good leveraging points for computational approaches.

Although this is a promising beginning, Alfalab is a time-limited project, and it has explored the variety of formalisation practices in humanities research only within this limited project scope. In order to network virtual research environments that support various heuristics and formalisation practices in humanities research successfully, we need far more explicit knowledge of epistemic cultures in the humanities (Wouters et al. 2012). As the Alfalab example shows, the active coupling of this knowledge to the development of new research practices and new tools would provide the greatest benefits for projects and initiatives developing digital infrastructures for humanities research.

Notes

1. Several institutes of the Royal Netherlands Academy of Arts and Science (KNAW) have joined forces in a cross-institute project named Alfalab (see http://alfalablog. knaw.nl/). All authors of this chapter are members of the Alfalab team. The KNAW has also set up a committee to develop a program of research on Computational Humanities; Beaulieu and van Zundert are members of the program committee.
2. The material presented here is part of an ongoing ethnographic project, Network Realism, pursued at the Virtual Knowledge Studio for the Humanities and Social Sciences, Amsterdam by Sarah de Rijcke and Anne Beaulieu. See the project blog: http://networkrealism.wordpress.com/.

References

Antonijevic, S., Dormans, S., and Wyatt, S. (2012), 'Working in Virtual Knowledge: Affective Labor in Scholarly Collaboration', in P. Wouters et al. (eds), *Virtual Knowledge* (Cambridge, MA: MIT Press).

Arzberger, P., et al., (2004), 'Science and Government: An International Framework to Promote Access to Data', *Science* 303(5665): 1777–8.

Auzépy M., (2007), 'State of Emergency (700–850)', in J. Shepard (ed.), *The Cambridge History of the Byzantine Empire c.500–1492* (Cambridge: Cambridge University Press, 251–91).

Bamboo (2011), http://projectbamboo.org/. Date accessed 7 February 2011.

Beaulieu, A. (2003), 'Annex 1, Case Study of Data Sharing at the fMRI Data Center, Dartmouth College, USA', in *Promoting Access to Public Research Data for Scientific, Economic, and Social Development, Final Report,* OECD Follow Up Group on Issues of Access to Publicly Funded Research Data.

Beaulieu, A., de Rijcke and van Heur, S. (2012), 'Authority and Expertise in New Sites of Knowledge Production', in P. Wouters, et al. (eds) *Virtual Knowledge* (Campbridge, MA: MIT Press).

Bock, B., et al. (2009), *Automatic Extraction of Topic Maps based Argumentation Trails* (Leipzig: Topic Maps Lab). http://www.topicmapslab.de/publications/automatic_ extraction_of_topic_maps_based_argumentation_trails?locale=en. Date accessed 7 February 2011.

Brey P. (2005), 'The Epistemology and Ontology of Human-Computer Interaction', in *Minds and Machines* 15(3–4) (Hingam: Kluwer Academic Publishers, 383–98).

Clarin (2011), http://www.clarin.eu. Date accessed 7 February 2011.

Dariah (2011), http://www.dariah.eu. Date accessed 7 February 2011.

Dédéyan, G. (2003), *Les Arméniens entre Grecs, Musulmans et Croisés: étude sur les pouvoirs arméniens dans le Proche-Orient méditerranéen (1068–1150)* (Lisbon: Fundação Calouste Gulbenkian).

Early Modern (2011), http://www.earlymoderntexts.org/VRE_What/index.html. Date accessed 7 February 2011.

Fuller, M. (2003), *Behind the Blip: Essays on the Culture of Software* (Brooklyn, NY: Autonomedia).

Honing, H. (2006), 'On the Growing Role of Observation, Formalisation and Experimental Method in Musicology', in *Empirical Musicology Review* 1(1), 2–6.

Knorr-Cetina, K. (1999) *Epistemic Cultures: How the Sciences Make Knowledge* (Cambridge, MA: Harvard University Press).

Linked Data (2011), http://linkeddata.org/. Date accessed 7 February 2011.

Mann, W. C., and Thompson, S. A. (1986), *Rhetorical Structure Theory: Description and Construction of Text Structures* (Nijmegen, NL: Information Sciences Institute).

Petersen S. M., (2009), *Common Banality: The Affective Character of Photo Sharing, Everyday Life and Produsage Cultures*, PhD thesis (Copenhagen: IT University of Copenhagen).

Schönfeld, M. (1950), *Veldnamen in Nederland* (Amsterdam: Noord Hollandsche Uitg. Mij.).

Sekine, S., and Ranchhod, E. (2009), *Named Entities: Recognition, Classification and Use* (Amsterdam/Philadelphia: John Benjamins).

Traweek, S. (1988), *Beamtimes and Lifetimes: The World of High Energy Physics* (London: Harvard University Press).

van Dalen-Oskam, K. H. (2005), 'Vergleichende literarische Onomastik', in A. Brendler and S. Brendler (eds), *Namenforschung morgen: Ideen, Perspektiven, Visionen* (Hamburg: Baar, 183–91). English translation: K. H. van Dalen-Oskam (2011), 'Comparative Literary Onomastics'. http://www.huygensinstituut.knaw.nl/vandalen. Date accessed 7 February 2011.

van Langendonck, W. (2007), 'Theory and Typology of Proper Names', W. Bisang (ed.), *Trends in Linguistics: Studies and Monographs* 168 (Berlin/New York: Mouton de Gruyter).

oac (2011), http://www.openannotation.org. Date accessed 7 February 2011.

Wouters, P., and Beaulieu, A. (2006), 'Imagining e-Science beyond Computation', in C. Hine (ed.), *New Infrastructures for Knowledge Production: Understanding e-Science* (London: Idea Group, 48–70).

Wouters, P., et al. (eds) (2012), *Virtual Knowledge* (Cambridge, MA: MIT Press).

Zeldenrust, D. A. (2005), 'DIMITO: Digitization of Rural Microtoponyms at the Meertens Instituut', in *Humanities, Computers and Cultural Heritage* (Amsterdam: Royal Netherlands Academy of Arts and Sciences, 301–7).

—— (2010), 'Spheres of Alfalab, Virtual Research Environments between Research Questions and Infrastructure' (Vienna: SDH 2010).

van Zundert, J. J., Zeldenrust, D. A., and Beaulieu, A. (2009), 'Alfalab: Construction and Deconstruction of a Digital Humanities Experiment', in *e-Science 2009, Fifth IEEE International Conference on e-Science* (Oxford, 1–5).

16

Transdisciplinarity and Digital Humanities: Lessons Learned from Developing Text-Mining Tools for Textual Analysis

Yu-wei Lin

Introduction

In recent years, with the emergence of Information and Communication Technologies (ICTs) and other social and political factors, national and international research funding councils have increasingly emphasised that research in the humanities should engage with data-intensive and evidence-based academic activities, as those in natural sciences and engineering do. As stated in the description of the cross-nation and cross-discipline 'Digging into Data Challenge' programme,[1] a call for 'data-driven inquiry' or 'cyber-scholarship' has emerged as a result of hoping to inspire innovative research methods, to transform the nature of social scientific enquiry, and to create new opportunities for interdisciplinary collaboration on problems of common interest.[2]

New types and forms of data, whether it be born digital data, transactional data, digitised historical records, archived administrative data, linked databases, or data generated or shared by Internet users, are all considered to be valuable input for research. And in order to facilitate access to and process such a massive amount of data, information technologists and computer scientists have been involved in constructing high-throughput, high-performance computing, grid computing, or cloud computing for research in the humanities. e-Research (or Cyber-Infrastructure in the United States) has been proposed as an umbrella term to describe such computationally enabled science that allows researchers from distributed locations and diverse backgrounds to access, discuss, analyse data, and work together. That said, such a shift to large-scale networked infrastructures for supporting research not only highlights 'big data'

and computational data analysis methods, but also suggests the importance of research collaboration across disciplines. The 'Digging into Data' programme sponsored by eight international research funders also shows that research funders have recognised that the complexities of subjects in society are beyond what a single discipline can deal with, hence interdisciplinary or multidisciplinary collaboration is needed. To address these challenges, research councils have been encouraging social scientists to adopt collaborative approaches, to share and re-use data, to explore and exploit mixed methods, and to develop innovative methods. To these ends, not only have various novel e-Research tools and services been created over the past years, but also a growing number of large-scale collaborative interdisciplinary research projects have been funded.

The development and implementation of these e-Research tools have signified and signalled a dramatic *computational turn* in conducting research in humanities. Digital humanities has been heralded as the future of humanities research. e-Research programmes often emphasise interdisciplinary and/or multidisciplinary (Schroeder and Fry 2007). Although to some extent these existing observations are valid, I will argue in this paper that the kind of digital humanities facilitated by e-Research tools, if widely adopted, is in fact transdisciplinary, a step further than multidisciplinary or interdisciplinary. The realisation of transdisciplinary research can be illustrated through looking at the process of developing text-mining tools for social and behavioural scientists in the case study to be introduced below. I will discuss the challenges and implications of such transdisciplinary research in light of this case study. The empirical case study provided here also contributes to the ongoing and long-standing discussion about interdisciplinariy and transdisciplinarity.

Before introducing the case study that demonstrates the development process of text-mining e-Research tools, I will provide some context for and elaborate what I mean by transdisciplinarity.

Transdisciplinarity

Many terms have been proposed over the past decades (arguably since the 1960s) to conceptualise contemporary scholarly activities. Inter-, multi-, and transdisciplinarity are the three widely recognised categories used to measure, analyse, or identify interdisciplinarity in actual research efforts (Huutoniemi et al. 2009). They suggest approaches that differ from existing disciplinary norms and practices.

Multidisciplinary and interdisciplinary research has been growing over the last four decades. They are not new concepts in scientific research. In his seminal work, *The Social and Intellectual Organization of the Sciences*, published in

1984, Whitley argued that, in addition to what they study empirically, scientific fields are shaped and affected by the degrees and types of *mutual dependence* and *task uncertainty* they possess (Whitley 1984: 88).

The New Production of Knowledge, by Gibbons et al. (1994) proposes a Mode 2 knowledge framework which has had far-reaching influence, especially in setting out an EU research agenda. It is said that three prerequisites are needed to produce Mode 2 knowledge: a context of application to allow knowledge transfer, transdisciplinarity, a diverse variety of organisations and a range of heterogeneous practice, reflexivity, an analogical process where multiple views in the team can be exchanged and incorporated (Gibbons et al. 1994; Hessels and van Lente 2008). Mode 2, which is context-driven, problem-focused, and transdisciplinary, involves multidisciplinary teams with heterogeneous backgrounds working together. This differs from traditional Mode 1 research that is academic, investigator-initiated, and discipline-based knowledge production. Nevertheless, to mark the distinction of Mode 2, transdisciplinarity is the key, and according to Hessels and van Lente (2008), it 'refers to the mobilisation of a range of theoretical perspectives and practical methodologies to solve problems' and goes beyond inter-disciplinarity in the sense that the interaction of scientific disciplines is much more dynamic' (2008: 741).

Whitley's theory of '*mutual dependence*' and '*task uncertainty*' and the Mode 2 theory proposed by Gibbons et al., and philosophical and sociological discussion on the production of scientific knowledge (now often termed 'science and technology studies – STS', e.g., Latour and Woolgar 1979; Knorr-Cetina 1982; Latour 1987; Klein 1990) have inspired many scholars to explore how interdisciplinarity, multidisciplinarity, crossdisciplinarity, or even transdisciplinarity approaches (Flinterman et al. 2001) are perceived and performed in different research fields, particularly in computer-supported environments. For instance, Barry et al. (2008) have conducted a large-scale critical comparative study of interdisciplinary institutions based on ethnographic fieldwork at the Cambridge Genetics Knowledge Park, an Internet-based survey of interdisciplinary institutions and case studies of ten interdisciplinary institutions in three areas of inter-disciplinary research: a) environmental and climate change research; b) the use of ethnography within the IT industry; and c) artscience. Fry (2003, 2006), whose research aims to understand similarity and difference in information practices across intellectual fields, has conducted qualitative case studies of three specialist scholarly communities across the physical sciences, applied sciences, social sciences, and arts and humanities. Schummer (2004) examines the patterns and degrees of interdisciplinarity in research collaboration in the context of nanoscience and nanotechnology. Mattila (2005) studies the role of scientific models and tools for modelling, and re-conceptualises them as 'carriers of interdisciplinarity' that enable the making of interdisciplinarity. Zheng et al. (2011) examines the development process

of the United Kingdom's computing grid for particle physics (GridPP), a grid that is itself part of the world's largest grid, the Large Hadron Collider Computing Grid, within a global collaborative community of high-energy physics. Most of these studies use qualitative research methods (notably ethnography and interview) to produce case studies that focus on how members of a project that involves more than one discipline communicate, negotiate, and cooperate, instead of measuring quantitatively the degree of heterogeneity of knowledge combined in research.[3]

In a similar fashion, this case study, based on my participatory observation, offers another channel of getting to know prospective users and involving them in the process of tool development. This will not only contribute to the continued discussion of what constitutes interdisciplinary work; more importantly, through understanding how that work is organised in the field of social sciences and the humanities, it provides an empirical glance into transdisciplinarity and what it means by 'digital humanities'.

However, it has also been noted that to date there remains an incoherence in the usage of these terms, which are largely 'loosely operationalised' (Huutoniemi et al. 2009: 80). Fuzzy definitions of these words mean that these categories are 'ideal types only' and serve mainly for theoretical discussion. Given this, before going on to present the case study, it is useful to make clear the working definitions of inter-, multi-, and transdisciplinarity in this paper. For the purposes of this paper, interdisciplinarity is referred to as an approach that allows researchers to work jointly and to integrate information, data, techniques, tools, perspectives, concepts, and/or theories from two or more disciplines or bodies of specialised knowledge to tackle one problem. Multidisciplinarity, instead, allows researchers from different disciplines to work parallel with each other but still from disciplinary-specific bases to address common problems. Transdisciplinarity radicalises existing disciplinary norms and practices and allows researchers to go beyond their parent disciplines, using a shared conceptual framework that draws together concepts, theories, and approaches from various disciplines into something new that transcends them all (Rosenfield 1992: 1351).

Here, for the purpose of this chapter, I have adopted Hessels and van Lente's interpretation of Mode 2, that is, 'the trans-disciplinarity proposed by Gibbons et al. implies more than only the cooperation of different disciplines' and 'co-evolution of a common guiding framework and the diffusion of results during the research process' are central to transdisciplinary research (Hessels and van Lente 2008: 751). Against this framework, disciplines involved in interdisciplinary or transdisciplinary research possess richer dependency than those involved in multidisciplinary research. Therefore, it drives a closer investigation into how researchers in different disciplines interact and transform over a period of an interdisciplinary or transdisciplinary project.

Background of the case study

The case study below is based on an 18-month ethnography of an interdisciplinary collaborative project funded by a UK higher education funder.[4]

With the information overload and data deluge, to be able to locate information within a short period of time and to conduct literature review, collecting and analysing data smartly and efficiently is one of the important milestones of the next generation computational tools. In light of existing examples in natural and life sciences where scientists use text-mining and data-mining tools to identify continuities and discontinuities in large bodies of literature or data sets, the initial idea set out by the funder was to demonstrate the usefulness of text-mining for the purpose of facilitating knowledge discovery, elicitation, and summarisation in the humanities. If these techniques could be successfully applied to social scientific data, it was hoped that not only could the time-consuming and labour-intensive manual coding of qualitative data be replaced (at least to some extent), but also enable social scientists to explore larger amounts of such data in a shorter time.

The project was funded to customise a range of pre-existing text-mining tools for application in studies analysing newspaper texts to reveal how contemporary events and issues are framed to shape the perceptions of their readers. And in so doing, the demonstrator produced by the project would provide a use case to extend awareness and promote adoption of text mining across all social science disciplines.

The project was designated to be an interdisciplinary collaboration where the pilot social science users (hereafter 'domain users') work with text-mining developers (in short, text miners). Instead of developing everything from scratch, customising pre-existing tools would allow the developers to demonstrate the functionality and applicability of text-mining tools to target users as well as the funder in a relatively short period of time. The original plan included an activity that resembled the Turing test – a competition between the text-mining (artificial-intelligence-enabled) programs and ordinary human researchers to find out whether a computer can act 'more efficient and more accurate' than a person. This was to be a comparison between computer-generated results and human-coded ones. As some participants in such a Turing test have revealed (e.g. Christian 2011), the march of technology isn't just changing how humans live, it is raising new questions about what it means to be researching the humanities and reading texts. Similarly, as will be discussed below, this 18-month project turned out to be more than a feasibility study on the technicality and performativity of text-mining tools in the context of humanities research; more importantly, it shed light on a methodological change and a shift of disciplinary practices.

Through closely participating in the project as a project manager, pilot user, as well as an ethnographer, my ethnography produced first-hand

account of working with the stakeholders (including PI, co-Is, developers, other users, and the funder) as well as close observation of the dynamics emerging in the development process and interdisciplinary collaboration. The reflection from auto-ethnography and traditional participatory observation offer fresher insight into the actual work practices in the cross-disciplinary or interdisciplinary research projects for better understanding of how these text-mining computational techniques are actually implemented and situated in real-life projects.

Every development task and activity in this project, ranging from constructing a database/corpus for carrying out text-mining tasks and training the algorithms to meet the needs of the pilot users, selecting and filtering out meaningful human-comprehensible terms, to communications between different project partners, all suggest that text-mining or other e-Research tools do not emerge out of the blue; instead, their realisation is the result of a negotiation of different disciplinary methodologies, practices, epistemologies and sense-making. As such, implementing any e-Research tools like the text-mining ones discussed here would suggest the move towards a settled/agreed/presumed/prescribed way of conducting research. As we will see later, adopting text-mining tools insinuates a radical shift from allowing diverse methodologies and theories to co-exist in the arts and humanities (hermeneutic readings) towards pattern-matching, statistics-led, algorithm-based practices which favour a statistical modelling-based mining paradigm. Given that, text mining leads to a transdisciplinary paradigm shift.

What is text mining?

The state of art and the way 'text mining' is referred to is more than text search. According to M. Hearst, Professor in the School of Information at University of California, Berkeley,

> Text Mining is the discovery by computer of new, previously unknown information, by automatically extracting information from different written resources. A key element is the linking together of the extracted information together to form new facts or new hypotheses to be explored further by more conventional means of experimentation.[5]

According to the UK JISC-funded National Centre for Text Mining (NaCTeM),

> Text mining involves the application of techniques from areas such as information retrieval, natural language processing, information extraction and data mining. These various stages of a text-mining process can be combined into a single workflow.[6]

These explanations suggest that text mining is considered as a set of technologies for 'extracting more information than just picking up keywords from texts: names, locations, authors' intentions, their expectations, and their claims' (Nasukawa and Nagano 2001). It is so applied that IBM, for example, has developed it further into sentiment analysis that can be used in marketing, trend analysis, claim processing, or generating FAQs (frequently asked questions).[7]

Given that, text mining can be understood as an umbrella term for incorporating and implementing a wide range of tools or techniques (algorithms, methods), including data mining, machine learning, natural language processing, artificial intelligence, clustering, knowledge mining and text analysis, computational linguistics, content analysis and sentiment analysis and so forth, onto a large body of texts (usually an enormous collection of documents) to support the users' decisions-making. Just like Lego units, there is a set of components in the field that can be assembled and reconfigured for the purposes of the tasks of the domain users.

To illuminate what text mining can do, the text miners demonstrated some existing applications, notably in the biomedical field, to the social scientific domain users at the beginning of the project. One of the examples is similar to what Uramoto et al. (2004) developed – an application named MedTAKMI, which includes a set of tools extended from the IBM TAKMI (Text Analysis and Knowledge MIning) system originally developed for text mining in customer-relationship-management applications, for Biomedical Documents to facilitate knowledge discovery from the very large text databases characteristic of life science and healthcare applications. This MedTAKMI dynamically and interactively mines a collection of documents to obtain characteristic features within them. By using multifaceted mining of these documents together with biomedically motivated categories for term extraction and a series of drill-down queries, users can obtain knowledge about a specific topic after seeing only a few key documents. In addition, the use of natural language techniques makes it possible to extract deeper relationships among biomedical concepts. The MedTAKMI system is capable of mining the entire MEDLINE® database of 11 million biomedical journal abstracts. It is currently running at a customer site.

What is textual analysis?

The domain users, in turn, also demonstrated how textual analysis is usually conducted, and how, in this case, the analysis of newspaper content is carried out.

The analysis of newspaper texts has been widely adopted for investigating how texts[8] are explicitly or implicitly composed and presented to re/present certain events in various forms of mass media and to shape the perceptions or opinions of the information's recipients. It is a labour-intensive form of

analysis, typically relying on the researcher to locate relevant texts, read them very closely, often more than once, interpret and code passages in the light of their content and context, review the codes, and draw out *themes*. As a result, research projects are often restricted to corpora of limited size.

It is not novel to use computers to assist human analysts to conduct textual analysis. Computer-assisted qualitative data analysis software (CAQDAS) is a competitive market; there are many mature CAQDAS packages available (Koenig 2004, 2006). Although some claim that CAQDAS tools support mixed methods (i.e., combination of qualitative and quantitative methods; e.g., Bolden and Moscarola 2000; Koenig 2004, 2006), the requirement of a large amount of human labour in using CAQDAS for coding emphasises the importance of the more interpretative, qualitative elements of textual analysis. Given that the amount of textual social data is growing at an unprecedented speed, a scalable solution which can support automatic coding and clustering of text for the textual analysis of large corpora is desirable.

Developing text-mining tools for textual analysis

Despite the effort of establishing a dialogue between the domain users and the text miners in this interdisciplinary project, such mutual sharing seemed asymmetrical in this instance. The text miners were more interested in building up a large data set of textual data and acquiring the code book of the domain user who was conducting a research on how certain governmental agenda was re-presented in UK national newspapers. The reason why the text miners were so keen on acquiring the domain user's code book was because they needed to use that document to categorise some exemplary documents in the corpus that contains thousands of news articles. As we will see below, such an instrumental/pragmatic attitude of the text miners poses some issues in this interdisciplinary collaboration.

The process of the tool development can be described in the following steps:

Step 1: Scoping and data preparation

The process of knowledge discovery and data mining has never been straightforward; it involves many steps, and some of them are iterative and contingent (Kurgan and Musilek 2006). Data preparation (including scoping and data cleaning) is an important first step before processing the data (Fayyad et al. 1996).

This scoping stage allowed the domain users and the text miners to know the domain and the data better. Having the domain users on board meant that the interdisciplinary team could have some quick access to this body of knowledge.

The scoping stage also involved the identification of data sets. For the domain user who was carrying out a baseline textual analysis using a popular CAQDAS package, a rather typical social research process was followed – she began by identifying a suitable topic and research question. These activities later on informed her of the generation of a set of keywords, which were submitted as queries to the search engine of a digital archive of UK newspapers. A corpus, including all newspaper items (news, comment, letters, sports, and so on) containing the keywords/phrases, was built by using the search facility of this newspaper archive.

On the other hand, the text miners devised an algorithm to build a corpus of nearly 5,000 newspaper items (or 'documents') by extracting them from the same archive. This was an order of magnitude larger than the domain researcher's corpus because text-mining tools work best on large corpora.

What's also interesting is the way the two corpora were built. The human analyst and the text miner took different steps and actions when building these corpora. The smaller corpus was built by the human analysts with a goal of having 200 to 300 items in the corpus. The human analyst, bearing the research questions in mind, went through the articles that came up from the keyword searches one by one, judged, selected, and then included them in this smaller corpus. The interpretation started even before retrieving articles from the archive. Decisions on which topic to study, which type of data (newspaper or other printed media; national papers only or also tabloids) to look at, which keywords to search for, which way to collect data all flag important steps in research processes. In contrast to the human analyst's approach of building a small-but-beautiful quality data set after carefully reviewing the source of data, the text miner's indiscriminative method of building a corpus as large as possible signals a fundamental difference between the two. The text miner applied the same keywords that the human analyst used to retrieve data from the same database. Data retrieved, except for that from local newspapers, were all included in this larger corpus.

The inclinations to different corpus sizes of the domain users and the text miners is interesting. For the domain users, what corpus size should be considered as representative has mainly to do with one's research questions. But a text-mining/data-mining turn has made the size of a corpus independent of the research question. In fact, text miners usually claimed that some 'unexpected' clustering results might come out of the data, and this aids the limitation of human interpretation. The text miners claimed that a bigger corpora with more documents would allow users to reduce noise by ignoring common words that carry little contribution to the analysis. If users wanted to find (lexical) patterns, the larger the data set for training purposes the better. According to the text miners, a sensible clustering usually needs 2,000 to 4,500 documents (short articles with 10 sentences usually).

Step 2: Data analysis and training the algorithms

Once the smaller corpus – comprising 200 to 300 items – was constructed, the researcher undertook a 'traditional' textual analysis, reading the newspaper texts and analysing them in light of her review of related documents and policy statements, using a CAQDAS tool to manage the hermeneutic coding process, and identifying themes through an iterative process of re-reading the full articles and examining the coded segments of the texts. The quality of the analysis was assured by presenting the substantive results at conferences; all these were well received.

In order for the process of conducting the baseline textual analysis to feed requirements to the text miners, the domain researcher met with the text miners occasionally to brief them and demonstrate her use of CAQDAS. The domain researcher showed the text miner how she built her own corpus and how she used a CAQDAS tool to code it; the text miner showed the domain researcher what text-mining tools were available and how they functioned. Ethnographic notes were taken on most of these meetings. In addition to learning from each other, the domain users and the text miners attended a CAQDAS training course where several CAQDAS packages were introduced and their strengths and weaknesses were reviewed. It provided the text miners with an opportunity to extend their knowledge of how social scientists conduct qualitative research aided by CAQDAS packages, discover what kinds of data they commonly analyse and the databases available to them, how they import the data into the packages, and the extent to which the packages automate the process of hermeneutic coding. Lastly, the domain researcher also produced a short report on how coding was undertaken within the usage of the CAQDAS tool, and how themes emerged through inductive reasoning, together with a detailed codebook. These materials, produced by one single researcher, were used to train the text-mining tools to search the content of the documents in the corpus.

Step 3. Software development

One component in the text-mining tool set is automated term extraction, where a term in this context refers to a compound of two or more words (or lexical items). This tool automatically generates, for each document separately, a list of terms that are significant within it. The users had the option to select one of three levels of significance – high, medium, or low – and this affected the number of terms appearing in the list, the minimum being five or six of high significance.

Another text-mining tool clustered documents in the corpus by estimating the degree to which their content fit together. When the users entered a query on the system's search screen, the system returned a list of cluster titles on the left-hand side of the screen. Clicking on one of them brought up a screen listing all the documents relevant to the query phrase within that cluster.

A third text-mining tool was a named entity recogniser, that is, a tool to identify the names of, for example, people or organisations. The users had the option of displaying the named entities contained in all the documents returned by a search. These appeared in pre-defined groups such as country, location, person, and organisation.

A fourth component of this text-mining system was a sentiment analyser, which calculates a positive or negative score of each sentence in a document according to values pre-assigned to each word it contains. Sentences on the screen were shaded from dark through light green to light and then dark red to represent the magnitude of the positive through to negative score.

To develop these tools, the text miners attached tags (terms in the domain user's codebook) to a document or to a sentence so that meanings were inferred from a sentence or a document. Unlike the domain researcher's inductive way of coding, the text-mining method appeared to be deductive and positivist. For example, the domain researcher started from zero code, and as soon as she found something as she read, she created new codes. This was part of a process of 'reading'. This intuitive interpretative flexibility cannot be found in the text-mining process as it needs a text miner to infer a fixed meaning to the original documents in the large corpus.

At this stage, the text-miners worked mostly alone with few interactions with the domain users. The infrequent communication between the text miners and the domain users also suggests an asymmetrical relationship in this interdisciplinary collaboration. Social scientific expertise was brought in to meet the practical purpose of computing development. The relationship with the domain users was disconnected temporarily once the text miners collected enough information for their development, and this temporary decision of jointing and disjointing/rearranging domain disciplinary expertise during the course of the project poses a risk to the interdisciplinary collaboration in this project. That is, the team members had a lack of trust and limited understanding of each other's work.

Step 4. Iterative development

The development of these tools underwent a series of iterative and continuous development (including fine-tuning) to ensure the software returned the right documents and highlighted the right/meaningful phrases desired by the domain researchers. This stage involved a series of user trials to identify the shortcomings and increase the accuracy (quality) of the software. The domain users typed a keyword into the search field of the designated text-mining interface, which appeared like a Google search page, and inspected the returned documents and results. At the Alpha testing stage in the eyes of human readers the documents returned or the sentences highlighted by the software were inconsistent in terms of meaning and semantics. Often a word, a phrase, or

a sentence was highlighted, not because of its meaning in the context but because of its lexical meaning. It was challenging to produce coherent and mutually exclusive categories which required more remedial action at the pre-processing stage or at the mining stage.

When the results were unsatisfactory, the domain users wanted to know how the search results were produced, how relevance between words and phrases was calculated and perceived; whether it was because of word frequency or some other modelling techniques.

Impressions on text-mining in the humanities

Although the text-mining software system described above was incomplete, the project was proved to be an excellent feasibility study of the opportunities for, and threats to, extending text mining to the textual analysis of newspapers and more generally to qualitative social research.

The domain users in the interdisciplinary project found that the text-mining system provided a user-friendly entry into text mining, with the initial screen – the search interface – resembling mainstream search engines and the results appearing in a familiar layout: a paginated list of the titles of the returned documents, their authors and dates, and snippets from each document in which the query word or phrase was highlighted. However, the term extraction and clustering results were found wanting in two respects. First, users were reluctant to accept 'black-boxed' results; instead, they wanted to know how the terms were extracted and the clusters created by the text-mining tools, this knowledge being critical to their judgement of the validity of the results. This poses a quandary: the more complex the search algorithm, the more successful it is likely to be at classifying documents according to their main theme (summarised by a term), but the more difficult it is likely to be to explain how the algorithm works to a user who is not a text-mining expert. The current system, where no explanation was offered and the phrases used to represent the terms were often obscure, left users inspecting the contents of the returned documents in an attempt to infer why they were clustered according to a specific term. They then encountered the second problem: there were often several hundred documents clustered under one term and users found themselves opening each one and reading its contents. The potential efficiency of the system was therefore lost; users were reading large numbers of documents to ascertain their meaning, just as they would in a 'traditional' textual analysis. Moreover, the system lacked the data management aids common in CAQDAS packages, leaving users hampered by clumsy navigation.

During the development of the system, the performance of its term-extraction tool was improved by one single domain researcher applying her knowledge gained in the baseline study to evaluate and edit a long list of terms

generated by the software. It was an advantage to have a system that can be trained in this respect. However, it was a disadvantage to have the quality of the system's output dependent on the extent of the prior training effort put into it by a domain expert, although this would be mitigated if the subsequent users' confidence in the results were increased. In that case, quality assurance would be provided not by understanding how the term-extraction algorithm works but by knowing that a domain expert had trained the system to validly identify the main topics of each article.

In light of their experiences of using the system, the users reported that they could envisage a scenario in which document clustering would be valuable. This would be as a preliminary scan through a very large number of documents, because it would reduce the number to be inspected to those clusters that the investigators found of interest. Similarly, they reported that term extraction could be useful if it were based on a domain expert extensively training on the system in a preliminary study and then if it were used by others in a large-scale follow-up study. Alternatively, there might be scope to use both tools in the first stages of a new textual analysis to generate some preliminary ideas about topics appearing in a large corpus, though this would need to be followed by a 'traditional' textual analysis to examine the emerging ideas in full detail.

Although users found the named entity tool straightforward to use, and the results intuitively understandable, they reported that it had three limitations. The first was that it did not immediately appear to have any advantages over using a keyword search in a standard search engine or in a CAQDAS package, although they recognised that the advantages might become apparent were the tool used in research where its disambiguation functionality was particularly important. The second was that the names that appear in the categories were taken from a pre-defined dictionary and the tool would therefore miss some of the persons, organisations, celebrities, and so forth appearing in the newspaper texts. The third was that there is little social research in which identifying named entities contributed significantly to the interpretive analysis of qualitative data.

The sentiment analysis tool was also straightforward to use but it found little favour among social scientists because they were aware of too many issues about language use and sentence construction that undermine the validity of scores for each sentence based on the individual words it contains.

Overall, using this pilot text-mining system raised two fundamental issues. One is the question of what semantic content mined from texts would be most useful to qualitative social researchers. A case could be made for the terms extracted by the text-mining system but that would involve explaining the routines that calculate their significance. The other, related, issue is how to present the text-mining tools in a way that builds trust among domain researchers that the results are valid.

One of the potential benefits of the system was its capacity to process enormous amounts of texts very quickly. However, this benefit was compromised when searches produced terms that were accompanied by long lists of results spread over dozens, even hundreds, of screens. Only if the user had confidence in how the terms were extracted would she be willing to take the results at face value. Yet users' confidence in the extraction of terms (alternatively described as coding the qualitative data), which lies at the heart of all qualitative analysis, was normally built up through an iterative process of reading and re-reading the texts until the analyst felt that she had fully grounded the codes in an interpretive understanding of the texts, recognising that there is an inevitable relation between the phrases coded and the contexts in which they appeared. The semantically richer the analysis that is sought, the more effort is invested by the analyst in extracting meanings. In general, the more unstructured the texts and the less limited the domain, the more difficult the task is. This might be expressed as a continuum from (A) highly structured text about a limited domain to (B) very unstructured text about an almost unlimited domain. A might be represented by bioinformatics journal articles, for which many existing text-mining tools were developed, through newspaper texts to informal interviews, conversations and blogs, representing B. At A, quantitative measures such as word counts, word proximities, and so on might suffice to summarise the meaning of the text. At B, much more interpretive effort is required.

Although A to B has just been described as a continuum, it is a matter of continuing debate across numerous social science disciplines as to whether there is discontinuity or break somewhere between the two poles. In linguistics, this appears in the discussions of whether semantics can be captured through syntax; in social research it appears in the arguments about whether quantitative content analysis is fundamentally different from qualitative textual analysis.

Beyond interdisciplinarity: a methodological transformation and transdisciplinarity

In light of Barthes (1977), interdisciplinary research 'must integrate a set of disciplines so as to create not only a unified outcome but also something new, a new language, a new way of understanding, and do so in such a way that it is possible for a new discipline to evolve over time' (Fiore 2008: 254). Adopting this system for textual analysis indeed denotes transdisciplinarity as set out in the Mode 2 knowledge production framework, with a distinct problem-solving framework, new theoretical structures, and research methods or modes of practice to facilitate problem-solving (Gibbons et al. 1994). And this change involves what a discipline constitutes, basically 'the body of concepts, methods, and fundamental aims...[and] a communal tradition of procedures and

techniques for dealing with theoretical or practical problems' (Toulmin 1972: 142). Using text mining for textual analysis leads to transdisciplinarity where 'a shared, over-arching theoretical framework which welds components into a unit' exists (Rossini and Porter 1979: 70). However, given the state of art of text mining, this shift to transdisciplinarity raises some methodological and managerial challenges.

The fundamental methodological challenge derived from transdisciplinary is: to what extent is the theoretical and methodological framework shared and by whom?

To develop a text-mining system requires not only textual analysts (social scientists) but also text miners (computer scientists) to be on board. As for models and modelling in science, some hypotheses would be formed to be tested with some factors pre-assigned and pre-categorised. The algorithms in the text-mining system would have learned the specific knowledge (reading and interpretation) of specific domain experts who participated in the initial development, and analyse, organise, and sort data out lexically and statistically. The intuitive human semantics are artificially programmed and inferred. Whoever wishes to understand the newspaper texts will be relying on these specific sets of concepts and methods developed through a small team of computer and social scientists. Although it may be claimed that there are some benefits (e.g., processing large amounts of data within a very short time, increasing inter-coder reliability), this has not taken the interpretative flexibility of texts into account. The same texts can be looked at from different perspectives, through different means and frameworks. That said, others may not want to use these text-mining tools which were initially developed for a specific team of researchers who were investigating different research questions and bearing different agendas.

To avoid such conditions, text-mining tools for textual analysis would need to be situated in each individual research project. And that denotes the kind of small group 'team science' that Fiore (2008) describes. This kind of 'team science' is not to be confused with 'big science' with large-scale networked computing infrastructures. The vision of 'big science' is well presented in the current research policies and strategies that the research councils in Europe and North America have been making (Jankowski 2009). This tendency of generalising methods and theoretical frameworks in arts and humanities as in natural science and engineering is not new. Rob Kling, for example, is one of those prominent scholars who constantly reminded developers of 'field differences' and the shaping of electronic media in supporting scientific communication (Kling and McKim 2000).

Based on the findings from the above case study, the text-mining system embodied mostly an engineering-driven mindset. Had the system been available for wider adoption, the disciplines involved would all need to be integrated

and re-conceptualised. However, the disciplinary boundaries in the studied project remained rigid. Without integration and re-conceptualisation of disciplines, the mutuality and interaction will remain superficial even if a shared platform or tool has been developed.

With such a technology-driven attitude, future arts and humanities is facing a risk of being instrumentalised by big linked data sets and (semi-)automated data analysis tools (such as the text-mining ones portrayed in this paper). This seemingly asymmetrical and asynchronous assemblage of artificial intelligence for knowledge mining and knowledge discovery only privileges the knowledge that is held by a specific group of experts. And the knowledge that is summarised, in the context of the humanities, is not going to be widely shared. Inserting the perspectives and desires of those e-Scientists, notably from scientific domains such as genetics, physics, biology, and clinical medicine, into the humanities has caused uneasiness in domain experts, as Pieri (2009) writes: 'many social scientists and scholars in cognate disciplines remain apparently unaware or unimpressed by the promises of linking up large-scale data sets of fieldwork, and having access to the new tools and technologies that are being developed to cope with this scaling up of data set size' (2009: 1103). To balance this 'inescapable imperative' (Kling and McKim 2000: 1311) and avoid blackboxing (Bijker and Law 1992) the e-Science technology and techniques and exaggerating the expectations and applications, she calls for a discussion about the limitations and drawbacks of these e-Science infrastructures and tools, and to 'explore the extent to which these values are shared across sections of the research community, or the extent to which they may be specific of certain stakeholders only' (Pieri 2009: 1103). The need for transparentising debates and for negotiation of values in research policy-making is interconnected with the need for better communication (Fiore 2008; Bammer 2008). This leads to the managerial challenge that transdisciplinarity brings.

As emphasised in existing literature on interdisciplinarity, collaboration is a key to the success of such conglomeration (Fiore 2008; Bammer 2008). In 1979, Rossini and Porter proposed four strategies for integrating disciplinary components: common group learning, modelling, negotiation among experts, and integration by leader. More than three decades later, Bammer (2008) proposes three strategies for leading and managing research collaboration: 1) effectively harnessing differences; 2) setting defensible boundaries; 3) gaining legitimate authorisation. Reviewing the case study against these suggestions, organisational learning for harnessing the differences and negotiation among team scientists took place. However, despite the leadership from the Principle Investigator and his effort to energise the team from time to time, disciplinary integration appeared to be difficult and that hinders transdisciplinarity. Although it has been acknowledged by text miners that technical processes of data and text mining are highly iterative and complex (Kurgan

and Musilek 2006; Brachman and Anand 1996; Fayyad et al. 1996), text miners have paid relatively little attention to the dynamics in the collaboration processes between interdisciplinary team members. In our experience, the domain users and text miners found it difficult to communicate their own taken-for-granted background assumptions about the data and methods, and this was a marked hindrance to the project. To the domain users, the miners appeared instrument-oriented rather than user-centred. To the text miners, the users appeared interfering by wanting more explanation about the operation of their tools and their criteria for preferring one algorithm over another. To some extent, the lack of open communication between domain users and text miners worsened once problems were encountered. Positive results might have strengthened trust between the team members but early failure undermined it. This demonstrates that collaborative strategies are not incidental to interdisciplinary projects but central to their functioning.

Conclusions

Based on a case study of an interdisciplinary project that gathered text miners and textual analysts together to develop a text-mining system for analysing newspaper articles, this paper: 1) examines how different disciplinary expertise was organised, integrated, jointed, and disjointed at different stages of the development process; 2) extends existing examination of interdisciplinary practices specifically to the context of the digital humanities; and 3) discusses the methodological and managerial challenges emerging from a seemingly shift towards transdisciplinarity. Such a practice-based view echoes what Mattila (2005) argues: that interdisciplinarity is 'in the making' as in Latourian metaphor 'science in the making' (Latour 1987: 7). This case study has offered an episode that explores what had not been known yet – 'which does not carry ready-made definition or categorisations' (Mattila 2005: 533) about what text mining can do for arts and humanities.

More than four decades ago, Rossini and Porter (1979) noted that 'Interdisciplinary research lacks the collection of paradigmatic success stories which accompany nearly every disciplinary research tradition. Not only are specific strategies for integration lacking, but the notion of integration itself has not been well-articulated' (1979: 77) The case study has demonstrated that it is not straightforward to re-purpose text-mining tools initially developed for biomedical research and customise them for arts and humanities. Nor should the software development effort be underestimated. Nevertheless, the knowledge exchange and mutual sharing did take place between the text miners and social scientists to some extent.

As to the Turing test, who won in the end? The aim of this paper is not to judge whether text-mining-enabled automatic coding is more efficient than

human manual coding. As this work symbolises the beginning of digital humanities, any conclusion would be premature since we had by no means exhausted the options available. But, at the moment, in light of the experiences of some social scientists who use computer-assisted qualitative data analysis (CAQDAS) tools (e.g. Seale et al. 2006a, 2006b), show that even if coding processes can be automated by computers, human intelligence would still be needed to make sense of the results based on their research questions. While nobody could say that computers can replace human intelligence, efforts will continue to seek ways of harnessing what computers are good at – in particular, processing huge amounts of data systematically – to support social science research advances that would not otherwise be possible. And this will be a long-term commitment of observing how this shift towards transdisciplinarity in the humanities transpires.

Notes

This writing largely benefited from the insightful discussion I had with Prof. Peter Halfpenny, Elisa Pieri, and Dr. Mercedes Arguello-Casteleiro during the period when I worked at the coordinating hub of the ESRC National Centre for e-Social Science (NCeSS) at the University of Manchester from 2006 to 2009.

1. The 'Digging into Data' initiative, launched in 2009, is sponsored by eight international research funders, representing Canada, the Netherlands, the United Kingdom, and the United States. The second round of the competition took place in 2011. For more information please visit the website http://www.diggingintodata.org/.
2. See the 2011 Digging into Data request for proposals document at http://www.jisc.ac.uk/media/documents/funding/2011/03/diggingintodatamain.pdf.
3. Beaulieu et al. (2007) have questioned the surplus of (ethnographic) case studies on e-Science to date and urged a need for conceptualising and theorising existing cases, especially from a perspective of science and technology studies (STS). Parallel to this qualitative-based stream of research, quantitative research methods such as econometrics, statistics, or bibliometric methodology are also used in studying interdisciplinarity (e.g., Morillo et al. 2003; Schummer 2004).
4. The data has been anonymised due to research ethics.
5. http://people.ischool.berkeley.edu/~hearst/text-mining.html.
6. http://www.jisc.ac.uk/publications/briefingpapers/2008/bptextminingv2.aspx.
7. http://www.trl.ibm.com/projects/textmining/index_e.htm.
8. Textual analysis can be applied to a variety of forms of texts including visual, textual or audio. However, in this project, text-mining techniques are being applied solely to the written text.

References

Bammer, G. (2008), 'Enhancing Research Collaboration: Three Key Management Challenges', *Research Policy* 37(5): 875–887.
Barry, A., Born, G. and Weszkalnys, G. (2008), 'HYPERLINK "http://dx.doi.org/10.1080/03085140701760841" Logics of Interdisciplinarity', *Economy and Society* 37(1): 20–49.

Barthes, R. (1977), *Image Music Text* (London: Harper Collins).

Beaulieu, A., Scharnhorst, A., and Wouters, P. (2007), 'Not Another Case Study: A Middle-Range Interrogation of Ethnographic Case Studies in the Exploration of e-Science', *Science, Technology, & Human Values* 32(6): 672–92.

Bolden, R., and Moscarola, J. (2000), 'Bridging the Quantitative-Qualitative Divide: The Lexical Approach to Textual Data Analysis', *Social Science Computer Review* 18(4): 450–60.

Brachman, R. and Anand, T. (1996), 'The Process of Knowledge Discovery in Databases: A Human-Centered Approach', in U. Fayyad et. al. (eds), *Advances in Knowledge, Discovery, and Data Mining* (Menlo Park, CA: AAAI Press, 37–58).

Christian, B. (2011), 'Mind vs. Machine'. *The Atlantic*. URL: http://www.theatlantic.com/magazine/archive/2011/03/mind-vs-machine/8386/. Retrieved on 23 Apr 2011.

Fayyad, U., Piatetsky-Shapiro, G., and Smyth, P. (1996), 'From Data Mining to Knowledge Discovery in Databases', *AI Magazine* 17(3): 37–54.

Fiore, S. M. (2008), 'Interdisciplinarity as Teamwork: How the Science of Teams Can Inform Team Science', *Small Group Research* 39(3): 251–77.

Flinterman, J. F., Teclemariam-Mesbah, R., Broerse, J. E. W., Bunders, J. F. G. (2001), 'Transdisciplinarity: The New Challenge for Biomedical Research', *Bulletin of Science Technology* Society 21(4): 253–266.

Fry, J. (2003), *The cultural shaping of scholarly communication within academic specialisms* (Unpublished Ph.D. Thesis, University of Brighton).

Fry, J. (2004), 'The Cultural Shaping of ICTs within Academic Fields: Corpus-based Linguistics as a Case Study', *Literary and Linguistic Computing* 19(3): 303–319.

Fry, J. (2006), 'Scholarly Research and Information Practices: A Domain Analytic Approach', *Information Processing and Management* 42(1): 299–316.

Gibbons, M., Limoges, C., Nowotny, H., Schwartzman, S., Scott, P., Trow, M. (1994), *The New Production of Knowledge: the Dynamics of Science and Research in Contemporary Societies* (London: Sage).

Hessels, L. K. and van Lente, H. (2008), 'Re-thinking New Knowledge Production: A Literature Review and a Research Agenda', *Research Policy* 37: 740–760.

Huutoniemi, K., Klein, J. T., Bruun, H., & Hukkinen, J. (2010), 'Analyzing Interdisciplinarity: Typology and Indicators', *Research Policy* 39(1): 79–88.

Jankowski, N. (ed.) (2009), *E-Research – Transformation in Scholarly Practice* (New York: Routledge).

Klein, J. T. (1990), *Interdisciplinarity: History, Theory and Practice* (Detroit: Wayne State University).

Kling, R., and McKim, G. (2000), 'Not Just a Matter of Time: Field Differences and the Shaping of Electronic Media in Supporting Scientific Communication', *Journal of the American Society for Information Science* 51(14): 1306–20.

Knorr-Cetina, K. (1982), 'Scientific Communities of Transepistemic Arenas of Research? A Critique of Quasi-Economic Models of Science', *Social Studies of Science* 12: 101–30.

Koenig, T. (2004), 'Reframing Frame Analysis: Systematizing the Empirical Identification of Frames Using Qualitative Data Analysis Software', *Paper Presented at the Annual Meeting of the American Sociological Association*, Hilton San Francisco & Renaissance Parc 55 Hotel, San Francisco, CA, August 14, 2004.

Koenig, T. (2006), 'Compounding Mixed-Methods Problems in Frame Analysis through Comparative Research', *Qualitative Research* 6(1): 61–76.

Kurgan, L. and Musilek, P. (2006), 'A Survey of Knowledge Discovery and Data Mining Process Models', *The Knowledge Engineering Review* 21(1): 1–24.

Latour, B. (1987), *Science in Action: How to Follow Scientists and Engineers Through Society* (Cambridge, MA: Harvard University Press).

Latour, B. and Woolgar, S. (1979), *Laboratory Life: The Social Construction of Scientific Facts* (London: Sage Publications Ltd.).

Mattila, E. (2005), 'Interdisciplinarity 'in the making': Modelling infectious diseases', *Perspectives on Science* 13 (4): 531–553.

Morillo, F., Bordons, M., and Gómez, I. (2003), 'Interdisciplinarity in Science: A Tentative Typology of Disciplines and Research Areas', *Journal of the American Society for Information Science and Technology* 54: 1237–49.

Nasukawa, T., and Nagano, T. (2001). 'Text Analysis and Knowledge Mining System', *IBM Systems Journal* 40(4): 967–84.

Pieri, E. (2009), 'Sociology of Expectation and the e-Social Science Agenda', *Information Communication and Society* 12(7): 1103–18.

Rosenfield, P. L. (1992), 'The Potential of Transdisciplinary Research for Sustaining and Extending Linkages between the Health and Social Sciences', *Social Science Med.* 35(11): 1343–1357.

Rossini, F. A., and Porter, A. L. (1979), 'Frameworks for Integrating Interdisciplinary Research', *Research Policy* 8: 70–9.

Schroeder, R. & Fry, J. (2007), 'Social Science Approaches to e-Science: Framing an Agenda', *JCMC* 12(2) http://jcmc.indiana.edu/vol12/issue2/schroeder.html.

Schummer, J. (2004), 'Multidisciplinarity, Interdisciplinarity, and Patterns of Research Collaboration in Nanoscience and Nanotechnology', *Scientometrics* 59(3): 425–465.

Seale, C., Charteris-Black, J., and Ziebland, S. (2006a), 'Gender, Cancer Experience and Internet Use: A Comparative Keyword Analysis of Interviews and Online Cancer Support Groups, *Social Science and Medicine* 62(10): 2577–90.

Seale, C., Anderson, E., and Kinnersley, P. (2006b), 'Treatment Advice in Primary Care: A Comparative Study of Nurse Practitioners and General Practitioners', *Journal of Advanced Nursing* 54(5): 1–8.

Toulmin, S. (1972), *Human Understanding: Vol. 1. The Collective Use and Development of Concepts* (Princeton, NJ: Princeton University Press).

Uramoto, N., et al. (2004). 'A Text-Mining System for Knowledge Discovery from Biomedical Documents, *IBM Systems Journal* 43(3): 516–33.

Weingart, P and Stehr, N. (eds) (2000), *Practicing Interdisciplinarity* (Toronto: University of Toronto Press).

Whitley, R. (1984), *The intellectual and social organization of the sciences* (Oxford: Clarendon Press).

Zheng, Y., Venters, W., and Cornford, T. (2011), 'Collective Agility, Paradox and Organizational Improvisation: The Development of a Particle Physics Grid', *Information Systems Journal* 21(3): doi: 10.1111/j.1365–2575.2010.00360.x.

Index